Palaces of Art
Art Galleries in Britain 1790–1990

Dulwich Picture Gallery 27th November 1991 – 1st March 1992

The National Gallery of Scotland 12th March – 3rd May 1992

Cover: F. Mackenzie, *Principal of Original Room of the National Gallery*, 1834 (By permission of the Board of Trustees of the Victoria and Albert Museum)

Page 2: T.H. Shephard, engraved by A. Fox, *The Hunterian Museum*, c. 1820–30

Catalogue edited by Giles Waterfield.
© Dulwich Picture Gallery, London, 1991.

Photoset and printed in England by The Lavenham Press, Water Street, Lavenham, Sudbury, Suffolk CO10 9RN.

Distributed by Lund Humphries Publishers Ltd., 16 Pembridge Road, London W11 3HL.

ISBN 0 9501564 5 0

Lenders to the Exhibition

Agnew's, London
David Alexander, Esq.
Visitors of the Ashmolean Museum, Oxford
The Barber Institute of Fine Arts, The University of Birmingham
Birmingham City Museums and Art Gallery
Trustees of the British Museum
Christie's, London
Alec Cobbe Esq.
Fine Art Society, London
Fitzwilliam Museum, Cambridge
Guildhall Library
Government Art Collection
Hunterian Museum, University of Glasgow
James Holloway Esq.
Leeds City Art Galleries
London Library
Museum of London
Manchester City Art Gallery
Mappin Art Gallery, Sheffield
Matthiesen Gallery, London
National Gallery, London
National Galleries of Scotland, Edinburgh
National Museum of Wales, Cardiff
National Portrait Gallery, Archive and Library
National Portrait Gallery, London
National Trust (Wimpole Hall)
Private Collections Royal Academy of Arts
HM the Queen, Royal Library, Windsor Castle
British Architectural Library Drawings Collection/Royal Institute of British Architects
Ruskin Gallery, Sheffield
Sheffield Archives (Sheffield City Libraries)
Trustees of Sir John Soane's Museum
South London Art Gallery, London
University of Manchester (Tabley House Collection)
Tate Gallery Archives
Tate Gallery
Victoria and Albert Museum, London
Watts Gallery, Compton
Whitechapel Art Gallery, London
Williamson Art Gallery and Museum, Birkenhead

Palaces of Art

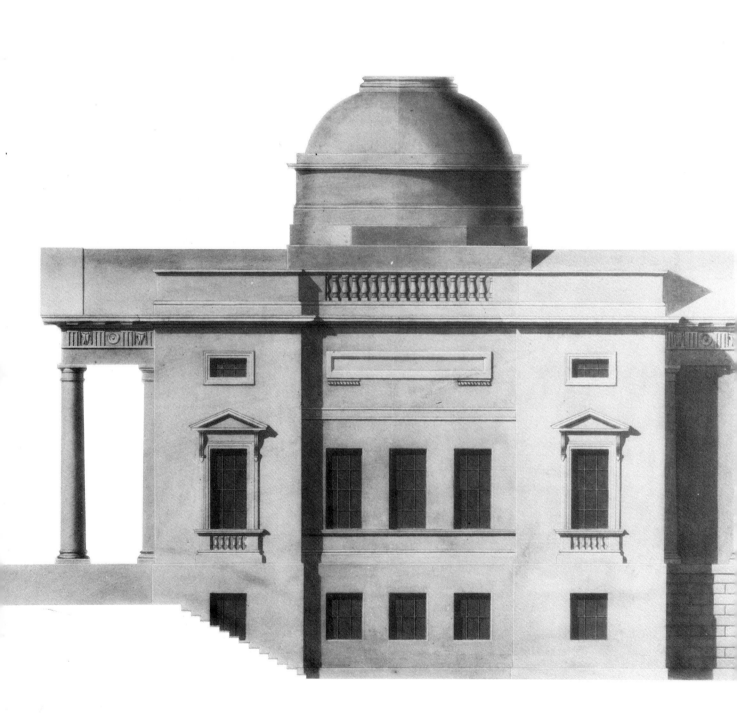

Contents

Sponsor's Foreword

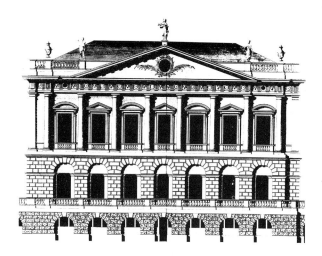

The role of the country house in Britain's artistic heritage has been studied exhaustively, but that of the private town palace and its successor, the public museum, has often been underestimated. However, the great aristocratic patrons of the eighteenth century understood the significance of the art collections which they formed. Their paintings and objects were potent symbols of power and prestige. The restoration and revitalisation of Spencer House have demonstrated how a great London house can be presented in the late twentieth century, giving an idea of how life was lived in the political, social and artistic salons of another age. It is a pleasure and a privilege to be associated, as sponsors of *Palaces of Art*, with an exhibition which does justice to a fascinating historical and aesthetic phenomenon.

Stephen Jones
Director, Spencer House

The sponsorship of *Palaces of Art* by Spencer House Limited has been recognised by an award under the Government's Business Sponsorship Incentive Scheme, which is administered by the Association for Business Sponsorship of the Arts.

Preface

As the oldest surviving art gallery, open to the public since its foundation, in England, Dulwich Picture Gallery seemed a most appropriate place to house an exhibition devoted to the architecture of art galleries, to the lighting and hanging of picture collections, and to the decoration of the rooms in which they are displayed. These are subjects that have stimulated much discussion over the past decade, and we believe that an exhibition on the theme will be not only historically useful but useful in practical terms to the many trustees and curators confronting the problems that their predecessors have battled with over the past two centuries. The showing of the exhibition at the National Gallery of Scotland is also extremely apt: not only is this one of the finest Neoclassical art galleries in Britain, but it has seen dramatic changes in its displays over the past few years.

We are delighted to acknowledge the generous sponsorship by Spencer House Limited. The recent renovation of Spencer House represents one of the most exciting restorations of a Palace of Art to be undertaken in this century, and we hope that as a result of this sponsorship public awareness of this magnificent building next to Green Park will be even further increased. Chartered surveyors Ryden have generously sponsored the exhibition in Scotland.

For their contribution towards the cost of producing the catalogue we are most grateful to the Trustees of the Royal Historical Society acting as Trustees of the Robinson Bequest, the Marc Fitch Fund, the Friends of Dulwich Picture Gallery, the Area Museums Service for South Eastern England, Lawrence's of Crewkerne and Patrick Matthiesen. The Paul Mellon Centre for Studies in British Art is generously supporting a symposium to be held in connection with the exhibition.

We have received much support and help from institutions to whom we have applied for loans; their interest in the exhibition is greatly appreciated. I would like to thank the staff of numerous libraries, museums and archives who have helped with my researches and with the preparation of this exhibition, and in particular Christopher J.

Allen, Janet Barnes, Valerie Batson, Mary Beal, Neil Bingham, Christopher Brown, Mungo Campbell, Peter Cannon-Brookes, Michael Clarke, Alec Cobbe, John Cornforth, Jane Farrington, John Fisher, Mireille Galinou, Antony Griffiths, Robin Hamlyn, Anna Harding, Ruth Harmon, Martin Hopkinson, Ralph Hyde, Peter Jackson, Richard Jefferies, Raymond Keaveney, Isabelle King, Tim Knox, Alastair Laing, Susan Lambert, Catherine Lampert, Jill Lever, Jeremy Maas, Andrew McIntosh Patrick, Jackie McComish, Sandra Martin, Douglas Matthews, Patrick Matthiesen, Sarah Medlam, Theresa-Mary Morton, Jane Preger, Margaret Richardson, Jane Roberts, Malcolm Rogers, Daru Rooke, Francis Russell, Nicholas Savage, Charles Sebag-Montefiore, Kenneth Sharpe, Joseph Sharples, Paul Spencer-Longhurst, Mary-Anne Stevens, Timothy Stevens, John Sunderland, Michael Tooby, Helen Valentine, Robert Venturi, Richard Verdi, Lucy Whitaker, Timothy Wilson, Alison Winter, Christopher Wood and Paul Woudhuysen.

The Museums and Galleries Commission has provided an indemnity for the exhibition in London and we are grateful to Gregory Eades for his help. The Scottish Office Education Department in Edinburgh has arranged the indemnity for the National Galleries of Scotland.

Thanks are due to all those who have contributed to the organisation of the exhibition, and in particular Sarah Agnew Forrester, Victoria Bethell, Kate Bomford, Lindsay Callander, Dick Richards, Dianne Stein, Peter Theobald, Tiffany Thomas and Barry Viney. Michael Clarke, Keeper of the National Gallery of Scotland, has coordinated the exhibition in Edinburgh. Stephen Fronk, acting as Exhibition Assistant, has made an indispensable contribution to all aspects of the exhibition.

Giles Waterfield
Director, Dulwich Picture Gallery

Timothy Clifford
Director, National Galleries of Scotland

Editor's Preface

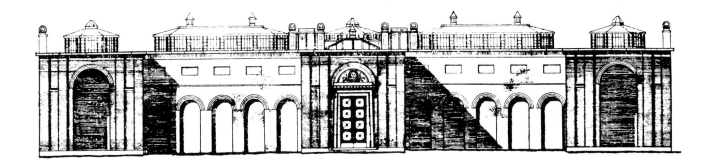

The last decade has seen a growing interest in the history of institutions associated with the arts, and in the development of museums and galleries, as well as much discussion over the design of new galleries and methods of picture display. This exhibition aims to provide a survey of this subject in Britain over the past two hundred years. It studies the history of art institutions, and the architecture of the galleries built to house and display paintings.

Although a small number of country houses and palaces are included in the exhibition to illustrate parallel developments in that field, the very large subject of the display of paintings in country houses is not studied. It is a history which deserves an exhibition of its own. Great London houses, which have received less attention and which exerted a considerable influence on the development of public galleries, do feature in the exhibition.

In dealing with such a large subject I have not tried to be comprehensive, and I must apologise in advance for any perceived omissions. My aim has been to suggest the principal developments in the history of art galleries, and to illustrate these with appropriate and fairly detailed examples. The recent appearance of various histories of individual museums means that much of the material has already been published, and I hope that this synthesis may be found useful. Short bibliographies have been provided for each section.

I am most grateful to all those who have contributed essays and entries for the catalogue: Colin Amery, Stephen Fronk, Ian Gow of the Royal Commission on the Ancient and Historical Monuments of Scotland, Robin Hamlyn of the Tate Gallery, Jane Roberts of the Royal Library, Windsor Castle, Nicholas Savage of the Royal Academy, and Elizabeth Wright of Partridge's. Stephen Calloway, Jeannie Chapel, Nicola Kalinsky, Margaret Richardson, Julian Treuherz, and David Watkin, have commented helpfully on the text. I am especially grateful to Michael Compton for the detailed help and advice that he has given me.

It has been particularly interesting to look at the history of commercial art dealers, and at the influence that they and the buildings that they erected have exerted on the art world in general. This is a subject that few people other than Jeremy Maas have studied, and I hope that this exhibition will illustrate that it deserves much more attention.

The same is true of many of the subjects studied in this exhibition. Several of the contributors to the catalogue, writing on subjects of particular interest to themselves, have told me on looking into their records that they have found a mass of interesting material which they have been obliged for lack of space to exclude. Imperfect though this catalogue may be (so far as my contributions go, not theirs), it will I hope stimulate much more discussion of an absorbing and topical field.

GAW

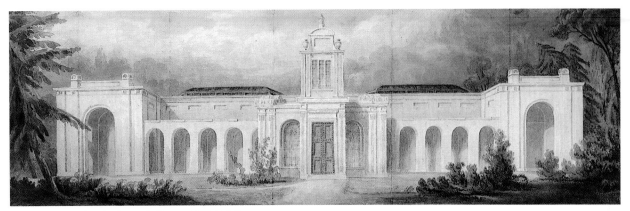

J.M. Gandy, *Dulwich Picture Gallery*, c.1823 (A18)

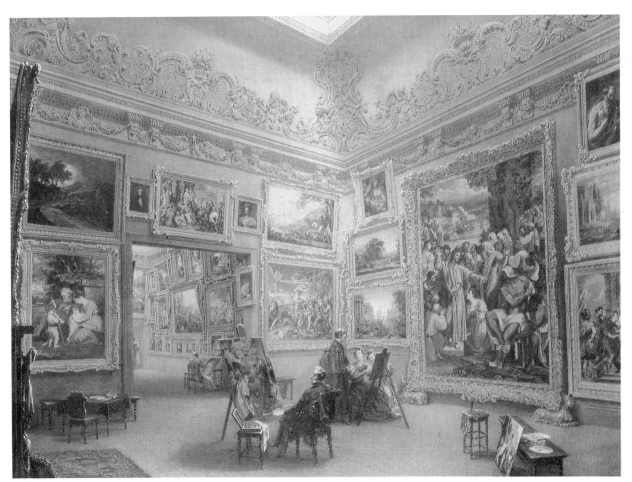

F. Mackenzie, *Principal Original Room of the National Gallery*, 1834 (C2)

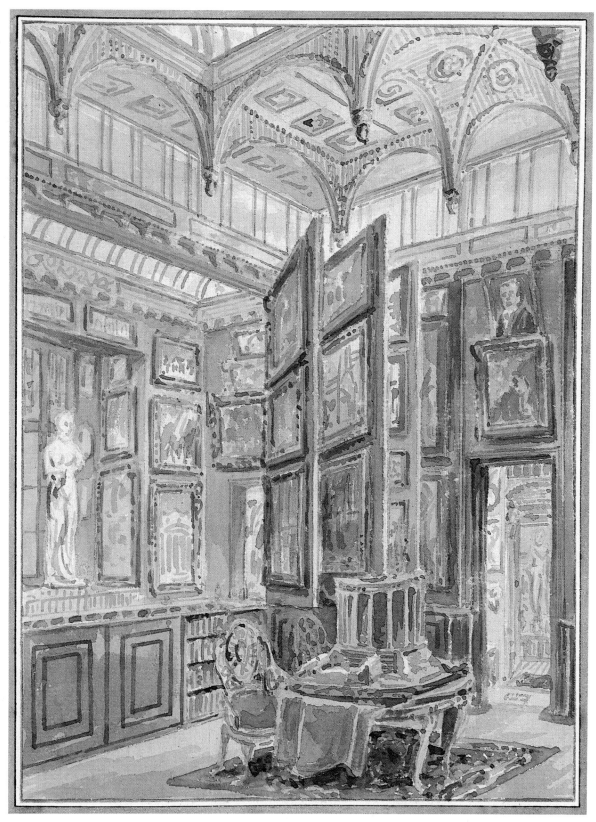

Sir J. Soane, *The Picture Room at Sir John Soane's Museum*, 1830 (A22)

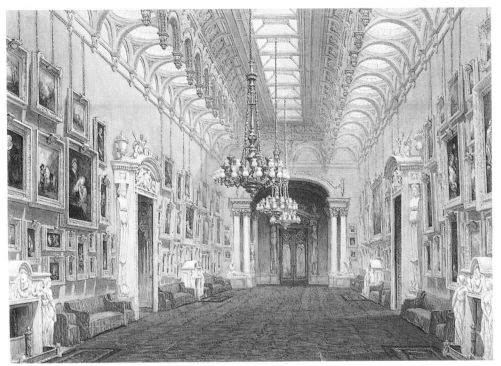

D. Morison, *The Picture Gallery at Buckingham Palace*, 1843 (E3)

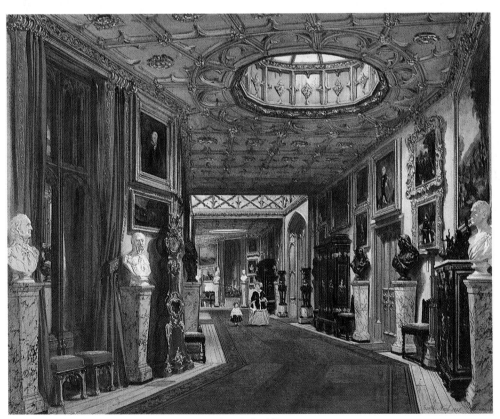

J. Nash, *The angle of the corridor, Windsor Castle*, 1846 (A7)

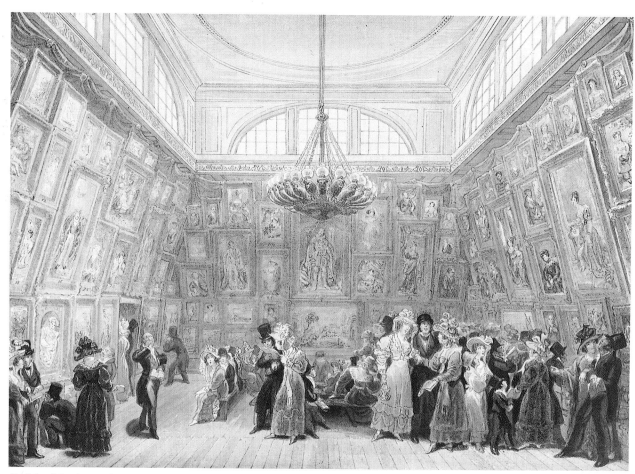

G. Scharf I, *The Royal Academy Exhibition of 1828* (D7)

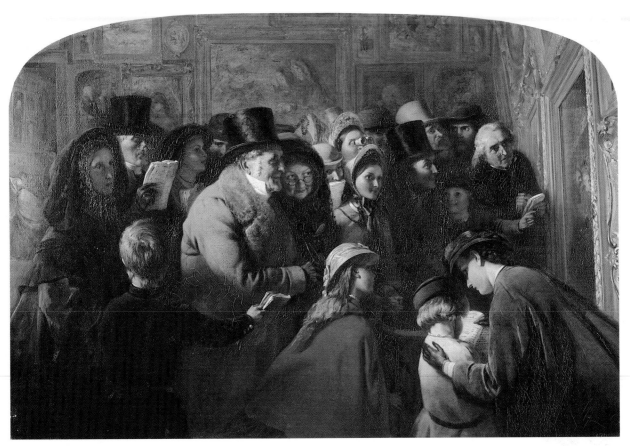

G.B. O'Neill, *Public Opinion*, c. 1863 (D10)

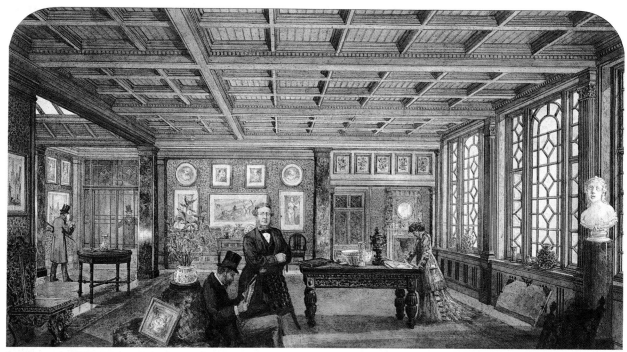

E. Salomons, *William Agnew in his Gallery*, c. 1880 (G12)

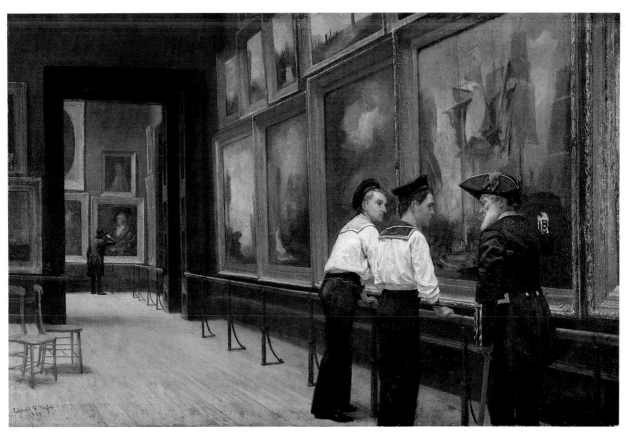

E.R. Taylor, *'Twas a Famous Victory*, 1883 (C11)

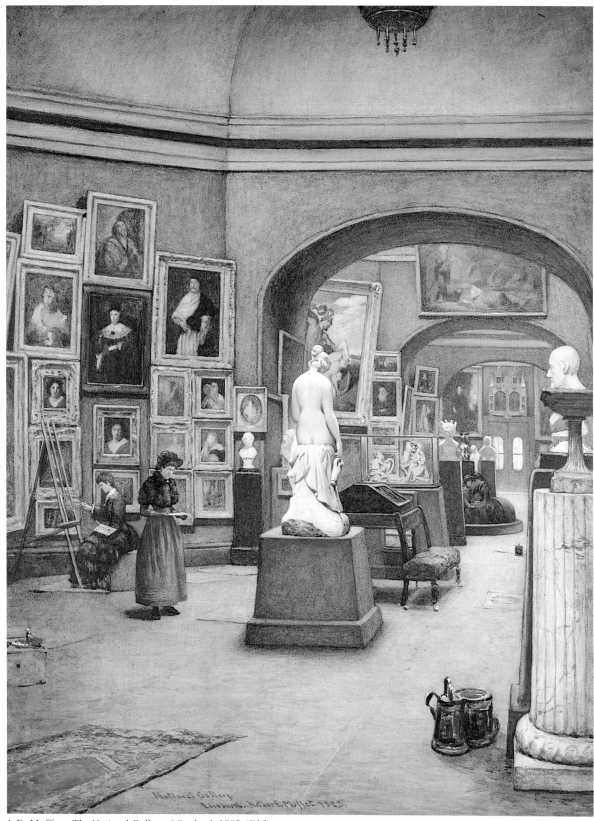

A.E. Moffatt, *The National Gallery of Scotland*, 1885 (C16)

Palaces of Art *Giles Waterfield*

Why *'Palaces of Art'*? Is the phrase, used of the Manchester Art Treasures Exhibition of 1857, an appropriate description for the art galleries of Britain?

The buildings housing the art museums of Britain are in no way as imposing as those of Paris or Lille, Berlin, Munich or Dresden, St. Petersburg, Madrid or Florence, or indeed New York or Washington. The national art museums of England – the history in Scotland, on a smaller scale, is more distinguished – consist in architectural terms of accumulations of piecemeal additions, while the Victorian museums of the regional cities architecturally represent solid worth rather than major talent. Real merit is to be found in the design of university museums, some privately funded galleries given to the public, and relatively modest individual enterprises such as artists' houses and commercial galleries. Though the public museums of Britain have not absorbed the collections of the Royal Family in the way that has occurred in many European countries, the idea of the 'Palace of Art', with its connotations of wealth and splendour and its implication that paintings should be shown in buildings of a special character, with their function externally identifiable and their interiors appropriately lit, planned and decorated, remained an expectation of patrons and public in this country from the late eighteenth century until at least the First World War. This exhibition explores some of the solutions offered in Britain to the challenge of creating appropriate buildings and interiors in which to show works of art, as well as changing attitudes to picture hanging and display.

Over two centuries, British Governments have been distinguished by their lack of generosity towards the visual arts. From the late eighteenth century, when repeated efforts were made to persuade governments of the economic advantages of a national collection of pictures and a flourishing native school of painters, ministers have consistently attempted to spend as little money as possible, with only the efforts of determined individuals persuading them into acts of isolated generosity. Proponents of public spending on the arts have seldom put their case in idealistic terms, or at best only in terms of national pride: the argument used in the eighteenth and nineteenth centuries was that the country's manufactures would benefit from the lessons in art and design to be given by flourishing museums. It is an argument which with a different emphasis is still used, in for example the Myerscough Report on *The Economic Importance of the Arts in Britain*, of 1988. Successive Treasuries have always hoped that money for building museums would emerge from private sources, and this has frequently been the case – Britain's history in this regard resembles the United States rather than Continental Europe. Of the national art museums in London, the expansion of the National Gallery has been fairly regularly funded from the public purse, but its history is one of compromise and over-crowding, of unending struggles to show the collection in decent surroundings. The National Portrait Gallery spent the first fifty years of its existence without a proper home, being carted from town house to exhibition shed, until a suitable building was provided – again, by a private individual. The Tate Gallery was originally built at the expense of a private benefactor (whose first offer was turned down by the Government). The existence of the Wallace Collection, again, results from private benefaction, while the history of the South Kensington Museum is one of individual initiative hampered by official obstructiveness. In this century the story has hardly changed. The long prelude to the building of the National Gallery's Sainsbury Wing is only the latest episode in this extended and dismal story. Neither the idealistic nor the pragmatic arguments for flourishing museums have made much impact on a tradition of official meanness.

Public galleries did not exist in Britain during the eighteenth century. Though the British Museum, established in 1753, was the first national museum

G. Scharf II, *National Portrait Gallery, South Kensington*, 1880

of its kind in the world, Britain's provision for the visual arts lay well behind that of the major countries of Continental Europe, and particularly France. Private collections could be seen, though not with great ease: some of the royal palaces were accessible by appointment, and it was generally expected that country houses would be opened to visitors. Though increasingly strenuous efforts were made as the century advanced to persuade the Government of the desirability of a national collection of pictures, the major successes of the artistic lobby lay in the establishment in 1768 of the Royal Academy, and in the foundation of such permanent displays of British pictures as the Court Room of the Foundling Hospital, opened, to much acclaim, in the 1740s. For the aspirant artist – and it was for this group that public art collections were considered particularly vital – the principal opportunity to see Old Master or modern paintings lay in viewing auctions.

During the early years of the nineteenth century, while the campaign for a national collection of pictures was being vigorously prosecuted, private collections were available to visitors – to those at least who could establish their respectability – in great aristocratic houses in London and the country, and in the London galleries of painters, sculptors and architects. The aristocrats, bankers, artists and picture dealers responsible for these semi-private galleries have left, at Apsley House and Attingham Park, Sir John Soane's Museum and Dulwich Picture Gallery, some evidence of their activities, but much more has disappeared. Apart from Soane's house and in a shadowy form Raeburn's studio in Edinburgh, there remain

almost no physical survivals of the many artists' or architects' houses of this period, or of the top-lit halls erected to meet the growing enthusiasm for temporary exhibitions.

Interest in the visual arts led, from the 1820s, to the construction of a fair number of public and university museums. Following Stark's Hunterian Museum of 1806, all these are correctly classical, the exception being one of the earliest, Soane's Dulwich Picture Gallery. The London National Gallery, the Fitzwilliam and Ashmolean Museums, Manchester City Art Gallery and the National Gallery of Scotland all used the classical language which was to dominate the architectural vocabulary for art galleries throughout the nineteenth century and into the twentieth; for other museums Gothic came to be regarded as acceptable from the middle of the nineteenth century – most famously at the University Museum in Oxford. Only with the emergence in the last years of the century of galleries directed at a working class audience did the language for the art gallery shift in some cases to a 'Queen Anne' or Arts and Crafts style. In the first half of the twentieth century, the classical tradition wavered, but though major art galleries of the inter-war period – the Barber Institute at Birmingham and the municipal gallery at Southampton – superficially abandoned classicism, their formality and symmetrical planning link them to their nineteenth century predecessors. Only since World War II has the classical tradition been, apparently conclusively, abandoned; unless the Sainsbury Wing should be seen as classicism reborn.

The idea of the art museum as temple of the arts is derived from the German Romantic idea that in such a building the visitor should enjoy a quasi-mystical experience. Though the cramped buildings actually constructed in Britain, at least for national collections, did not encourage such a frame of mind, the influence of this idea is important – not only for its promulgation of classicism but because it is an early example of the awareness of Continental practice shown by those involved in museums. Financially constricted the patrons, architects and curators of nineteenth century art museums may have been, but intellectually constricted they were not. From the artists and politicians who flooded to Paris to see the Musée Napoléon, to such learned architects as Wilkins and Basevi; from the mid-nineteenth century museum reformers such as Charles East-

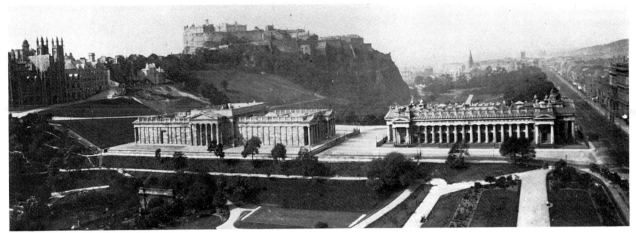

National Gallery of Scotland, c. 1880

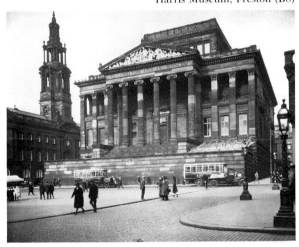

lake, Richard Redgrave, Henry Cole, and indeed Prince Albert, with their detailed knowledge of contemporary practice in Germany and their close personal contacts with foreign colleagues, to the architects of the Mappin Art Gallery or the Barber Institute who travelled overseas to study museums, a study of foreign practice has been consistent. Certain buildings stand out as particularly influential: in the late eighteenth century the Uffizi, and the Museo Pio-Clementino in the Vatican; and in the mid-nineteenth century, Schinkel's Altes Museum in Berlin, Klenze's Alte Pinakothek in Munich (and perhaps his extension to the Hermitage), and Semper's museum at the Zwinger, in Dresden. At the beginning of this century museums in the United States, notably the Museum of Fine Arts in Boston, and some Dutch examples such as the Boymans Museum in Rotterdam, were the most consistently mentioned prototypes.

The later nineteenth century saw the emergence of several phenomena that were to play an important part in the development of art museums: in particular the great trade exhibitions, and thence exhibition halls on a large scale; the decision by the Government to allow spending by boroughs on museums and libraries, which stimulated the building of municipal art galleries and museums from the 1860s onwards; and a remarkable rise in the prices paid for contemporary British paintings and of prints after them. This rise resulted in the construction of artists' houses of extraordinary splendour, notably in London, and of commercial premises of equal grandeur. However insular the taste of the general population

G. Aitchison, *Leighton House*, 1895 (E7)

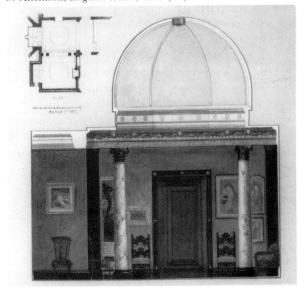

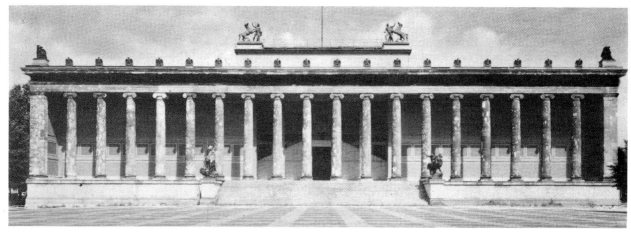

Altes Museum, Berlin

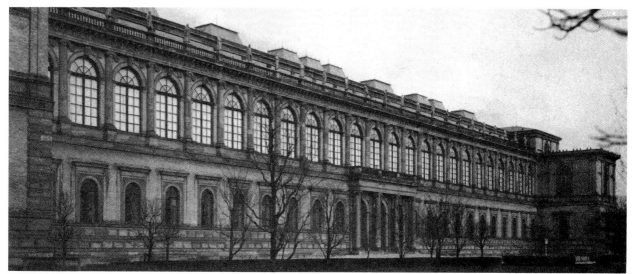

Alte Pinakothek, Munich

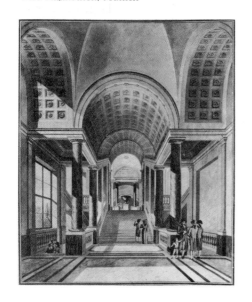

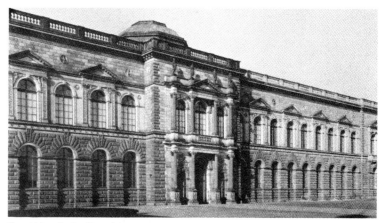

Gemäldegalerie, Dresden

Museo Pio-Clementino, Rome, Vatican

20

may seem in retrospect, the last three decades of the nineteenth century witnessed a burst of interest in art, apparent not only in the increasing number of art museums and of visitors to them, but in the changing character of the art trade, the growth in the number of exhibition places in London and elsewhere as efforts were made to escape the influence of the Royal Academy, the rise in the number of art schools, and the new power and wealth of art dealers.

The Great Exhibition of 1851 and, still more, the Manchester Art Treasures Exhibition of 1857, reflected the revolutionary improvements in communications in Britain. In immediate terms, the 1851 Exhibition gave birth to the South Kensington Museum which was to develop into the Victoria and Albert Museum, while the Manchester enterprise showed how large an audience existed for Old Master and contemporary paintings. The 1850s witnessed the establishment of a succession of national museums: the National Gallery of Scotland in 1850, South Kensington in 1852, the National Gallery of Ireland (again, following an exhibition) in 1854, the National Portrait Gallery – encouraged by two exhibitions of historic portraits at South Kensington – in 1856. Continuing into the twentieth century, the foundation of a number of art museums followed a successful exhibition of fine or industrial art. Outside London, this occurred at the York City Art Gallery, Cartwright Hall at Bradford, and most spectacularly at the Glasgow Art Gallery at Kelvingrove. The character of a great exhibition – welcoming a popular audience to a huge open hall, designed for instruction but also for entertainment and accessibility, and indeed financial profit – radically affected the museums that resulted. Nothing could differ more from the old type of classical temple, as the contrast between the erudite aristocratic severity of the National Gallery of Scotland and the cheerful welcoming exuberance of Kelvingrove in its people's park, nicely illustrates. It is revealing that for many years the Glasgow Art Gallery has been central to the life of its city in a way never achieved, at least until recently, in Edinburgh.

The Museums Act of 1845 and the Museums and Libraries Act of 1850 allowed local boroughs to charge a proportion of the rates for the establishment of these public amenities, as they had come to be seen. The 1850s and 1860s saw the creation of a number of municipal museums,

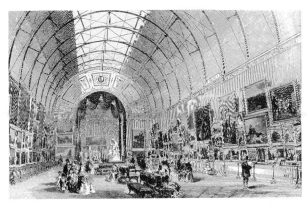

Manchester Art Treasures Exhibition (D16)

generally through the borough's absorption of the Philosophical or Literary Society's museum set up by private subscription thirty or so years before, which often by the middle of the century was experiencing severe financial problems. It was relatively rare for such early museums to contain works of art unless these had strong local connections. This pattern reflected the wide-spread interest during the early and middle parts of the century in semi-scientific subjects such as geology, which under the influence of such intellectual heroes as Professor Adam Sedgwick of Cambridge University commanded a wide following in academic circles and in ordinary society. In the second half of the nineteenth century, popular interest moved steadily away from geology, archaeology and natural history towards art, including works by the Old Masters but more particularly contemporary British art.

This rise was fostered by a very large number of entrepreneurial art dealers. Under the influence of Thomas Agnew and Son (based at the time in Manchester), the assembly of a large collection of expensive contemporary British paintings became from the middle of the century one of the goals of successful businessmen, who were generally not interested in buying the type of 'high art' which had attracted aristocratic patrons. Ernest Gambart (1814–1902), a figure about whom an unusually large amount of documentation survives, may stand as an example of the more entrepreneurial type of art-dealer. As Jeremy Maas has shown in *Gambart, Prince of the Victorian Art World* (1975), Gambart, through a well-organised system of publicity, the organisation of one-picture shows which often toured the country, and the production of cheap engravings after new paintings by

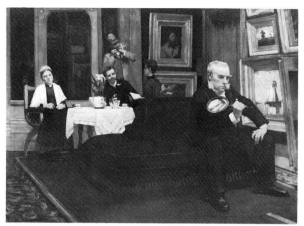

H. La Thangue, *The Connoisseur*, 1887 (Cartwright Hall, Bradford)

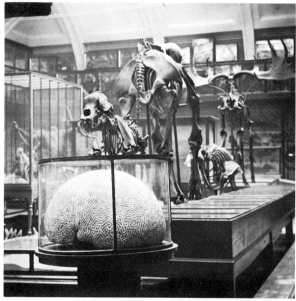

Leeds Museum, c. 1880

such artists as Frith and Rosa Bonheur, appealed to a newly rich audience as well as to less wealthy buyers of engravings. Numerous private picture-rooms were built by wealthy businessmen in the North of England, notably in the West Riding of Yorkshire and Lancashire: though few survive, the collections shown in them became the basis for the many municipal art museums, generally named after the founding donor, erected in Northern towns. Cragside, in Northumberland, of 1870–80, still contains a gallery (no longer housing its original collection) which exemplifies the numerous rooms of this type; few other examples survive.

During the same period, the great wealth achieved by painters also resulted in much investment in buildings associated with works of art. This can still be seen in the spectacular artists' houses of Holland Park, while records at least survive of a series of ambitious galleries in London. Partly exhibition spaces organised on altruistic principles and partly commercial premises, these included the Grosvenor, New and Piccadilly Galleries.

In terms of the establishment of art museums, the increasing popular appetite for contemporary art had a powerful effect in late nineteenth century Britain. The first civic gallery devoted to the fine and decorative arts was established at Nottingham Castle in the 1870s and opened in 1876. It was followed by the foundation of great numbers of other museums and art galleries in the following thirty years. A museum which exemplifies this development, and survives in an unusually well-preserved condition in a fine building, is Warrington Museum and Art Gallery, in Cheshire. In 1855 Warrington was one of the first towns in Britain to adopt the new museums legislation, taking over in the process the collections of the Warrington Natural History Society. The first building, based on plans by John Dobson of Newcastle, contained museum collections rather than works of art, and it was not until the 1870s that an extension was made to house painting and sculpture. In many cases the new museums combined under one roof accommodation for works of art with specimens of all the other disciplines, leading the delighted visitor from Roman sherds to Bow porcelain, and from stuffed birds to the paintings of Augustus Egg, though in recent years such generous confusion has often been tidied up.

In the large centres, and particularly in the great industrial cities of the North, the division in the new buildings between art gallery and museum was clearly stated, with works of art sometimes housed in a distinct building. Important municipal galleries include: the Royal Albert Memorial Museum, Exeter (1865, by John Hayward), a shared building which also housed the School of Art; Brighton Museum and Art Gallery, of 1873, by Philip Lockwood; the Walker Art Gallery, Liverpool, of 1877, by Cornelius Sherlock; Wolverhampton Art Gallery of 1884, by Julius Chatwin; Birmingham Museum and Art Gallery, first opened in 1885; the Mappin Art Gallery, Shef-

field, of 1887; Aberdeen Art Gallery and Museum, of 1885, by Matthews and Mackenzie; Leeds City Art Gallery, of 1888, by W.H. Thorpe; the Harris Museum and Art Gallery, Preston, of 1882–93; the Norwich Castle Museum, of 1894; Bury Art Gallery and Museum, of 1899; the Laing Art Gallery, Newcastle, of 1900, by Cackett and Burns-Dick; and Cartwright Hall, Bradford, of 1904. To this list should be added a large group of museums in Lancashire and West Yorkshire, particularly around Manchester and Liverpool; some of these were built in the 1880s and 1890s but development continued well into the twentieth century.

The galleries formed by the proudly civic-minded collectors of contemporary art were frequently accompanied by statements of the desirability of educating the masses and of giving them the opportunity to appreciate the possibility of a better life through the medium of art. There emerged during the latter part of the century a movement in favour of educational art museums, inspired by Henry Cole at the South Kensington Museum and by John Ruskin. Ruskin's ideas were put into practice in his various galleries, including the Ruskin Museum at Meersbrook Park, near Sheffield. A comparable approach, fostered by Ruskin, was that of T.C. Horsfall, who in 1886 established the Manchester Art Museum at Ancoats on the fringes of central Manchester. The Ancoats Museum did not contain elevated or expensive works of art: it was intended to allow the population of a gloomy and deprived area an opportunity of glimpsing through the medium of drawings, photographs and casts – in other words, reproductions – the possibility of a more beautiful and sensitive existence than the one to which they were condemned. This philanthropic approach – for such it was, in a style quite different to that of the early nineteenth century – developed in two directions. Firstly, in the continuing proliferation of the didactic museum, such as the Harris Art Gallery at Preston of the 1890s, which aimed, partly through the rapidly advancing technology of facsimile, to present to a working class audience the whole development of Western art and, by implication, civilisation. And secondly, in the movement to create new art galleries in the poor areas of great cities. These were intended initially to function through temporary exhibitions of loaned paintings, an idea which at least in theory inspired many municipal galleries in the North of England and was supported by a number of

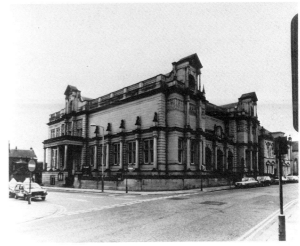

Bury Art Gallery (B13)

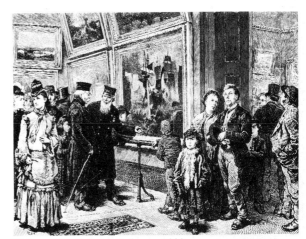

Visitors at the National Gallery, c. 1880

prominent artists. Watts, Leighton, Burne-Jones and others lent or gave pictures and money, and in some cases bequeathed their own galleries or houses. Theirs was almost a religious cause in its strength of purpose and altruism, and was sometimes associated with such overtly Christian missions to the poor as Toynbee Hall in east London. In the Whitechapel Art Gallery and the South London Art Gallery evidence of their labours survives.

The zeal of these artists was well-timed. A century later, when visiting an art gallery is perceived as a largely middle class pursuit, it is hard to appreciate the enormous popularity of art museums from around 1870 into the early twentieth century. In London the social and geographical stratification was so pronounced, and the

resistance of the ruling classes to such reforms as the Sunday opening of museums so strong, that the increase in visitors was not as apparent as in such cities as Sheffield, Birmingham, or Glasgow, where the newly opened museums, viewed with pride as a local possession, were thronged by local inhabitants drawn from every level of society.

In some respects ideas of display in art museums did not change greatly during the nineteenth century. The role of sculpture, for example, though it underwent some modifications, became subsidiary to that of painting. In the eighteenth century classical sculpture and sculpture galleries were on a par with pictures and picture galleries, indeed as representatives of the antique world their status was greater. In private pantheons of art such as Holkham Hall or Chiswick House sculpture and picture galleries were paired, with modern sculpture contributing to the display. The development of specialised sculpture galleries in the late eighteenth and early nineteenth centuries – in private houses such as Lansdowne House, London (where the gallery was originally designed by George Dance around 1792) and in public collections, notably the Townley Gallery at the British Museum of 1804–08 by George Saunders – exerted considerable influence on picture galleries, although the accepted view that high side lighting was suitable for sculpture was not usually applied to paintings. With the development of public museums, it was at first felt that, as in Germany, antique sculpture and paintings should be shown together. This was the expectation of the Trustees of the British Museum when the National Gallery was mooted in 1824, and the university museums at Oxford and Cambridge followed the pattern, with sculpture galleries on the ground floor and paintings upstairs. With the diminution in popular appreciation of classical sculpture from the mid-nineteenth century, the British Museum's and the university museums' classical collections became exceptions. Pictures were hung, almost always, in rooms from which the plastic arts were excluded, and though views of later Victorian galleries show one or two statues in the centre of some rooms, these were clearly subsidiary to the pictures.

The unhappy distinction made between painting and sculpture was reinforced by the lack of interest shown at the British Museum during the mid-nineteenth century in collecting Renaissance sculpture. Although this omission was mended by J.C. Robinson at the South Kensington Museum in the 1850s and 1860s, in national terms South Kensington was a suburban museum intended for the instruction of designers and manufacturers, or a dumping ground for collections that could not be accommodated elsewhere, rather than a sister institution to the National Gallery. Renaissance and later sculpture came, during the nineteenth century, to be regarded as a poor relation to painting. Efforts were made from time to time to persuade the National Gallery to absorb sculpture in its displays but these were never seriously entertained by the authorities. Although in Scotland the situation was, and remains, different, the English tradition has regrettably contributed to the general, if seldom explicit, view of sculpture as inferior to painting.

The idea of the period room was viewed with equal scepticism. The creation of a unified ambiance containing the sculpture, painting and the decorative arts of a particular period and allowing the works to be appreciated in the conditions for which they were intended (though not going so far as the architectural re-creation of a period setting), was perfected by Wilhelm Bode in the Kaiser Friedrich Museum (now the Bode Museum) in Berlin, from the 1890s to the 1920s. Though much imitated in the United States (notably at the Isabella Stewart Gardner Museum, Boston, developed from 1902 onwards), this was not an idea that exerted much appeal in Britain. Suggestions that period interiors might be installed in such a building as the Barber Institute, for example, were rejected at an early stage of planning. It was rare in public museums even to show furniture in the same rooms as pictures: though furniture was included in most private galleries, often set against the wall, there seems to have been an unstated reservation about arranging public galleries in a similar manner, often no doubt for pragmatic reasons such as the enormous numbers of visitors. Apart from public seating, the decorative arts were relegated to South Kensington, and later to period houses or special displays. Only in such museums as the Wallace Collection and the Lady Lever Art Gallery, which contained intact private collections, was the distinction between branches of the visual arts abandoned. In a more conventional establishment such as the Bowes Museum, the decorative art collections were and are shown on the lower floors, while the pictures hang disconsolate in cavernous sky-lit halls upstairs.

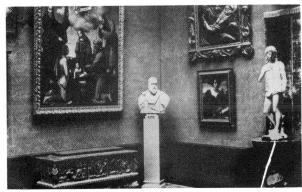

Kaiser Friedrich Museum, Berlin

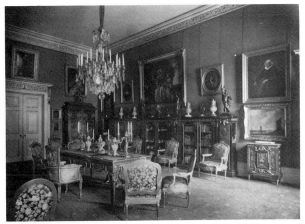

Above: Wallace Collection, Gallery XII, c. 1897 (C29).

Below: J. Lavery, *The Opening of the Duveen Galleries*, 1926 (C27)

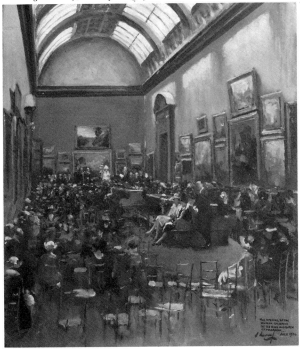

Between the World Wars the growth in the number of art museums slowed down. Some cities, towns and even villages acquired new galleries, frequently funded by private generosity: notably the Lady Lever Art Gallery, Port Sunlight, opened in 1922; the handsome Usher Art Gallery, Lincoln, by Sir Reginald Blomfield, of 1927; the Williamson Art Gallery, Birkenhead, of 1928; the Graves Art Gallery, Sheffield, of 1934, by W.G. Davies, the city architect; the Barber Institute, and the Southampton Art Gallery of 1939. Though, variously, Beaux Arts and cautiously Modernist, these galleries are distinguished by the thought given to their planning and lighting, and their pleasant airy interiors. The ethos of the time advocated the avoidance of decoration in such buildings, an aim which is evident in the completed galleries. In London, the twenties and thirties saw the expansion of several of the national museums, frequently through the benevolence of the art-dealing Duveens, who paid for extensions at the British Museum, National Gallery, National Portrait Gallery and Tate Gallery; and by some careful exploration of lighting problems, of which the Tate's 'experimental' gallery of 1926 is the most striking example. In spite of the foundation of the first institute for the study of the history of art, these were not outstanding years for the development of art museums in Britain. With the exception of a small coterie of artists and critics, the British remained blindly insular in their attitude to painting, no doubt feeling as much spiritually and intellectually threatened by artistic developments in France and Germany as did the National Socialists. The torpor that afflicted many of the country's art museums is vividly conveyed by Frank Rutter and John Rothenstein in their memoirs of directing provincial institutions in the 1930s.

In terms of planning public circulation, certain ideas recurred in the design of galleries during most of the period under review and were only succeeded by a much more flexible approach after the Second World War. The module for a gallery was a rectangular room, generally top-lit; the side walls were usually considerably longer than the end walls, to provide as much space as possible for hanging pictures. Such rooms, deriving from Renaissance prototypes, were frequently articulated by the introduction of a columned screen at either end. Galleries of this sort were built in country and town houses from the eighteenth

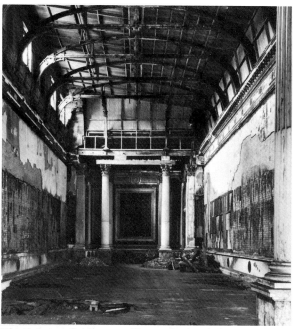

The Gallery at Bridgewater House after bomb damage, c. 1943

century onwards and, in adapted form, were used by commercial dealers: the upstairs gallery at Agnew's is a good example. Many of the picture galleries in great London houses – Apsley House, Bridgewater House and indeed Buckingham Palace – followed this pattern. In the case of rooms intended to accommodate a very large public, the shape of the principal room tended to be closer to a square, allowing easier circulation: this applied to the Great Room at Somerset House, and to the main rooms at Christie's and other auction houses. Developing from the single room was the idea of the tribuna, or Great Gallery, inspired in particular by the Salon Carré of the Louvre: here major works could be shown, in a space more splendid than the rest of the building. This idea, implicit in the addition of a picture gallery to a private house, was carried out at the Fitzwilliam (and to a lesser extent, the Ashmolean); in various forms at the National Gallery; and in such regional museums as Nottingham Castle, with its magnificent long gallery built in the 1870s.

A further development from the single gallery was the enfilade of rooms, connected by arched or square openings, and often alternating rectangular with square apartments. This was the classic pattern of galleries on the Continent, articulated by French Neoclassical theorists and executed in the principal German museums of the nineteenth century, notably Munich and Dresden. In such early examples as the Shakespeare Gallery and Dulwich Picture Gallery, the original space consisted only of a single enfilade. As museums became larger and more complex, a new plan emerged, with three or four rooms arranged in rows around a central core formed by a great hall or staircase, a plan used in Schinkel's Altes Museum. As early commentators on the Fitzwilliam remarked, such an arrangement reduced fatigue in the visitor. This plan became a staple of gallery design, being used at Manchester in the 1820s, at Preston and Glasgow in the 1890s, at the Barber in the 1930s and at the Staatsgalerie, Stuttgart in the 1980s. In buildings on a large scale it was sometimes developed further into a grid system with two or more parallel enfilades of rooms linked by transverse galleries. Such a system was used at the National Gallery of Scotland, at Burlington House, in the original Tate Gallery and at the Lady Lever Art Gallery. Organised planning of this type implies an authoritarian attitude to the display of paintings, as well as some lack of imagination. An exception to this approach is the exploration of free access to rooms seen at the Glasgow Museum and Art Gallery, where a generous arrangement of balconies around the central hall allows visitors to select the room they will visit. Post-War designers, more deferential to their visitors' tastes and less certain about the absolute value of the works they show, have in many cases adopted a much more open and flexible attitude to planning. The Clore Gallery, intended for the display of early nineteenth century paintings, is an instructive exception.

Apart from Dulwich and the National Gallery of Scotland, which originally could show all their exhibits on the ground floor, art museums in Britain traditionally housed their paintings on an upper floor – on account of a constricted urban setting, co-habitation with other collections or the need for top lighting. This custom has not, in all honesty, stimulated an impressive range of halls and staircases: the history of what is perhaps the most striking entrance hall in a British art museum, the Fitzwilliam's, illustrates, ironically, the lack of confidence with which British architects and patrons have approached this problem. Though in the heyday of art museums at the end of the nineteenth century some successful solutions were found (Bury Art Gallery, for example, offers an imposing approach to its exhibition

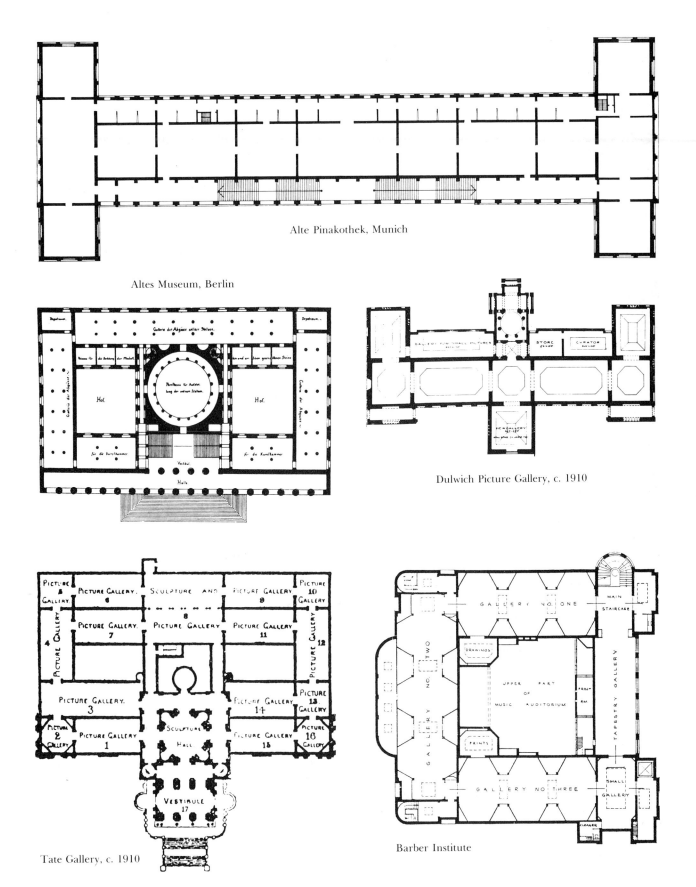

Alte Pinakothek, Munich

Altes Museum, Berlin

Dulwich Picture Gallery, c. 1910

Tate Gallery, c. 1910

Barber Institute

rooms), the creation of processional routes or indeed the stimulation of a sense of occasion in the arriving visitor were most satisfactorily worked out in such ambitious non-museum enterprises as the Grosvenor Gallery. The monumental staircase at the Sainsbury Wing is an unusual phenomenon.

Two other aspects of gallery planning deserve notice: suites of cabinet rooms, and offices. The idea of a series of top-lit exhibition halls for large paintings, parallelled by small side-lit cabinets for small works, was first put into practice by Klenze in the Alte Pinakothek in 1826–36, and developed by Semper at Dresden. This idea (which echoed the division in seventeenth century great houses between big rooms for large paintings and cabinets for little works of art) was familiar to British art experts in the mid-nineteenth century, and was much discussed when, for example, the Ashmolean was being planned. The German example was admired in principle, and on several occasions ambitious plans were made to build suites of cabinets, as in E.M. Barry's schemes for the National Gallery and the early proposals for Burlington House. It was, however, rare for such schemes to be carried out. This may have been because money was often scarce or because the idea seemed dispiriting: the Commissioners reporting on the 1866 proposal for a new National Gallery commented on the wearisome effect of a long sequence of small identical rooms, a view also voiced in the 1920s. A few examples do exist. The National Portrait Gallery in St. Martin's Lane was built with rows of side-lit cabinets on the ground and first floors, but its character as a primarily historical museum was a special one. Other cabinet rooms can be seen at the National Gallery of Scotland and the Barber Institute: in both cases the accommodation consists of a number of distinct rooms, rather than a row of cells on the German model.

As for ancillary spaces, and indeed temporary exhibition areas, these were hardly allowed for in the nineteenth century museum of high art. Temporary exhibitions were not regarded as their function: even the Tate scarcely organised exhibitions on any scale until the late 1930s, and the National Gallery in London survived until the 1980s (its equivalent in Edinburgh, until the present) without proper spaces assigned to this purpose. Exhibitions were the province of the Academies, or of museums which had themselves developed out of great exhibitions. At a time when the curatorial staff of most galleries was extremely small, and conservation work was generally done off the premises or when the building was closed to visitors, minimal space was needed for offices or studios, while little thought was given to adequate storage. With the establishment of the Museums Association in 1889, and the growth of a new professionalism supported by debate and the study of foreign examples, attitudes changed. The planning of such buildings as the National Museum of Wales early in this century is marked by the attention given to the relationship between display spaces, and stores and offices. Much the same applies to public amenities such as cafés, or refreshment rooms as they were known: though purpose-built refreshment rooms (the first of their type in the country) existed from the first at South Kensington, such facilities were beneath the attention of the aristocratic trustees of the London National Gallery until 1947 (though a canteen was provided in 1939 for those attending wartime concerts).

Since the Second World War the growth in the numbers of visitors to our national museums has been remarkable. National and regional museums have responded by increasing the services they offer, notably in education and exhibitions, though the physical expansion of national museums has hardly kept abreast with the new demands made of them. The interesting but, in comparison with France or Germany, rather low-key history of post-War art galleries in Britain is discussed later in this catalogue by Colin Amery. Also important, if in a somewhat negative way, has been the rise in the value of works of art and the media attention accorded to this rise. In a society that has abandoned traditional icons, it has become accepted wisdom to view art galleries as the cathedrals of the late twentieth century. This is not an attitude to which the British have been trained to respond easily, unlike the Germans or the French, and the situation has been complicated in recent years by the strenuous official efforts to persuade those responsible for administering these new 'cathedrals' to consider them, rather, as businesses. It is to be hoped that these efforts will be resisted: however fragmentary, disappointing and haphazard the development of art museums in this country may have been, they represent a tradition of idealism which deserves better than to be sacrificed on the altars of political expediency and parsimony.

The Picture Gallery in Scotland *Ian Gow*

Most studies of the arts in Scotland view the departure of the Court for London in 1603 as a major set-back to the patronage of future generations of artists who chose to pursue their careers within their native land. It is satisfactory to record that in one area of artistic endeavour, the display of paintings, Charles II, from the luxury of his metropolitan 'exile' and perhaps unwittingly, provided his Scottish subjects with the very model of a modern picture gallery.

The Gallery at Holyrood, Edinburgh, comprised part of the rebuilding programme commanded by the King in 1670 to repair the damage inflicted by Cromwell's troops. Sir William Bruce, entrusted with this task, created the first Scottish building to display the classical language of architecture. The plan reflects the Palace's monastic origins but the fact that the new Gallery linked the King's and Queen's Apartments suggests that the architect was aware of Continental fashions. In 1682, Jacob de Wet, a Dutch artist, was employed to paint portraits of every Scottish monarch to demonstrate the Stewarts' right to the throne.[1] Miraculously, this scheme survives in its entirety in spite of the low critical esteem in which de Wet's performance has been held. Although there has been some debate about the manner in which the series was originally displayed, the general effect is noble, with the rhythm of the ranked pictures subordinate to the architectural rigour imposed by the fluted Corinthian pilasters which flank the chimney-pieces and support a properly detailed entablature running around the room in Bruce's characteristic manner.

Surprisingly, this Picture Gallery, in which architecture supported her sister art, had no immediate peers. It was not that there were to be no picture collections in Scotland but rather that their titled owners had fastened on another aspect of the Palace's interior splendours: the sumptuous chain of state rooms forming the Royal Apartment, soon imitated in new country houses and converted tower houses.[2]

The extent to which these ceremonial suites, rooted in court etiquette, were also used to display works of art emerges from the *Journey Through Scotland* published by John Mackay, a professional country house visitor, in 1723.[3] At Newbattle, Midlothian, a house with some pretensions to be regarded as the Scottish Wilton, mirrors were apparently used to heighten the display.

Inevitably, the decoration of these apartments succumbed to changes in fashion. Crimson silk damask and white paint ousted tapestry and oak panelling, as at Hopetoun House, West Lothian. Perhaps the finest state room in Scotland was 'Ossian's Hall' at Penicuik House, Midlothian, which Sir John Clerk's son, James, had rebuilt in 1761 to receive the Mavisbank collection. It owed its name to its ceiling painted by Alexander Runciman in 1772 with scenes drawn from tales of the supposed Gaelic Bard.[4] If the programme was Scottish, the effect was Italianate, recalling the princely palaces and villas of Rome. Sadly, Penicuik's handsome interiors were destroyed by fire in 1899, and elsewhere few eighteenth century state rooms retain their original pictures. Many collections were swelled with the fruits of nineteenth century prosperity only to be drastically thinned in the twentieth century.

A ceremonial mode of living encouraged collecting, but inevitably the display of the paintings took second place to the creation of an ambiance.

Where a nobleman was also a serious collector innovations might have been expected. There can be no doubting the zeal of the second Earl of Fife whose approach to collecting as outlined in the introduction to his Catalogue of 1807 strikes a surprisingly modern note in its advocacy of the study of costume as an aid to dating portraits.[5] Unusually, however, he had no need to build afresh because his principal seat at Duff House, Banffshire, had been abandoned in a half-finished state in 1743. The *piano nobile* was finally brought into commission in the early 1790s as picture rooms in the long established state apartment tradition. Recent stripping of later wallpapers has revealed evidence of the original picture hang

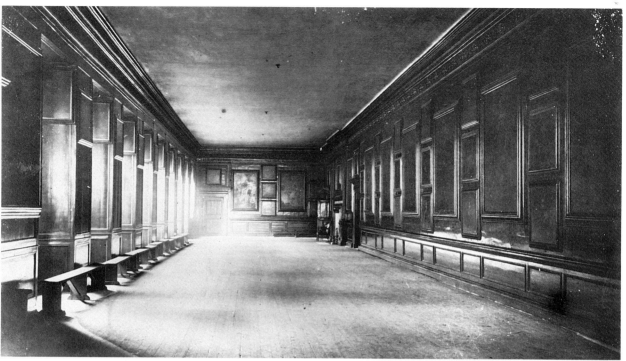
Picture Gallery at Holyrood Place, Edinburgh

Hopetoun House, Red Drawing Room

through the fading of the second Earl's pigments with almost photographic realism, down to the 'shadows' of picture rings and nails and evidence for the subsequent replacement of individual pictures by ones of a different size.

The Earl of Wemyss was an equally enthusiastic collector of paintings but, since he was also the greatest of all Scottish patrons of architects during the later eighteenth century, he seems to have commissioned the first Scottish house in which the display was a primary consideration. The Earl's patronage had commenced at Amisfield, East Lothian, near Haddington, where designs were obtained from the English Palladian architect, Isaac Ware, in 1756. A description of Amisfield published in 1792 stated that the 'gallery contains many capital paintings, some of them by the first masters'.[6] It is not known if the house was completed in accordance with Ware's published designs for his *Complete Body of Architecture* of 1768, or whether this gallery may have been introduced by the young architect, John Henderson, who was busy classicising Amisfield at the time of his early death in 1786. By 1790, however, the Earl's attention had moved to his nearby coastal estate at Gosford, East Lothian, where Robert Adam was commissioned to build a new house. It was a design

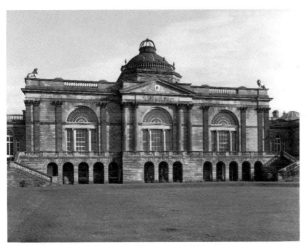

West elevation of Gosford House, c. 1900

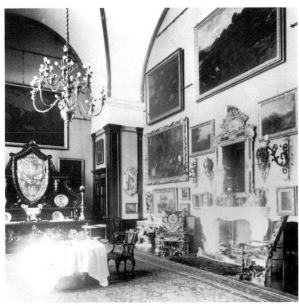

Above: Gosford House, c. 1900.

Below: J.P. Neale, *Kilfauns Castle*

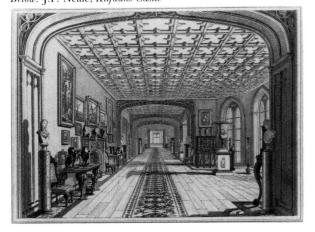

of striking originality with a very large rectangular drawing room and dining room arranged axially and interlinked by a domed Saloon which was probably top-lit. The house was only to be completed during the 1880s and late-Victorian photographs show how well its lofty rooms were adapted to the display of pictures.[7]

The idea of the gallery[8] seems finally to have taken hold in Scotland not as a response to picture collecting, but as a by-product of the Gothic revival. The Adam brothers' engraved design for their Gothic Douglas Castle, Lanarkshire, of c.1757 depicts an impressive 145 foot long 'Gallery' but this remained on paper.[9] Of the executed galleries the most celebrated must be that at Scone Palace, Perthshire, rebuilt in 1803 by the English architect, William Atkinson, in a Gothic style with a run of plaster vaults. This was ostensibly a replacement of a medieval original and it found a new purpose in the display of part of the Earl of Mansfield's art collection, as a detailed oil painting by Robert Gibb of 1826 records. Gibb's similar view of the Gallery at nearby Kinfauns Castle is now lost but it was fortunately engraved for the second edition of Neale's *Views* in 1828.[10]

Paxton, Berwickshire, was the first Scottish country house to contain a room where the architectural brief put the pictures first.[11] The Paxton picture gallery was begun in 1811 but until recently had been lost to view: following the dispersal of the collection earlier this century it was partitioned into flats and a small Catholic chapel. Now the Paxton Trust has been formed to preserve this important house and the Gallery is being restored (with the support of Historic Scotland). The scale of this newly-revealed interior is startling in contrast to the diminutive mid-Georgian villa to which it is linked by a conventionally proportioned library. The wing was commissioned by George Home whose decision to concentrate at Paxton a Grand Tour collection formed by his uncle during the 1770s arose through inheritance. The 'public' character of the new Gallery stemmed from his selection of Robert Reid, Master of the King's Works in Scotland, who had almost no experience of country house practice. Reid conceived a very large rectangular hall rising to a domed circular roof-light with apsidal ends, screened by Ionic columns. Additional roof lights dramatically and practically illuminated the apses. The single-minded determination to put the needs of the pictures first is revealed, ironically, by the solitary

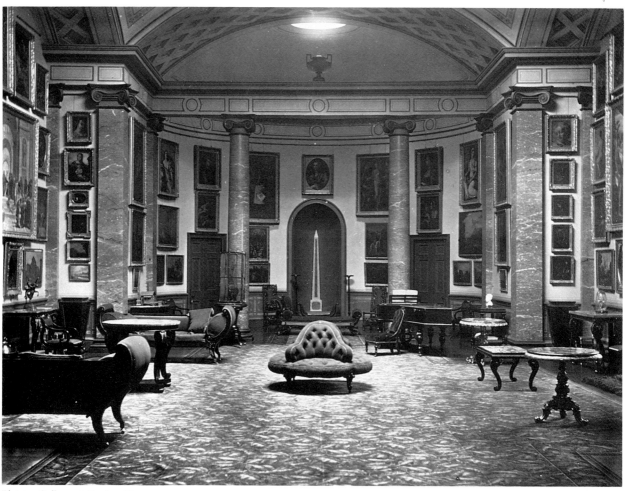

Picture Gallery at Paxton House

conventional sash window which commands a spectacular view south across the Tweed; otherwise the unbroken expanse of the walls gave ample space for paintings.

The experimental nature of the Paxton Gallery is revealed in extracts from the correspondence between patron and architect.[12] At one stage, Reid suggested an internal umbrella which could be adjusted in response to the strength of the sun.

Revealingly, Reid discussed the practicalities of top-lighting with Raeburn. The architectural effect of the Gallery was strengthened by an innovative decorative scheme. Imitative painting, realistically simulating costly natural finishes, appears to have been taken up with enthusiasm by the Scots in the second decade of the nineteenth century. Its theatrical effects were especially suited to Gothic Revival houses like Abbotsford, Roxburghshire, but it soon spread to Classical designs. At Paxton

the columns were marbled while the entire wall-face and vaulting were tinted in imitation of polished ashlar masonry with appropriate mortar jointing simulated by lines of thick white paint. The profits from inherited West Indian plantations enabled a sumptuous suite of furniture to be commissioned for the room from William Trotter, Edinburgh's leading cabinetmaker.[13] This was made from solid rosewood with upholstery of '*marone cloth*' which would have added a note of warmth to this cool-toned architectonic interior. A set of tables in specimen marbles, resting on richly carved trussed stands, completed the ensemble.

Paxton set a new standard for the display of works of art at a time when concern over display was passing from a matter of merely aristocratic interest to satisfying the needs of educationalists and of artists hoping for a sale. The poverty of provision within Scotland is graphically revealed in

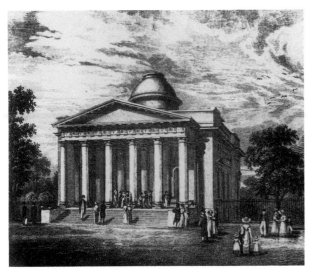

Hunterian Museum

Above: Hunterian Museum, c. 1871.

Below: Edinburgh Royal Institution, 1829

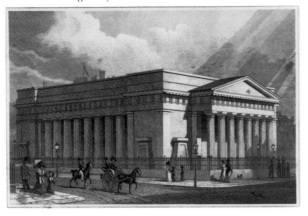

the celebrated engraving, possibly dating from 1761, of the exhibition of paintings held by the Foulis brothers on the walls of the courtyard of the College of Glasgow,[14] where their academy to train young artists had been granted accommodation. This mode of *alfresco* exhibition formed part of a European tradition with which contemporaries were familiar. This same courtyard was to attract Scotland's first purpose-designed modern museum building, the Hunterian (the building is discussed under F2–5), in 1804, to house the magnificent bequest left to his old university by William Hunter, a successful London doctor.

Stark, architect of the Hunterian Museum, died young and his place was taken by his young pupil William Playfair, for whom the design of Edinburgh's national museums and art galleries was to be central. Playfair particularly admired the Hunterian Museum, writing to friends: '*I would rather be the author of that sweet little bit of good proportion than of all the other ostentatious Glasgow buildings put together and most of those in London.*'[15]

Playfair's early success was a result of winning the competition to complete Robert Adam's scheme for Edinburgh University, where his uncle was a professor. The provision of a museum was one of the complex requirements he had to tackle and the difficulties of lighting a large interior on the enclosed site must have contributed to his top-lit solution. In 1820 he had the chance to provide rooms specifically designed for pictures, when the Board of Manufactures asked him to design their new headquarters on the Mound. The brief was intricate and ever-changing and his mastery of its difficulties further illustrated his ability.[16]

The Board was a uniquely Scottish government body whose finances partly derived from the Treaty of Union in 1707. Their involvement in the encouragement of art stemmed from recognition that the only way that they could make Scotland's humdrum domestic manufactures, like textiles, attractive for export, lay in improving their standard of design. To this end in 1760 they established a drawing academy to train artisans in Edinburgh.

Playfair's new building, christened the Royal Institution, for the Board's site on the Mound, was to include accommodation for the School and its extensive teaching collections of drawings, books and casts. In a mood of enlightened self-interest the Board also resolved to house the learned societies of Scotland within the building and their

annual rents helped to off-set the costs. Since accommodation within the building was soon seen as an emblem of respectability by all fledgling bodies, the occupants increased continuously. Picture galleries were deemed necessary to make available masterpieces for educational purposes, and to house exhibitions by living artists. The former purpose was promoted by the aristocratic Institution for the Encouragement of the Fine Arts in Scotland, founded in 1819, which enjoyed the Board's support, while the latter was eventually championed by the Royal Scottish Academy, of 1826.

Playfair's difficulties were aggravated by the complexities of the site. The Mound comprised the 'travelled earth' dumped there after excavation from the basements of the New Town. The fashion for Greek architectural models imposed a temple-like ring, round a set of interiors which recalled the ingenuity of the Hunterian's nest of Chinese boxes, with an understandable loss of geometric elegance in response to almost impossible demands. The pair of large and small picture galleries occupied a central position, as the cella of the apparent temple and the top-lighting offered the best solution to the architect, hard pressed to apportion windows to so many competing spaces. In 1832, Playfair was invited to extend his building with a further gallery and two conventionally side-lit rooms for exhibitions of manufactured goods, creating a 'T'-shaped suite of exhibition rooms.

Unfortunately, there seems to be no discussion of the evolution of these rooms among the extensive documentation deposited in the Scottish Record Office. The building was gutted in 1907 to serve new purposes, and extensively altered. A lithograph[17] of 1826 shows the larger of the original pair of octagonal galleries in use, as do a few later photographs. The octagon shapes were doubtless selected to permit even illumination with no dark corners while the cove connecting the wallfaces to the skylights aided diffusion by reflection. To suit their various purposes, flexibility was promoted by inter-connecting doors which slid away into the walls. The sole survivors of their fittings are a pair of painted glass panels with allegorical female figures from the inner entrance doors. A stray bill from Trotter of Edinburgh, the leading furniture maker in Edinburgh and the Board's contractor, refers to the walls and floor being lined with maroon felt for a forthcoming exhibition. The intensive use of these handsome, if austere rooms, led to a series of disputes among the occupants only resolved by Playfair's third and final extension, of 1849.

The Board never held a monopoly on the provision of exhibition space, and private initiatives continued to be important to the promotion of art. The efficient lighting of rooms, and new scientific attitudes to display, were of great importance for artists' studios. In Scotland, the most important must be Sir Henry Raeburn's at York Place, Edinburgh, which has an ingenious system of light control by means of shutters in this north-facing room.

In the middle of the century, John Ballantyne painted a memorable series of portraits of artists in their studios including several Scots, but by this date picturesque studio props seem more prominent than fancy lighting methods.

No private individual was to do more to investigate the best conditions for the display of painting than D.R. Hay (1798–1866), who was Edinburgh's leading interior decorator during the second quarter of the nineteenth century. Hay's success owed much to his being the protegé of Sir Walter Scott. Scott's initial intention was that Hay should be an artist but he soon discovered that the improvement of house decoration was a more realistic ambition and offered Abbotsford to Hay as his first commission.[18] Hay soon revolutionised his new profession through the application of scientific principles of colour theory and aesthetics which won him many commissions in the 'Modern Athens', and he was appointed contractor by the Board of Manufactures, where Playfair was to be one of his staunchest supporters. Hay now had the means to promote the work of the emergent Scottish School, some of whom, including David Roberts, were close personal friends. Hay turned his business premises into a picture gallery which created an ambiance redolent of art and won much useful publicity for his firm. His first gallery at 51 George Street (designed in conjunction with his partners, the Nicholson brothers) survives as auction rooms.

In 1828, following a quarrel with the Nicholson brothers over the patent rights to one of his improvements,[19] he moved to 89 George Street. In 1837, having purchased 90 George Street, Hay designed his ultimate gallery solution. Happily it survives and is now occupied by Laura Ashley Ltd. The Gallery was built over the garden behind the

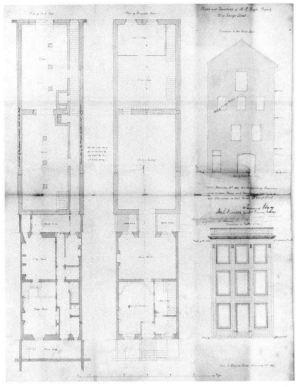

Proposed alterations by D.R. Hay to 90 George Street, 1837

staff, framing was a logical extension of the business and his agency for artist friends in London also promoted this branch of activity. Many Hay frames survive in Scottish collections today and have been identified from a stamped example.

Unfortunately no contemporary views of Hay's Gallery survive. The sophistication of the surviving elements, however, tends to eclipse contemporary rivals, such as The Vine at Dundee or the domed gallery at Balbirnie of c.1815.

In 1849, with the design of his National Gallery of Scotland (see C14–19), Playfair made his outstanding contribution to the design of the picture gallery, through which Scotland earned an important place in the development of this building type throughout Europe.

In preparing this paper I would particularly like to thank Kitty Cruft, Michael Clarke, Timothy Clifford, James Holloway, Alistair Rowan, Kenneth Scotland, and Giles Waterfield.

original New Town property. Boundary considerations ensured that it was top-lit, but it is illuminated by banks of rectangular lights, separated by scrolled brackets, in the flat angled coves. A single rear roof-light throws a further light across the back wall, which offers the best position for pictures; this may be an attempt to compensate for the shadow cast by the back wall of the mews buildings which Hay had adapted as his workshops.

Hay was presumably his own architect and the room is devoid of extraneous ornament, in line with his rationalist approach. He was no less interested in the best background colour for showing off works of art, and scientific experiment had convinced him that a particular shade of purple cloth sometimes described as *'claret coloured'* was the best mode of compensating for the often damaged pigments of Old Masters. When he redecorated, at his own expense, the Hall of the Society of Arts in London early in 1846, he had this cloth especially dyed to suit the condition of Barry's celebrated history paintings. He was equally concerned with the design of picture frames. With gilders already on his decorative

1 James Holloway, *Patrons and Painters, Art in Scotland 1650–1760*, 1989.
2 Ian Gow, 'William Adam: A Planner of Genius', *Architectural Heritage* I, 1990 (ed. Deborah Howard).
3 John Mackay, *A Journey Through Scotland*, 1723.
4 A Victorian watercolour of the view is reproduced in Duncan Macmillan, *Painting in Scotland: The Golden Age*.
5 James Duff (Second Earl of Fife), *Catalogue of Portraits and Pictures at Duff House*, 1807 (copy in SNPG).
6 Rev Dr George Barclay, 'Account of the Parish of Haddington', *Archaeologia Scotica* Vol 1, 1792.
7 The Earl of Wemyss and March, 'Gosford New Mansion House' *Transactions of the Edinburgh Architectural Association*, Vol I, p.118.
8 Robert Mitchell, *Plans etc of Buildings Erected in England and Scotland*, 1801.
9 William Adam, *Vitruvius Scoticus*, 1811, pl.135.
10 John Cornforth, 'Scone, Perthshire', *CL*, August 11 and 18, 1988.
11 Alistair Rowan, 'Paxton, Berwickshire', *CL*, August 17, 34 and 31, 1967.
12 ibid.
13 Francis Bamford, *The Journal of the Furniture History Society*, Vol XIX, 1983, pp.118–121.
14 Reproduced in T.Crouther Gordon, *David Allan, The Scottish Hogarth*, 1951, plate facing p.8.
15 National Library of Scotland, MS9704.
16 Esme Gordon, *The Royal Scottish Academy*, 1976.
17 Source unknown, published in Colin Thompson, *Pictures for Scotland*, 1972, p.19.
18 Ian Gow, 'Elegance on a Shoestring', *CL*, July 30, 1987.
19 D.R. Hay, 'On the Decoratioins of the Great Room', *Society of Arts Journal*, report of meeting of December 16, 1846.

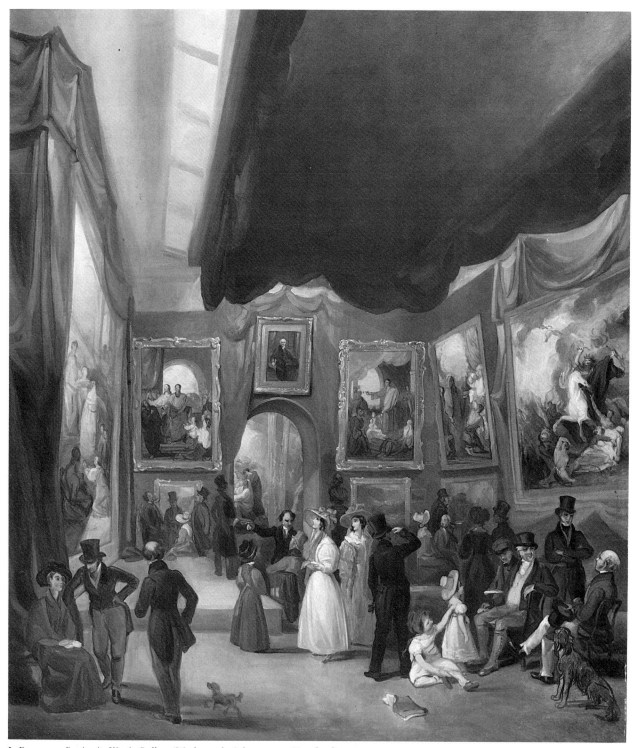

J. Pasmore, *Benjamin West's Gallery* (Wadsworth Athenaeum, Hartford)

The Architecture of Daylight *Michael Compton*

The two most important issues affecting the design of art museums and galleries were already under consideration before the earliest galleries were erected and have remained unresolved to this day: how to arrange collections and how to light them. This article is primarily about daylighting, but attention also needs to be directed towards the arrangement of pictures.

By the mid eighteenth century two kinds of display were generally considered, both calling for walls to be as densely hung as possible.[1] The first was that in which very varied works were shown together, so that artists and connoisseurs could make comparisons and distinguish the best features of each artist and school. The other kind grouped work by Schools, to demonstrate their 'rise' and 'fall'. In addition, owners naturally wanted to build up their collections and display all their treasures, while the growth of buildings may have lagged behind. The crowded displays which resulted were reflected in conditions for viewers: galleries were built wide, so that those nearest the wall could examine the smallest most detailed works on the lowest register, while those behind were admiring major works placed six or seven feet from the floor, and those yet further away were scanning the highest pictures. The system was very similar to that used in temporary exhibitions, in the Salons including the Royal Academy.

Either model required uninterrupted wall surfaces of moderate length (in which symmetry could be perceived), a good height and a reasonably even spread of light. The demerits of side lighting in relation to such arrangements quickly appeared. Windows not only divided and took up wall space, reducing the number of works that could be hung in a group and consequently the comparisons that could be made, but, from any given position, major works at and above eye level would suffer from reflections on their varnished (later, glazed) surfaces from the windows in the opposite wall. The lesser works below and above would be relatively exempt. If windows were opposite one another and widely spaced, the central pictures would not suffer from reflections while viewed from more or less in front, but would be in the darkest parts of the room. If windows were closely spaced on one long wall, this wall would be useless for hanging, and reflections would be multiplied on the facing one.

Nevertheless, side lighting was not ruled out. The development of European museums from princely collections and palaces may have favoured windows, the museum's role in leisured social life giving a value to views of gardens and rivers. More important was the belief that the best lighting must be that in which the work was created, commonly a studio with a high north light.[2] In spite of the fact that artists were said to have preferred top lighting for the display of their pictures, this principle was followed in the first conversion of the Grande Galerie of the Louvre by Percier and La Fontaine in 1808, with its alternation of bays with side windows giving views of the river and court, and bays with glazed apertures at the springing of the vault. Schinkel in his Altes Museum, Berlin, of 1823–30, also deferred to the studio with his tall side windows to north east and west, which could be screened from the bottom up. He avoided the problems of reflection and excessive variety of light level by arranging the main hanging surfaces, mostly quite short screens, at right angles to the windows in the outer walls.

Another consideration led to the perpetuation of the option of side lighting. In the lofty, top-lit galleries of many museums the illumination at the level of the lowest pictures was below what was required for the close scrutiny of the fine detail vital to many smaller paintings.[3] Side lighting was especially favoured for such works, which would be hung in smaller rooms corresponding to collectors' private cabinets. The Alte Pinakothek in Munich by Klenze, of 1824–36, combined large top-lit saloons for the large scale, generally history, pictures and a parallel range of cabinets for these smaller pictures, early ('primitive') works and studies. Without ranges of small pictures beneath them the major works could be seen at a more

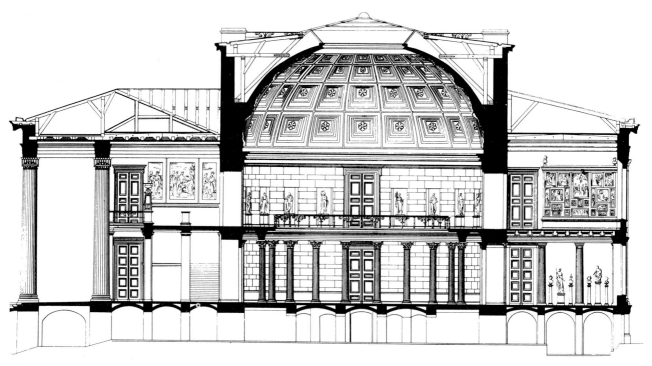

Altes Museum, Berlin

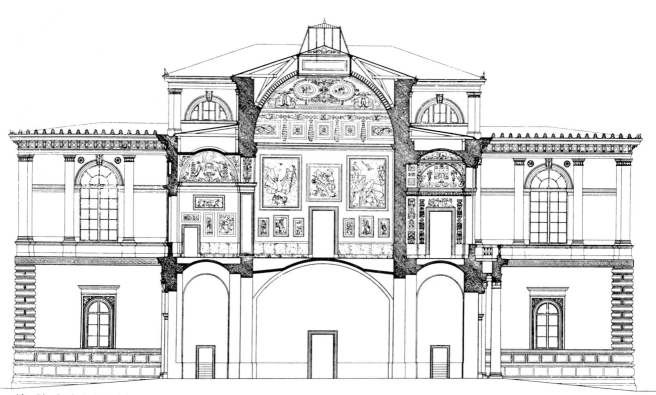

Alte Pinakothek, Munich

favourable height. This museum was the dominant example and remained influential for a hundred years. The prevalence of cabinet pictures in Dutch art may have prompted the provision of side-lit cabinets in both the main museums of Amsterdam in the late nineteenth century and in later galleries in the Netherlands, like the Boymans Museum in Rotterdam, of 1931–5.

The trend towards exhibiting paintings in the context of sculpture and decorative art in a reconstructed or pastiched architecture of the same period also demanded side windows. This tendency was at its height from the 1890s to the 1920s, after which renewed theories of the special-ness of painting and sculpture reversed it. All the same, some very distinguished museums, especially that at Louisiana, Denmark, built in several stages since the war, have large 'picture' windows, which allow works of art to be seen in a quasi-natural setting. Some of the galleries of the Burrell Collection in Glasgow, of 1978–83, follow this principle, but the objects placed near the glass can hardly be seen because of the brilliance of the illumination behind them.

Top-lighting also had its artist's prototype in Rubens' studio, as well as precedents in temples and churches. It soon became the dominant tradition, especially for large museums in confined urban sites, where galleries had to be packed together. Generally restricted to a single floor, such galleries could be grouped to allow a compact circulation pattern. Top-lighting also presented constant technical difficulties. As with side lighting, direct rays of the sun had to be kept off the pictures. An angle of incidence low enough to provide a strong, even illumination will produce reflections and glitter on the surface of pictures. Skylights and laylights large enough to illuminate wall surfaces brightly are likely to illuminate the floor and the viewers even more brilliantly. Though less conspicuous than windows, the source of light tends to be much the most brilliantly lit zone of the room, and will dazzle the viewer unless lifted out of the line of sight, where its ability to light adequately is compromised. Finally, a very large source is necessary to light the gallery under overcast skies but, when the sun is out, too much light and heat are admitted, and the means of control tend to be conspicuous, distracting and, if manual, unused.

In eighteenth century buildings, before the appearance of specially designed art museums and

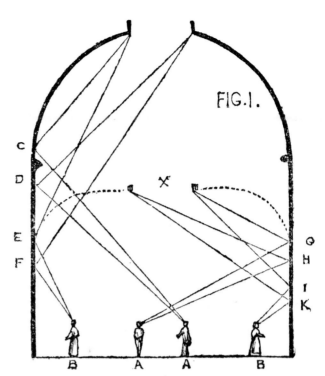

From *The Builder*, 28 Nov 1857

galleries, there were three principal types of top lighting to be seen, which will be termed 'clere-story', 'skylight' and 'monitor' (often called 'lan-tern'). The clerestory type has vertical windows high in the plane of the wall and was familiar in churches. Its drawback was that low windows dazzled the viewer and produced reflections or glitter on the paintings, whereas higher ones, while reducing these problems, made the room dispro-portionately high, with extreme falling off of illumination from top to bottom. Accordingly, this form was not often chosen for picture galleries as distinct from sculpture halls, in spite of the great fame of the prototype, the Tribuna of the Uffizi. Recent avatars include the Duveen Sculpture Galleries at the Tate.

The skylight form offered glazing in the roof, at an angle ranging from a few degrees to about 45 from the horizontal. Skylights were at first gener-ally not large because the available panes of glass were small, fragile and difficult to set in a waterproof structure. Cast glass had been available in sheets as large as six feet square from the beginning of the eighteenth century but was too expensive. The gallery of the dealer Le Brun in Paris (1785–86) had a relatively large skylight, making use of a glass that was somewhat diffusing

because of the way it was handled in manufacture.[4] This was cylinder glass, available in larger sheets than the crown glass that was more popular in England because it was smoother and clearer. W.H. Playfair designed similar skylights for the elegant rooms of the Scottish Royal Institution of 1822 and National Gallery of Scotland of 1849–55, with attention to science.[5] He varied the height of the rooms and size of the skylight in relation to the floor areas and the type of objects displayed. The picture gallery of the former allowed works to be hung to a height of 18 feet, without creating reflections for a viewer in the middle of the room. The funnels and coves of the latter are not too deep nor the walls excessively high; the corners are generously splayed. Although many skylights have been constructed, no more attractive galleries than those of Playfair's National Gallery have since been built in Britain. The only problem seems to have been the complication of cords required to manage the many triangular blinds.

The third type of top lighting, the monitor, comprised a structure built onto the roof, well within the margins of the walls on which pictures were to be hung, with vertical or slightly inclined glazing on its sides and an opaque top. This type, long used in churches, was adapted for enclosed saloons and staircase halls in Italy and applied early in the eighteenth century to three rooms of the Duc d'Orléans' Palais Royale in Paris.

The monitor-lit gallery may have been introduced to Britain in sale rooms like that of Aaron Lamb in Pall Mall, used for the earliest exhibitions of the Royal Academy. Sir William Chambers adopted it for the Academy's Great Room in Somerset House in 1780, so it must be presumed the preferred choice of the leaders of the profession. Certainly the importance of the Academy's exhibitions made it a leading prototype. It had the advantage of throwing a higher proportion of light onto the walls than other types of top lighting. Moreover, provided a gallery lit in this manner is high enough and not too long, the light source is virtually out of the sight line of viewers and there is a minimum of glare. It works better when the sky is overcast and sunlight is diffused from all round. Pictures high on walls could be canted forward to reduce reflections, excess illumination and the obliquity of the angle of sight. In addition, simple technology allowed good ventilation and the control of direct sunlight by blinds or curtains (later louvres), while the glazing was

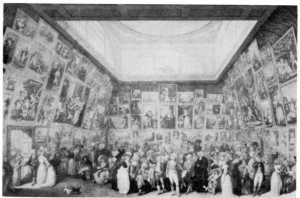

J.H. Ramberg, *Royal Academy*, 1787

less likely to leak or break. Leaks or condensation could be prevented from running down the walls onto the pictures.

This example was followed by George Dance in his Shakespeare Gallery of 1786, with larger windows. Dance's pupil John Soane employed monitor lighting in a number of buildings, above all the Dulwich Picture Gallery. This was a change of direction for Soane, in that his earlier gallery at Fonthill, 1787, had large skylights, not unlike those in Le Brun's gallery but elliptical. Visitors to Dulwich were divided in their opinion of the lighting, some finding it excellent, others dim. Certainly the depth of the monitor was not great and the glazing was interrupted by many fairly thick bars. The light level must have been low when the weather was heavily overcast and on winter afternoons. The monitors were eventually top-glazed in the early twentieth century, and the new galleries provided with skylights. A number of private galleries, including those in Cleveland House, Attingham and Thomas Hope's London house, followed the monitor principle with vertical glazing. But later monitors, like those of Taylor in the London National Gallery, of 1886, were designed to admit more light, being larger and having canted glazing to expose the pictures to a wider arc of the sky. However, they gave a greater proportion to the floor and increased the probability of glare and reflections.

Some considered that monitors gave too little light in the body of a room. Wilkins glazed the top of his monitors in the National Gallery/Royal Academy of 1834–38. George Basevi's well-studied principal gallery in the Fitzwilliam Museum, 1836–45, also had monitors punctured by skylights. In both cases the glazing opened only

40

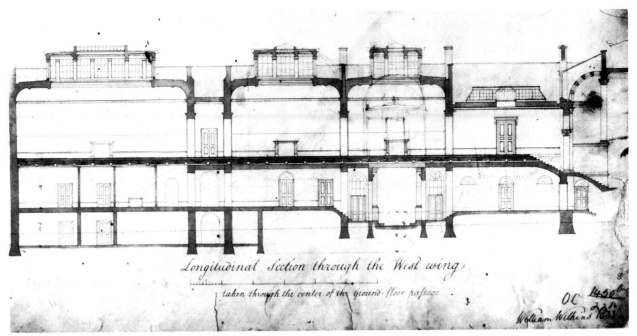

Longitudinal Section through the West wing, taken through the center of the ground-floor passage

William Wilkins 1833

W. Wilikins, National Gallery, London (PRO)

a part of the top. The Wilkins solution seems to have been a good one, although at least one commentator thought it shed too much light on the centre of the room to the advantage of the ladies' dresses.[6]

Sir Charles Eastlake, Keeper and later Director of the National Gallery, was, however, attracted to the side light proposals, with oblique walls, of the German professor Magnus. This would have allowed pictures to be shown on several floors but he emphasised, as Soane had done, that the light source should not be in the view of people looking at pictures.[7]

The problem of hiding the light source led to some radical designs. Dance had earlier contrived a form of lighting by which a vertical window threw light onto a vault and so to the room below, for the library of Lord Lansdowne.[8] His precedent may have been the design for the alterations to St John Lateran which Piranesi was working on when Dance met him in Rome during 1763–65.[9] The principle of indirect lighting was not developed in museums until later; Benjamin West's gallery in Newman Street, 1821, had a shaded central viewing area with hidden skylights around the edge, directing illumination only to the walls. J.B. Papworth, who probably designed this, built a similar gallery on Clapham Common, 1829–33.[10] The Doré Gallery (now Sotheby's) and Alma-Tadema's Gallery in King Street installed baffles (devices to regulate light) in about 1880 to direct the light onto the walls and hide the source. The intention seems to have been to create a theatrical effect for their pictures, which were to influence the film epics of the early twentieth century. The large gallery of the Mappin in Sheffield and the principal room of the Whitechapel Gallery had top-lit aisles in which the glass was hidden from the centre of the space, but in the latter at least, the room was so large because it was intended not only for circulation but as a nave in which the gospel of art could be preached.[11] In principle such galleries (except the last) could be extended or multiplied to form a large museum but this was not attempted until the twentieth century, although Cockerell had proposed variants of the Papworth system for the National Gallery in 1850 and 1867.[12] The disadvantage of the Papworth type is that, if the angle at which the light falls on the pictures from the glazing is not to be too steep, the walls cannot be high and the ceiling at the centre will be low as well as dark.

There was one other major variant to top lighting. Captain Francis Fowke designed the Sheepshanks Gallery of the South Kensington Museum in 1855–56 with large skylights which formed the weather protection and let in the light, and, beneath them, a diffusing laylight. This may

41

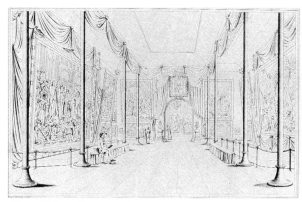

West's Gallery, Newman Street (A19)

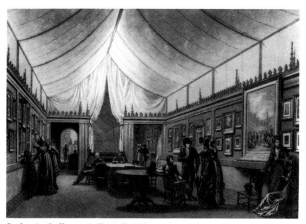

Isabey's Gallery, Pall Mall (G7)

have been an architectural version of the gauze laylights which artists are said to have used and which were employed by dealers and for temporary exhibitions.[13] An engraving of Isabey's exhibition rooms in Pall Mall, c. 1821, shows such a velum in the form of a tent. Its function was to prevent direct rays of the sun striking the picture surface. An engraving of 1843 shows another type of cloth velum around the edges of the very large skylight of Nash and Elmes's Suffolk Street Galleries of 1820–3, and can only have been intended for this purpose. The skylights stretched the length of Fowke's building, which would allow divisions to be inserted beneath. It is not clear why the double glazing designed by Fowke did not become the preferred option in Britain, unless it was because the sky was considered to be overcast so often as to render it unnecessary. Fowke's Queen's Gallery at the National Gallery of Ireland, 1860, and both Pennethorne's 1860 and Barry's 1876 extensions

to the National Gallery did have laylights, but the illumination was considered dull and Taylor reverted to monitors for his rooms at the National Gallery in 1885. On the other hand in Europe and the United States laylights became generally fashionable. They were introduced into the Grande Galerie of the Louvre in 1856–8 and the principal galleries of the Altes Museum in Berlin in 1878–84; many others had them from the start.

Fowke's principal innovation was to install gas lighting, in the form of long pipes with many naked jets, to accommodate evening openings. This demanded very good ventilation since it was known that the sulphur dioxide it produced could attack pictures. The air was forced in, heated and humidified but not filtered. A test carried out by Michael Faraday and others showed that paints suffered less damage than at the National Gallery, which was located in an area of very high pollution. Fowke's was the first British public art gallery to be designed with artificial lighting in mind. Rooms hung with works of art in private houses had often been gas-lit; Thomas Baring's Gallery in Grosvenor Street is cited in the Faraday test. In 1812 the Prince Regent had given a massive candelabrum of 30 oil lamps to furnish the Great Room of the Royal Academy at Somerset House.[14] This was converted to gas in 1817 and the other rooms were lit with gas the following year.[15] In 1836 the Academy's Council decided to have their new galleries at Trafalgar Square lit by gas. The Regent's candelabrum seems to have been rehung in the East Room and another large lamp was made, presumably for the West Room.[16] All the galleries were used for the annual Dinner and for other functions when the exhibition was not open; the principal use of the lighting was for these occasions, and galleries containing pictures seem only to have been lit on the two days before and after the exhibition.[17] It was only in 1861, following South Kensington, that the gas fittings were altered and in 1862 regular evening viewings began.[18] Smirke's galleries for the Royal Academy at Burlington House were in turn supplied with £2,512 worth of gas fittings, a very large sum in 1869. However they blackened the gilt decorations of the roof structure to such an extent that evening openings were discontinued the same year.[19] This setback may have pleased the Trustees of the National Gallery, who had resisted the clamour for evening openings for parts of their own collection at South Kensington. They swept away all gas

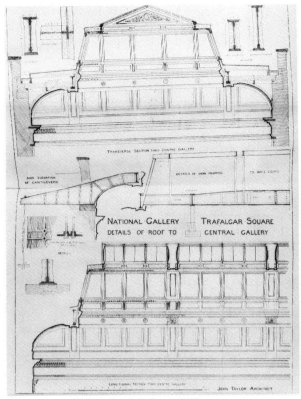

J. Taylor, roof of National Gallery, 1887

fittings from the east wing at Trafalgar Square as soon as they inherited it from the Academy in 1869 and in 1886[20] remained of the opinion that the risks of gas lighting were so obvious that they needed no further argument.

The South Kensington Museum also pioneered electric light, sending a delegation to Paris in 1877 to view the first (barely) practicable system of arc lights. In 1878 they experimented with another system, placing arc lamps above a calico velum, and in 1881 installed arc lamps in the Raphael cartoon court and the Sheepshanks Gallery. This type of lighting was difficult to maintain, the rods having to be replaced at short intervals, and their adjustment was unreliable. Sir William Armstrong fitted arc lights in his private gallery at Cragside at the end of 1880 and changed them for the new filament lamps of his friend, the inventor Swan, by January 1881. The Royal Academy installed electric lighting in an exhibition in 1882, and by 1893 in all galleries.[21] Other public art museums in England seem to have followed these prototypes very slowly. The National Gallery, the Tate and several large municipal galleries did not introduce full systems of artificial light until the mid 1930s.

The combination of relatively low levels of natural light and resistance to the use of artificial light in Britain meant that skylights had to be very large to provide adequate levels at all seasons and hours. Ruskin had proposed that all pictures should be glazed so that, if hung at high level, they would reflect the skylights and become invisible. He hoped that curators would then be obliged to hang pictures in a single, or at most double, line at eye level and in a chronological sequence.[22] More and more works were in fact glazed and heavily varnished to protect them from increasing pollution. The brilliant day-lighting offered by wider skylights and more sloping monitors made it difficult to see those placed high, and the ranks of pictures were slowly reduced. The creation of study collections and the wish not to over-tax the public contributed to this trend.

Towards the end of the century this development should have been affecting museum design, but little change occurred, and up to 1914 wall heights were only moderately reduced and were simply left empty above a certain height. The preferred angle of incident light was usually 45 degrees, and this would be provided over a hanging surface rising some 15 feet above a dado, according to the influential specifications of the German authority, Tiede, and followed by the Dutch architect Weissman.[23] However, when Weissman's Stedelijk Gemeente Museum opened in 1894, it was hung with a basically single row of pictures, almost touching, but leaving a vast area of strongly lit blank wall above. The same thing can be seen in many photographs soon after the beginning of this century.

It seems that the brightly lit galleries of the later nineteenth century set a standard of expectation by which the scientific galleries of the Papworth type appeared gloomy. However the pendulum swung again when museum daylighting received another scientific boost from a paper by S. Hurst Seager of 1912.[24] He condemned virtually all the galleries built up to his time, on the old grounds that the light was directed mostly onto the viewers who saw their reflections rather than the pictures at eye level, while the higher pictures could not be seen because of the glare and reflections of the light source. He may have disregarded the problem of the reflection of pictures across the room because paintings were generally canted slightly forward and only reflected the floor at a distance.

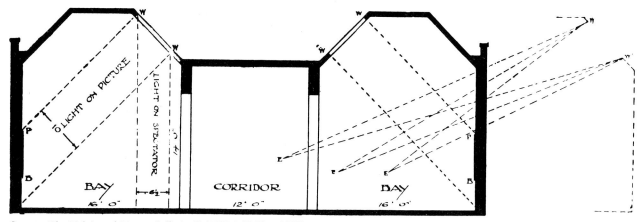

Seager, *The Lighting of Picture Galleries* (*Jnl RIBA* 23 Nov 1912)

The system proposed by Seager was virtually identical to Papworth's, having been developed in experiments at the National Physics Laboratory, London, in the 1920s. It influenced the design of the Duveen Gallery of 1925 in the National Gallery, the Courtauld Gallery of the Fitzwilliam, 1927, and the Barber Institute, Birmingham, of 1939. The Laboratory introduced the idea of an opaque external reflector to keep direct sunlight from south-facing, and to redirect it to north-facing, glazing. This schema was realized in a room built at the Tate Gallery in 1927.[25] It comprises only half the Seager system, leaving one of the long display walls in the light intended only for circulation, to avoid reflections on pictures on the main wall. It creates a large, excessively brilliant half-vault, directly over the latter. The failure of this formula was so obvious that it has not been copied, but a number of relatively successful adaptations of the basic Seager principles were built all over the world in the decades before and after the hiatus in construction during 1939–47. These included an acceptable compromise in which the centre of the room was lit artificially or by a translucent laylight (velum), while stronger daylight and artificial supplements were directed to the (now rather lower) peripheral picture walls, by means such as louvres. Leading examples were the Boymans Museum (A. van der Steuer, 1931–35), Rotterdam, and the Hague Gemeente Museum (J.C. Eymers, 1932–36), which employed several different systems for rooms of different shape, size and height.

The diffusing laylights, long popular in America and continental Europe, had been found to have certain advantages not originally intended. They made it easy to install fittings above, and electric lighting was quickly introduced. Wiring and fittings, whether lamps, blinds, louvres or ducting, would be invisible, and accessible for replacements and maintenance. The zone between skylight and laylight could be separately ventilated, an important factor in hot climates. In addition, new demands for variable display on screens could be met by extending the laylight close to the perimeter walls. The inherent drawback of such a lighting system – excessively high illumination of the ceiling – would be mitigated by the subdivision of the space beneath into quite small units, so that the angle of vision which would bring the ceiling into view would be well above that directed to the pictures. On the other hand, the focused illumination provided by the Seagerite Duveen Gallery at the National Gallery was felt to be so poor that it had to be supplemented at once with electric lamps, the first in the building. Soon after, the call for evening opening was at last heard and electric light in the form of hanging lanterns was installed throughout in 1935.[26] These were calculated to throw most of their light onto the picture zones.

In the post-1945 era, museum requirements were elaborated in directions that created far more complications than before. Among these were the greater importance of temporary exhibitions, which have demanded highly contrived individual installations; the progressively more exacting prescriptions of the powerful conservation profession; and the infinite resourcefulness of artists in testing the limits of what is provided in museums.

At first, solutions were relatively uncomplicated developments of what had gone before. The 1958 reconstruction of the Birmingham City Art Gallery followed Seagerite principles,[27] but with fixed

Dureen Wing, Tate Gallery, 1927

baffles like those of the old Doré Gallery to shield views of the skylight; it had a light-transmitting, egg-box central laylight to soften the contrast. The gallery of Christ Church, Oxford, of 1969, is also of a modified Seager type. In many old galleries, including the National and Tate, temporary or permanent diffusing laylights were inserted under skylights or monitors to reduce the redundant height of walls or allow the installation of screens providing extra wall space, or to facilitate the introduction of air-conditioning.

In new buildings some novel solutions appeared. The roof structure itself could be divided into the equivalent of an egg crate, although on a large scale, as in the Commonwealth Centre gallery of 1962, or the upper rooms of the Hayward Gallery, opened in 1969. These devices can reduce the drawback of an excessively bright ceiling, while permitting a flexible display beneath, but they tend to create an obtrusive pattern out of harmony with walls and exhibits.

The Hayward Gallery, in those parts which are day-lit, illustrates a contradiction that has dominated lighting design but has not been resolved. It arose from research into the effect of light on works of art, especially by the scientific department of the National Gallery. An influential paper on this topic was published by Garry Thomson in 1961.[28] To admit enough light to illuminate a gallery for most of the opening hours in mid-winter, a day-lighting system needs a capacity many times greater than that sufficient under good summer conditions. When there is plenty of daylight, it will be necessary both to deal with the effects of solar gain and to reduce light levels,

because any light, particularly on a drawing, painting, fabric or photograph, causes damage. Guidelines on illumination were put forward by Thomson and others[29], based on compromises between the vulnerability to light of various materials and adequate levels for their appreciation. 50 lux was quoted for works on paper and 150 or 200 lux for oil paintings, on the understanding that ultraviolet light would be filtered out, galleries would be blacked out when not open to the public, and the more vulnerable objects would only be exhibited for short periods.

The damaging effects of light are proportionate to both intensity and time. If very low levels are acceptable at times, higher levels can be permitted at others. If, however, 100 lux is felt to be a minimum below which visitors can reasonably complain and 150 the average, there is little margin for higher levels and control must be tight. In Victorian galleries the natural variation is from almost nil up to 5000 lux plus. At the same time, variations in the humidity levels must be minimized. Accordingly systems had to be devised to shield glazing and hanging surfaces from direct sunlight, to black out galleries when not in use, and to respond to the intensity of exterior light, to keep the interiors within the limits required. In addition, the acceptability of lowish levels of illumination on pictures depended on there being no areas with much higher levels. In the Hayward Gallery, for example,[30] the necessary equipment, including the building structure, so reduces the light level that artificial supplements are almost always necessary, and so change its quality that it is no longer perceptible as daylight. It is almost self-defeating as well as very expensive.

The roof structure of the extension of the Tate Gallery, designed by Llewelyn Davis, Weeks and Partners (briefed by the present writer among others) in 1970–9, was more ambitious than the Hayward, since it sought to give the viewer the possibility of directly experiencing natural light, and to create a traditionally spacious environment for works of art, while conforming to the scientist's recommendations on light levels.[31] At the same time the gallery had to cope with the demands of contemporary art. It was recognised that controlled day-lighting was incompatible with complete flexibility and the brief asked only for the placement of walls on a module related to that of the old building. The control system was designed to allow curators to adjust light levels on walls in

these positions to any selected range, with delays so that it did not constantly react. Light is excluded when galleries are not open to the public and artificial light is programmed to supplement daylight when necessary. The scheme has been partially vitiated by the inflexibility of the original controlling electronic programme, and by the problem of finding screening equipment capable of functioning without failure. Pressures exerted by the Government spending programme led to construction beginning before this problem could be resolved. After trials, a system of louvres was superimposed on a structure designed for blinds. Some people find the result obtrusive, but it is at a very high angle and should be outside the range of vision of most visitors most of the time. In terms of its basic geometry, this scheme is a descendant of the Papworth-Seager systems, with daylight principally directed to the walls. But the opaque central zone is designed to be unobtrusive and is lightened by a large panel intended to provide ambient illumination.

The feeling that nineteenth century galleries look much better than most of those of the mid-twentieth century, already expressed in the 1960s, became almost universal about 1980. This was partly due to the fact that the equipment needed to provide reasonable control of light and atmosphere had become less obtrusive and it became possible to remove much glass from frames or replace it with non-reflective glass. Screens and laylights have been removed but heavy Victorian decorations have not been reinstated. The charm of these galleries is also partly due to the fact that, hung as they now are with relatively few, widely spaced pictures, they seem generous as a setting and assert their architectural integrity.

The Clore Gallery by James Stirling, Michael Wilford and Associates, is a manifestation of this sensibility applied in a new design. Technically it is a combination of the monitor with an ingenious variant of the Papworth-Seager system. A simple system of louvres which adjust hourly to a limited number of fixed positions controls the incoming light so that it reaches an annual aggregate, and an internal structure reflects most of it towards the pictures, while largely obscuring direct views of the glazing.[32] It avoids the sense of an oppressive descending roof that has marred many related designs. Above all, it declares that a gallery should be a gallery (as established in the nineteenth century) and that this requirement should over-

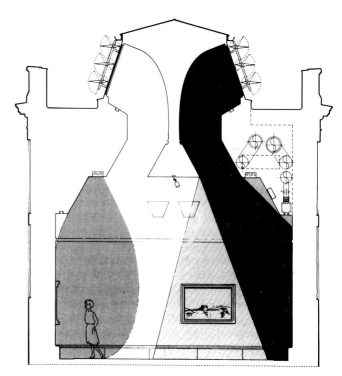

ARTIFICIAL LIGHT DAYLIGHT

Close Gallery, Tate Gallery

ride the demand for obtrusive systems designed to rectify and control illumination. This view had been expressed long before by Sir Kenneth Clark in a lecture to the Museums Association in 1945,[33] which condemned not only the National Gallery's own Duveen Gallery but even any attempt to illuminate the corners of a room as strongly as the centres of walls. The barrel-vaulted Sackler Galleries at Burlington House by Norman Foster, of 1991, are intended to create such a definite space; the sensation of pervading light is very strong, even though much of it is again directed at the viewer rather than the walls.

The National Gallery extension by Venturi and Scott Brown, 1988–91, is a manifestation of the same sensibility.[34] It is even more determined to look like an art museum, taking as its prototype Dulwich Picture Gallery. The structure and equipment required to fulfil scientific demands have been provided by a series of ingenious attics which mediate the daylight to the monitors. These attics are entirely glazed and cover about half the total area of the galleries. The inside surfaces are light grey so as to reflect most of the light, and much of the monitor glazing is frosted, diffusing the light

46

into the galleries. The attics are provided with louvres controlled by a computer which averages light levels on the pictures over a period and adjusts them to a set figure of about 200 lux at quite long intervals, preserving some of the variability of natural light. This figure includes the contribution of two sets of spotlights which provide respectively a cool light on the wall around the paintings, and a more concentrated warmer light, automatically switched on when the combined daylight and cool light fall below a selected level. While the picture lighting provides good colour rendering, it is not natural: the proportion of artificial light varies upwards from about 25% and its colour becomes warmer as the overall level falls to the minimum set at about 150 lux. At this point the light is most concentrated in the picture zone. Fluorescent lights illuminate the monitor windows when daylight falls too low and the louvres have closed to eliminate the rest. In some rooms windows provided a modified side light that is pleasant without contributing much functional illumination, but pictures set against it are affected by glare. The natural variations of light affect the whole space, while the artificial light stabilises illumination on the pictures. Combined with the elegance of the architectural forms the effect of the interiors is excellent and in accord with the sensibility of today. It seems likely to be emulated.

1 A good account is in Andrew L. McClellan, 'The politics and aesthetics of display: museums in Paris 1750–1800', *Art History* VII no 4, p.438–64.

2 C.A. Guillaumot, *Mémoire sur la manière d'éclairer la galerie du Louvre* (1796) p.23. He gives the artist's usual angle of lighting as 45 degrees but considers artists would prefer a higher angle if they could get it; see note 7. See also J.G. Soufflot, quoted in McClellan, op. cit., p.463, note 81. Galleries built specifically for artists generally had top lighting such as those of Turner, the Royal Academy and Benjamin West, described below.

3 See for example C.L. Eastlake quoted in *Builder* III, 14 June 1845 p.282 and Richard Redgrave, 'Construction of Picture Galleries', *Builder* XV, 28 Nov 1857, pp.689–70.

4 M. Gallet, 'La Maison de Mme Vigee Lebrun', *Gazette des Beaux Arts*, 8me per no 56, p.277 and Guillaumot, pp.24, 35, 37–38.

5 Esmé Gordon, *The Royal Scottish Academy*; Ian Gow and Timothy Clifford, *The National Gallery of Scotland* (1988).

6 Review in *Atlas*, May 1837, RA press cuttings book.

7 'The National Gallery, Arrangements of Pictures Generally' *Builder* III, 14 June 1845, p.282–3, reporting an open letter from Eastlake to the Prime Minister, Sir Robert Peel. Eastlake quotes other museum Directors advocating side light as that in which the paintings were executed.

8 John Soane, *Lectures on Architecture*, ed. A.T. Bolton, 1921, p.126, pl.63, describes ambiguously a form of common hidden-source lighting in galleries that could be a monitor, but the illustration was Dance's Library.

9 John Wilton-Ely, *Piranesi*, Arts Council, 1978, no 220.

10 *Report of the Select Committee on the National Gallery* (1850) Appendix p.82, evidence of Charles Eastlake; also J.W. and W. Papworth, *Museums, Libraries and Picture Galleries* (1853) pp.72–3, pl.9.

11 Charles Aitken, 'The Need for Intermediate Art Galleries', *The Toynbee Record* May 1908 pp.107–9.

12 *Report of the Select Committee* (1850) p.xx and F. P. Cockerell, *Description of the Design for the Proposed national Gallery* (1867).

13 The most accessible account of Fowkes's work for the museum is John Physick, *The Victoria and Albert Museum* (1982) pp.33ff., also M. Faraday and others, *Report of the Commission appointed to consider the subject of lighting Picture Galleries by Gas*, South Kensington, 20 July 1859. The museum prototype for Forke's laylights was presumably Voit's Neue Pinakothek, Munich, 1846–53, published in *Builder* IX no 549, 13 Aug 1853 p.513.

14 Hutchinson, pp.71–2.

15 Minutes of the Council of the Royal Academy, 5 April 1817, 8 Aug 1817.

16 Scattered references in Minutes of the Council, vol VIII, pp.255–432. The Regent's Candelabrum appears in the East Room in an engraving of about 1855.

17 Letter in National Gallery Archive, Secretary of RA to Director, Jan 1862.

18 Royal Academy Accounts 1862–8.

19 Royal Academy Building Accounts April 1869 to Jan 1870 and Annual Report 1869, p.10.

20 National Gallery *Return to an Address of the Honourable House of Lords* 9 March 1886.

21 Hutchinson, p.72.

22 John Ruskin, letter to *The Times* 7 Jan 1847.

23 A.W. Weissman, *Het Gemeente Museum te Amsterdam* (1895) pp.52ff.

24 S. Hurst Seager, 'The Lighting of Picture Galleries and Museums' *RIBA Jnl* 23 Nov 1912 pp.43–54.

25 'The National Gallery, Millbank, Lighting of the new Duveen Galleries', *Builder* 9 July 1926.

26 Letter from HM Office of Works to the Minister, Ormesby Gore and his speech at the inauguration, 28 March 1935, National Gallery Archive.

27 A.G. Sheppard Fidler, 'Reconstruction at Birmingham', *Museums Journal* LVIII (1958) pp.151–8.

28 Garry Thomson, 'A new look at Colour Rendering, Level of Illumination and Protection from Ultra-violet Radiation in Museum Lighting', *Studies in Conservation* VI nos 2–3, Aug 1961 pp.49–70.

29 For example 'Recommendations for Good Interior Lighting', *Illuminating Engineering Society* (1961) and Michael Brawne, *The New Museum* (1965).

30 'Building Illustrated, Hayward Gallery Appraisal', *The Architectural Forum* CXLVIII no 28, 10 July 1968 pp.56–60.

31 'Tate Gallery Extension Lighting', *Studio International* CLXXXIX no 975, May–June 1975 p.210.

32 Peter Wilson, 'A New Light on Turner: Reconciling Conservation and Display in Tate Gallery', *The Clore Gallery* (1987).

33 Sir Kenneth Clark 'Ideal Picture Galleries', *The Museums Journal* XLV no 8, Nov 1945 pp.129–34.

34 Colin Amery, *A Celebration of Art and Architecture* (1991).

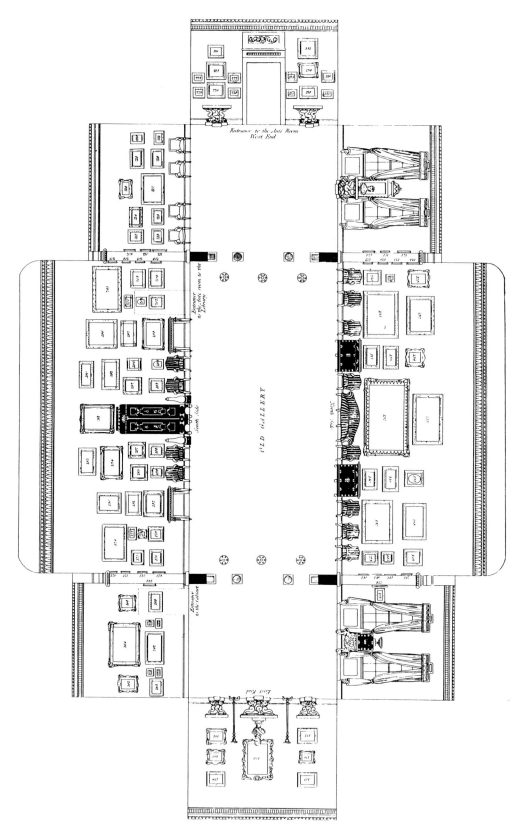

Marquess of Stafford's gallery, Cleveland House, London (A11)

Picture Hanging and Gallery Decoration *Giles Waterfield*

This catalogue frequently illustrates and refers to the changing attitudes to picture hanging and to wall decorations in galleries over the last two hundred years. This very large subject could occupy many pages: only a few are available here for a brief discussion of the changing attitudes to these two closely related aspects of gallery history.

Styles of picture hanging can, broadly speaking, be divided into four principal groups: the 'Picturesque', or decorative, hang; the didactic historical arrangement; the 'cluttered hang'; and the single row of paintings, linked with the Aesthetic hang of the late nineteenth century. Other types of arrangement can be found, notably in private houses, where paintings were often dispersed around the rooms of a house in a domestic rather than organised manner, the idea of a discrete gallery not always being welcome. The arrangement of paintings according to subject-matter has also been popular since the eighteenth century, as the comments of a late Georgian traveller suggest: *'In my great hall...would be pictures of magnificent horses by Wooton* (sic)*; in my dining room, full length Vandykes as Dukes of Richmond, Hamilton &c; in my library, some rare Holbeins; and in my drawing room the most finish'd picturs of Hobbema, Ruysdael, and Berghem'.*[1] This is, however, an approach which has been considered appropriate to private houses rather than public galleries.

The idea of the decorative arrangement derived from the Continental collections seen by Grand Tourists who experienced both the Picturesque hangs to be seen at, for example, the Pitti Palace, and the more discriminating arrangements at the Tribute of the Uffizi. Among the most influential statements of this type of hang was the publication of the catalogue of the Gallery of the Electors Palatine, in 1778. This work illustrates the arrangement in their palace at Düsseldorf of the collection amassed by the Elector Johann Willhelm in the early eighteenth century.[2] Particularly strong in Italian, Dutch and Flemish paintings, it was shown in five rooms, arranged by School.[3] The whole collection, and the rooms in which it was displayed, formed a unified work of art. To this ensemble not only the paintings but the associated elements of the gallery contributed: the frames, the wall decoration, the furniture, the bronzes, and the disposition of the pictures. The frames played an important part in this and other galleries. It was important that they should present a coherent appearance: at its most extreme this meant that an entire collection would be shown in one type of frame, as at Dresden, where the Elector of Saxony ordained around 1746 that all his pictures should be placed in uniform Rococo frames. The eighteenth century favoured gold-coloured frames, and it was usual for entire collections to be so accommodated: this was the case at Dulwich, where the pictures bequeathed as a single collection in 1811 had been put into gold-leafed plaster frames, even small Dutch cabinet pictures which would originally have been shown in ebony, or brown or black fruit-wood, frames. Gilt frames emphasised the value of the work of art that they surrounded, and the use of a single type, or of a limited range of types, for a large group of paintings of different Schools, periods and sizes, asserted the fact that they belonged to a single collection. (Such period frames create a problem today at such a gallery at Dulwich, where the unity of much of the founding collection is an important element in the Gallery's history. Many of the smaller Dutch paintings, in particular, are in frames which to modern eyes are too large and fully modelled for their intimate character: to reorganise them in quasi-original frames would, however, detract from the collection's identity. The experiment made by Sir Gerald Kelly after the Second World War of reframing four major Spanish paintings in Spanish frames of a seventeenth century type, though it may be individually pleasing, disrupts rooms otherwise filled almost entirely with frames of specific, related, types, very different to the black and gold Spanish examples.) The creation of balancing frames was of great importance; and no doubt was felt, at a time when the individuality of the work of art was less highly regarded than it is today, over adding to or subtracting from a painting to create matching

49

Above and below: Cleveland House, London

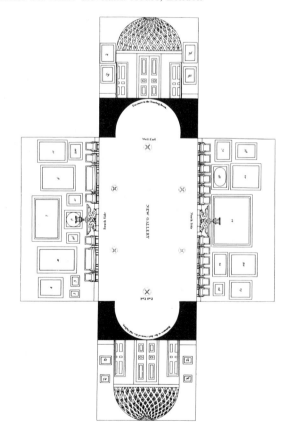

pendants.

This type of decorative scheme was applied throughout Europe from the seventeenth century onwards. One major picture was arranged as the centre of a composition or, more usually, of a wall. It was flanked by one, two or more pairs of paintings, arranged symmetrically on either side, and the pattern might be repeated again left and right of the central group. Paintings arranged in tiers of up to six works might contribute to the effect. A continuous row of smaller paintings was often introduced below the central picture; as Michael Compton explains above, such smaller works were intended to be studied by spectators standing close to the wall. The central painting was often used as a Giant Order, occupying the whole height of its section of wall, though the group could also be centred on a landscape-shaped picture.

This style of hanging was particularly suitable to a private collection, in which the owner could shape the group of pictures to his own taste. As well as being common in country houses in eighteenth century England[4] (many examples of which have been disrupted over the years, though some, as at Holkham and Kedleston, have been restored in recent years), this style remained the norm in great London houses throughout the nineteenth century. It could be seen in Regency interiors at Carlton House, Apsley House and Cleveland House (later Bridgewater House), both in the rooms specifically designated as 'galleries' and in more obviously domestic apartments. These houses were not, however, arranged on purely visual principles. As at Düsseldorf, the Schools were sometimes divided from one another. At Cleveland House, the Marquess of Stafford's paintings were arranged from 1805–06 onwards in the symmetrical manner, but considerable thought was given to their disposition, with the Schools being kept largely apart. At Grosvenor House, as recorded in 1821,[5] the classification of types was looser, the main division being between 'High Art' on the one hand (a category extended to include Joshua Reynolds), and Dutch and Flemish landscape or genre on the other, with British painting occupying a subsidiary position of its own.

The principal advantage of the Picturesque Hang was, and is, visual. In much simplified form it has continued to guide the arrangement of pictures in many public collections, though the skying of pictures (i.e. placing them high on the

wall) has generally been replaced by a single, or, at most, double, row. Its principal disadvantage is that it is not sympathetic to historical principles: the organisation of paintings according to period which requires the spectator to view the paintings in a progressive line along the wall, can hardly be accommodated in an arrangement in which not only the sizes of paintings but their prevailing tone, the scale of the figures (life-sized figures being placed, where necessary, in a row above the smaller figures) and subject matter are the most important considerations. Additionally, such schemes were generally devised to suit Baroque canvasses, painted in many cases to be seen from a distance and capable of making an impact above eye-level, or eighteenth century pictures which were often specifically intended to be shown in crowded hangs on the walls of Salons or Academies. As early Italian Renaissance paintings came during the nineteenth century to be shown in public collections, whether as works of art or as historical specimens, this approach became increasingly unsatisfactory. Such pictures cannot happily be skied, since their generally small-scale figures and their quality of detail can only be read at eye-level, they do not follow standard sizes and are seldom shown in uniform frames, and their original function in an ecclesiastical setting is too strongly apparent for such pattern-making not to be incongruous. Other difficulties would affect the attempt to double-hang much nineteenth century painting, especially Impressionist works, dependent as they are on their immediate sensuous impact.

Early public galleries used the Picturesque Hang, as at Angerstein's house while it was serving as the National Gallery. At the British Institution the paintings in the annual exhibitions of Old Masters from private collections were arranged, under the supervision of the aristocratic Directors, in the symmetrical patterns familiar to them in their own houses. Views of the interiors of later nineteenth century museums of art and of temporary exhibitions sometimes show the old principles, but they weakened as the nineteenth century reached its close. This style of hanging has, however, been revived in recent years in public galleries, a phenomenon discussed below.

The Picturesque Hang, and the associated idea of the Tribuna or Great Gallery, rests on the assumption that works of art of certain Schools and periods form an accepted canon. This canon consisted in 1800 of Italian art from Raphael to the late seventeenth century, with Claude, Dughet and Poussin representing the French School (otherwise not much esteemed in England).[6] Flemish and Dutch art were strongly represented, divided between elevated works by, notably, Rubens and Van Dyck, and cabinet paintings, which though in principle not considered to be of the highest quality were greatly admired. Murillo and Velasquez were the only well-known Spanish artists. It was, however, primarily by the strength of its Italian pictures that a great collection was judged. Eighteenth century art, other than the work of favourite *vedute* painters such as Canaletto and Panini, played a minor and ambiguous role within the canon, sometimes achieving approval when it aspired to history. Among the accepted artists, a heirarchy of excellence existed which could be formally stated through the order of precedence created by the patterns of the Picturesque Hang. With the emergence of a new approach to the history of art in eighteenth century Italy and in Revolutionary and Napoleonic France, this type of hang ceased to satisfy.

From the mid-eighteenth century, historians began to explore the early development of painting in Italy, and to a lesser extent in the North.[7] A new style of collecting emerged, concentrating not on the accepted range of Masters but on 'primitive' artists, acquired for their historical value rather than for any perceived artistic quality. Their paintings were regarded as historical specimens, illustrating the gradual improvement in the ability of artists, and to the paintings that were acquired names taken from Vasari were arbitrarily applied. By the turn of the century this approach was becoming known to some collectors in Britain, though the country's isolation during the Napoleonic Wars, linked to the influx of Old Masters of the traditional sort as a result of the French Revolution and ensuing wars, delayed the process. An early follower of the new style was the Earl-Bishop of Bristol and Derry who in a letter of 1796 announced his intention – never fulfilled – at his new palace of Ickworth of *'showing the historical progress of the art of Painting in all the five different schools of Germany and Italy [which] I deem both happy and instructive.'*[8] The various Italian Schools he defined on conventional lines as each exhibiting particular strengths (Venice for Colouring, Rome for Sentiment and so forth). This letter represents one of the first indications on the part of a British

collector of a detailed historical interest in early art. The implications of this approach were considerable. With a historical *raison d'être* for the collection, paintings needed to be hung for purposes of study in a continuing line, illustrating historical development and invalidating the grand ensemble.

Such an historical attitude to collecting began to influence official collections before the end of the eighteenth century, notably in Vienna, where the imperial collection at the Belvedere Palace was organised on historical lines in the 1780s (by Christian von Mechel, who had catalogued the Düsseldorf paintings). A similar approach was apparent in France. The protracted discussions of the 1780s about the most effective way of showing paintings in the much-planned royal gallery at the Louvre were swept aside during the Revolution. When the Musée du Louvre opened in 1793, it displayed paintings on semi-traditional lines, but the view was increasingly voiced that pictures should be shown in a chronological sequence, and by School. This arrangement would teach a political lesson: the competence of the new regime would be illustrated, and the new political seriousness of the Revolutionary Government would contrast with the frivolity of the old.[9] The Musée Napoléon continued the idea that all really great art should be displayed in museums.

It was to be some time before such ideas were reflected in British museums. The National Gallery in its first incarnation in Pall Mall was shown on traditional lines, partly because as it began to expand, space became a major problem: by 1828, four years after its opening, the Trustees were writing to the Treasury that the building did *not afford space for the display of any other Painting.*[10] It was not until the 1840s that an attempt was made to organise the prime national collection of paintings historically. A novel exercise was, however, undertaken in Liverpool. William Roscoe (1753–1831), a Liverpool banker, interested himself from an early age in the political and artistic history of Italy, publishing works on Italian history. These included a study of *Lorenzo de' Medici*, whose success in animating the artistic life of Florence Roscoe regarded as a model for Liverpool, a city he considered comparable to Florence in its financial success and its artistic potential. For Roscoe, the study of Florentine history held more than antiquarian interest: the city could, and should, provide a model for his

flourishing home town.[11] Roscoe also made a collection of prints and of early Italian paintings. Such works were not frequently assembled in Britain at the time: their role for Roscoe was historical, as illustrations for his projected but not completed *Historical Inquiry into the Rise, Progress and Vicissitudes of Taste, as exemplified in Works of Literature and Art.*[12] It does not appear that Roscoe actually enjoyed these paintings, but they were valuable documents for him. They were arranged in a gallery in his house at Allerton, on the outskirts of Liverpool, in chronological order (as Roscoe considered it to be – contemporary knowledge of early Italian art was sketchy in the extreme). This display was thought by the owner and his visitors to be historically and morally improving, in that it illustrated the progress that determined humanity could oblige itself to make. When Roscoe became bankrupt, 37 of his paintings were bought in 1819 by the Liverpool Royal Institution, an innovative step on the part of a society of private individuals. The paintings formed the core of the collection opened to members of the Institution in their premises in Liverpool, where Roscoe's aspirations were followed in the arrangement of the paintings. They were hung as far as possible by School, with early Italian pictures grouped together on one wall, later (sixteenth century) Italian works on another, Northern (including French) works on the third. The catalogue emphasised the historical nature of the collections, which formed *'a series from the commencement of the art to the close of the fifteenth century.'*[13]

Roscoe's collection needs to be emphasised because it was the first major historical collection in Britain (surviving in considerable part in the Walker Art Gallery, Liverpool), and because the attitudes that it exemplified came to dominate attitudes to picture hanging in museums. In the first half of the nineteenth century there were few institutions in Britain capable of organising a full historical hang, since the collections needed for such an exercise did not exist in public ownership. At Dulwich Picture Gallery, which opened to the public in 1817 and where the paintings were arranged under the direction of Royal Academicians, almost 350 pictures were placed in the five rooms. Though the collection had, rather loosely, been intended as a comprehensive one (according to the principles laid down by such traditional authorities as William Buchanan, which did not

allow for early Italian or Northern works), there was insufficient space to arrange paintings chronologically, or by artist as had been done when the pictures were kept in a private house in Marylebone, which boasted a room devoted to Cuyp and another to Poussin.[14] The most that could be done was to group the paintings of the Northern Schools in two rooms at one end of the gallery, and French, Italian and Spanish pictures at the other end, with the central room seemingly conceived as a tribuna for some of the finest paintings. It was perhaps not surprising that William Hazlitt regretted the arrangement of the paintings in the Charlotte Street house.

The National Gallery was to be the principal battleground for the introduction of the historical hang. When the collection first moved into the new building in Trafalgar Square, the paintings were crowded into the rooms with little care given to their arrangement. This changed when Charles Eastlake was appointed Keeper in 1843 (to 1847). Eastlake wished to rearrange the paintings on historical lines and with a view to improving their visibility: as he wrote to the Trustees in May 1845, *'it is not desirable to cover every blank space at any height, merely for the sake of clothing the walls, and without reference to the size and quality of the picture.'* Quoting this letter in a memorandum of 1 February 1847,[15] he commented on the extreme difficulty of displaying the pictures in a building much too small for its contents. Eastlake's endeavours were also frustrated during this first period of office by the opposition from some influential trustees to collecting early works as historical specimens. A particularly articulate opponent was Sir Robert Peel, himself a major collector, who made a classic statement of the statutory grand collection: opposing the acquisition of a work by Gaudenzio Ferrari, he wrote to his fellow-Trustees, *'It seems to me that we should give a preference to works of sterling merit that may serve as examples to the Artists of this country, rather than purchase curiosities in painting valuable as illustrating the progress of Art, or the distinctions in the styles of different Masters, but surely less valuable than works approaching to perfection.'*[16]

When Eastlake returned to the National Gallery as Director in 1855 (to 1865) he was, politically and intellectually, in a much stronger position. The increasingly general acceptance in the meantime of the idea of an historical hang emerges from a Report dated 14 November 1853, on the arrangement of the Gallery, by Thomas Uwins RA, the then Keeper.[17] In a sharply worded statement, Uwins explained that he had *'adopted as a principle to class the pictures as far as the space and circumstances would admit according to the different schools.'* The Venetian paintings would hang on one wall of the West Room, with the Roman and other Italian Schools opposite them, separated by a Claude, since *'something was wanting to relieve the monotony of so many figures.'* The Dutch and Flemish pictures were placed together in one room, Claude, Poussin, Raphael and Turner in another, while the Spanish paintings were arranged in one small room with assorted cabinet paintings. The Small South Room contained a miscellaneous selection: *'All that could not be well disposed of in other Apartments must of necessity find place here.'* Uwins' problems in trying to organise a logical – if not yet fully chronological – hang are apparent from his final comments that any faults in the arrangement are *'not the faults of inadvertancy or want of reflection. The place of every picture was well debated and well tried before it was hung.'*

These principles were elaborated by Eastlake as Director, with the support of an officially stated change of policy towards collecting. In 1853 a Parliamentary Select Committee was set up to examine the National Gallery. In its Report, it recommended a purchase policy which, at last, gave official sanction to the idea of a comprehensive historical collection:

'In order to understand or profit by the great works, either of the ancient or modern schools of art, it is necessary to contemplate the genius which produced them, not merely in its final results, but in the mode of its operation, in its rise and progress, as well as in its perfection...What Chaucer and Spenser are to Shakespeare and Milton, Giotto and Masaccio are to the great masters of the Florentine School; and a National Gallery would be as defective without adequate specimens of both styles of paintings, as a National Library without specimens of both styles of poetry.'[18]

This crucial statement at last expressed official approval of a style of collecting, and of arranging paintings, already current for at least sixty years on the Continent. It has been followed by the National Gallery to this day: only in 1991 was the principle of housing works of different Schools in separate sections of the building relaxed, in the Sainsbury Wing. The attitude expressed in the 1853 Report influenced other major collections. The Annual Report of the Fitzwilliam Museum for 1856 illustrates an attempt in the mid-nineteenth century to

reconcile the decorative approach with the newly current expectation of historical continuity. The Report remarks that *'the leading principle...is that of arrangement according to different Schools of Painting'*, since such a system is *'far more instructive'* than any other. Nonetheless, *'A certain degree of symmetry with respect to the sizes, forms, and positions of pictures in a gallery, however subordinate in some cases to other principles of arrangement, seems to be absolutely essential in a large collection in order that its general aspect may give that pleasure to the eye which the pictures are capable of affording.'*[19]

Eastlake's endeavours to accumulate a historically continuous collection were brilliantly successful, and he competed in buying Italian pictures with such major Continental rivals as Dr. Waagen, Director of the National Gallery in Berlin. The example of the great German museums exerted a strong influence on Eastlake and such important contemporaries as Richard Redgrave.[20] Accounts of foreign museums, and the views of leading German authorities, were frequently published in the British art press: Waagen, for example, wrote at length in the *Art Journal* on the proper historical presentation of art museums, with specific reference to the National Gallery.[21] Though the principle of the historic hang was accepted, it was not easy for Eastlake to show the paintings he had acquired in the approved manner, since space continued to be very inadequate at Trafalgar Square. Only by exiling pictures to alternative sites at Marlborough House (to which many of the British paintings had already been sent) and South Kensington (where in 1859 works by Poussin, Bassano and Caravaggio were dispatched), was he able to modify the Gallery's arrangement. These adjustments had to be made piecemeal: in November 1857, for example, he reported to the Trustees that he had brought *'the works of the earlier painters together; and this room is now almost exclusively appropriated to works of the fifteenth century, and chiefly Italian...Seventeen early Italian works are placed together, and give a distinct character to the room, illustrating the quattrocento Schools of Italy.'*[22]

The gradual expansion of the Gallery in the 1860s and 1870s allowed further progress towards the organisation of the collection. Eastlake's successor, Sir William Boxall (1800–79; Director 1865–74), was able in the late 1860s to rehang the paintings so that, as the *Illustrated London News* reported in 1869, it was possible to see all the finer pictures at eye-level, *'generally with a small margin of*

wall between them'. Further progress was also made by Boxall towards hanging the paintings in Schools, even though, the critic felt, the installation was still insufficiently chronological. Not until the 1880s could a truly historical hang be installed, under the Directorship of Sir Frederick Burton (1816–1900; Director 1874–94). This arrangement was much praised for its finely judged reconciliation of historical with visual considerations, but even so the authorities of the Gallery did not think it fully adequate. In his 1887 Report to the Trustees, Burton wrote that while the desirability of classifying the paintings in the collection had been apparent *'in the earliest development of the Gallery, and from time to time various efforts had been made to attain that object'*, the rapid growth of the collection had always made this aim impossible to achieve. The recently added rooms had given *'an opportunity, the first in the history of the Gallery, for attempting a more complete and systematic sub-division of the pictures'*, but even that was a compromise and over-crowded, and a new building was needed to achieve a properly extensive hang.

The third style of hang is hardly a style at all: rather, it tended to result from a shortage of space and lack of thought about display. This was the 'cluttered hang', the custom of hanging paintings extremely closely together, often with their frames touching one another, and with their positions largely regulated by the pictures' sizes. This custom had some honourable antecedents: Teniers shows galleries hung in this way, and on the Continent some princely collections were so arranged in the eighteenth century.[23] In Britain, as in France, this style was at first especially applied to temporary exhibitions. At the Royal Academy, where the paintings were shown with no wall visible between them and often with draped fabric high on the walls, the 'line' and a set of symmetrical patterns on the walls gave some coherence, but by the middle of the nineteenth century such displays, which had degenerated into incoherence, came under increasing attack. In 1849 the *Art Journal* commented on the poor quality of the hang at the Royal Academy's Summer Exhibition, which adversely affected the works of the best masters: as so often before, the paper wrote, *'We have still...the lines of paintings over the miniatures and architectural drawings; the lines of paintings close to the ceilings and touching the floors...'*.[24] Such attacks were frequently

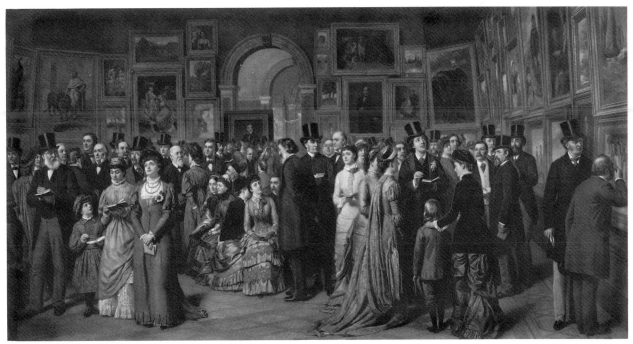

Frith, *Private View Day at the Royal Academy* 1881 (D11)

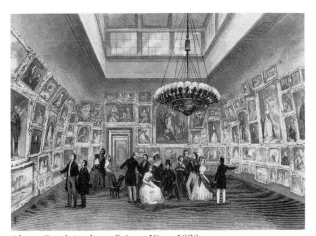

Above: Royal Academy, Private View, 1828
Right: F. Emanuel, *Royal Academy, 1907*

repeated: and in the 1860s the Academicians resolved that once in their new home in Burlington House they would reform their ways.

The National Gallery during its early years at Trafalgar Square was obliged to hang its paintings in equally crowded conditions, and by the 1840s was incurring violent criticism. It was surely the National Gallery that the art teacher and writer C.H. Wilson (1809–82) had principally in mind when, in a long article written in 1851, he compared the excellently lit galleries in Munich, Versailles and the Vatican with British examples:

'*It is a singular system which arranges pictures by the size, upholsterer-fashion, without the slightest reference to school, sentiment or subject, and crowds them together in shabby rooms of a monotonous dingy tint, with dirty floors, and miserable furniture and fittings; everything offending the eye of taste, depressing the spirits, and annoying the senses. Naturalisti, Tenebristi, and all the other isti jumbled together, the saints of Italy and the nudities of the Flemish School in strange juxtaposition.*'[25]
Other early art museums profited by the warning: when the Fitzwilliam was being planned in the 1830s, the point was stressed that the purpose of

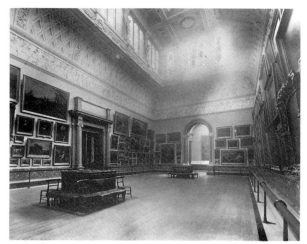

Fitzwilliam Museum, c.1895

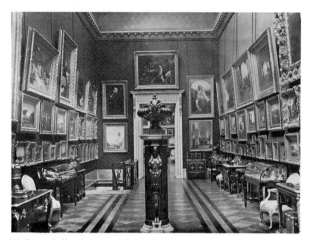

Wallace Collection, c.1897 (C29)

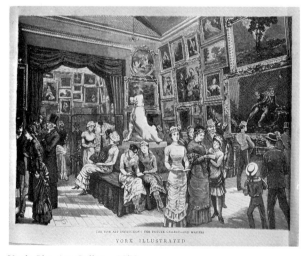

York City Art Gallery, 1879

the rooms was *'to exhibit pictures, instead of merely covering the walls with them.'*[26] Gradually replaced by less crowded arrangements, at least in public collections, the 'cluttered hang' continued to feature in private collections and in some museums until the end of the century, as photographs of the Fitzwilliam Museum and the Wallace Collection in the 1890s illustrate. The Old Master display at the York Fine Art Institution, of 1879, vividly illustrates the jumbled quality of the typical late Victorian provincial gallery.

The fourth major type of picture arrangement is the single sequential row of paintings. Execrated though it is in some circles at present, this was the ideal of many nineteenth century gallery directors. It had been anticipated at Carlton House, where a highly selective approach to picture hanging had been taken by the Prince Regent at the beginning of the century: in some rooms he hung his major paintings singly, within decorated panels, a style that had not been adopted elsewhere in Britain. The advantages of the selective limited hang were put by Dr. Waagen in his article of 1853 entitled *Thoughts on the New Building for the National Gallery.*[27] Though Waagen did not insist that paintings must be hung in a single row, his comments on the proper arrangement of pictures implied the desirability of such a scheme. He stressed the need for *'a certain space between the pictures...Each painting becomes in this manner isolated and its effect heightened, and these intervals must be wider or narrower according to the artistic value and requirement of the pictures.'* Waagen also insisted that paintings should only be arranged at a height where their finer points were within the view of the spectator, so that large paintings would not be more than 15 feet from the ground, and small ones not more than six. *'If pictures are hung higher than this, they have a merely decorative value.'* He also commented that care should be given to arranging paintings symmetrically, and not less than three feet from the floor. As Eastlake put it in his letter to the Trustees of 1 May 1845,[28] all the paintings on view at the National Gallery ought to be worthy of individual study, which the crowded conditions never allowed. The attitude behind Waagen and Eastlake's comments was a new seriousness about paintings, a belief that they needed to be studied closely from a 'scientific' historical point of view to determine dating and attribution, an approach which the old decorative style of the nobleman's gallery had not permitted. As has been seen,

Eastlake's ambitions were not fully realised: one of the points that was praised in the new arrangement of the National Gallery in 1887 – and not before – was that in many of the rooms the pictures were for the first time arranged in a single line.[29]

By the 1880s the principle of the single, or at least very spare, hang was generally accepted as desirable. Much of the inspiration for this view derived from the Aesthetic Movement, already influential in the 1870s; changing attitudes to domestic interiors, with fewer, carefully chosen and related objects shown in harmoniously decorated rooms, were closely related to picture display in more public spaces. At the Grosvenor Gallery, which represented the most innovative approach in this field, the sympathetic arrangement of paintings, in contrast to the rudely crowded hangs at the Royal Academy, was a cardinal element. Charles Hallé, an assistant director at the Grosvenor and later the New Gallery over many years, wrote that it had always been his endeavour in hanging the paintings *to try in the first instance to make the walls look beautiful. Symmetrical hanging, and carefully contrasted tones of colour, give a good general impression, which is of the utmost value, and from which each individual picture derives benefit.*[30] This attitude was fundamental to the Gallery: Coutts Lindsay, its founder, *determined that no pictures should be hung except where they could be seen, and it was arranged that six to twelve inches of space should separate them from each other on the walls.* This would avoid *the usual patchwork-quilt effect of an exhibition... and people could take breath before passing from one work to another.*[31] Relationships between the paintings, in terms of scale, style and colour, were also taken into account. The attitudes expressed at the Grosvenor Gallery were specifically based on the wish to create an environment comparable to and as sympathetic as a private house. The attitudes expressed in art magazines of the late nineteenth and the early twentieth centuries,[32] and in such books as Edith Wharton and Ogden Codman's *The Decoration of Houses* of 1897, reflect those of the Grosvenor Gallery.

The one-man shows staged by J.M. Whistler from the 1870s onwards, beginning with his first one-man exhibition of 1874 at the Flemish Gallery, helped to diffuse the idea of the work of art as a single perfect entity, to be studied on its own without the distraction of other works of art around it, an idea given support by the increasing interest in Japanese art and furnishings. They also

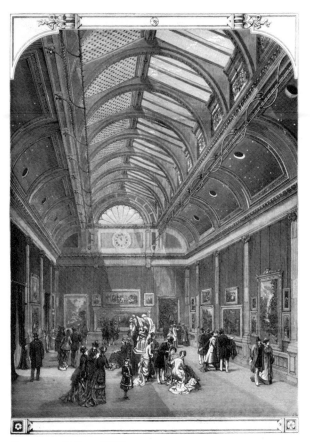

Grosvenor Gallery (G20)

contributed to an understanding of the desirability of sympathetic settings for pictures.[33] Increasingly, the art periodicals and the museums of the late nineteenth century reflected this belief in the power of the isolated and sympathetically shown painting. This attitude is expressed for example in a review of an exhibition at the New Gallery in *The Studio* of 1893, by Francis Bate:

Enjoyment of the beauty of works of art is exquisite and sensitive, easily marred, easily dissipated. A picture, like a scented flower, has a charm and an essence peculiarly its own. Every effort should be made to preserve its individuality unspoiled and undisturbed. To do this when many pictures are shown together is difficult...[34]

An article in the same issue of *The Studio*, by C.T.J. Hiatt, attacked the arrangement of provincial galleries, contrasting them unfavourably with the National Gallery, and declaring that municipalities *encourage ... precisely that which is most trivial and most stupid in the painting of the day* and that most modern galleries were *little more than gorgeous éditions de luxe of a portfolio of coloured Christmas supplements.*[35] Though he disapproved of the

Academy paintings accumulated by the new regional art museums, the writer was unjust to their aspirations. Accounts of newly built galleries in the 1890s reveal that much thought was given to their arrangement, and that the elusive quality of 'harmony' was a prime objective in the decoration and hanging. At Bury Art Gallery, for example, which opened in 1901, the paintings (which formed a standard High Victorian collection) were almost all hung in a single line to allow proper study, and a contemporary critic commented on the *'quiet harmony'* of the galleries, which created the sense of repose necessary for full appreciation.[36] Though not universal, such an approach was current by the end of the nineteenth century, encouraged by the assiduous reporting in the art press of exhibition and museum display on the Continent.

In the first decade or so of the twentieth century, many old-established galleries moved towards adopting Aesthetic principles. At Dulwich Picture Gallery the hang, which had become desperately crowded, was eased in 1910–12 with the addition of three new rooms. The main Soane rooms were deprived of their top line of pictures, so that they contained two rather than three rows, while one of the new rooms was arranged with a selection of the finest paintings, hung with at least a foot between them, and in a single row. This was evidently the style preferred by the Chairman of the Gallery Trustees, Henry Yates Thompson, himself a considerable collector. The Bowes Museum, too, was rehung around 1914: the extremely close hang installed when the Museum opened was replaced not by a single line, but by a much sparer arrangement, with the relationship between the paintings carefully considered, the introduction of considerable areas of empty space, and attention paid to such details as clear labelling. At the Bowes Museum, as at Birmingham Art Gallery, photographs of around 1900 illustrate a favourite way of trying to deal with what was perceived as the problem of excessively lofty galleries. The upper part of the wall was painted in a different (generally lighter) colour to the lower part, in an attempt to lighten the effect of the very high walls, and even to suggest that two rooms, rather than one, were on view.

By 1910, *The Times* was able to comment in an article on the newly opened Turner galleries at the Tate, that they had at last realised *'the ideal of all makers of exhibitions, that there should be one line of pictures and one only.'*[37]

During the twentieth century the principle of single hanging continued to be followed in most galleries, the architecture and decoration of which, particularly in the more florid Victorian examples, became increasingly irksome to curators anxious to create an environment suited to the display of contemporary pictures. The reinstallation of the Fitzwilliam Museum by Sydney Cockerell (see below), may stand as an example of an early twentieth century arrangement of the highest quality. The National Gallery, having at last in the 1880s achieved the goal which it had long sought, has kept to the principle of the single hang, its Director having recently declared that only such an approach is suitable for a collection of such quality. It is not a universally shared opinion, but it is one with a long and distinguished ancestry.

Changing ideas over picture display have naturally been accompanied by changing attitudes to wall coverings and colours. The two developments are related but not exactly parallel.

As with picture hanging, the decoration of public galleries was influenced by private collections, and in particular great aristocratic houses. Dr. Waagen commented approvingly on the way in which paintings were displayed in country houses in the 1840s and 1850s. At Bowood, Wiltshire, he admired the *'walls of crimson silk, which have an excellent effect'*, to which the sculpture, marbles, mirrors and ceramics also on display contributed.[38] At Panshanger, Hertfordshire, where the famous Cowper collection was on view, he found fine apartments, with the paintings arranged with much taste, the drawing-room affording *'the most elevated gratification'*, with its light from skylights and windows. Describing how the Italian pictures at Panshanger were *'well relieved by the crimson silk hangings'*, he allowed himself to expatiate: *'I cannot refrain from again praising the refined taste of the English for thus adorning the rooms they daily occupy.'*[39]

During the first half of the nineteenth century, installations in public galleries were frequently, perforce, utilitarian: both Dulwich Picture Gallery and the National Gallery at Trafalgar Square originally had painted wooden walls. Materials were always plainer than they would have been in a private house containing paintings of comparable quality. Nevertheless, private collections did exert influence on, notably, the choice of colours. Just as red was used in many of the houses that Waagen

visited, so red – whether Pompeian red, crimson or maroon – was the norm for public galleries almost throughout the century.

Certain principles in the selection of colours came to be commonly accepted, particularly Sir Charles Eastlake's views on tone. Writing in 1845, he established a rule that was to be repeated by him and others: '...*it may be observed that a picture will be seen to advantage on a ground brighter than its darks and darker than its lights, and of so subdued a tint as may contrast well with its brighter colours.*'[40] Eastlake and his contemporaries were concerned that the wall colour should show to advantage both the gilt frames in which almost all pictures were displayed, and the paintings themselves, executed in the case of many seventeenth century works on a reddish ground, and generally darker, on account of the dark varnishes still generally left on or applied to Old Master paintings, than they are today. Eastlake did, however, add the proviso – far-sighted, as it turned out – that the colours which might be found suitable in a public gallery might not appeal to a private collector, since paintings darkened the walls, and the lightest grounds in wall coverings might well be used to counter-act this effect.[41]

Most nineteenth century art museums and exhibition spaces were painted in what came to be regarded as the orthodox dull crimson: the approach taken by D.R. Hay at the National Gallery of Scotland was planned with unusual care. Though the National Gallery, on first opening in Trafalgar Square, showed at least some of its pictures on green walls, this colour – traditionally the principal alternative – was soon replaced there by red. Thus, in 1853, after considering '*the present unsightly appearance of the Rooms of this Gallery*', the Trustees decided that the ceilings should be whitewashed, and the walls covered with '*a flock paper of the colour which may be considered the most advantageous for the pictures.*'[42] The colour chosen was a maroon similar to that on the walls of Colnaghi's large room in Pall Mall. The Trustees' wishes were carried out, but not without argument. The Keeper, Thomas Uwins, reporting to the Trustees some months later,[43] commented on a disagreement between himself and the '*painters*' – whom he did not identify. They wanted a hot colour, he a cool one. It ended in compromise, with Uwins hoping that the chosen tone would become greyer with the passage of time.

In 1861, the Gallery was again redecorated, under Eastlake, with some colour variation introduced: the west (principal) room was given crimson paper, while other rooms were maroon and green. A small ante-room was originally yellow but was later changed to crimson, the colour also chosen for the new Turner Room, which had just been added by Pennethorne. Contemporary attitudes in artistic circles to colour schemes may be gauged from an article in the *Art Journal* on this work at the National Gallery: to the writer, the '*lively red hue*' used in the west room '*entirely overpowers the pictures*', while he thought the '*pale green paper...cold and repugnant to the last degree.*'[44] For this critic, the choice of a '*dull maroon colour*' was much more successful, this being '*the best general tint to oppose to pictures.*' The Papworths wrote in similar terms:[45] they commented that many paintings, notably classical landscapes, hung to great advantage on deep purple (i.e. a colour close to if not identical to maroon), whereas for Rubens and other Flemish painters, a deep red could be attempted. It was difficult, they continued, to achieve the right red, since pure drop lake was required for the formation of the colour, '*and it is rarely that decorators will produce so expensive a colour.*'

The subtleties discussed by the Papworths applied particularly to private collections: in art museums and temporary exhibition places such as the Royal Academy the paintings were generally hung so closely together that it was difficult to detect any colour on the walls at all. In some institutions, such as the Academy and Dulwich Picture Gallery, red walls remained the norm throughout the nineteenth century and into the twentieth. This faithfulness to red was echoed in many circles: in 1891, for example, the *Magazine of Art*, describing Lord Armstrong's drawing-room and gallery at Cragside, Northumberland, commented that the crimson of the walls, with the top-lighting, made the rooms particularly suited to showing pictures.[46] Equally, the new museums built in the North of England in the last two decades of the century, though susceptible to new ideas about hanging, were generally given red walls, while much care was taken in decorating the cornices and skirting as attractively as possible.

By the middle of the century the appearance of public galleries in Britain was the object of much unfavourable comment. An article in the *Art Journal* in 1851, for example, decried the ugliness

and meanness of public collections, in contrast to the fineness of museums designed by Klenze and such palaces as the Pitti and Colonna, and enquired, *'Do the marbled columns, the frescoed ceilings, the gilded cornices, the silk hangings, the superb furniture, the parquet floorings...make the pictures less interesting, less effective, less important?'.*[47] By the end of the century writers looked back to the mid-Victorian period as one which embraced *'ideals of splendour'.*[48] The 1861 and 1876 additions to the National Gallery exemplify this approach. At the same time, a belief in the desirability of simple unornamented spaces continued to be held in the 1850s and 1860s, as another article in the *Art Journal,* for 1855, reveals. Praising the crimsons and Pompeian reds used in the new Zwinger Gallery in Dresden, the writer comments on *'the perfect simplicity and total absence of elaborate ornament which is alone suitable to the purposes of a picture gallery.'*[49] Such restraint, together with recurring limits on funding, prevented extremes of luxury. By the 1870s luxury was indeed beginning to be unfashionable, and the use of expensive materials, especially brocades, came to be associated unfavourably with Bond Street galleries. Barry's decorations at the National Gallery in 1876 were felt to distract the eye from proper attention to the pictures.

A new attitude to the display of paintings was beginning to emerge, one stimulated by artists and writers on aesthetics. The ideas that an art gallery should resemble a palace, or merely be a plain functional space, were succeeded in the minds of many thoughtful critics by a new ideal of the gallery as a harmonious setting, enshrining the work of art. This ideal was to assume different forms. It developed into the concept of the reposeful and exquisite interior, in which furnishings, wall and floor colours, rugs, flowers would contribute to a perfect whole. It also influenced the twentieth century concept of the neutral and minimally decorated interior in which nothing competed with the paintings. The development of the Aesthetic approach, as it may reasonably be called, to galleries, was neatly categorised by the writer, already quoted, in the *Morning Post* of July 1910.[50] Commenting that the effect of the new Turner galleries at the Tate, with their walls covered in *'rich patterned silk crimson damask',* verde-antico skirting and white and gold ceilings, was that of an expensive Bond Street gallery, the writer recalled that red was the colour favoured by

Turner himself for the walls of his gallery, but commented that *'those of us who grew out of Morris through Whistler into Rickitts* (sic) *and Shannon will be horribly shocked at the décor of Rooms VI and VII.'* Not only is his comment indicative of the change of attitude, but he identifies the men who, in conjunction with leading artists, overturned the expectation of Universal Red.

The change of attitude was clarified by the opening of the Grosvenor Gallery in 1876, a showplace famously satirised as the 'greenery-yallery, Grosvenor Gallery' in W.S. Gilbert's *Patience* of 1881 – an indication of its notoriety. This gallery, intended to provide a beautiful and appropriate setting for the display of works of art, was decorated with considerable richness in a traditional manner, with crimson silk damask wall coverings. This was not to the taste of many artists, whose paintings were no longer executed on the dark ground of the Academic tradition, but on a much lighter ground, which showed to less advantage on crimson or maroon. Burne-Jones, whose work found a new success as a result of the Grosvenor's policy, was most unhappy with its red walls: he found them *'far too glaring to be tolerable near any delicately coloured picture...It sucks all the colour out of pictures...both red and green are far too strong – far; to stand them one would have to paint up to their level, which is rather inverting the first idea we had.'*[51] He proposed instead an olive or moderate red. Walter Crane, also an exhibitor at first the Grosvenor and then the New Gallery, expressed similar misgivings. Crane found that the crimson silk at the Grosvenor did not suit *'either the pictures or the cooler scheme of the cove'* (decorated by Whistler).[52] The situation was not improved at the New Gallery, which held its first exhibition in 1888: Crane lamented that *'The traditional heavy red was clung to...in the walls of the picture-galleries, although it is a colour really very rarely suited to set off pictures successfully, cool and neutral tones, or white, being much better.'*[53]

By the end of the century, the influence of William Morris, whose papers came to be much used in the decoration of galleries, and of Whistler's exhibition installations, had made the old reds hopelessly unfashionable in advanced artistic circles. The Aesthetic approach was championed in such papers as the *Burlington Magazine,* where Charles Holmes (1868–1936), Editor from 1903 to 1909 and a close associate of Ricketts and Shannon, espoused the cause of better display for

C.A. Ionsides' House, Addison Gdns: an important 'Aesthetic' interior

pictures. *The Studio*, founded in 1893, was especially active in publishing articles on galleries and exhibitions in Britain and overseas which provided good examples of the harmonious style. Thus in 1905 the exhibition room in Venice created by Frank Brangwyn (1867–1956) was the subject of an article. The room, its furnishings, hangings and woodwork, were all conceived by the artist to create a *'unit of design.'*[54] Brangwyn's intention was *'to cause the person who enters to feel the presence of a quiet richness, a certain sense of harmony, without being able for the moment to give any reason for it.'* Apart from the ambitiously designed decorations, the colour scheme was believed by Brangwyn to be the best for the purpose: *'The greater part of the walls are of a grey buff, which as a background for the pictures, will neither take away from the subtleties of tone, nor force into prominence any particularly strong tones of colour occurring in the works shown.'* The Studio also reviewed art exhibitions in Turin, a lively centre for contemporary art exhibitions in the late nineteenth century, and in Germany and Austria, illustrating ideas about the decoration of galleries similar to those becoming prevalent in Britain.

One of the most evocative descriptions of the new approach was made by Charles Ricketts (1866–1931) in 1916, towards the close of his career and at a time when such ideas had become established. Regretting his refusal some months before of the Directorship of the National Gallery, he wrote in his diary *'It would have been a fine end to my life to nurse the dear old place; to put the Italians on whitewash or grey walls, reframe them in the gold and azure of their period, to use the dimly polished walnut at times for subsidiary frames of drawings; to place the Venetians on brocade, the Flemings on brocade or stamped leather, the Dutch on this or on whitewash, the Spaniards in black frames on grey walls, the British on panellings, etc.; to group the Bellini movement together with Mantegna away from Veronese, etc.; to give effect to certain gems, to give Michelangelo his mouldings, and to Rembrandt the frames he has painted; to efface the trade stencilling of the ceilings, and to slowly remould the place from a Board of Works aspect to that of a palace.'*[55]

Here he summarises the Aesthetic treatment of galleries: the preference for subtly neutral colours; the wish to show each School, and each work of art, in an individually appropriate setting; the replacement of the traditional gilt frames by period ones; and the introduction of a variety of textures in wall coverings.

The ideas of the Whistler-Ricketts school – if often in a paved-down and impoverished form – came, during the first third of the twentieth century, to exert considerable influence on the decoration of British galleries. Flock paper, a cheaper substitute for the damask considered ideally suitable for galleries in the early nineteenth century, and capable of reproducing the damask patterns, was widely used in galleries during the nineteenth century. By the last years of the century it was regarded as unhygienic and impractical, and was frequently replaced by a variety of textured papers, to which much thought was given. The walls of the new Tate Gallery were covered in embossed paper to a new formula, and a similar material was used in the new rooms opened on the west side of the National Gallery in 1911, to the designs of the Office of Works. After much consideration by the Director (Sir Charles Holroyd) and the architect, a *'painted embossed Morris canvas'* was selected.[56] In contrast to the flock previously used, this fabric was considered to be unobrusive without dullness and easily cleanable, and it concealed nail-holes. In their decoration of the rooms, the authorities also showed enlightened ideas: three rooms were green, one *'a rich Cordova*

Drawing Room of Ricketts' and Shannon's apartment, Holland Park, 1902

red', while in the west gallery a *'dull gold'* was used. This west gallery (the present Room IX containing Venetian paintings) represented the climax of the new set of rooms, and it is notable that a room of such importance should have been decorated in a style close to Aesthetic principles.

At much the same time, Charles Holmes, appointed Director of the National Portrait Gallery in 1909, was attacking that already dreary building – as he saw it – with equal vigour. Holmes found the Gallery crowded with paintings *'in monotonous rows, according to size, against a shabby green wall-paper.'*[57] Weeding out dead judges and bishops from the principal rooms, Holmes followed Scharf in evoking an historical ambiance for the collection. Finding under the old wallpaper some deal panelling, he stained the woodwork, painted the upper part of the walls white and added cornices as necessary: *'we managed to give the galleries a far-off resemblance to panelled rooms in a Tudor mansion.'*[58] On his move to the Directorship of the National Gallery in 1916, Holmes as soon as the War was over applied similar economical artistry (he was himself a painter) to the redecoration of what, following use as an office in the War, had become a dirty and neglected building. Paint *'was all the Nation could afford'*[59] and paint was applied, often over the existing wall coverings: this was to Holmes' satisfaction since he considered that paint provided a more practical and hygienic surface than woven fabrics. Since to *'make the place cheerful, much lighter schemes were needed'* than the long-established reds and greens, Holmes and his assistants themselves repainted the room, stippling over the existing walls, with particular success in one room where *'an unexpectedly rich effect came from hatching a thin coat of gray over the original deep red.'*[60]

The influence of Aestheticism continued to be felt in public galleries between the Wars, though under the influence of the Modern Movement the subtleties of Whistler and Ricketts were often replaced by a pervasive fondness for light coloured, and often for white, walls. Eric Maclagan (1879–1951), Director of the Victoria and Albert Museum and also a friend of Ricketts and Shannon, delivered a paper on Museum Planning to the RIBA in June 1931,[61] in which he remarked on the current view that museums should not be housed in palaces and that almost all forms of architectural decoration were superfluous in galleries. He referred to *'the light backgrounds now fashionable'*, because of the influence of contemporary painting – even though he questioned the suitability of light backgrounds for paintings of every type. Though extremely light backgrounds were frequently used in art galleries from the 1920s until the very recent past, for paintings of all periods, and are still to be found in modern installations in Europe and America, the taste was not ubiquitous, and the more thoughtful gallery directors used such backgrounds with discrimination.

One of the most important examples of an inter-War museum refurbishment, partly surviving, was the redecoration and extension of the Fitzwilliam Museum, carried out by Sidney Cockerell (1867–1961), its Director from 1908–1937.[63] Cockerell was a close friend of Ricketts and Shannon, and his work at the Fitzwilliam represented a faithful and at the same time individual execution of their ideals. Cockerell transformed the Basevi galleries and was responsible for two sympathetic additions to the buildings. In the old building, wood panelling, in Gaboon mahogany, was applied to the walls of several rooms in place of the plum-coloured walls then existing. The variegated scagliola columns, a prominent feature of the original design, were painted white, over Basevi's polychrome effects, while in the principal gallery wooden bays were introduced in 1931, supporting a balcony for the display of watercolours. The upper portions of the walls were distempered in cream, *'replacing the previous hot red surface'*.[64] In the Marlay Extension, of 1924, and the Courtauld Wing, of 1931 (by Dunbar and Smith), Cockerell applied similar ideas. The Marlay gallery, devoted to early Italian paintings, was covered in a roughly tex-

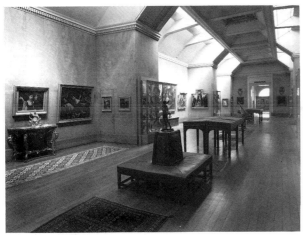

Marlay Gallery, Fitzwilliam Museum

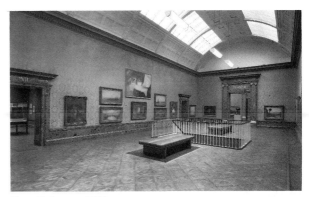

Tate Gallery, c.1950

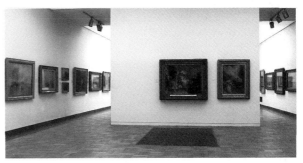

Tate Gallery, c.1976

tured gold paper, of a type already used in galleries, and still handsomely *in situ*; while in the Courtauld Galleries the Gaboon mahogany panelling, variously textured and austere, was generally applied. *The Architect and Building News*[65] while lamenting the choice (in the new Octagonal room) of brocade '*in the fin-de-siècle manner of some Bond Street dealers*', felt that the '*rather daring experiment*' of the mahogany (of which some fragments also survive) was visually justified. An important element in Cockerell's plan for the galleries was the creation of a sympathetic, almost domestic atmosphere, in which furniture, ceramics and plants, all chosen with fastidious taste, contributed to the appeal of the whole.

A similar approach was taken by John Rothenstein in the decoration of the new Graves Art Gallery at Sheffield, which opened in 1934.[66] Containing a largely eighteenth century and nineteenth century collection, the decoration of this new gallery reflected many of Cockerell's ideas. The Victorian oils were shown on '*three-ply unstained oak, wax-polished*', a roomful of miscellaneous seventeenth, eighteenth and early nineteenth century works on '*dull gold, rough textured paper*', while a group of more contemporary works, as well as the watercolours, were hung on '*natural-coloured canvas.*'

The post-Second World War period saw, surprisingly, the introduction of brocade at the National Gallery in the 1950s.[67] This was not a usual phenomenon. The tendency between 1945 and 1980 was, as far as possible, to obliterate or disguise the architectural character of Victorian or Edwardian galleries, in favour of minimally articu-

lated spaces with false ceilings and walls, decorated in hessian either in light neutral colours or in dark fashionable browns and olives. It was an understandable reaction to the lofty, inhospitable, and often war-damaged apartments with which gallery directors found themselves saddled. In the 1960s and 1970s much of the Tate Gallery was transformed in this way. A similar method was applied in some rooms at the National Gallery, where brocade, with its connotations of luxury, was replaced by assorted more demotic fabrics and where the shapes of the rooms were often disguised by false ceilings and walls. Many galleries throughout the country were treated in a similar manner, sometimes with great success: York City Art Gallery being a particularly good example. Its Director from 1947 to 1967 was Hans Hess, one of a group of distinguished exiles from Nazi Germany who worked in British art museums after the War.[68] Hess inherited a building and a collection of which he disapproved equally. The Victorian exhibition hall with its lofty ceiling was halved in height by the introduction of a laylight, while the bulk of the collection of Victorian oils was put into storage. The walls of the main hall were decorated

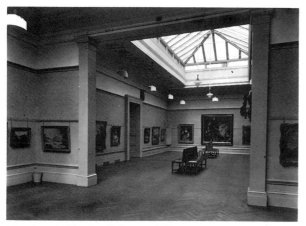

Manchester City Art Gallery, c.1960

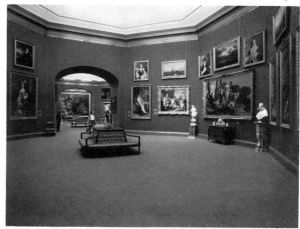

National Gallery of Scotland, 1988

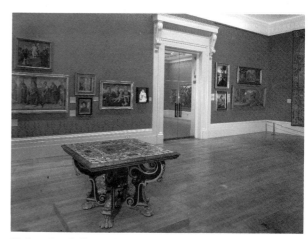

Walker Art Gallery, Liverpool 1991

around 1950 in *'parchment-coloured damask of Scottish manufacture in a traditional pattern'*, a fabric which in Hess' view created a splendid background for the display of pre-1900 paintings, while modern paintings were shown in three rooms *'covered with plain hessian'*. A few years later Mervyn Levy, in one of a series of articles on *'Museums or Mausoleums'*,[69] testified to the success of the Gallery, transformed in 1955 by the gift of the Lycett Green collection of Italian paintings. Levy stressed its harmony and simplicity, with its pure white walls and screens sometimes *'faced with unobtrusive fabrics in gentle colours'*, since Hess varied the neutral walls with occasional areas of richly-coloured velvets, behind selected objects. Many galleries, Levy thought, could benefit from Hess' example.

Since the late 1970s a new traditionalism has emerged in the display of public collections. This new traditionalism is linked to increasing interest in the restoration of historic interiors, and to the growing body of information about paint colours of the past: it is significant that enthusiasm for redisplaying galleries in a nineteenth century manner – or what is considered to be nineteenth century – should be especially strong in a country where an unusually large number of furnished historic houses survives in the hands of the National Trust and of private owners. Such restorations have been carried out in various galleries over the past decade. Already in the 1970s Cockerell's panelling at the Fitzwilliam was being replaced by richly coloured fabrics, though the paintings continued to be hung only at eye-level. In 1981, Manchester City Art Gallery and Dulwich Picture Gallery were redecorated in traditional deep colours, with their paintings hung two or three deep. During the 1980s the Wallace Collection has been redisplayed, with many more paintings on view and a much fuller use of double hanging; the walls of the National Gallery of Scotland have been lined with red felt, and its collections double and triple hung; and the Walker Art Gallery, Liverpool, has seen the beginnings of similar treatment. A new enthusiasm for the architecture of the traditional gallery has prompted the destruction of the false ceilings and partitions installed in the National Gallery since World War II, and, most notably, the release of the Tate Gallery from years of accumulated subdivision in an enlightened refurbishment and rehanging in 1989. Over the last eight years the London National Gallery has been sumptuously redecorated in a style more splendid than at almost any period in its history.

Whether a "right answer" has been arrived at is a matter for debate. Few, seeing the re-hung Tate, will regret that traditional gallery buildings have come to be regarded as an asset rather than embarrassment: though for many directors and curators the problem remains of reconciling the display of a contemporary collection with huge Victorian halls. Nor can the oatmeal hessian applied in a last fling of the Modernist ethic to the walls of the Clore Gallery, on which the Turners darkly lower, do anything but justify the red backgrounds chosen by Turner himself and generations after him. The pleasing visual effects produced by double and triple hanging cannot be denied, but the problems of visibility do not go away, nor does the damage inflicted on fine paintings, by works of lesser quality around them.

I am much indebted to Stephen Calloway for his helpful comments on this essay.

Many of the images referred to in this essay are illustrated elsewhere in the catalogue.

1 Viscount Torrington, *The Torrington Diaries* (1936) III p.157.
2 *La Gallerie Electorale de Düsseldorf* (1778) 2 vols. I am grateful to Michael Compton for bringing the importance of this publication to my attention.
3 See Haskell (1963) pp.281–3. The collection is now largely in the Alte Pinakothek, Munich.
4 See Russell (1987).
5 See J. Young (1821); E9 in catalogue.
6 Ottley in the *Stafford Collection Catalogue* remarked that the French School had '*never been in very high reputation out of France*', p.xi.
7 Haskell (1963) p.350ff.
8 Quoted in Brian Fothergill, *The Mitred Earl* (1974) p.177.
9 McLellan p.190ff.
10 Minutes of the National Gallery Board Meetings, April 1828.
11 See Henry Roscoe, *The Life of William Roscoe* (1833); Michael Compton, 'William Roscoe and Early Collectors of Italian Primitives' in *Liverpool Bulletin (Walker Art Gallery)*, 1960–61 pp.27–51; Fawcett (1974) p.92ff.
12 Roscoe (1833) I p.461 for a summary of this book.
13 For an account of the Institution, see Edward Morris, unpublished.
14 John Britton, *Inventory* (Dulwich College archives) and G. Waterfield (ed.), *Collection for a King* (1985).
15 National Gallery Minutes, op. cit.
16 ibid 13 May 1844.
17 ibid 6 Feb 1854.
18 Quoted in P. Hendy, *The National Gallery, London* (1960) p.41.
19 I am indebted to Mr. Paul Woodhuyzen for this quotation, as for other information regarding the Fitzwilliam Museum.
20 In, for example, his evidence to the Select Committee on the Turner and Vernon Pictures, 18 July 1861 p.23.
21 *Art J* 1849 p.165.
22 Trustees' Minutes 16 Nov 1857.
23 Such a room survives at Pavlovsk, outside St. Petersburg.
24 *Art J* 1849 p.165.
25 *Art J* 1851 pp.205–07.
26 Wright (1847) p.x.
27 *Art J* 1 May 1853 pp.121–25.
28 op. cit.
29 See for example *Bldg News* 8 July 1887.
30 Charles Hallé, *Notes from a Painter's Life* (1909) p.110.
31 G. Burne-Jones, *Memorials of Edward Burne-Jones* (1904) II p.69.
32 See Herbert Everett, 'How to Hang Pictures', *House and Garden* Dec 1906.
33 See David Park Curry, 'Total Control: Whistler at an Exhibition' in *Studies in the History of Art (National Gallery, Washington)* vol 19 pp.67–82.
34 *The Studio* 1893 p.78.
35 ibid p.229.
36 Supplement to *The Bury Times* 12 Oct 1901.
37 *The Times* 19 July 1910.
38 Waagen (1854) III p.157.
39 ibid p.7ff.
40 C. Eastlake, *The National Gallery. Observations on the Unfitness of the Present Building for its Purpose* (1845) p.15. His statement could still be read with advantage today.
41 ibid p.16.
42 Minutes of the Trustees of the National Gallery, 7 July 1853.
43 ibid 6 Feb 1854, with report of 14 Nov 1853.
44 *Art J* 1 May 1861 p.151.
45 Papworth (1853) p.78.
46 *Mag Art* 1891 p.159.
47 *Art J* 1851 p.207.
48 *Morning Post* 19 July 1910.
49 *Art J* 1855 p.75ff.
50 See note 48.
51 G. Burne-Jones (1904) p.77.
52 W. Crane, *An Artist's Reminiscences* (1907) p.175.
53 ibid p.322.
54 A.S. Covey, in *The Studio* 1905 pp.285–92.
55 *Self-Portrait Taken from the Letters & Journals of Charles Ricketts, RA* (1939) p.262.
56 *AR* Jan–June 1911 pp.226–31.
57 Charles Holmes, *Self and Partners* (1936) p.267.
58 ibid p.290.
59 ibid p.368.
60 ibid.
61 *Jnl RIBA* 6 June 1931 pp.527–43.
62 ibid p.531.
63 See Wilfrid Blunt, *Cockerell* (1964).
64 Information from Annual Reports, Fitzwilliam Museum.
65 5 June 1931 pp.318–22.
66 Reported in *MJ* Sep 1934 pp.217–20.
67 National Gallery Report 1938–54.
68 For Hess' own account of his work see *MJ* Feb 1952 pp.277–78 and *MJ* Aug 1953 pp.122–24; for an appreciative commentary see Mervyn Levy in *The Studio* 1960 p.175ff.
69 Levy op. cit.

The Catalogue

The catalogue is divided into eight sections, according to type of gallery. A short general bibliography is given at the end of the catalogue. Works related to specific museums or galleries are listed at the end of individual entries. Notes in the text may refer to either of these lists.

All catalogue entries are by Giles Waterfield, with the exception of those for which credit has been given to: Stephen Fronk; Ian Gow; Robin Hamlyn, Jane Roberts; Nicholas Savage; and Elizabeth Wright.

Abbreviations used in catalogue citations:

AJ	*Architects' Journal*
AR	*Architectural Review*
Art J	*Art Journal*
Builder	*The Builder*
BN	*Building News*
CL	*Country Life*
RIBA Jnl	*Journal of the Royal Institute of British Architects*
Mag Art	*Magazine of Art*
SM	*Soane Museum*

A catalogue entry marked with an asterisk indicates that the work has been reproduced in colour.

We would like to thank all the photographers who have assisted over this exhibition, in particular Michael Duffet, Geremy Butler Photography and IBIS Creative Consultants. Acknowledgements are due to all the institutions that have supplied photographs for this catalogue and to the following:

Ashmolean Museum, Oxford
James Austin, Esq.
The British Museum
Crispin Boyle, Esq.
Richard Bryant, Esq.
Cartwright Hall, Bradford
Gerald Cobb, Esq.
Richard Davies, Esq.
John Donat Photography
Dennis Gilbert, Esq.
Glasgow Museums
Guildhall Library
The Illustrated London News Picture Library
Ken Kirkwood, Esq.
Manchester Public Libraries
National Portrait Gallery, London
The Trustees, The National Gallery, London
Norfolk Museums Service
Mrs. Home Robertson
Royal Commission on the Historical Monuments of England/
 National Monuments Record
Doris Saatchi
Victoria and Albert Museum
Wadsworth Atheneum, Hartford. The Ella Gallup Sumner and
 Mary Catlin Sumner Collection
The Trustees of the Wallace Collection, London
Warburg Institute, London
Windsor Castle, Royal Library © Her Majesty the Queen
Witt Library, Courtauld Institute of Art

A Early Galleries

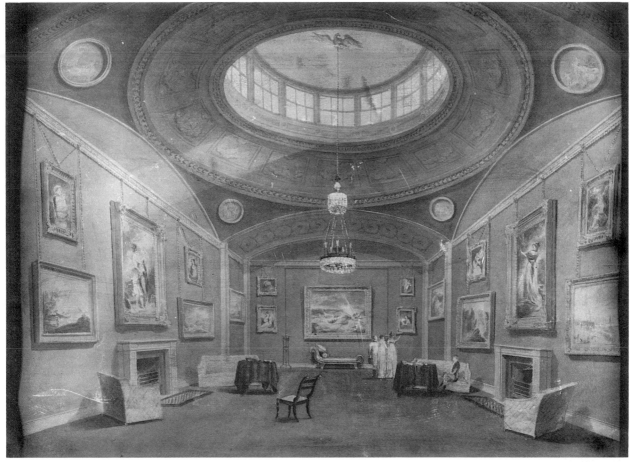

A12

This section illustrates some of the most important precursors of the public gallery of the nineteenth century. Collections assembled by various monarchs, especially Charles I, George III and George IV, played a vital part in accustoming the British public, and in particular artists, to the custom of visiting galleries. Royal palaces were generously accessible to visitors during the eighteenth and early nineteenth centuries, a practice inspired by Continental examples.

Though eighteenth century guidebooks to London record various houses as accessible to visitors, during the first thirty years of the following century the number of private galleries in London open, to at least a select public, increased markedly. In the absence of any public collection of pictures, and with the example of the Musée du Louvre (open from 1793) to hand, the opening of these galleries formed part of a campaign to strengthen the role of British art, a campaign which gathered momentum in the 1820s. The private galleries that could be visited included great aristocratic collections, often kept in London rather than the country, and much strengthened by the acquisitions made during the French Revolution from Continental collections. A number of these were opened to approved artists and to general visitors, from the first decade of the century onwards. Painters, sculptors and architects also built galleries to display their own work and their other possessions, and these too could easily be visited. The fashion for speculative one-man shows, increasing during the century to reach a high point in the 1840s, is represented here indirectly by West's gallery.

Although country houses are not included within the scope of this exhibition, the growing fashion for erecting purpose-built picture galleries as extensions to a great house is represented by one influential example, at Fonthill.

HAMPTON COURT

A1
J. Stephanoff (1787–1874)
Cartoon Gallery at Hampton Court c.1815
Watercolour, 19.9 x 25.4 cm

HM The Queen

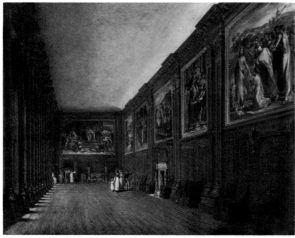

A1

The Cartoon Gallery at Hampton Court neatly illustrates the transition from the gallery as an element of the state apartment, an extended space for circulation and communication, into a room specifically intended for the display of pictures. In 1697 Sir Christopher Wren put forward proposals for a room *'to be fitted for the cartoons with wainscote on the windowe side and below the Pictures and between them, to preserve them from the walls...'.*[1] This room was to form part of the King's state apartments, being fitted up in the second phase of William III's work at Hampton Court. At the same time, it was dedicated to one of the Crown's greatest possessions, the set of Raphael cartoons acquired by Charles I and retained (probably for practical use, as cartoons for further tapestries) during the dispersal of Charles' collection. Having until then been kept in strips and unexhibited, the cartoons were restored and put on view in 1697. The final version of the gallery was carried out by Wren and William Talman two years later.[2] The carvings, including the Corinthian columns, were executed by Grinling Gibbons, while the chimneypiece was carved by John Nost. The early installation, differing from that seen in this watercolour particularly in the frames, was engraved by Simon Gribelin in 1707.

As John Shearman has pointed out, the arrangement of the cartoons looks back to Renaissance galleries such as Fontainebleau. They are side-lit, as was the custom in galleries at the time, and arranged above the level of the doors, for practical as well as visual reasons, though the lighting cannot have been altogether favourable. The plan for the room was based on the paintings' proportions, rather than their subject-matter, making it perhaps the earliest example in Britain of a purpose-built picture room.

From the middle of the eighteenth century, when it ceased to be used by the court, the palace became accessible to respectable visitors, who were shown round by the housekeeper as was the practice in country houses. The cartoons were removed to Buckingham House in 1763 by George III, and in 1787 to Windsor Castle, but their return to Hampton Court in 1809 was greeted enthusiastically by artists. According to Pyne, they were reframed by the Prince Regent in the Maratta frames fashionable at the time, at a cost of $500.[3] When the palace was opened on a regular basis to the public in 1838, they became the object of much popular interest. In 1865 they were removed for reasons of conservation to their present home at the South Kensington Museum, tapestries being hung in their place.

It would be difficult to over-emphasise the importance of the Raphael cartoons in the consciousness of British artists and art-lovers in the late eighteenth and early nineteenth centuries. They were revered more deeply than any other works in Britain: replicas hung in the Great Room at Somerset House during the winter, while the Ashmolean Museum kept a further set in its Great Room for almost a century. They were totemic works, described by Pyne in Royal Residences as *'almost divine.'*

1 Law (1891) III p.65.
2 *King's Works V* pp.163–4.
3 Pyne II p.76ff.
□ Ernest Law, *The History of Hampton Court Palace* (1891)
□ John Shearman, *Raphael's Cartoons* (1972)

A2
Charles Wild (1781–1835)
The King's Gallery at Kensington Palace 1816
Watercolour over etched outlines, 19.7 x 25 cm

HM The Queen

The Palace at Kensington grew out of the house purchased from the Earl of Nottingham by William and Mary in 1689. In the following half century extensive alterations were made by Wren, Vanbrugh and Kent. As at Windsor, there are two distinct suites of apartments at Kensington, one (on the southern side) for the King and the other (towards the north) for the Queen. The King's Gallery occupies the first floor of most of the southern facade of the main block and was among the alterations made at Kensington in 1695 to the designs of Christopher Wren, Surveyor of Works. A model of the new room was prepared by

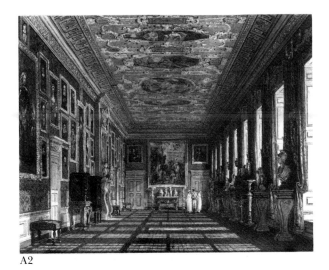

A2

Nicholas Hawksmoor in pasteboard and other materials. By the end of 1695 Constantijn Huygens was assisting the King with the arrangement of paintings in the Gallery, which is over 95 feet long and 21 feet wide. In the following year Evelyn noted that *'all the best Pictures of all the Houses'* had been hung there.[1] The inventories of pictures at Kensington in 1697 and 1700[2] itemise over seventy paintings *'in the Gallery'*, including Van Dyck's equestrian portrait of Charles I.[3] The King's Gallery served as an area for both display and exercise: its originator, William III, took *'several turns'* there between the date of his accidental fall from his horse in February 1701 and his death two weeks later.[4] It was redecorated between 1725 and 1727 by William Kent, who designed new chimneypieces and doorcases and painted the ceiling canvas.

The royal apartments at Kensington were scarcely used in the second half of the eighteenth century, except as a quarry to provide paintings for the other royal residences. Thus in 1804–05 Ramsay's portrait of Queen Charlotte was transferred from the King's Gallery at Kensington to the Queen's Ballroom at Windsor, where it is shown in A5. A2 is part of the great series of finished water-colours associated with W.H. Pyne's *History of the Royal Residences* which show a number of rooms at Kensington used as stores. The King's Gallery was still evidently accessible to visitors, but the arrangement of the 35 or so paintings shown on the left-hand wall in this view can hardly be described as well thought out.

In 1818 Benjamin West, Surveyor of Pictures to George III, made an inventory of the paintings at Kensington.[5] This provides an accurate guide to the pictures shown by Wild in the King's Gallery. According to Pyne, who had access to West's inventory, *'several of the finest pictures that formerly enriched the walls of this extensive apartment, have been removed to other of the royal residences of late years; and indeed as Kensington Palace is so rarely visited, it would be well to*

select the remaining graphic works, particularly the portraits, to add to the interest of the other royal collections'.[6]

The State Apartments at Kensington have been opened to the public since 24th May, 1899, the eightieth birthday of Queen Victoria. The King's Gallery remains an important display area for paintings in the Royal Collection.

Jane Roberts

1 King's Works V, p.190.
2 Millar Inventory (1963) Nos. 20 and 21.
3 Millar cat. 144.
4 Pyne (1817–20) p.9.
5 Millar Inventory No. 43.
6 Pyne (1817–20) p.78.

A3
George Vertue (1684–1756)

King James the Second's Collection to which is added a Catalogue of the Pictures and Drawings of the late Queen Caroline 1758
Book, octavo, iv + 144pp.

Charles Sebag-Montefiore

Vertue, distinguished antiquary, was employed by Frederick Prince of Wales to catalogue the royal collection. His list of the works of art belonging to Caroline of Anspach, the Prince's mother, was published posthumously. It includes four wall plans of the Queen's closet, with the paintings shown in the precise position in which they were displayed on the wall. Very tightly arranged, the display was dominated by the Holbein drawings which the Queen, an enthusiastic lover of the visual arts, famously rediscovered in the drawer of an old table. Vertue's diagrams illustrate the seventeenth and eighteenth century tradition of the private cabinet for smaller works of art, a distant ancestor of the nineteenth century museum cabinet room.

WINDSOR CASTLE

A4
Anonymous, English school

The Queen's Ball Room Early 19th Century
Watercolour with pen and ink, 15.7 x 37.1 cm

HM The Queen

A5
C. Wild

The Ball Room at Windsor Castle 1817
Watercolour, 19.7 x 25.1 cm

HM The Queen

A6

Joseph Nash (1808–78)

The Van Dyck Room, Windsor Castle 1846

Watercolour and bodycolour, 32.5 x 47.9 cm

HM The Queen

These three watercolours depict the same room now known as The Queen's Ballroom, at the west end of the north side of the Quadrangle in the Upper Ward of the Castle. It is one of the apartments formed by Hugh May for Charles II in the 1670s and 1680s. In part they retain their late seventeenth century division into two suites, for King and Queen. The Queen's Ballroom, 63 feet long and 21 feet wide, runs along the south-western end of the State Apartments, between the Queen's Privy Chamber and the Queen's Drawing Room. In the seventeenth and eighteenth centuries it was known as the Queen's Gallery.

The walls were originally punctuated by four doors and two chimneypieces. The spaces above these appear always to have been filled by paintings (portraits, religious or allegorical subjects), while the larger intervening areas were occupied by Brussels tapestries. According to the inscription on A4, '*On the ceiling of this room* (painted by Verrio) *King Charles the 2nd is represented giving freedom to Europe by the figures of Perseus and Andromeda*'. Early Windsor inventories[1] note a pair of paintings of full length allegorical figures[2] hanging over the chimneypieces. The elongated proportions of these paintings could not be accommodated within the carved surrounds shown in A4 and A5. It appears likely that the carvings had been introduced to the Queen's Ballroom some time before 1817; they had been removed by the time that A6 was painted, in 1846.

Both A4 and A5 record the room as altered by James Wyatt in the first decade of the nineteenth century as part of his major works to make the Castle fit for occupation by George III and his family. One of the royal inventories, entitled *A Catalogue of Pictures sent from the Queen's Palace, St. James's, Kensington and Hampton Court Palaces and Kew House, to His Majesty at Windsor Castle. 1804 & 1805* lists the sources of the paintings involved.[3] Thus Ramsay's *Queen Charlotte with Her Two Eldest Sons*[4] and Copley's *The Three Youngest Daughters of George III*[5] were brought from Kensington to hang at either end of the Ballroom at Windsor, while Zuccarelli's *Meeting of Isaac and Rebecca*,[6] was moved from Hampton Court and placed in the centre of the east wall. On the main wall surfaces to the left and right of the Zuccarelli were two full-length portraits by Van Dyck: *Beatrice de Cusance, Princess of Cantecroix and Duchess of Lorraine*[7] and an unknown woman, then thought to represent Lucy Percy, Countess of Carlisle.[8] Both had been acquired by Frederick, Prince of Wales, and had formerly hung at Buckingham House. The spaces over the doors and chimneypieces were scarcely affected by these changes. The paintings (respectively by Van Somer, after Correggio, after Van Dyck by Van Dyck, after Reni, and by Hanneman) are already noted in this room in late eighteenth century guidebooks. Most can be identified in Royal inventories of the late seventeenth century.

A4 belongs to a series of eight schematic drawings of rooms at Windsor, while A5 is part of the series of watercolours associated with Pyne's *Royal Residences*. Other rooms at Windsor recorded in Pyne (including the adjacent Queen's Drawing Room) show George III's newly introduced pictures hanging on top of tapestries. Pyne considered that '*the whole-length portraits by Van Dyck, the rich carvings of the frames to those over the chimneypieces by Gibbons, and the magnificent pier tables, frames of the pier glasses, chandeliers, candelabra, and fine ornaments elegantly designed and wrought in silver . . . render the Ball-Room one of the most imposing features of the Castle*'.[9]

Although Wyatville's remodelling of the Castle between 1824 and 1840 was principally concerned with the King's Apartments and the private apartments on the east and south sides of the Quadrangle, his work also incorporated some of the Queen's Apartments. The room depicted in A6 is essentially that shown in the two earlier views, but Verrio's ceiling has been replaced by a horizontal cream-coloured surface, off which the light reflects to advantage onto the paintings. Instead of two fireplaces there is now a single central one, and in place of the panelling, a flat surface covered with red cloth; the doors at either end of the long wall have also been eliminated. These changes increased the area on which paintings could be hung, and introduced a rich background colouring.

It is not known whether a decision had been made before the start of redecoration concerning the paintings that would hang in the room. But by 1835 a visitor recorded that the room was hung with paintings by Van Dyck, hence its new appellation, the Van Dyck Room.[10] The decision to concentrate the works of a single artist in one room was almost certainly made by George IV as part of the overall redistribution of the Royal Collection begun during his reign. Van Dyck's patron, Charles I, was revered by George IV, as forebear and collector. An important group of the artist's works (including a number seen in A7) had been gathered at Carlton House, which George IV had finally decided to abandon in 1826.

The Royal Windsor Guide of 1837 noted that '*At present, the apartments shewn to visitors have not yet received their final decorations; the furniture, some few of the pictures, and all the gilt frames, are yet in the workman's hands*'. It can be assumed that the arrangement of pictures in the Ballroom changed little in the decade following 1835 and A6 remains a valuable record of the new display. All the paintings are now shown in gilt frames. In some cases the plain wooden frames

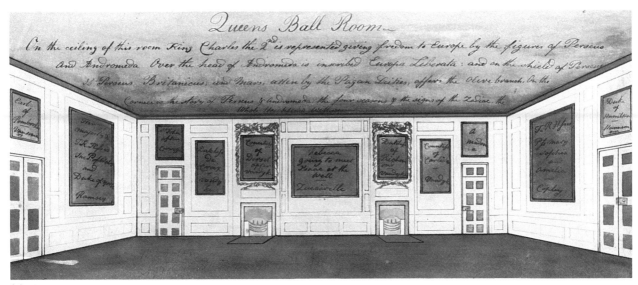

A4

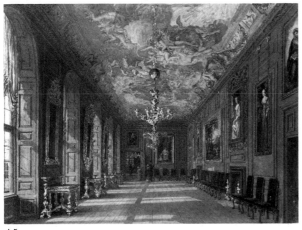

A5

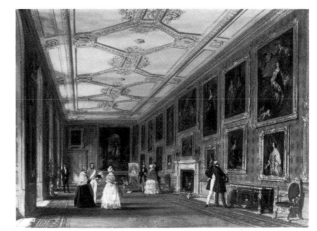

A6

were gilded, occasionally with additions, while in other cases the frames were newly made: the full-length portraits which were introduced to the room in 1804–5 and are shown in A4 and A5 were rehung in adapted frames at the upper level to right and left of the fireplace. The best-known of the paintings shown in A6 is the vast equestrian *Charles I*[11] on the far wall; it had once hung in the King's Gallery at Kensington. Above the chimneypiece is *Charles I in Three Positions*, reacquired for the Royal Collection in 1822 (see A2). One of the three portraits of Queen Henrietta Maria on the long right-hand wall is being copied by an artist.

A6 was reproduced as a plate in Nash's *Views of the Interior and Exterior of Windsor Castle* (1848). In the accompanying text, Nash notes that *'The highly-valuable historical portraits preserved here recall associations and recollections connected with English history which cannot fail to interest the spectator'*. Waagen, who had

been unable to see the paintings at Windsor in 1835, noted, following a visit in 1851, that *'No gallery in the world can display so large a number of portraits by this great master'*. In 1855 the room was adapted by J.G. Crace to serve as a reception room for Napoleon III. The changes included the introduction of seat furniture in green and gold, matching curtains, a new carpet and three large chandeliers; the organisation (and choice) of pictures remained largely unchanged. In the present reign the wall covering has been changed to blue. The paintings shown in the room change from time to time, but at present include eight portraits by Van Dyck, many of which were hanging in the room in 1846.

It was possible to visit the State Apartments soon after their completion in the late seventeenth century. There are guidebooks listing the contents of the State Apartments from 1742. Originally arrangements for visits were probably made with the Housekeeper of

the Castle, and visitors would be shown around, or at least supervised, by royal servants. In 1828 *The Visitants' Guide to Windsor Castle* stated that '*The Round Tower and State Apartments are open every day for the inspection of the public*'. The *Companion through the State Apartments of Windsor Castle* for 1851 noted that the open days were Mondays, Tuesdays, Thursdays and Fridays. Admission was by ticket (supplied free of charge), available at Windsor and through a number of printsellers and booksellers in London. Although the selection of rooms shown to the public has changed from time to time, entrance to the State Apartments has been granted almost continuously since that time, apart from those periods when the monarch is actually resident in the Castle.

Jane Roberts

1 Published in Millar (1963 and 1969).
2 Shearman cat. 162 and 163.
3 Millar Inventory (1963) No. 39.
4 Millar cat. 998.
5 Millar cat. 712.
6 Levey cat. 689.
7 Millar cat. 158.
8 Millar cat. 154.
9 Pyne (1817–20) p.99.
10 Millar (1963) p.31.
11 Millar Inventory (1963) No.146.

☐ O. Millar, *The Tudor, Stuart and Early Georgian Pictures in the Collection of Her Majesty The Queen* (1963)
☐ O. Millar, *The Later Georgian Pictures in the Collection of Her Majesty The Queen* (1969)
☐ W.H. Pyne, *History of the Royal Residences* (1817–20)

* A7

Joseph Nash

The angle of the corridor, Windsor Castle 1846
Watercolour and bodycolour, 32.8 x 41.5 cm

HM The Queen

The Grand Corridor was added by Sir Jeffry Wyatville (1766–1840) to the inner face of the eastern and southern blocks surrounding the Quadrangle, to provide a much-needed outer communication route for the main first floor rooms in the private apartments. A7 shows the canted angle between the east and south parts of the Corridor. With the exception of this area, the Corridor was lit by a series of windows looking out on the Quadrangle. Within the angle Wyatville formed the Sovereign's Entrance, with the Oak Room above, which interrupted the flow of light from the Quadrangle. The Corridor therefore had to be top-lit from three separate light wells, as shown here.

The architectural detailing of the Grand Corridor is mainly Gothic. The scarlet curtains were supplied in 1828 by Morel & Seddon, the partnership set up to supply furniture for George IV's new works at

A7

Windsor. This furniture included the stools against the door in the left foreground, a set of 46 gilt bronze candelabra, and 41 scagliola terms for the support of marble and bronze busts. In the text accompanying the plates relating to the three views of the Corridor in his *Views of . . . Windsor Castle* (1848), Nash noted that '*In traversing this noble gallery, the rarity of design, of tone, of decoration, and of contour or general form, will at once strike the eye of the spectator . . . The minor details of furniture and accessories are well and skilfully designed and selected so as to form appropriate subordinate adjuncts*'.

From the start, as well as '*forming a noble and spacious ambulatory*'[1] 500 feet in extent, the Corridor had been envisaged as a display area for sculpture and paintings: in George IV's accounts it is often referred to as '*the Gallery*'. In 1827 and 1828 William Seguier, Surveyor of the King's Pictures, charged for '*Travelling expenses to Windsor Castle by His Majesty's Command to prepare an arrangement of the Pictures for the New Gallery*'.[2] A consignment of paintings, furniture and sculpture from Buckingham House, St James's Palace, Kew and Cumberland Lodge was delivered to the Castle in the second half of 1828. Earlier in the same year work had been carried out on the frames of many of the pictures selected to hang in the Grand Corridor, to ensure that they harmonised.[3] The most notable items to receive such attention were the paintings by Canaletto and Zuccarelli, part of Consul Smith's collection acquired by George III in 1762. Alongside these Italian works, George IV planned to hang paintings by English artists, such as Wootton and Wilkie (responsible for the three paintings closest to the right hand edge of the watercolour), Lawrence, Reynolds and Hoppner. In November 1828 the King's favourite artists, Wilkie and Chantrey, were at Windsor advising on hanging and arrangements.[4] It is likely that the very dense arrangement shown here, with pictures hanging three-deep in places, is essentially that conceived by George IV in the 1820s.

All visitors to the Castle at this date remarked on

the Corridor. In January 1829 Lady Dover informed her sister that *'the first coup d'oeil of the long gallery or corridor is the most strikingly beautiful thing you can conceive . . . it is now splendidly furnished and lighted, filled with pictures and admirably arranged, and with busts and bronzes which make it as interesting as it is magnificent. There is perhaps too much gilding; but this heightens the fairy-like appearance, and excepting this, all the ornaments and decorations are in the best possible taste'.*[5]

The private apartments at Windsor have never been freely open to the public in the same way as the State Apartments, although W.F. Taylor's *Guide to Windsor* for c.1856 indicates that entrance was occasionally granted. Taylor suggested that, in the light of these difficulties, the visitor would be better advised to inspect the Royal Exhibition opposite Windsor Parish Church, which consisted of large stereoscopic copies of Nash's interior views (including A7).

Jane Roberts

1 Nash (1848).
2 De Bellaigue and Kirkham, p.10, n.19.
3 De Bellaigue and Kirkham, pp.3 and 18.
4 De Bellaigue and Kirkham, p.3.
5 De Bellaigue and Kirkham, p.18.

□ G. de Bellaigue and P. Kirkham, 'George IV and the Furnishings of Windsor Castle', *Furniture History* VIII (1972)
□ J. Nash, *Views of the Interior and Exterior of Windsor Castle* (1848)

A8

Sir John Soane RA (1753–1837)

Fonthill Splendens, Wiltshire, design for a Picture Gallery 1787

Sepia pen and pencil, 36 x 29.5 cm

Trustees of Sir John Soane's Museum

In 1787 Soane was asked to design a picture gallery for William Beckford (1760–1844), one of the richest men of his day, distinguished collector of art and the source of scandal throughout his life. Beckford had briefly returned to England at the beginning of the year from involuntary exile on the Continent, and had commissioned various alterations to the house built by his father at Fonthill Splendens, Wiltshire. The work was supervised by his mother, whose cousin, the Marquess of Abercorn, had already employed Soane.

The architect carried out work for Beckford between April 1787 and early 1788, including designs for chimneypieces and niches in the Tapestry Room at Fonthill. His most important job in the house was to create a gallery for Beckford's expanding picture collection, in place of several bedrooms on an upper floor. Soane considered two principal ideas for the

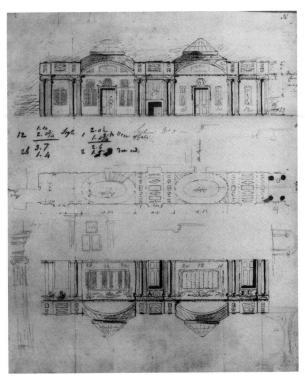

A8

organisation of this room. One, not executed, would have created a gallery with an oval dome and lantern at the centre of the room, and two smaller circular domes at each end – he commented on one scheme (in the Soane Museum) *'Center is left plain to contrast with the richness of each end & side'*, and planned to include a cast of Apollo on a pedestal at one end. The design shows an arrangement of panels much more elaborate than what was finally executed.

The drawing exhibited is one of several preliminary sketch designs, in Soane's own hand, very close to the presentation watercolour for the gallery, as executed (in Soane Museum). The watercolour shows blue-grey walls, with wooden doors. The chosen design alternates rectangular spaces for the display of paintings with pillared and barrel-vaulted areas to accommodate doors and chimneypieces, producing a pattern of light and dark the length of the gallery; the design of the opposing walls creates a contrapuntal effect, comparable to some of Robert Adam's interiors. The top lighting imposed on Soane by the exigencies of the site is an early example of its use in the English country house; most mid-eighteenth century galleries such as Temple Newsam maintained the tradition of side lighting from Elizabethan houses. The form of dome and lantern introduced here resembles that in many of Soane's later buildings except that there is no vertical monitor lighting: in this respect it is close to the lanterns later built for Chantrey (A23) and at the Soane Museum.

The gallery was used for the display of topographi-

cal views of Fonthill, and family portraits, as well as Hogarth's *Rake's Progress*, which Soane himself acquired at Christie's in 1802. Unlike the ground floor of the house, it was not publicly shown, and served as a means of communication to the bedrooms and dressing rooms.[1]

The architect did not meet his patron on this occasion, though they became friendly late in life. Dorothy Stroud[2] suggests that Soane was greatly impressed by Beckford's collection, and that it inspired him in due course to create his own Picture Room at Lincoln's Inn Fields.

Fonthill Splendens was demolished in 1807, in favour of Beckford's new extravaganza, Fonthill Abbey.

1 J. Britton, *The Beauties of Wiltshire* (1801) I p.234ff.
2 D. Stroud, *Sir John Soane Architect* (1984) p.60.

A9

John Le Keux (1783–1846) after G. Cattermole (1800–68)

Mr. Thos. Hope's Picture Gallery

Engraving, 11.7 x 17.7 cm (for C. Westmacott, *British Galleries of Painting and Sculpture* (1824))

Peter Jackson

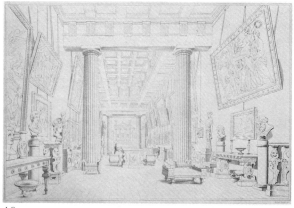

A9

This gallery represents the ideal of early nineteenth century gallery design. A Greek Doric interior, divided into three sections with the longest section in the centre, top-lit, it unites not only the arts of painting, sculpture (antique and modern), and architecture, but the decorative arts, and, in the form of the portico-encased organ at the far end of the room, music. It was indeed a Temple of the Muses. It also ranks as one of the earliest purpose-built galleries. Easily accessible (from 1804 it was open to visitors with tickets on Mondays during the social season), it exerted a considerable influence on the development of private, and to a lesser extent public, galleries.

Thomas Hope (1769–1831), plutocrat, connoisseur and designer, bought a large house off Portland Place, between Queen Anne Street and Duchess Street, in 1799. He did not make substantial alterations to the exterior of the house, which had been designed by Robert Adam, or to the ground plan, but within this framework he created a series of dazzling Neoclassical apartments, demonstrating his ideas of correct taste. Hope's account of this gallery in *Household Furniture and Interior Decoration*, of 1807, stresses the range of references that he was making in designing the room, which became a compendium of the most important sources in Greek Classical architecture: the columns in the centre of the ceiling were derived from the Temple of the Winds in Athens, the larger columns from the Propylaea, while the organ, which '*assumes the appearance of a sanctuary*', used an Order from the Temple of Erechtheus in the Acropolis.[1]

Originally consisting largely of seventeenth century Italian pictures, the collection expanded into contemporary British art after 1805, reflecting the increasing acceptability of native art. The paintings are shown in the manner becoming fashionable at the time, with pictures on the higher level canted forward and the chains suspended from a picture rail. Another engraving of this gallery, reproduced in *Household Furniture*, shows the walls on which the paintings hang entirely covered in long drapes – evidently a form of conservation at a time when there was much concern over damage to works of art from sunlight. The tables in the centre of the room were intended for portfolios of drawings and books of prints, and like all the furniture were conceived as part of a decorative whole: '*The massive tables . . . and the antique pedestals and implements, which adorn the sides of the chamber, have all the classic uniformity of the general decoration.*'[2]

A further room, the Flemish Picture Gallery, was added in the garden at the back of the house in 1819.

1 Hope (1807) p.22.
2 Westmacott (1824) p.224.

☐ T. Hope, *Household Furniture and Interior Decoration* (1807)
☐ C. Westmacott, *British Galleries* (1824)
☐ D. Watkin, *Thomas Hope and the Neo-Classical Idea* (1968)

THE STAFFORD COLLECTION

When in 1803 George Leveson-Gower became Marquess of Stafford, he was described by the *Gentleman's Magazine* as probably the richest nobleman in England. He inherited not only vast estates but the very considerable collection of pictures assembled by his

uncle, the third Duke of Bridgewater, which included part of the Orléans collection bought in London in the 1790s. The Marquess was one of the noblemen who was swayed by the contemporary belief that works of art should be made available to the public by private owners on as generous a basis as possible. He added a purpose-built gallery to his house in 1805–06 to the designs of C.H. Tatham (1772–1842), something of a specialist in gallery design. The collection was first opened to visitors during the summer of 1806; this was the first nobleman's house to be so opened in London, and it persuaded other major owners to show their own paintings. The impact was enormous: so great was the response that Lord Stafford was forced to introduce regulations, restricting admission to those known to the owner, his family or friends. In his Preface, Britton comments on the difficulty for private owners of showing their pictures in view of *'the ignorance, vulgarity, or something worse'* on the part of the lower orders, and the *'frivolity, affectation and insolence...in a class of lounging persons, who haunt most public places.'*[1]

Britton's catalogue lists the pictures according to the rooms in which they were shown. The list is interesting in that it illustrates how the collection was arranged by School. The Italian paintings, and particularly those with a religious subject, were shown in the top-lit New Gallery (the rooms in domestic use had conventional windows). Further Italian paintings were hung with French works in the Drawing Room. The 'Anti-Room', also known as the 'Poussin Room', contained Poussin's *Seven Sacraments*, now in the collection of the Duke of Sutherland (by inheritance) and on loan to the National Gallery of Scotland. The Old Gallery contained a very large group of Dutch and Flemish paintings, while in the ante-room a few English paintings were displayed. Britton commented that the room should have been *'wholly appropriated'* to the British School.[2]

The frontispiece to Britton's tome shows the New Gallery, architecturally and decoratively plain. An interesting touch is the set of curtains, ready to pull over the monitor lights in case the sun became too strong.

Ottley's catalogue of ten years later, in four volumes, aims to give a comprehensive illustrated account of the major works in the collection, on the model of the 1786 catalogue of the Orléans pictures before their dispersal. Its interest lies in the detailed plans it gives of the picture hang, which allow a full reconstruction of the house's appearance. The pictures are shown in symmetrical arrangements, with much thought given to visual relationships between works.

Ottley, leading connoisseur and adviser to many private owners, become keeper of prints at the British Museum in 1833.

1 Britton, *Preface* p.v.
2 Britton p.112.

A10

John Britton (1771–1857)

Marquess of Stafford Collection 1808

Book, octavo, viii + 147pp.

Charles Sebag-Montefiore

A11

William Young Ottley (1771–1836) and Peltro William Tomkins (1759–1840)

The Stafford Gallery 1818

Book, folio.

Charles Sebag-Montefiore

COLLECTIONS OF SIR JOHN LEICESTER

Both 24 Hill Street, Mayfair, and Tabley House, Cheshire, were the property of Sir John Leicester, Bart. (1762–1827), created Lord de Tabley in 1826. Leicester has a particular importance in the development of British galleries as one of the first and most active advocates of the British School: in the words of his friend Sir Richard Colt Hoare, of Stourhead, also a collector of native paintings, his *'taste and liberality . . . nobly set the first example in favour of the British school, in the worst period of its discouragement.'*[1] At a time when the purchase of contemporary British works was despised by the wealthy public, Leicester was hailed by such admirers as William Carey as a champion of the native school, *'attacking the enemy in his entrenchments, sword in hand.'*[2] Both his galleries were filled with British paintings to the exclusion of any others, reflecting a point of view more extreme than that of such fellow enthusiasts as Lord Egremont at Petworth or Colt Hoare, who continued to believe in the benefits offered *'by the extensive introduction of ancient paintings'*.[3] Leicester became increasingly interested in the presentation of his possessions and in their potential role as a national collection of British art, culminating in his offer to the Prime Minister in 1823 to sell his pictures to the nation as the basis for a National Gallery of British Art.

Leicester bought a town house in Hill Street in 1805, with the intention of showing his pictures there: work on a gallery was immediately put in hand to the designs of Thomas Cundy the Elder (1765–1825). A13 shows the gallery in its first incarnation, with the top lighting which was by this time *de rigueur*, and a shallow dome. Leicester devoted much time to presentation, constantly chang-

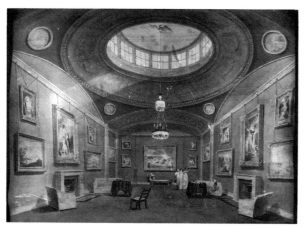

A12

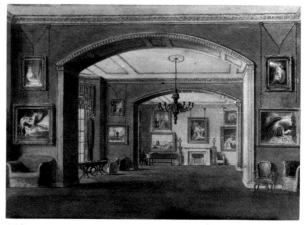

A13

ing the arrangement of the pictures and laying much emphasis on hanging in symmetrical patterns, even at the expense of such criteria as the pictures' quality. They are hung on gilt iron chains, artfully looped: the eighteenth century style had been to attach paintings directly to the wall so that no chain was visible, and this is an early example of a change of taste that was to become common in the nineteenth century.

The lion's masks (of which three types exist, all made in composition plaster of the type used for picture frames) were introduced at both Hill Street and Tabley, in a bold decorative stroke, to conceal the hooks and the huge iron nails (driven straight into the plaster of the wall) which fixed the tops of the picture chains to the walls: no picture rail was used in the original arrangements. A chandelier now at Tabley House is decorated with lion's masks *en suite* with those on the walls, and came originally from the London gallery.[4]

This gallery was subsequently altered, since Leicester expanded his collection with the purchase of large history paintings, an expansion stimulated by his decision in 1818 to open the gallery to the public. Though this public was a select one, limited to ticket-holders known to the owner and his friends, and the house was only open during the social season, the decision was an important one. According to Carey, the first opening represented '*a memorable epoch in the British school. Who that witnessed it can ever forget the feelings which it excited? The crowd of beauty and fashion, the chief nobility and gentry, the distinguished members of the legislature and of the learned profession, the taste and educated mind of England, assembled to share in the triumph of their countryman.*'[5]

Tabley House, the family seat built by John Carr of York in the 1760s, provided further space for Leicester to expand his collection. By 1809 he had formed a new gallery, to the designs of Thomas Harrison (1744–1829), and the room is shown by Buckler in his signed and dated drawing of that year.

Like the London apartment, the new room was handsomely decorated, but the furniture, though comfortable, was subsidiary to the room's principal purpose.

The information bat is an example of a type used at both galleries; though not unique to Leicester's collections, it shows the seriousness with which Leicester viewed the task of informing his visitors. The two catalogues emphasise the importance of Leicester's role as a champion of the British School.

By the time of Leicester's death, his battle for British art was almost won, but his fortunes were ruined. The London house and its paintings had to be immediately sold, though a few of the more important paintings were moved to Tabley. There the gallery and other state rooms remain largely intact, a rare document of one of the most important episodes in the history of English taste. They are currently under restoration.

1 Carey (1819) p.viii.
2 Carey (1826) p.106.
3 Carey (1819) p.iv.
4 Information from P. Cannon-Brookes.
5 Carey (1819) p.x.
☐ W. Carey, *A Descriptive Catalogue of a Collection of Paintings, by British Artists, In the Possession of Sir John Fleming Leicester, Bart.* (1819)
☐ W. Carey, *Some Memoirs of the Patronage and Progress of the Fine Arts, in England and Ireland* (1826)
☐ P. Cannon-Brookes, *Paintings from Tabley* (1989)

A12

Thomas Jackson

Sir J. F. Leicester's Picture Gallery, Hill Street, London 1806–07

Watercolour, 43.2 x 71 cm

University of Manchester (Tabley House Collection)

A13

John Chessell Buckler (1793–1894)

Picture Gallery at Tabley House 1809

Watercolour, 29.2 x 40.7 cm

University of Manchester (Tabley House Collection)

A14

William Carey, with comments by Sir Richard Colt Hoare

A Descriptive Catalogue of a Collection of Paintings by British Artists in the Collection of Sir John Fleming Leicester, Bart. 1819

Book, octavo, xii + 152pp.

Charles Sebag-Montefiore

A15

John Young

Sir John Fleming Leicester Collection 1825

Book, quarto, 31pp.

Charles Sebag-Montefiore

A16

Information Bat from Tabley House c.1820

University of Manchester (Tabley House Collection)

A17

Lion's Head from the Hill Street gallery c.1810
Composition plaster

University of Manchester (Tabley House Collection)

* **A18**

Joseph Michael Gandy ARA (1771–1843)
Dulwich Picture Gallery c.1823

Watercolour, 22 x 70.5 cm

Dulwich Picture Gallery

Soane's Gallery for the collection bequeathed to Dulwich College in 1811 by Sir Francis Bourgeois was built between 1811 and 1813, though additional work went on for some years. The completed building represented a considerable change from his original plans: the east facade was not built at all as he had intended, and the appearance of the building was much less impressive, for reasons of economy, than he had hoped it would be. When the Gallery was ridiculed in the Press by the Rev. T.F. Dibdin, Soane defended himself by commissioning a series of drawings of the building as it ought to have looked.

This is a version of one of these drawings, forming part of a set of which a complete example is on view at Sir John Soane's Museum.

Dulwich Picture Gallery was one among many early nineteenth century galleries in London and the country. Few of its fellows survive, especially so in London; and none has been as influential on later gallery design in Britain.

☐ T. Mellinghoff, 'Soane's Dulwich Picture Gallery Revisited' in *Architectural Monographs, John Soane* (1983)
☐ G. Waterfield, *Soane and After* (1987)

A19

John Le Keux (1783–1846) after George Cattermole (1800–68)

Benjamin West's Gallery, Newman Street, London 1821

Engraving, 14.2 x 22.5 cm

Trustees of The British Museum

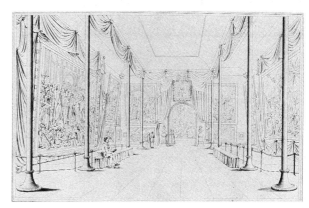

A19

As the second President of the Royal Academy, and as the producer of vast numbers of very large history paintings, Benjamin West (1738–1820) was accorded during his life a celebrity never regained after his death. He was given important commissions by George III, and a whole gallery in Buckingham House was devoted to the display of his pictures. West's paintings could regularly be seen in his house and studio at 14 Newman Street, off Oxford Street, where he also showed his important Old Master collection. He died a very rich man, worth over £100,000.

On his death in 1820 his two sons found themselves the owners of well over a hundred of the late President's works. They immediately built a gallery in the garden of his house, to accommodate at first 94 and, from 1822, 142 of his pictures. The gallery was open to visitors and a catalogue was produced. Though the paintings were not for sale, the Wests

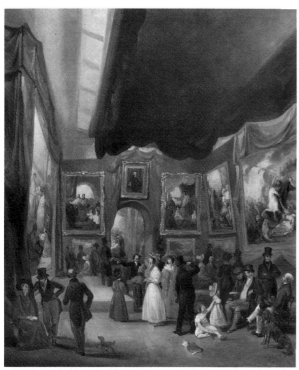

J. Pasmore the Younger, *Benjamin West's Picture Gallery* (Wadsworth Athenaeum, Hartford)

The construction of the gallery was of great interest, being an early example of a system of lighting with the light directed at the walls and excluded, through a false ceiling under the glass, from the centre of the rooms, so that the source of light was not visible to the spectator entering the gallery. According to J.W and Wyatt Papworth, writing in 1853, such lighting was considered perfect by the architect Charles Barry, who quoted the West gallery as the best example of the type. The Papworths wrote that Barry *'never heard with whom the principle originated; and . . . he never saw a gallery lighted upon that principle, but that he should say it was the correct principle of lighting a gallery with effect; that the advantage of the plan was, that it avoided all tie-beams, and consequently that all sources of shadow which might be cast on the pictures were done away with'.*[3] Although the gallery was designed by John Nash, the Papworths were confident that the lighting scheme emanated from their father J.B. Papworth (1775–1847): an intimate friend of West, *'he often spoke of the room with satisfaction, as a successful experiment.'*

The gallery was also depicted by John Pasmore, in an oil painting of c.1821 (Wadsworth Athenaeum, Hartford, Conn.). The two views give a clear impression of the organisation of light and of the wall hangings, arranged in the festoons held in place by decorative rosettes that were to be popular, especially in commercial galleries, throughout the nineteenth century. Partly decorative, these festoons were also intended to absorb the light from above, which would otherwise have struck the highest part of the walls with excessive strength.

After the dispersal of the collection, the West gallery underwent various vicissitudes. During the 1850s it served as the Apostolic church of the 'Irvingites'. It has been demolished.

1 *West's Gallery* (1823 ed.).
2 Quoted in 'B. West and his American Students', *National Portrait Gallery of America, Smithsonian* (Oct 1980).
3 Papworth (1853) p.72ff.
☐ Helmut von Erffa and Allen Staley, *The Paintings of Benjamin West* (1986)

A20

W.F. Witherington RA (1785–1865)

A Modern Picture Gallery 1824

Oil on canvas, 69.4 x 90.4 cm

Wimpole Hall, The Bambridge Collection (The National Trust)

In their catalogue entry for this picture (unpublished, in the National Trust archives), Sir Brinsley Ford and Alastair Laing dismiss identifications of this interior as Sir John Leicester's gallery in Hill Street or as the British Institution (neither of which it resembles). Their argument that the picture is a plea for the

hoped to raise income from admission fees: admission cost a shilling, with a further shilling for the catalogue. In spite of initial interest, the new gallery did not achieve the commercial success for which they hoped. In 1826 they tried to persuade the United States Government to buy the collection as the foundation for a national gallery of America, and three years later they sold some of the paintings at auction.

As the engraving shows, the gallery was devoted exclusively to West. His *Christ rejected by the Doctors*, of 1814, hangs on the left hand wall, with draperies above and barrier in front, marking it as a major work. A long description is devoted in the catalogue to this picture and to *Death on a Pale Horse*,[1] reflecting the fact that both paintings had in their time been major successes, attracting to the one-man exhibitions that West had organised in Pall Mall large audiences of a relatively unsophisticated type. The West sons hoped to re-create such success in their new gallery.

The paintings were shown in four rooms: the Entrance Gallery, the Room of Drawings, the Great Room and the Inner Room. The latter two are visible in this print. An early account, by an American engraver, John Sartain, describes the room: *'A canopy resting on slender pillars stood in the middle of the room, its opaque roof concealing the skylight from the spectator, who stood thus in a sort of half-obscure dimness, while both pictures received the full flood of light. The effect was very fine and at that time novel.'*[2]

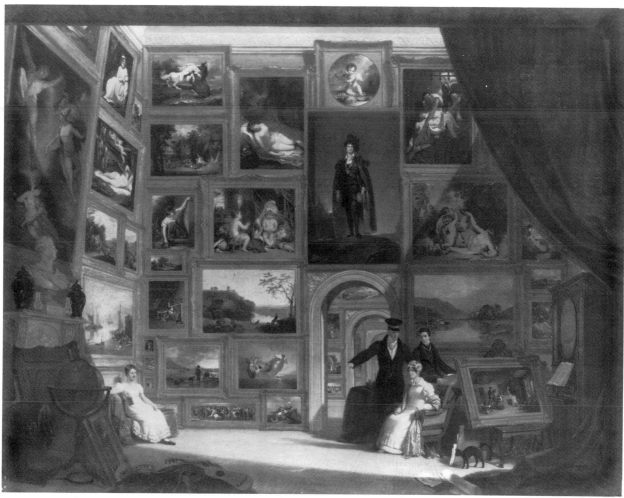

A20

collecting by British patrons of native art is convincing: the attempt by a group of determined apologists, led by Leicester and supported by such propagandists as William Carey and Haydon, to turn British collectors away from their dogged enthusiasm for Old Masters towards a form of collecting both patriotic and beneficial to the national economy, was at its height in the 1820s. A number of the paintings have been identified: they are all British and broadly contemporary with the picture (apart from a Gainsborough), and come from various collections, including in several cases Leicester's own.

The painting is an important document in the development of picture collecting in this country.

The rooms, which exemplify the 1820s view of an appropriate interior for a picture gallery, convey the impact made by such buildings as the British Institution and Dulwich, both enfilades of rooms linked by round-headed arches. The type of painting, with fashionably dressed figures viewing the paintings in a gallery, which derives ultimately from seventeenth century Flemish art (especially the work of David Teniers), enjoyed a vogue in the early nineteenth century, notably in paintings by J. Scarlett Davis, prolific depictor of British and foreign galleries.

Shown at Dulwich Picture Gallery only

A21

Lady Dover, born Lady Giorgiana Howard

A Drawing-Room of Old Dover House c.1828

Pen and black ink, 22.9 x 33 cm

Private Collection

One of ten sheets in the same collection showing eight interiors and two exteriors of Dover House which document most accurately its original appearance and especially the picture arrangement. The Hon. George James Welbore Agar-Ellis, 1st Baron Dover (1797–1833), eldest son of the 2nd Viscount Clifden, was a politician, founder member of the National Gallery, pall-bearer of Sir Thomas Lawrence PRA, and wrote a standard work on Frederick the Great of Prussia. He was a patron of contemporary artists including Thorvaldsen, Hayter, Lawrence and Chantrey.

Here we see some of Agar-Ellis' old master picture collection in contemporary heavy gilt gesso frames suspended from chains in the multi-level symmetrical arrangement so fashionable in his day.

* A22

Sir John Soane

The Picture Room at Sir John Soane's Museum 1830

Watercolour, 21 x 15 cm

Trustees of Sir John Soane's Museum

Soane designed his first Picture Room at the back of 12 Lincoln's Inn Fields in 1819, on the site of the present New Picture Room (rebuilt in 1889). In 1824 on his acquisition of 14 Lincoln's Inn Fields this Picture Room was added, in place of the stables, to house his paintings. As the watercolour, pasted into a copy of Soane's *Description of the House and Museum* opposite the print taken after it, demonstrates, the room was intended to celebrate the union of the arts – architecture, sculpture and painting – to which Soane aspired, even though the limitations of his picture collection gave his achievement a strange quality. Dominated by the two Hogarth series, it contains principally works by Soane's British contemporaries, drawings of classical architecture by Piranesi and Clérisseau, and numerous watercolours by Gandy of Soane's own buildings. The room itself is equally individual. Fusing the classical and Gothic styles, with ingenious monitor lights, and opening startlingly into a recess containing Westmacott's *Nymph*, set against coloured glass windows and a view of the Monk's Parlour beneath, it is also notable for its hinged picture panels. As the *Description of the House and Museum* of 1832 puts it: 'On the north and west side of this room are single folding shutters, and on the south they are

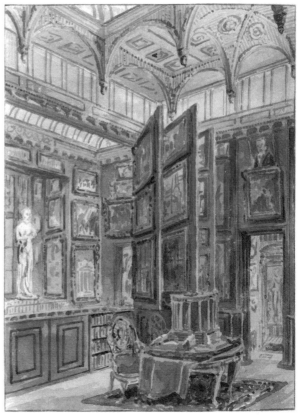

A22

double, with sufficient space between for pictures...by this arrangement a small space is rendered capable of containing more pictures than a room of much greater extent.'[1] The writer points out that the arrangement allowed '*the pictures to be seen in every possible direction.*'

This picture room must be typical of many, long vanished and unrecorded, small galleries in artists' and architects' houses. To visit it was and is an intensive experience, not like a visit to a conventional gallery: the experience, unusually, is static, for it is the pictures that move around the visitor. In spite of the Hogarths and the Piranesis, Soane here puts himself and his work on display, just as Romney or Gainsborough in their picture rooms exhibited their talents. The room was open by appointment, like the rest of the museum, during Soane's life.

Prototypes existed for Soane's picture room – in Thomas Hope's house and, revealingly, in commercial premises. A young German visitor to London in 1786 describes the shop of Alderman Boydell, founder of the Shakespeare Gallery, in the Strand: '*Since Mr. Boydell's house is situated in the old city and is hence not planned according to modern method and leaves him very little room, he has made use of the corner space, filling it with nothing but doors a foot apart, five of which are as wide as the wall and open very easily into one another,*

so that on the side facing the window he can show a number of fine paintings with the light full on them, keeps the dust off, and is able to hang them, for which purpose the remainder of the room was neither large nor light enough.[2] Though this room was not top-lit, the resemblance to Soane's Picture Room is clear.

The watercolour emphasises a number of important objects: the portrait of Soane's friend, Sir Francis Bourgeois (founder of Dulwich Picture Gallery, a building to which Soane was particularly attached), over the entrance; the chairs from the palace of Tippoo Sahib; the view through the door of the Apollo Belvedere at the centre of the Museum Room (most conventional of images, the Apollo, revealing Soane's desire to offer the visitor a correctly encyclopaedic range of the great works of the past); and the model of the Temple of Vesta, a favourite source for Soane, on the table.

John Britton, in *The Union of Architecture, Sculpture and Painting*, praised this room at length, commenting on the excellent quality of the detail, and on the stunning effect created by Westmacott's *Nymph*. As seen in the watercolour the walls and panels were painted a dull olive-green. This colour was overpainted in a severe grey in the 1950s, but has recently been restored to its original colour.

1 *Description* (1832) p.14.
2 Sophie von la Roche, in (ed.) Clare Williams, *Sophie in London* (1933) p.238.

☐ J. Soane, *Description of the House and Museum* (1832)
☐ J. Britton, *The Union of Architecture, Sculpture and Painting* (1827)

A23

Sir John Soane, drawn by Charles J. Richardson (1806–71)

Design for an Ante-Room to a Sculpture Gallery for Sir Francis Chantrey RA 1830–31

Pen and coloured washes, 98 x 65.5 cm
Insc: *View of the Entrance into the Sculpture Gallery of Francis Chantrey RA/ John Soane Archt.*

Trustees of Sir John Soane's Museum

In 1830 Soane designed a sculpture gallery at 30 Belgrave Place for his friend, the sculptor Francis Chantrey (1771–1841). Chantrey had sculpted a bust of Soane in 1827–29 and had given it to the architect. This present was indeed a compliment: Chantrey was at the head of his profession, occupied on a series of statues of George IV and able to command higher fees than any of his rivals. Soane's design was a gift in return. Richardson worked on the drawing in March and April 1831, and it was exhibited at the Royal Academy in that year (no. 1004). Soane considered it, though small, sufficiently important to merit inclusion in his *Designs for Public and Private buildings* of 1828 (Plate LII, fig. 3).

Chantrey lived at Belgrave Place, a town house with a sculpture gallery added at the back, from 1810 until 1841. This gallery contained a mixture of casts of the *most celebrated statues that adorned the Louvre* under Napoleon,[1] and of his own works, and provided a showplace at a time when dealers did not organise exhibitions of contemporary artists. Such artists' galleries were easily accessible: according to *The Picture of London* of 1802, *'the general compliment for seeing them is a shilling to the attendant.'*[2]

As the circumstances of the commission suggest, the two men were on the friendliest terms. Chantrey was particularly pleased with the bust that he produced of his friend, writing to Soane *'I will however maintain that as a work of art I have never produced a better.'*[3] Soane's own satisfaction with the bust is apparent from the position of honour he gave it in the Dome area of his Museum, and from his use of an engraving of it as a frontispiece to the *Description of the House and Museum*. He was given *carte blanche* in his design, Chantrey writing *'Make whatever cornice you please and it shall be executed'*[4] and *'I wish for your commands about the inside furnishings for the windows . . . The cornice is capital.'*[5]

The exotic design illustrates the ornateness explored by Soane in his later work. This little room, with its red walls, green surrounds to the bronze doors, and stone-coloured pillars and domes, lit from above by partly yellow glass, was distinguished also by the unusual forward-sloping forms of the bases to the columns. The ante-room was a piece of theatre: from the drawing-room, a door opened into it, to reveal to the visitor the *Laocoon* in the gallery beyond.

Further drawings in the Victoria and Albert Museum[6] illustrate the care given by Soane to such details as the fenestration. As Pierre du Prey has commented, the tall windows that the architect created to light this room were highly advanced: *'Long before the advent of plate glass and the artists's mansions in Chelsea, Hampstead or Bedford Park, Soane had set out basic ground rules for designing a fashionable studio/show room.'* It is not known who designed the main gallery beyond: it, too, was top-lit.

Appropriately, Chantrey's inquest was held in the ante-room: *'It was a solemn sight not to be effaced...In an exquisite little gallery built for him by Sir John Soane, lay (seen by many lighted tapers) the breathless body and torpid hand that had given life to helpless clay and shapeless stone . . . Calm and solemn was the scene.'*[7]

1 J. Britton, *Original Picture of London* (26th ed.) p.322.
2 *The Picture of London* p.221.
3 SM, Private Correspondence, Sir Francis Chantrey, 5 April 1829.
4 ibid 19 June 1830.
5 ibid n.d.
6 Du Prey (1985) pp.69–70.
7 P. Cunningham, *Builder*, 14 Feb 1863.

☐ Pierre du Prey, *Sir John Soane* (1985)

B Public and Philanthropic Galleries

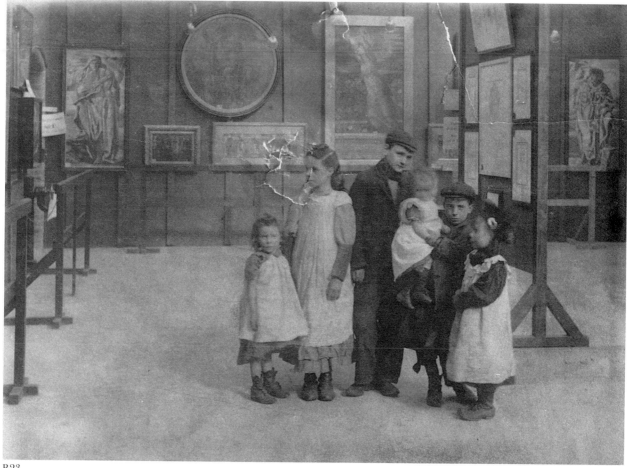

B23

Several types of institution are included in this section. The phenomenon of the literary, philosophical or scientific society which played an important role in establishing local museums in the early nineteenth century was not principally directed at fine art, but is represented by the relatively unusual example of the Royal Manchester Institution. In the 1870s it became common for cities and towns to set up their own art collections, often associated with museums and libraries, and a small selection of the most important and architecturally interesting examples of this type has been made – many could have been added.

Linked with these are the private art collections which were set up as trusts and opened in purpose-built accommodation: in most cases the trusts encountered financial difficulties within a few decades and have been absorbed by their local authority.

'Philanthropic galleries' is a term used to describe the collections set up in the late nineteenth century by a group of idealistic artists and social reformers, who believed in the socially regenerative power of art or, in one or two cases, in their own genius.

MANCHESTER CITY ART GALLERY
(founded as Royal Manchester Institution 1823)

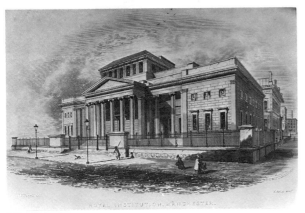

B3

The building which now houses Manchester City Art Gallery is of an earlier generation than most municipal galleries; though always intended primarily for the display of pictures, it ranks with the many premises built by literary and philosophical societies in early nineteenth century Britain. It reflects the energy of a city which appeared to many contemporaries a terrifying phenomenon, the hub of the Industrial Revolution, a city feared by the ruling class. Though King George IV was prepared to extend his patronage to the artistic endeavours of the city, Sir John Leicester's efforts to arouse aristocratic interest in the new Manchester Institution met with little success, and almost no titled names are to be found among the early supporters.

The idea of the Institution was mooted in 1823 by a group of artists who had visited exhibitions of contemporary art held in Leeds: their aim was to combine in their Northern city the activities of the British Institution and the Royal Academy, by organising exhibitions of contemporary British artists and establishing a school of art. The response of Manchester businessmen to this proposal – inevitably presented as offering economic benefits to the city – was so enthusiastic that by November 1823 a General Meeting of the Governors was voting firstly to invite the King to become patron and secondly to erect a building which would combine *'ample interior accommodation, and chaste Architectural Design, with the advantages of an eligible situation.'*[1] The Society of Artists in Manchester had already decided that they required *'a larger room with a lantern light, such a building only being adapted to display works of Art to advantage'*, with possibly another smaller room where artists could study, provided with prints and casts from the antique.[2] These demands expanded when it was decided in April 1824 that a museum should be housed in the same building as the gallery: this was to contain, in addition to the accommodation required by the artists, a lecture room, *'A Room for Philosophical Apparatus'*, a committee room, a library, and rooms for showing botanical and antiquarian specimens. An architectural competition, by invitation, was announced in April 1824, and the prize was awarded in December to the scheme submitted by Charles Barry.[3]

The winning design met with approval from such virtuosos as Sir George Beaumont (1753–1827), leading patron of the new National Gallery, who expressed his pleasure *'to find such alacrity among Mercantile Men in behalf of the arts, it shows the progress they have made'.*[4] Sir John Leicester commissioned a presentation drawing of the new building from Barry (Tabley House Collection; on loan to the Manchester City Art Gallery) to show to the king, who declared his approbation.

Handsome, decisive, understated, the building exhibits Barry's professionalism in any style he attempted. Less opulent than the Fitzwilliam and more assured than the National Gallery, it is the paradigm of modest-sized Neoclassical museums in Britain. The most extravagant feature is the attic storey lighting the entrance hall; with its pilasters set *in antis* and its severe proportions, it recalls Schinkel's Schauspielhaus.

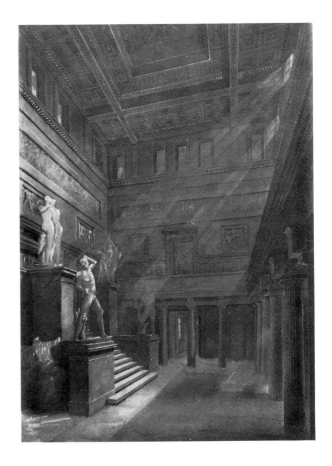

84

The ground floor was devoted to the museum, and has been completely rebuilt, while the first floor, devoted from the first to the fine arts, was substantially altered in the late nineteenth century. The most striking interior is the staircase hall, a dramatic means of emphasising the dignity of this new edifice, and of uniting a building dedicated to two distinct purposes. Hance's drawing of 1838 (B2) is the earliest view of this hall, illustrating the display of plaster casts, which allowed the combination of sculpture and painting on the model of the Neoclassical museum. Originally painted in relatively restrained colours, the hall was given a polychrome decorative scheme in the mid-nineteenth century: this may have occurred in the 1840s with Barry's involvement, but it was certainly in place by 1880. The polychrome scheme survived until, in a dingy state, it was removed around 1950 in an attempt to brighten the hall; and was reinstated in the 1980s.[5]

Tidmarsh's gouache of around 1894 was an illustration for W.A. Shaw's *Manchester, Old and New*. By the 1890s the building had passed into the hands of the Manchester Corporation. Among the pre-Raphaelite paintings that the citizens flocked to see, hung works by Millais, Leighton and Holman Hunt. The general appearance of the galleries in this watercolour was recreated in the influential restoration of the Gallery carried out under Timothy Clifford's Directorship in the early 1980s.

1 RMI Council Minute Book (Manchester City Archives) 6 Nov 1823.
2 Minutes of the Proceedings of the Society of Artists, bound with RMI Archives: 5 Sept 1823.
3 ibid 24 Dec 1814.
4 ibid 7 March 1825.
5 Information from Sandra Martin.
☐ H.G. Archer, *Art and Architecture in Victorian Manchester* (1987)
☐ Manchester City Art Galleries, *A Century of Collecting* (1983)

B1
William Wyon (1795-1851)

Manchester City Art Gallery

Struck bronze medal, 51 mm diam.

Private Collection

OBVERSE: Bust to right of Sir Benjamin Heywood
REVERSE: Elevation of Royal Institution, Manchester

B2
J.W. Hance

Royal Manchester Institution, entrance hall at the 1838 Exhibition

Bodycolour over pencil, heightened with white, 44.8 x 32.4 cm

Manchester City Art Galleries

B3
Alfred Ashley (fl. 1850), after Burrell (fl. 1851–54)

Royal Manchester Institution c.1852

Engraving, 13.3 x 20.3 cm

Manchester City Art Galleries

B4
H.E. Tidmarsh (1858–1939)

Manchester City Art Gallery, interior c.1894

Pen and wash, 25.4 x 36.8 cm

Manchester City Art Galleries

BIRMINGHAM MUSEUM AND ART GALLERY (founded 1867)

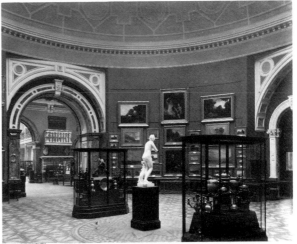

B5(b)

Following various smaller temporary galleries, the first part of the present building was constructed during the years 1881–85 by H.Y. Thomason (1826–1901). Further additions have been made to Thomason's design. The Feeney Art Galleries on the upper floor were opened in 1912 while further galleries and a new entrance in Great Charles Street were added in 1919.

The present Birmingham Art Gallery contains one of the finest Old Master and British painting collections in the country, with important decorative art collections as well. Externally the building is somewhat lacklustre, with its principal facade on a secondary street behind municipal offices: in its present state this facade combines an ambitious portico and campanile with a decorated but essentially utilitarian elevation, which emphasises the building's structure.

This lack of flair in designing the exteriors of municipal art galleries is not unusual in the late nineteenth century. Internally, the Round Room at the head of the stairs forms an impressive introduction to the sequence of picture galleries, as well as to the museum rooms accommodated on the same floor.

Though originally intended to contain collections of Industrial Art, to educate the craftsmen of the city, Birmingham soon became famous for its collection of Pre-Raphaelite paintings. It was also, like the Walker Art Gallery, Liverpool, heavily used in its early years for temporary exhibitions, which were housed in the main galleries.

☐ Stuart Davies, *By the Gains of Industry* (1985)

B5
Photographs:
(a) Main Gallery 1877–78
(c) View of Dome Room 1890s

THE BOWES MUSEUM, BARNARD CASTLE (founded 1869)

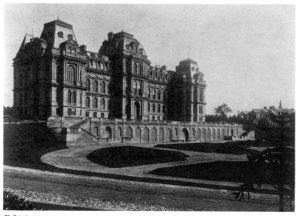

B6(a)

John Bowes, illegitimate son of the tenth Earl of Strathmore, and his French wife Josephine, founded the museum in 1869. The architect was the Parisian Jules Pellechet (1829–1903), though supervision was carried out by the Newcastle architect John Edward Watson. The museum opened to the public in 1892.

Scarcely typical of British art museums, the Bowes reflects the cosmopolitan background and tastes of its founders. The closest parallels are the Wallace Collection and Waddesdon Manor, where the same taste for the French decorative arts can be seen. It is an early example of a collection where the decorative

arts were awarded as much attention as painting. Sublimely incongruous in the relationship of the building to the surrounding countryside, the Museum internally reflects the financial problems that arose during erection of the building. Though the staircase is executed on a splendid scale, the exhibition rooms are generally plain, most unlike the Wallace or Waddesdon. The three picture galleries were modelled on the Alte Pinakothek and contain a large group of paintings of all the principal European Schools, with an emphasis on nineteenth century France.

The photographs illustrate the traditional way in which the galleries were arranged before the First World War; and the attempt to thin them out thereafter.

The Museum was administered by a private trust until 1956, when responsibility was taken over by Durham County Council.

☐ Charles Hardy, *John Bowes and the Bowes Museum* (1970)
☐ Elizabeth Conran, *The Bowes Museum* (n.d.)

B6
Photographs:
(a) Exterior view from southwest c.1890
(b) Main picture galleries, looking east, before 1914
(c) Main picture galleries, looking east, after 1914

GLASGOW ART GALLERY AND MUSEUM, KELVINGROVE (founded 1870)

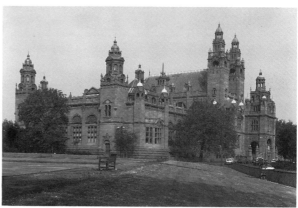

B7(a)

The museum was established in 1870 and was originally housed in the old Kelvingrove Mansion House, with the bulk of the collection coming from the bequest of Archibald McLellan. The present building was funded by public subscription and from

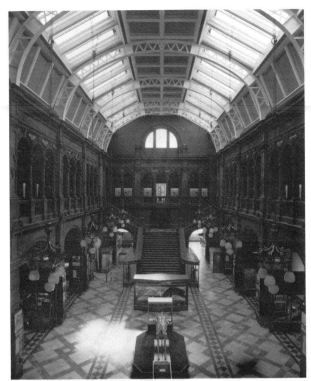

B7(b)

the profits of the 1888 International Exhibition in
Kelvingrove Park. In 1891, a competition was
launched for the design of the museum; it was won by
Simpson and Allen of London. The foundation stone
was laid in 1897 (after work had started), and in 1901
a further International Exhibition was held in Kelv-
ingrove Park, with the museum holding an exhibition
of British art. The outstanding success of this
exhibition helped to endow the museum, which
opened in 1902.

Kelvingrove is a triumphant statement of the
vigour of late nineteenth century Scotland, and of the
city's faith in popular culture. Built in an almost
indefinable style (described by the architects as *an
astylar composition on severely Classic lines, but with free
Renaissance treatment in detail*)[1], it was originally
conceived as an element of Kelvingrove Park: its
principal entrance was planned to the north towards
the park, whereas the entrance used by most visitors
today is on the south side. The Museum is remarkable
for the huge hall, intended for musical events and
other entertainments. The ground floor was and is
devoted to a wide variety of 'museum' collections,
while the picture galleries are arranged on the first
floor around the central hall. Access to these rooms is
by a broad balcony, skirting the hall.

Since its inception, Kelvingrove has spoken to the
hearts of the citizens of Glasgow and has been a part
of their life in a way true of very few other museums
in Britain, at least since the First World War. It offers

the citizens a welcome which they have always been
delighted to accept.

1 Preface to competition entry, Strachclyde Regional Library.

B7
Photographs:
(a) Exterior view, from south east with the Italian
 Garden 1989
(b) National History Gallery and east staircase
 1986

HARRIS MUSEUM AND ART GALLERY
(founded 1877)

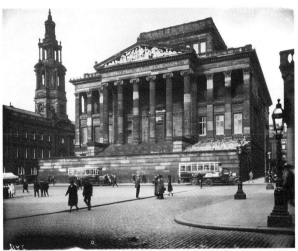

B8(a)

In 1877, Robert Edmund Harris of Preston
bequeathed a large fortune to his native city, the
benefactors of which were the Harris Free Public
Library and Museum. A local architect, Alderman
James Hibbert (1833–1903), gained the commission;
this was a convenient arrangement since he also
became Chairman of the Board of Management.
Construction began in 1882 and continued until
1893, when the Museum opened.

The Harris is one of the most stunning buildings in
England. Though its resolutely classical elevations
were already old-fashioned by the time the building
was completed – most contemporary galleries were
using Baroque architecture in the William and Mary
manner, or were exploring Queen Anne or vernacu-
lar alternatives – it is built on the grandest scale, with
a monumental interior reminiscent of an operatic
stage set. The Harris aimed to present the develop-
ment of Western civilisation from Assyrian, Egyptian,

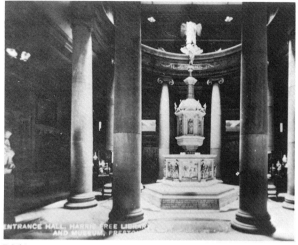

B8(b)

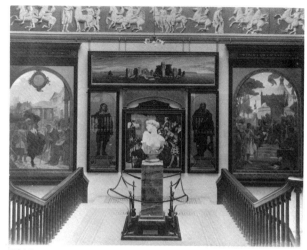

B8(e)

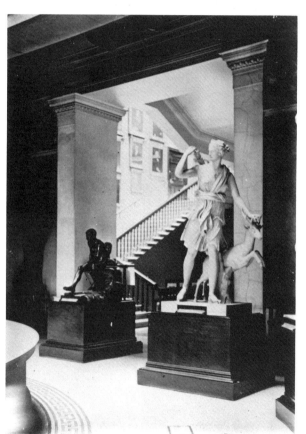

B8(d)

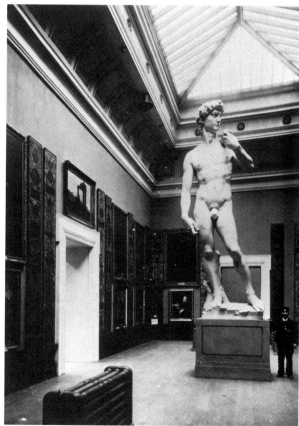

B8(f)

Greek and Roman art to the Renaissance, through casts in bronze and plaster, photographs and a series of paintings by one John Somerscales (Puvis de Chavannes and Watts having turned down the commission). This development was, and is, demonstrated in the central hall, which rises the height of the building and contains the displays on the balconies of four floors, like a vertically planned cast court. The picture galleries, relatively conventional by contrast and containing largely works of the British School, are organised around the sides of the hall.

The internal arrangement of the Harris survives to a considerable extent and has recently been faithfully restored.

☐ J. Hibbert (ed.) *Notes on Free Public Libraries and Museums* (1881)

B8
Photographs:
(a) Exterior view
(b) Central hall, ground floor
(c) First floor balcony
(d) First floor balcony
(e) View from central sculpture hall
(f) Second floor, gallery 6

MAPPIN ART GALLERY, SHEFFIELD (founded 1887)

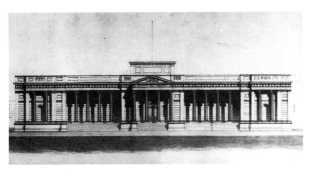

B9

The Mappin Art Gallery was, and to an extent still is, one of the most elegant public galleries in Britain. Its porticoed facade, set in a landscaped park intended to complement the building, used to lead the visitor to the Special Gallery, an outstandingly well-planned and well-lit exhibition space. The Special Gallery disappeared in the bombing of 1941, but two of the Mappin's original rooms, and the exterior, survive.

The Mappin is a typical example of a private art collection bequeathed to a city corporation to form a municipal art gallery. It took its name from an uncle and nephew. J.N. Mappin (1800–83), a successful Sheffield brewer, was a high-spending art collector at the Royal Academy and elsewhere, concentrating on small contemporary British paintings. He bequeathed his pictures to three legatees, including his nephew Sir Frederick Mappin (1821–1910). Frederick Mappin, known latterly as the 'grand old man' of Sheffield, was an active politician and contributed strongly to the city's development, notably through the foundation of the Sheffield Technical School, which formed part of the new University. J.N. Mappin's bequest was made on condition that the pictures should be given to the town if a special building was erected to house them. The donation was made on completion of the Mappin in 1887,

when Sir Frederick added 48 of his own large narrative Academy paintings to the gift.

The architects were Flockton and Gibbs, a Sheffield practice responsible for numerous public buildings in the city and favoured by J.N. Mappin. Michael Tooby[1] shows that though T.J. Flockton (1824–99), the senior partner, received most recognition, his former pupil E.M. Gibbs (1847–1935) carried out the detailed work. A set of drawings in the Sheffield City Archives records the stages of the design and the consideration given to providing the best lighting. The exterior is in the central tradition of temple-museum, scarcely appropriate perhaps to the work on view inside but executed with skill and delicacy. It was admired by contemporaries, *The Builder considering the building 'a great success'*, with the Greek style of the exterior '*unusually carefully and successfully carried through.*'[2]

The interior consisted of the central Special Gallery with five galleries around it, and a corridor communicating with the pre-existing City Museum. Gibbs proposed that instead of providing central top-lighting for the whole space, it should be divided into smaller bays, divided from one another by columns. Each would show separate groups of J.N. Mappin's collection: the fact that this Gallery was intended for a permanent collection encouraged the strongly architectural character of its design. Each of these bays was to be top-lit by diagonal skylights designed to shed the best possible light on the area of wall between the dado (about thirty inches high) and a line about ten feet from the floor. This extensive area was united by the central crossing, also top-lit from a shallow dome. The result was a refined version of West's Gallery or Barry's proposals for a Landscape Room at the National Gallery, while the arrangement of columns and vaults and the cruciform shape recall the Museo Pio-Clementino. The rooms were decorated in rich dark colours, the Special Gallery being red.

The Mappin opened in 1887, and scored an enormous success, particularly since admission was free and, unlike most museums at the time, it was open on Sunday afternoons. In the first year it was visited by some 350,000 people, with six or seven thousand entering on some Sundays. It remained popular until the Second World War, though the permanent collections came under increasing criticism. They were to some extent purged, the gallery being redisplayed in lighter colours with pictures less densely hung during John Rothenstein's tenure as Director.

After war damage, the Mappin remained in a state of near-dereliction until rebuilt in the early 1960s by the City Architect, J.L. Womersley. The rebuilt rooms are uncompromisingly Modernist.

1 Tooby (1987).
2 *Builder*, 9 Oct 1897.

☐ M.Tooby, *in perpetuity and without charge; The Mappin Art Gallery 1887–1987* (1987)

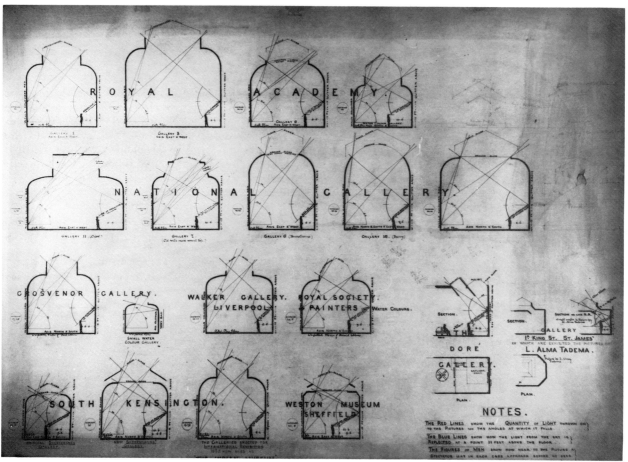

B11

B9

Mappin Art Gallery, competition design for front elevation c.1885

Pen and coloured wash, 60 x 10.2 cm

Sheffield Archives (Sheffield City Libraries)

B10

The Victorian Gallery, Mappin Art Gallery

The British Architect, 7 March 1890

Engraving, 40 x 32 cm

Mappin Art Gallery

B11

Information on Picture Galleries in London, Liverpool and Sheffield c.1885

Black, red and blue ink, 76.1 x 10.2 cm

Sheffield Archives (Sheffield City Libraries)

Among the plans relating to the construction of the Weston Park, or Mappin, Art Gallery, is this informative drawing, illustrating in section the galleries considered of particular importance in the 1880s and comparing their system of lighting to that proposed for the Mappin. The galleries include the Royal Academy and the National Gallery (for both, several rooms are shown); the Grosvenor and the Doré Gallery (now Sotheby's) in Bond Street; Alma-Tadema's gallery at 1 King Street, St. James's; and the Walker Art Gallery in Liverpool.

THE RUSKIN MUSEUM, MEERSBROOK PARK, SHEFFIELD (founded 1889)

B12

The Guild of St. George, founded by John Ruskin in 1878, was an idealistic attempt by the social reformer/art critic to forge a community of honest labourers committed to the ideals of agriculture, industry and art. Integral to the moral and aesthetic education that Ruskin hoped such an experiment might offer was the provision of an art museum, endowed with objects from his own collection, through which the average guild-member would learn the essential truths of the world. Sheffield was Ruskin's city of choice, due partly to its proximity to the areas of England he considered most beautiful, partly to its mastery of the art of iron-work, and finally *'because Sheffield is in Yorkshire, and Yorkshire yet, in the main temper of its inhabitants, old English, and capable therefore yet of the ideas of Honesty and Piety by which old England lived'*.[1]

The St. George's Museum was established in a small cottage at Walkley, situated on a hill two miles out of Sheffield. It contained plaster casts that Ruskin had commissioned in Venice and Rouen, prints and drawings from his own hand, illuminated manuscripts, minerals and coins, all arranged so as to be *'a readily accessible repository of Specimens of the finest work hitherto done, whether in Painting, Illumination, Engraving, Drawing, or Sculpture, etc., and of the finest natural productions in the shape of crystallised Gems and Precious Stones'*. The collection would serve, as well, as *'a guide to the Rise and Development of Nations, as evidenced in their art'*.[2] Ruskin considered the collection as the seed for a much larger museum in Sheffield, as well as a model for other cities.

Although a small gallery was added to the cottage in 1884, it was apparent from the start that the building was inadequate. A solution was found when the town acquired a Georgian mansion at Meersbrook Park, and offered to devote the house to the Ruskin Museum. The suite of rooms served the purposes of the museum well: a long room, with three large windows, became the picture gallery, while ancillary spaces were well-suited for the display of casts and minerals as well as for copying and study. The new museum was opened on 15 April, 1890.

Having gradually been abandoned during the 1950s and 60s, much of the collection was again brought together in the reborn Ruskin Gallery. This opened in the former commercial premises of the Hays Wine Shop, a Victorian building in the centre of Sheffield, in 1985, and powerfully evokes the character and purpose of Ruskin's own museums.

Stephen Fronk

1 Cook and Wedderburn (1907) p.52.
2 Howard Swan, *Preliminary Catalogue of the St. George's Museum* (1888).
☐ E.T. Cook, *Studies in Ruskin* (1891)
☐ E.T. Cook and A. Wedderburn (eds.) *The Works of John Ruskin*, Vol XXX (1907)

B12

Meersbrook, the Picture Gallery

View of gallery from *Studies in Ruskin* (1891)

BURY ART GALLERY (founded 1897)

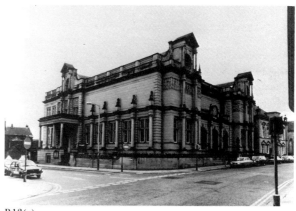

B13(a)

Bury Art Gallery, which is combined with a Museum and Library, was inspired by a family donation, which included the art collection of Thomas Wrigley (1808–80), a local businessman who had made his fortune in paper, banking and railways. The building was erected in 1899 to 1901 to the designs of Woodhouse and Willoughby of Manchester. The new Gallery was seen as a symbol of the town's rising

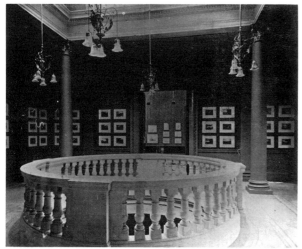

B13(b)

status: at the laying of the foundation stone, the Mayor said that the donation '*raised the status of Bury among the municipalities of the kingdom.*'[1]

Bury Art Gallery must stand for the many art museums erected in Lancashire and the West Riding between 1870 and the First World War. It has the character of a little palace and was designed in what was described as '*the English renaissance style of the eighteenth century, freely treated.*'[2] The sculpture of the exterior refers to Painting, Architecture, Sculpture and '*such handicrafts as Modelling, Wood Carving, Needlework, and Repoussé.*'[3] An imposing flight of stairs leads from the ground floor (where the library was housed, with a museum opening in the basement in 1907) to a large lobby with a balcony overlooking the hall below, and then to a series of six top-lit galleries. In the first arrangement, the paintings were almost all hung in a single line to allow proper study, while the walls were painted in '*a flat Pompeian red*', with the dados and woodwork in a subdued green.[4] A contemporary critic commented on '*the quiet harmony*' of the galleries, which created a sense of repose necessary for full enjoyment of the paintings.[5] Characteristically of such a collection, the paintings were almost all of the British School.

The early history of the Gallery typified a problem that beset such fixed collections. In the first year of opening (1901-02), almost 143,000 visitors were recorded, but by 1905–06 the number had fallen to 58,000, representing a steady decline deplored in the Gallery's Annual Reports. Temporary exhibitions were introduced in 1911 in an attempt to arrest this fall, as were school visits.

1 Supplement to *The Bury Times*, 12 Oct 1901.
2 Sparke, p.2.
3 ibid.
4 ibid.
5 Supplement *op. cit.*

☐ A. Sparke, *The Bury Art Gallery and the Wrigley Collection* (n.d.)

B13
Photographs:
(a) Exterior view
(b) Interior of gallery

CARTWRIGHT HALL, BRADFORD (founded 1898)

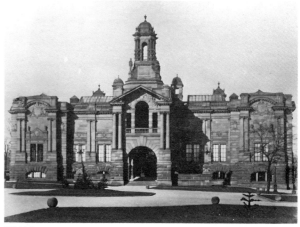

B14(a)

Following an architectural competition in 1899, the firm of Simpson and Allen, who had already worked on the Glasgow Art Gallery, designed Cartwright Hall as a new art gallery and museum for the important and prosperous city of Bradford, a centre of the textile industry. It was named after Edmund Cartwright, inventor of the wool-combing machine, and was funded by Samuel Cunliffe Lister, later Lord Masham, who had made his fortune by developing Cartwright's ideas. The museum opened to the public in 1904, with museum collections on the ground floor and paintings upstairs.

This large exuberant building illustrates the confidence of the great Northern cities at the close of the last century. Built in an opulent Imperial Baroque style, Cartwright Hall was set in the midst of a new public park. It served as a memorial to Cartwright and as a palace for the people. It was also a palace for the aldermen and councillors, since it was meant to accommodate not only exhibitions but civic entertaining: among the public galleries were panelled rooms for municipal receptions and dinners, while one of the upstairs galleries also served as Lord Mayor's Parlour. This role as a venue for civic receptions required a grand processional route and circulation spaces.

The fittings of the interior were very advanced, with the most up-to-date heating and ventilation systems, and electric light. The pictures were arranged by the first Director with close attention to harmony and to the relationship between works.

☐ *Edwardian Reflections* (Cartwright Hall, 1975).
☐ D. Church and P. Lawson, *Cartwright Hall* (1987).

B14
Photographs:

(a) South front
(b) Reception, first floor
(c) Sculpture hall

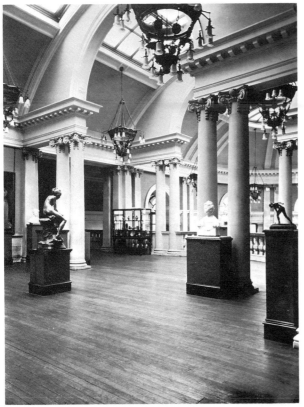

B14(b)

B14(c)

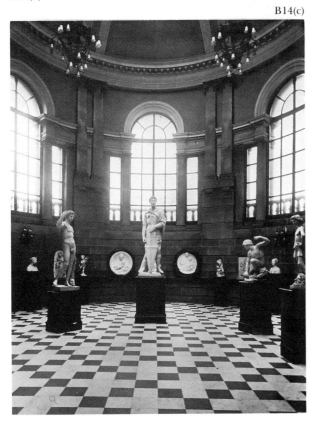

LADY LEVER ART GALLERY, PORT SUNLIGHT *(founded 1913)*

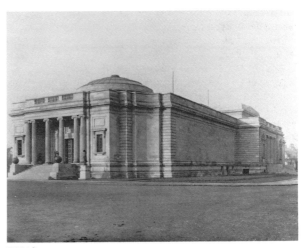

B15(d)

William Hesketh Lever (later the first Viscount Leverhulme) (1851–1925) dedicated this museum in 1913 to his wife who died in that year. The architects, William and Seagar Owen of Warrington, completed construction in 1922.

The restrained classical building forms part of the model village of Port Sunlight, built to accommodate workers at Lever's soap factory. The collections are Lever's own: he was an enormously rich man, and paternalistic towards his workers. His attitude to them is conveyed by the Gallery's dominating position in the village: it serves as a memorial to the family which created the community, and as a reminder of their benevolence. Lever believed in the importance of attractive visual surroundings, and wished to share his own experience with his employees, both in the village and in the Gallery. The latter was to be seen

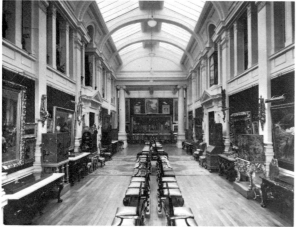

B15(g)

WILLIAMSON ART GALLERY, BIRKENHEAD
(founded 1917)

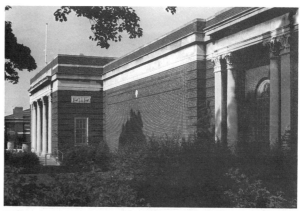

B17

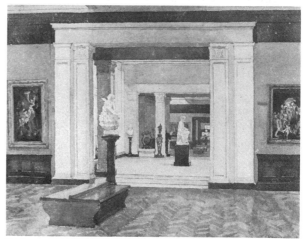

B16

not merely as an art museum, but as *'the artistic embodiment of a great personality.'*[1] It takes to extremes the philanthropic attitudes of the late nineteenth century with regard to galleries.

As *The Museums Journal* wrote, *'the interior is inspired with a higher ideal than the mere exhibition of pictures on plain walls...it conveys the impression of a palatial home enriched with art treasures ... suggesting intimate personal selection, and intellectual aesthetic companionship.'*[2] Lever's favourites included British painting, in the Duveen taste which favoured the eighteenth century: one of his aims in establishing the Gallery was to prove the supremacy of British art in decorating a home.[3] He was also interested in furniture and Oriental ceramics. The galleries were arranged to his instructions, with a large central Main Hall, two circular sculpture galleries, and two rows of smaller rooms. All the rooms are given a strongly architectural character: some include furnishings from old houses, developing the idea of period rooms. An unusual feature was the black background introduced for the display of pictures.

The Gallery was administered by private trustees until 1978 when, after various sales of contents, it passed into the ownership of Merseyside County Council. It is now part of the National Museums and Galleries on Merseyside.

1 *Record* (1928) II p.5.
2 *Museums Journal*, March 1923 p.205.
3 *Record* 1928 II p.v.
□ *A Record of the Collections in the Lady Lever Art Gallery* (1928)
□ *Guide to the Lady Lever Art Gallery Port Sunlight* (c.1980)

B15
Photographs:
(a) Interior, Main Hall, 1930
(b) Interior, Tudor and Stuart Room, December 1922
(c) Interior, Main Hall, December 1922
(d) Exterior from south-west 1922

Financed through bequests made to the Birkenhead Corporation in 1917 by John Williamson and his son Patrick, the gallery was designed by the Liverpool-based architects Leonard G. Hannaford and Herbert G. Thearle. The gallery opened in 1928.

An austere brick building, the Williamson still pays tribute to the classical tradition in its entrance facade. The galleries are arranged on a grid, around two internal wells, and the classical theme of the exterior is repeated on the interior.

B16
Eleanor Jane Whineray (fl. 1899–1933)
Gallery Interior c.1929
Watercolour, 35.8 x 45.9 cm

Williamson Art Gallery and Museum

B17
Photograph of the exterior, main facade

PHILANTHROPIC GALLERIES

SOUTH LONDON ART GALLERY
(founded 1898)

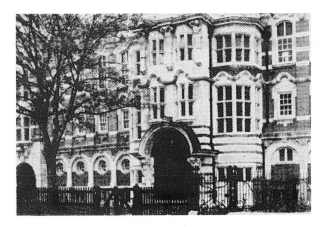

With the Whitechapel, the South London Art Gallery illustrates the desire on the part of a small number of late Victorian artists and educators to bring art to the urban masses. The South London is also a surviving example of a type of gallery often discussed but relatively seldom implemented in the nineteenth century: one linked with a school of art. Since the destruction by bombing of almost half its exhibition area, the Gallery has been a shadow of what was intended. It still possesses (usually in store) a fine collection of Victorian narrative paintings given by the artists and, under linoleum, an inlaid wooden floor by Walter Crane.

The Gallery derived from the determination of a local tradesman, William Rossiter, who was associated with the Working Men's College in Great Ormond Street, to establish a similar College in South London. This privately funded institution was established in 1868 and moved to various locations before reaching the Peckham Road in the late 1880s. From an early date, art exhibitions were held there, with loans from wealthy benefactors and artists, including (at the first exhibition in 1887) Lord Leighton, Burne-Jones, Crane and G.F. Watts. Like the Whitechapel, the South London seemed to realise Henry Cole's dream of making works of art physically and intellectually accessible: it was seen as one of a number of museums that were to be planted in outer London for the benefit of the local population, the Bethnal Green Museum being another. An art gallery opened in 1891 and was followed in 1893 by a lecture-cum-exhibition room designed by Sir Ernest George (1839–1922) of George and Peto, a sympathiser with the cause of popular education. This was paid for by J. Passmore Edwards, famous for his generosity in erecting libraries and museums.

The foundation stone for the lecture room was laid

by Watts and the completed building was opened in October 1893 by the Prince of Wales. The Prince expressed his pleasure in opening a gallery that would provide a benefit for the working man, while the Bishop of Rochester enthused over the new building.[1] The gallery held exhibitions of works by established British artists. These were open free of charge, and the trustees insisted that the gallery should be open on Sundays, urging on the Prime Minister the advantages of the *'rational Sunday'*, and suggesting that what was sauce for Camberwell should be sauce for South Kensington.[2] The Trust Deed for the new Gallery, dated 25 May 1891, stressed that its hours of opening should be those *'most suitable to the convenience of the artisan and poorer classes of South London, care being taken to encourage women and children to visit.'* In addition to the exhibitions, it was to provide a *'library of high character'*, with lectures on art, science and literature.

The accommodation consisted of two lofty top-lit rooms, with a narrow 'Engraving Gallery' to one side. The *Prospectus* (B19) emphasised that the paintings would be hung in not more than two lines, with space between them *'allowing each picture being seen to the greatest advantage.'* Ernest George's drawing (B18) illustrates the innocently improving nature of the lecture room, conceived as a quasi-medieval Great Hall, with a minstrels' gallery at one end and a queenpost timber roof, containing skylights.

In 1898 the Camberwell School of Art opened on a site next to the art school, and the two institutions were informally amalgamated. This link was confirmed by the erection of a new red brick 'Renaissance' facade to the Peckham Road by Maurice Adams (B20), offering accommodation for the art school in front of the galleries, and dedicated to Leighton. One of the most cheerful and welcoming of gallery elevations, the facade bears no resemblance to the traditional classical elevation, from which the founders were keen to escape.

An article in *The Studio* of 1898[3] conveys the character of the early exhibitions, the numerous paintings being shown in *'rooms filled with porcelain, metal work and various examples of applied art'*, an instructive display in tune with the most advanced contemporary approach to decorative interiors.

1 Macdonald (1900) pp.6–7.
2 Herbert Beerbohm Tree, Chairman, in Annual Report for 1894.
3 *The Studio* p.266.
□ J. Macdonald, *Passmore Edwards Institutions* (1900)

B18

George and Peto

South London Art Gallery

Sepia pen and wash, 35.5 x 25.5 cm

British Architectural Library Drawings Collection/RIBA

B19
South London Art Gallery, publicity pamphlet
c.1900
Pamphlet, 4pp.

South London Art Gallery

B20
Maurice Bingham Adams (1849 – 1933)
South London Art Gallery, elevation to Peckham Road, and plan
Pen over pencil, 64 x 84 cm.

South London Art Gallery

WHITECHAPEL ART GALLERY, LONDON (founded 1901)

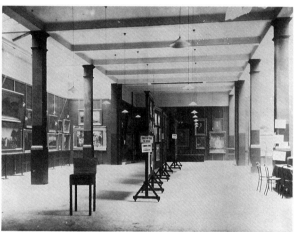

B22

From 1881, Canon Samuel A. Barnett (1844-1913) and his wife Henrietta (1851–1936) began to organise exhibitions of paintings in St. Jude's National Schools in Whitechapel, a part of London's East End thought to be inhabited by a 'depraved' citizenry in need of moral education. *'Amid lives cramped by continuous toil'* Canon Barnett claimed, *'there lingers a craving for the ideal and a capacity to respond to the manifold thought of beauty in form and colour'*; he hoped *'to lessen the dead ugliness of their lives'*.[1] The exhibitions generally contained the works of contemporary British painters (Watts, Leighton, Burne-Jones, Rossetti) with an occasional Old Master painting, all lent by Academicians, dealers, collectors, philanthropists and, on two occasions, the Queen.

Influenced by contemporary views on the power of culture to civilise and tame the lower classes, as expressed by Matthew Arnold in *Culture and Anarchy*, these exhibitions were an attempt to de-brutalise the poor through exposure to moral perfection, attained in paint and canvas. The Barnetts' Christian message was preached through lengthy catalogue entries which attempted to relate the scenes represented in the paintings to the daily life of East London.

Owing to the success of the exhibitions and the difficulty of accommodating the increasing number of visitors, in late 1897 the innovative architect Charles Harrison Townsend was employed to design a building, on a cramped site in Whitechapel High Street. The buff terra-cotta facade was characterised by a set of towers, originally intended to be crowned with small cupolas, whose bases were lightened with a foliage motif in relief; the entrance and the tympanum-like archway above it were set off-centre, creating a circulation system which allowed visitors to enter and leave the building through different doorways. A row of inconspicuous windows was introduced on the first floor. An elaborate mosaic panel, intended to fill the rectangular space formed by these windows and the two turrets, had been designed by Walter Crane; this was a casualty of the extremely restricted budget, mostly supplied by Passmore Edwards.

Harrison was partially hampered in designing the interior of the gallery by the long and narrow site. It immediately became apparent that two levels of galleries would be necessary to accommodate the number of pictures intended for exhibition; the lower consisted of two aisles with top-lighting for a central nave, while the upper gallery was completely top-lit, with a small annexe for special exhibitions. Ancillary spaces were situated directly behind the main facade, stacked on four levels.

An outstandingly sensitive and imaginative re-organisation of the building, providing a considerable increase of space in a style sympathetic to the original design, was carried out by Colquhoun and Miller in 1982.

Stephen Fronk

1 *Daily Chronicle*, 19 March 1901.

B21
Charles Harrison Townsend (1851–1928)
Whitechapel Art Gallery, elevation and section
1899
Drawing and wash, 46 x 63 cm

Whitechapel Art Gallery

B22
Whitechapel Art Gallery, Spring Exhibition of 1901
Photograph

Whitechapel Art Gallery

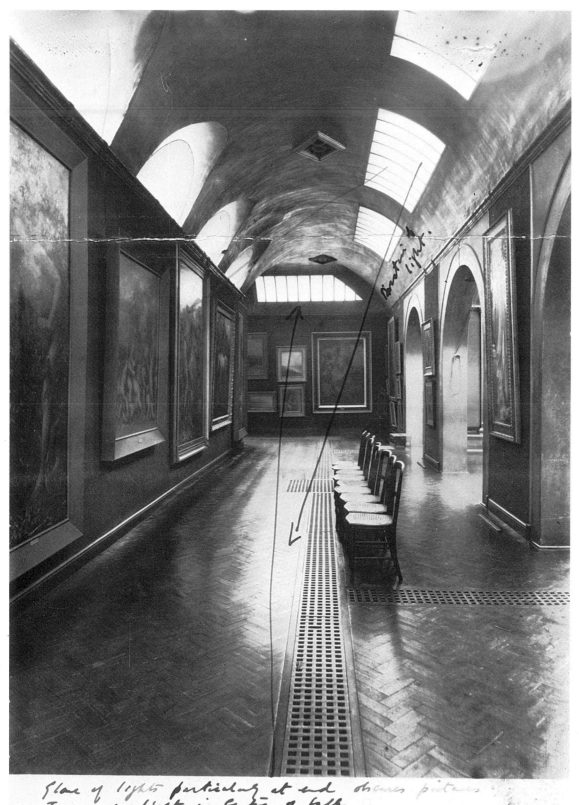

B25(c) The Watts Gallery, 1937, with inscription concerning light-levels

B23

Children at the Whitechapel Art Gallery 1901
Photograph

Whitechapel Art Gallery

B24

The First Five Years of the Whitechapel Art Gallery 1906
Publicity pamphlet, 6 pp.

Whitechapel Art Gallery

WATTS GALLERY, COMPTON (founded 1905)

B25(d)

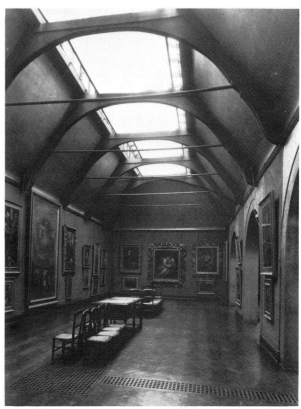

B25(b)

The Watts Gallery, designed and built in 1903-04 by
Christopher Turnor (1873–1940), is situated at Compton, Surrey, a few hundred yards from Limnerslease, the country house of G.F. Watts RA (1817–1904) and his formidable wife.

Turnor, despite a brief association with Lutyens,
was not a professional architect, but was known
chiefly as an agriculturalist and educator. Designed in
a vernacular style appropriate to its setting, the
building served two purposes: to house a range of
works by Watts, and to provide housing for potters
who had come to the area to participate in the pottery
art workers' guild set up by Mrs. Watts in 1899. The
Gallery was constructed entirely in concrete, a rare
solution for its time. To the original main picture
gallery a sculpture gallery was added in 1906, with
further additions being made in the 1920s.

In its early days, when Watts was revered by great
sections of the British public, the Watts Gallery
offered an impressive spectacle. As *The Art Journal*
put it, '*Now Compton is the object of pilgrimage to many
people coming from all parts of the earth.*'[1] The principal
exhibition room was decorated in green, gold and
silver, a scheme which has recently been restored in
place of the intermediate beige. The original hang
was supervised by Sir Charles Holroyd, the first
keeper of the Tate Gallery, who arranged the
pictures densely with their frames overlapping and
some paintings leaning against the wall. Five
uniformed attendants supervised the numerous visitors who came to pay homage.[2] From the 1920s, as
interest in and respect for Watts waned, the Gallery's
fortunes declined. Only in the past decade has it
regained the character (though not yet the audience)
that it once possessed.

1 *ArtJ* 1906 p.321ff.
2 Information from Richard Jefferies

☐ Wilfred Blunt, *England's Michelangelo* (1975)

B25

Watts Gallery, views:

(a) Exterior – postcard pre-1906
(b) Main Gallery – photograph c.1937
(c) Long Gallery – photograph c.1937
(d) Exterior – photograph c.1930

The Watts Gallery

C National Galleries

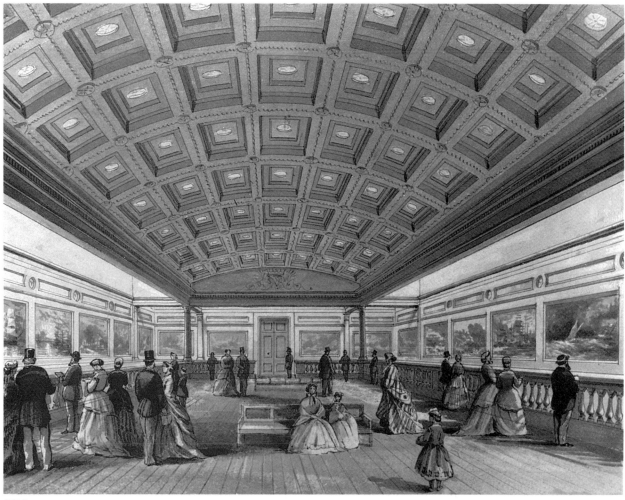

C6(d)

The formidably rich public art museums of Britain are discussed in this section: but picture collections only, so that the British Museum (in spite of its print room) and, by and large, the Victoria and Albert Museum, are excluded.

THE NATIONAL GALLERY, LONDON
(founded 1824)

In April 1842, Parliament, having obstinately resisted pressure to found a national gallery, authorised the purchase for the nation of 38 paintings from the collection of the financier, John Julius Angerstein, together with the lease of his house at No. 100 Pall Mall (C1 and C2).

A new home for the growing national collection was included in John Nash's proposals for a square at Charing Cross (Trafalgar Square) of 1825, in the form of a long columned gallery for painting and sculpture on the north side of the square. In 1832, William Wilkins (1778–1839), Nash and C.R. Cockerell were invited to produce designs. Wilkins' scheme was selected and his revised design was approved in 1833. It housed the Gallery in a suite of rooms to the west of the entrance hall, and the Royal Academy to the east.

The National Gallery was Wilkins' last major commission and the architect was hampered throughout by the need for economy. The plan of the galleries was determined by the need for top-lighting (their dimensions were limited as they had to support the weight of cast-iron skylights) and by Wilkins' own wish that the paintings be hung by School and size. The only space appropriate to a grand civic building was the Great Hall, altered by E.M. Barry in the 1870s. The gallery was opened by William IV in 1837.

Wilkins' building had been subjected to criticism from its inception. The need for more space was immediately evident and, from 1838, proposals were made to improve or replace the gallery, the first major alteration being made to the entrance hall in 1860 (C9). In 1866 the Royal Academy's rooms were absorbed by the Gallery when the Academy moved to Burlington House. In the same year, a competition was held for new premises for the gallery (C6). Although no winner was selected, E.M. Barry was appointed architect for the new National Gallery in 1868. His extension opened in 1876 (C7), but the proposal to rebuild was abandoned finally in 1879. There followed various further extensions (C3), the most recent being the Sainsbury Wing by Venturi, Scott Brown and Associates which opened in 1991.

□ R.W. Liscombe, *William Wilkins 1778–1839* (1980)
□ C.H. Collins-Baker and Charles Holmes, *The Making of the National Gallery* (1924)
□ Philip Hendy, *The National Gallery of London* (1960)
□ Gregory Martin, 'The Founding of the National Gallery in London' in *Connoisseur* (1974)
□ Colin Amery, *A Celebration of Art and Architecture* (1991)

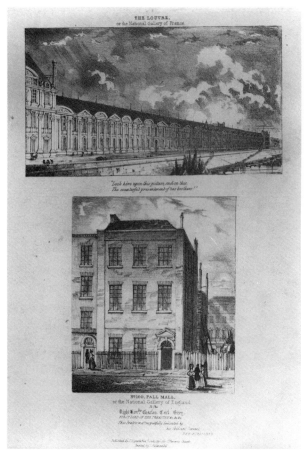

C1

C1
Charles Joseph Hullmandel (1789–1850)
The Louvre and 100 Pall Mall c.1830
Lithograph, 30.5 x 21.6 cm

The Trustees of the National Gallery

At 100 Pall Mall, his former house, the collection of John Julius Angerstein, newly acquired for the nation, was opened to the public in May 1824.

Growing dissatisfaction with inadequate space for the nation's pictures is vividly expressed in this contrasting view of the French and English national galleries. The Grande Galerie of the Louvre is contrasted with Angerstein's modest house, on part of the site of the present Reform Club.

* C2

F. Mackenzie (1787–1854)
Principal Original Room of the National Gallery
Watercolour, 47 x 62.5 cm

Board of Trustees of the Victoria and Albert Museum

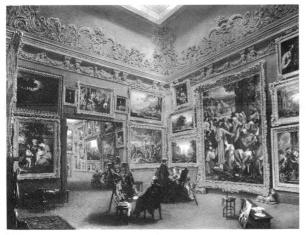

C2

Angerstein had built two galleries for his paintings: top-lit, and decorated in the neo-Rococo manner made popular by Apsley House. The nearer room is dominated by Sebastiano del Piombo's *Raising of Lazarus*, fulfilling the intention of the Prime Minister, Lord Liverpool, that the new national collection should include larger works than could be shown in most private collections. The base of the frame is supported on two sphinxes, the Egyptian theme being picked up in the frieze decoration.

Though easily accessible to all visitors, the National Gallery was intended to offer the opportunity to art students to copy the Old Masters. It was open for copyists only on Fridays and Saturdays and to the general public on other days of the week from 10 a.m. to 5 p.m. It was closed on Sundays. This custom of reserving days exclusively for artists lasted until 1880.

In the further room, Rubens' *Rape of the Sabine Women* is flanked by curtains, a practice common in the eighteenth century; whether these were introduced here on conservation grounds or on account of the subject-matter is not clear. The frames around the Angerstein pictures are of three or four principal types, all popular during the Regency.

C3

A Catalogue of the Pictures in The National Gallery, Pall Mall 1830

Book, octavo, 12pp

The Trustees of the National Gallery

C4

W. Young Ottley (1771–1836)

A Descritive (sic) Catalogue of the Pictures in the National Gallery, with Critical Remarks on their Merits 1832

Book, octavo, 72pp

The Trustees of the National Gallery

These two booklets are characteristic of the two early types of gallery catalogue. Following Dulwich, the National Gallery produced a minimal list of its paintings, giving number, painter, subject, size, support and donor. Since paintings were not labelled, merely numbered, such modestly priced aids were essential.

Young's catalogue was printed at the author's expense and sold at the Gallery by *'permission of the Noblemen and Gentlemen, Directors of the National Gallery.'* It followed the popular guides produced by William Hazlitt and P.G. Patmore in 1824, in offering an instructive and entertaining text, one which visitors, unused to looking at pictures, studied with avidity. The text offers a description of each painting, with an assessment of its merit and an explanation of the principal figures.

Descriptive catalogues for use in the Gallery played a vital part in shaping public reaction to works of art, and did not go out of fashion until this century. They have recently been replaced by the practice of providing detailed labels for paintings.

C5

Robert Sands (1792–1855), after Thomas Allom (1804–72)

National Gallery, exterior 1836

Engraving, 27 x 48.2 cm

Museum of London

C6

E.M. Barry RA (1830–80)

Designs for the Rebuilding of the National Gallery 1866

Pen and wash (a – d)

(a) Corridor of Great Hall
(b) Intersection of Principal Picture Galleries
(c) Grand Staircase
(d) The Landscape Picture Gallery
(e) Galleries completed, 1876
 Photograph
(f) Plan of Principal Floor
 Pen and ink, stuck on mount.
Overall dimensions, 73 x 139.6 cm

The Trustees of the National Gallery

In 1866 a limited competition was organised for the design of two possible solutions to the National Gallery's space problems: a wholly new building on the site of Wilkins' structure, or an addition behind the existing west wing. *The Report of the Trustees and the Director* on the requirements for a new National Gallery stipulated that *'the principle of ample and unobstructed light should be carefully observed'* by lighting the galleries from the top, and quoted *'recent experi-*

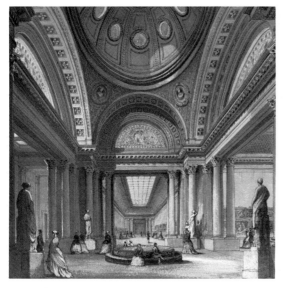

C6(b)

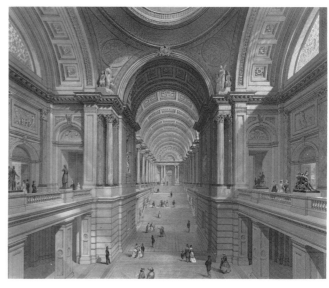

C6(c)

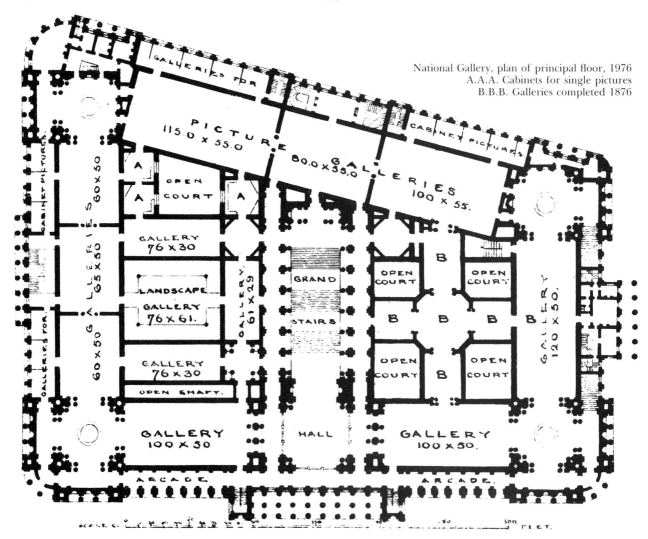

National Gallery, plan of principal floor, 1976
A.A.A. Cabinets for single pictures
B.B.B. Galleries completed 1876

ment' as proving that the *'opening for the admission of light...should in no case be less than one half of the superficies of the floor. In addition the lights should not be too high.'*[1] It also stated that the longest halls should be between 40 and 45 feet wide.

E.M. Barry, son of Sir Charles Barry and already known for his work at the Royal Opera House, produced a scheme for a Renaissance palace overlooking Trafalgar Square, comparable in magnificence to the ministries of Whitehall, but this was not realised.[2] None of the schemes found favour with the judges. Their Report, dated 28 February 1867, recommended none of the competition entries to the Commissioners of Works and Public Buildings. They did, however, consider that the best, if imperfect, design for a new gallery was Barry's.

Although this exhibition does not examine unexecuted schemes, this project has been included because it illustrates forcefully the disparity between the aspirations of architects and the works they were allowed to execute; and because Barry was to make a substantial addition to the Gallery (see C7). His scheme reflects knowledge of advanced museum planning on the Continent, especially in Germany, through such features as the inclusion of sculpture in the hall and staircase, and the provision of three types of rooms: top-lit main galleries, cabinet rooms, and rooms devoted to individual artists.

1 *Correspondence relating to the New National Gallery* (1867) p.5.
2 Presentation drawings for the elevation are in the RIBA Drawings Collection and at the National Gallery.

C7

Giuseppe Gabrielli (fl. 19th Century)

Room 32 in the National Gallery 1886

Oil on canvas, 111 x 142 cm

Government Art Collection

This painting shows the North Room of the E.M. Barry block, opened to the public in 1876. This block, arranged in the area behind the east (Royal Academy) wing of the Wilkins building, was intended to have a palatial quality, resembling the great museums of Italy and Germany. As the Report stated, the architect should remember the necessity of obtaining the longest possible extent of wall space *'for paintings consistent with grand architectural effects.'*[1] The Barry Rooms represent the apogee among national museums of the art gallery as palace. In practical terms, much was sacrificed to this ideal: the imposing central Dome affords little space for hanging pictures in proportion to its square footage. The entrance between the North Room and the Dome, shown open here and revealing the ambitious picturesqueness of the plan, has since been blocked to allow the display of Guido Reni's *Nativity*.

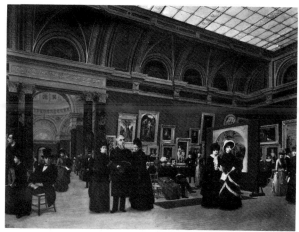

C7

This strangely mournful painting conveys not only the extreme respectability of the Victorian art museum but the efforts made by nineteenth century directors to transform the National Gallery into an organised and well-displayed unity. The deep maroon colour of the walls is traditional, but the paintings are placed as far as possible by school, with the Venetian paintings hung together. An effort is made to avoid skying (i.e hanging paintings high on the walls): the pictures are not arranged in patterns, and by and large the upper part of the wall is left blank with pictures placed as near as possible to eye-level. The screen in the centre of the room continues the device introduced early in the Gallery's history to provide further space for showing pictures. There is no artificial light, but a new central heating system of hot water-pipes under the floor has been brought into use. A rail (common in galleries from around 1860) protects the paintings, but visitors are allowed plain seating. They concentrate on improving themselves, with their opera glasses, catalogues and expressions of gloom.

Admired at the time of opening, the Barry Rooms fell out of fashion in the twentieth century. Sir Philip Hendy (1900–1980), who as Director of Leeds City Art Galleries had played an active role in simplifying what he considered the excessive elaboration of Temple Newsam House, wrote guardedly in 1960 of the Barry extension that although *'erudite in its combination of classical features from a variety of periods and splendid in its use of marble and gold...it defies modern tastes for more intimate and neutral settings.'*[2] In the 1980s the renewed taste for magnificence in art museums led to the re-creation of the original decorative schemes for the rooms, providing an environment deliciously suited to the current fashion for using art galleries as banqueting halls.

1 *Report relative to the design for a New National Gallery* (1876) p.4.
2 Hendy (1960) p.54.
☐ P. Hendy, *The National Gallery of London* (1960)

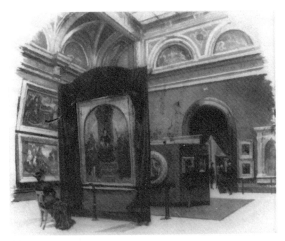

C8

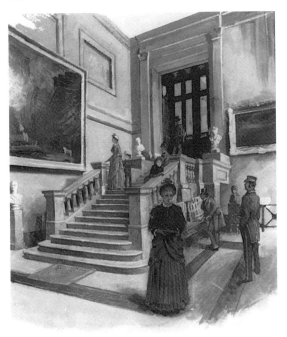

C9

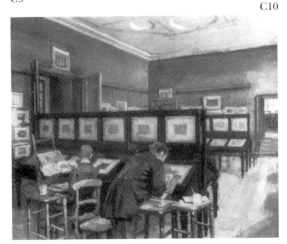

C10

C8

H.E. Tidmarsh (1858–1939)

National Gallery interior c.1885

Wash and bodycolour, 10 x 12.8 cm

Guildhall Library

This is the North Room of the Barry extension. A new acquisition, the *Ansidei Madonna* of Raphael which was bought in 1885, is hung in a position of honour, on a screen draped in fabric.

C9

H.E. Tidmarsh

Staircase in the Hall of the National Gallery c.1883

Wash and bodycolour, 18 x 16 cm

Guildhall Library

The entrance hall of the National Gallery, as rebuilt in 1860 by Pennethorne before the complete reconstruction by Sir John Taylor in 1887. The steps lead to the east wing of the Wilkins building. On the right is the balustrade for the staircase to the basement, with the surviving rail. Assorted works from the British Collection hang on the stairs.

C10

H.E. Tidmarsh

The Turner Room, National Gallery c.1885

Wash and bodycolour, 10 x 13.5 cm

Guildhall Library

The Turner watercolours and drawings were accommodated in a basement room at Trafalgar Square in an arrangement by John Ruskin. He designed the cases seen in this drawing. The works on paper remained in this room until they were moved with the Turner oils to the Tate Gallery in 1910.

* C11

Edward R. Taylor (1838–1911)

'Twas a Famous Victory 1883

Oil on canvas, 79.3 x 121.8 cm

Birmingham City Museums and Art Gallery

C12

Bertha Garnett (exhibited 1882–92)

The Turner Gallery at the National Gallery 1883

Oil on canvas, 25.5 x 36 cm

The Trustees of the National Gallery

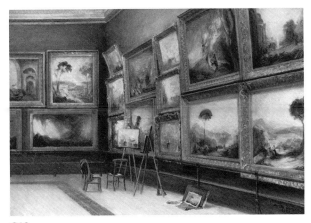

C12

Turner's bequest of almost 300 paintings and over 19,000 drawings and sketches reached the custody of the Trustees of the National Gallery in 1856, five years and a law-suit after his death. The crowded building in Trafalgar Square had no room to show the paintings, a selection of which was sent first to Marlborough House and then to the South Kensington Museum. They returned to Trafalgar Square in 1876 on the completion of the Barry extension. Both C11 and C12 show the old Room VI, in which a selection of the oils was hung: many of the paintings bequeathed by Turner were felt to be unfinished and not worthy of permanent display. In Taylor's painting, Turner's *The Battle of Trafalgar* is under inspection. Gainsborough's *Mrs. Siddons* is seen in the further room, one of those devoted to the British School. Room VI, now destroyed, was on the site of the present upper staircase; other Turners were hung in smaller room near the old staircase.

Henry Blackburn's *Pictorial Notes in the National Gallery* of 1877 criticised the arrangement: '*This long narrow room is crowded almost to the ceiling with paintings...; many of them are better seen than formerly, but many are injured in effect by close juxtaposition – the style and colour of Turner's work seeming especially to demand space and isolation.*'[1]

With the rearrangement of the new Gallery in 1886, the bulk of the Turners were moved to a position of honour in the room at the western extremity of the Wilkins building. It was dismantled in 1910 when the paintings were moved to the newly built Turner Rooms of the Tate Gallery.

1 Blackburn (1877) p.60

C13

John Dibblee Crace (1838–1919)

National Gallery, design for hall 1887

Watercolour, 34.8 x 46.8 cm

The Trustees of the National Gallery

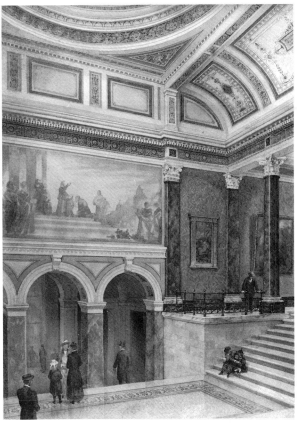

C13

In 1887 a major reorganisation of the entrance hall of the National Gallery was carried out, and four new rooms were added. The architect was Sir John Taylor (1833–1912) of the Office of Works, Surveyor of Royal Palaces and Public Buildings. Taylor created the present main staircase with flights leading northwards (to his new rooms), eastwards and westwards, while leaving minor staircases off the lower hall. The decoration of the rooms and hall was assigned to J.D. Crace, last in a distinguished line of interior designers. Crace's extensive practice, which included work at Windsor Castle and substantial modifications to Longleat House, Wiltshire, was based on his travels in Italy and the Middle East, and his profound consideration of '*how colour affects Architecture, and.-...how all-important is the distribution of colour values in assisting or marring Architectural effect.*'[1]

Though the new arrangement was fulsomely praised in the daily Press, *The Builder*[2] rated the work competent but declared that it did not '*show any stroke of architectural genius*': this was the result of entrusting public buildings to official staff rather than to an independent architect. The article criticised the retention of the old stairs and the muddled arrangement of the hall, and deplored the unhappy planning by which Barry's octagon, the most striking apartment in the old building, was not on axis with the

principal staircase but 'merely a side feature.' After listing the variety of marbles used by Taylor for his columns and pilasters – they included Rouge trusque Numidian for the columns of the staircase and the doorcases, *giallo antico* for the sides of the staircase, Derbyshire alabaster and Carrara marble – the article prints Crace's account of his scheme: *'The fine display of real marbles in columns, pilasters, and the constructive features have here governed the colouring. It was impossible to continue the red walls where the rich reds of the 'Numidian' columns would come into direct contact with them. A warm dull green has therefore been adopted for these walls as the next best ground for the pictures which will hang here. And in the friezes and the margins of the upper panes, the deep maroon red tone of the columns is again recalled. The large plain panels of the upper coves are decorated with ornament painted in the dull gold colour, neutral grey and dull red...'.*

The mural shown over the entrance doors was not executed. Crace explained[3] that he had always recommended this to the Trustees as a suitable space for a mural, and showed it as such in his design. Green flock paper was hung there as a temporary measure, disturbing Crace's carefully planned scheme.

The four rooms beyond the staircase were also decorated by Crace. They were intended to provide two large galleries, of which the northern would be the largest and most impressive in the whole building, and two cabinet rooms for smaller pictures; the effect of these is now diminished by their serving as ante-rooms to larger rooms. The natural lighting of the bigger rooms was much admired; they were lit by large lanterns with no artificial ceiling above. No artificial light was provided. The walls were covered in *'double flock paper of a deep red tone, the result of many experiments'*, according to Crace;[4] it was described as much quieter than the decoration of the Barry rooms. This red was considered a suitable background to the early Renaissance paintings that hung there; for in the new disposition of the National Gallery the chronological arrangement of the collection began in the great room facing the main entrance. The Director's arrangement of the pictures was considered to show discrimination in balancing questions of style, chronology and symmetry. The paintings were *'placed in a single row round the walls'*[5], an innovative practice at Trafalgar Square.

Though apparently fragmentary, Taylor's work represents among British galleries one of the more ambitious publicly-funded schemes. It was intended to provide a central axis for the National Gallery, which was expected to develop both to the east (on the site of the National Portrait Gallery) and, more immediately, to the west. The work was conceived on a grand scale and carried out without economy in the use of materials. Taylor's unsatisfactory resolution of the lower hall is still apparent today, after many changes, in the mean entrance lobby, but the staircase

hall, recently redecorated as far as is possible to Crace's design, and with Leighton's *Cimabue* taking the place of the intended mural, is an imposing space, well designed in terms of circulation – even though the paintings that were originally to have hung there have been replaced by lists of benefactors.

1 J.D. Crace, *The Art of Colour Decoration* (1912) quoted in M. Aldrich, *The Craces: Royal Decorators 1768–1899* (1990) p.107.
2 *Builder* 9 July 1887.
3 *Builder* 16 July 1887.
4 *Builder* 9 July 1887.
5 *BN*, 8 July 1887.

NATIONAL GALLERY OF SCOTLAND (founded 1850)

After much debate, the decision was taken in the late 1840s to build a National Gallery of Scotland on the Mound, in Edinburgh. The new building was to stand next to the Royal Institution, by Playfair, of 1822–26. The foundation stone was laid on 30 August 1850, and the entire gallery was opened to the public on 24 March 1859.

The National Gallery of Scotland was the product of Playfair's maturity and a lifetime's experience was brought to bear on the design. He could do little to alter the constraints which dogged this commission, imposed by the site and public financing. Once again he had to establish a sure foundation on the Mound but this time there was in addition a transverse railway tunnel and a longitudinal sewer. The Gallery was raised on an immense concrete raft with bracing arches under every major wall, while the sewer was diverted elsewhere. The costs were continuously cut back and he had to rub out figurative sculpture, cupolas and even parapet vases, producing an unusually astringent design relying only on its order and proportions for its beauty. Finally there had been a hardening of taste, schooled in Picturesque aesthetics, which deplored the erection of any building amid the natural charms of this site in the shadow of the Castle rock.

The brief was straightforward in requiring provision solely for an art gallery, or rather an art gallery with an identical suite of exhibition rooms alongside. This duality reflected many years of quarrels over the fact that to clear space for temporary exhibitions, of which the most important was the annual show mounted by the Royal Scottish Academy, the valuable Old Master and other loan collections deposited in the Royal Institution building had to go into store. The 'high art' was now viewed as the nucleus of the new National Gallery while the exhibition suite solved

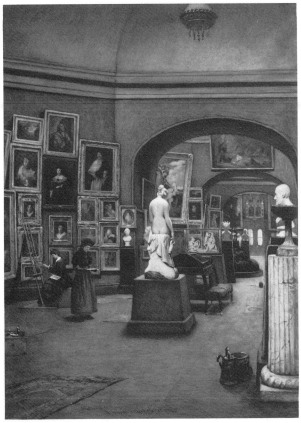

C16

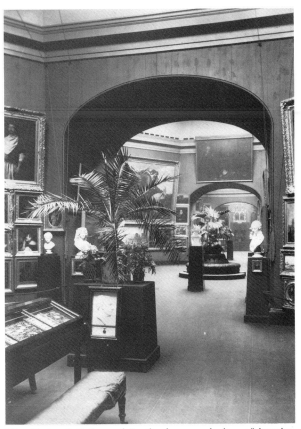

The National Gallery of Scotland, general view of interior, looking north

the problem of the Royal Scottish Academy and of other exhibitions.

The plan of the galleries is again distinguished by octagons but here Playfair selected the pure geometrical form inscribed by a circle rather than a rectangle. By placing the two lines of octagons comprising the sets of longitudinal galleries side by side, he achieved an ingenious 'honey-comb' arrangement permitting each user to gain an additional smaller octagon at the heart of their building. An arrangement of interconnecting doors permitted great flexibility. This plan also allowed for deep arches connecting the longitudinally arranged rooms, with sufficient wall-space for additional pictures. This fused the chains of octagons into a pair of impressive long galleries creating an organic effect. Because the exterior was modelled for purely external effect amid the natural beauties, the slack round the outside of the octagons was exploited to provide the service areas which were one of the most innovative features of the building and allowed for the efficient mounting of exhibitions with sufficient space for packing and storage.

The unornamented rooms are designed solely for the efficient display of paintings. The octagonal rooms are free of dark shadows and the architect's skill ensured that they were evenly lit in spite of their varying volumes. An expanse of cream painted cove reflected and diffused light over the wall-faces. The walls were lined out with thick vertical planks allowing for direct nailing of the largest pictures and the low dado, or skirting, freed the entire wall surface for hanging. The paintwork was equally rational with the walls painted a claret colour, recalling Hay's experiments, while the other architectural trim was oak-grained to harmonise.

Tragically, Playfair suffered a crippling stroke while his building was being erected and he was to die before it was finally opened. The prominence of loan items in the National Gallery's collections precluded a unified hanging scheme. The building was simply furnished with benches and chairs, transferred from the Royal Institution galleries. The final details were settled by Playfair's clerk, James A. Hamilton, who was able to copy details, where necessary, from the earlier building.

Ian Gow

□ Ian Gow and Timothy Clifford, *The National Gallery of Scotland: an Architectural and Decorative History* (1988).

C14

Foundation stone being laid at the National Gallery of Scotland 1850

Photograph

National Galleries of Scotland

C15

Anonymous

National Gallery of Scotland, interior c.1867–77

Oil on panel, 50.5 x 61 cm

National Galleries of Scotland

This view of the central octagon of the Gallery depicts a temporary exhibition of the Royal Institution, with the decorative scheme devised by D.R. Hay for W.H. Playfair. The walls of the Gallery were covered in a claret-coloured fabric, which provided a direct contrast with the gilt frames of the paintings, while it was also sensitive to the often damaged pigments of Old Master paintings. The green of the Dutch weave carpet was chosen to complement the walls, as were the geranium pink pedestals, forming a total decorative scheme specifically designed for a gallery interior.

* C16

Arthur E. Moffatt (fl. 1886–90)

National Gallery of Scotland, interior 1885

Watercolour and bodycolour, 88.5 x 64.4 cm

National Galleries of Scotland

This view illustrates a series of modifications made to Hay's decorative scheme: the colour of the carpet was changed to blue while the pedestals were painted black.

C17

D.Y. Cameron RA (1865–1945)

The Royal Scottish Academy 1916

Etching and dry point, 18 x 34.9 cm

James Holloway

C18

Stanley Cursiter (1887–1976)

Folder of sketches representing a room in the National Gallery of Scotland c.1937

Watercolours

National Gallery of Scotland

C19

Stanley Cursiter

National Gallery of Scotland, interior 1938–39

Oil on board, 40.5 x 30.5

National Galleries of Scotland

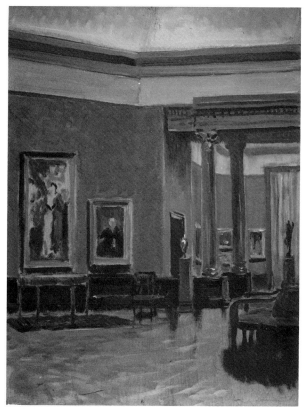

C19

Major alterations were carried out to the National Gallery of Scotland by Stanley Cursiter, including the replacement of the arches in the main rooms by columns, recently in their turn removed. Cursiter, an accomplished artist, made miniature watercolours, to scale, of the paintings in the collection to assist in his complete rehang. His painting of the Gallery shows it after his substantial alterations.

SOUTH KENSINGTON MUSEUM
(established 1852)

In the history of the South Kensington Museum (renamed the Victoria and Albert Museum in 1899) the display of paintings has played a relatively small part. The development of the Museum in the nineteenth century is painfully characteristic of England: this was the earliest museum devoted to the decorative arts in the world, and was to exert enormous international influence, but its development was spasmodic and haphazardly planned, with the growth of its collections and buildings dependent

on the energy of a few brilliant individuals. These included notably Sir Henry Cole (1808–82) who directed its affairs from its foundation in 1852 until 1873, Richard Redgrave (1804–88), artist, and Cole's principal assistant, who exerted great influence on gallery planning in the mid-nineteenth century, and J.C. Robinson (1824–1913), Curator of the Museum and inspired collector. In architectural terms the vast building demonstrates to an almost ludicrous degree the refusal of British officialdom to conceive of the grand or comprehensive approach in dealing with building projects.

The collections of the newly founded Science and Art Department, established in 1852, were moved in 1856 from their first home in Marlborough House to the estate at South Kensington, recently purchased by the Commissioners for the Exhibition of 1851. On this site arose, over the next half-century, a series of structures, many of them temporary or utilitarian, to house the growing collections. The confusion of these structures was disguised to some extent by various impressive ensembles (such as the main courtyard) and more conclusively by the addition in the early years of this century of the monumental block on the Cromwell Road by Aston Webb (1849–1930), a piece of theatrical planning which conceals the hugger-mugger nature of the buildings behind it.

The complex development of the Museum has been recounted in detail elsewhere, and only a few rooms in it are relevant here – though as a symbol of the seriousness with which the didactic aspect of art and its potential as an agent for social improvement were regarded in the nineteenth century, it is of crucial importance.

The Victoria and Albert possesses a picture collection, as well as important holdings of prints and drawings. The curious presence of a considerable number of British and other paintings in a decorative arts museum is due to a considerable extent to the ambiguous nature of the early museum, and of South Kensington in general: in its early days it was seen as an alternative artistic centre to the West End, at a time when the National Gallery was felt to be plagued not only by old-fashioned aristocratic trustees unwilling to accept British paintings or to welcome working people into their galleries, but by the appalling atmospheric pollution of Trafalgar Square, of which informed people were aware. The gift to South Kensington in 1856 of the British paintings belonging to John Sheepshanks illustrates these attitudes: as stated by Cole, Sheepshanks had 'an abhorrence of trustees; he dislikes the noise and crowd and clatter and dirt of Trafalgar-square',[1] and felt that the British paintings already at the National Gallery were inadequately displayed. His paintings were to be shown in a decent building, in the vicinity of the parks. Similar considerations guided later gifts and bequests to South Kensington.

The Sheepshanks Gallery was added to the recently

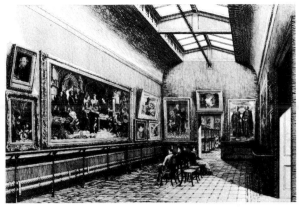

C20

erected 'Brompton Boilers' (now the Bethnal Green Museum) in 1856–57, to the designs of Captain Francis Fowke (1822–65) of the Royal Engineers, who played a major part in planning the developing museum. The brick exterior, in a restrained Roma-nesque style, was decorated by polychrome brickwork and by sgraffito work illustrating famous artists and architects. The lower storey contained objects from the existing museum collection, while the pictures were shown on the first floor, in rooms supervised by Redgrave. The top lighting and the longitudinal coving were planned to throw light onto the walls and to avoid 'glitter', while from the beginning gas jets were provided. The walls were sage green, with the dado and doors in grey, and there was little orna-ment. The floors were covered in durable red tiles. These galleries (which survive internally within the present Museum) were intended to provide decent and effective spaces for the display of paintings: they were specifically *not* intended to emulate palatial interiors.

Two years later, in 1858, work began on the Vernon Galleries, next to the Sheepshanks rooms. Robert Vernon had left his paintings to the nation in 1847, in one of the attempts to foster a national collection of British art. Exhibited initially by the Trustees of the National Gallery in their basement to much public protest, they were later moved to Marlborough House. An alternative home was needed for them and for the Turner Bequest. Permission was granted for a new temporary gallery at South Kensington for the two groups of pictures, and this was designed and erected at great speed by Fowke. He built a wholly utilitarian exterior, little more than a warehouse, but to the interior more care was given, on the model of the Sheepshank rooms.

These galleries aroused the proprietorial instincts of the Trustees of the National Gallery. Since the two collections belonged to them, they were most unwill-ing that the pictures should be understood to be the property of the South Kensington Museum, and insisted that the communicating doors between the

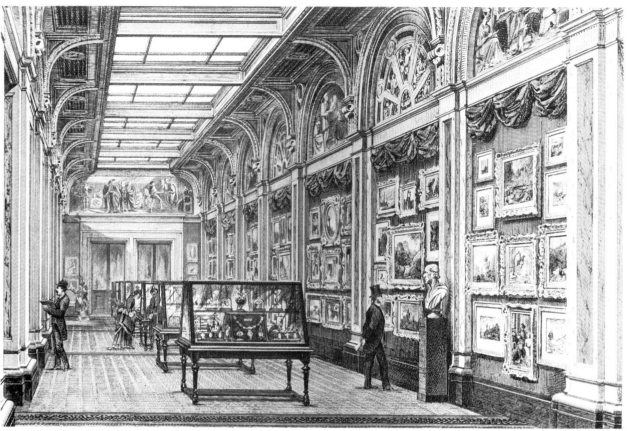

C21

Sheepshanks and the Vernon rooms should be kept locked so that visitors would approach the National Gallery's pictures by a separate entrance. Only after much pressure did they relent. Temporary though the galleries were intended to be, they remain in situ, though the pictures have long departed.

From its earliest days the South Kensington Museum was run on very different lines to the National Gallery, of whose approach the South Kensington authorities were, by implication, critical. In 1858 the *Fifth Annual Report of the Department of Science and Art* reported on the highly successful experiment of opening the Museum at night, so that working people could visit it. As the Report (no doubt written by Cole) commented, the evening openings had been organised in order *'to ascertain practically what hours are most convenient to the working classes. It would appear to be less for the rich that the State should provide public galleries of painting and objects of art and science, than for those classes who would be absolutely destitute of the enjoyment of them unless they were provided by the State'.*[1] The experiment was a great success: the number of evening visitors exceeded daytime ones by five to one, and a survey carried out of these visitors revealed that a relatively small proportion had ever visited the National Gallery. The Report, written at a time when the organisation of museums was seen as a socially and economically beneficial crusade, evoked the atmosphere of these evening openings: *'In the evening, the working man comes to the Kensington Museum accompanied by his wife and children. The looks of surprise and pleasure of the whole party when they first observe the brilliant lighting inside the Museum show what a new, acceptable, and wholesome excitement this evening entertainment affords to all of them.'*[2]

This attitude on the part of Cole and his colleagues anticipated the opening of museums in poorer parts of London and other cities, described above (B18–25).

1 *Fifth Annual Report* p.80.
2 ibid p.81.

☐ Nicholas Taylor, 'Victoria and Albert Museum' in *Survey of London XXXVIII (South Kensington)* (1975)
☐ Anna Somers Cocks, *The Victoria and Albert Museum* (1980)
☐ John Physick, *The Victoria and Albert Museum* (1982)

C20

John Watkins

South Kensington Museum, Sheepshanks Gallery

Etching, 14.5 x 22 cm

Board of Trustees of *the Victoria and Albert Museum*

C21

John Watkins

South Kensington Museum, Watercolour Galleries

Watercolour, 29 x 43 cm

Board of Trustees of *the Victoria and Albert Museum*

C22

South Kensington Museum, Vernon Gallery

The Illustrated Times, 17 March 1866
Engraving, 17.4 x 23.2 cm

Peter Jackson

C23

NATIONAL PORTRAIT GALLERY
(founded 1856)

The idea of a collection of portraits of the famous had been current in Europe since the sixteenth century, but the development of this idea into a museum of portraits of sitters of all types linked by nationality is peculiarly Anglo-Saxon. Such national portrait galleries exist only in London, Edinburgh, Dublin (as part of the National Gallery) and Washington; of these London was the first. From its beginnings, the Gallery was seen as a means of historical instruction and as an incitement to virtue, inspired by Thomas Carlyle's belief that the history of the world was expressed through the lives of its Great Men. Carlyle's *On Heroes, Hero-Worship and the Heroic in History* was published in 1841. In 1846 Earl Stanhope made his first proposal to the House of Lords for the establishment of a national collection of portraits, and on his third attempt in 1856 the government agreed that the sum of £2,000 should be made available for the purchase of suitable works. Collecting notable examples of the arts of portraiture and engraving was acknowledged as a subsidiary purpose.

The new museum opened in 1859. It was accommodated in a house in Great George Street, Westminster, which provided for the display of pictures and other material *'two apartments of very moderate size, a very small back room on the same floor, and the walls of the staircase'*, as the Annual Report of 1862 stated. The shortage of space was not eased by the activities of

George Scharf (1820–1895), Secretary and later Director of the Gallery, who from his appointment in 1857 worked tirelessly to make the collection inclusive; or by the Gallery's growing popularity. The early Reports are filled with the Trustees' laments over the lack of space, but the solutions offered were at best makeshift.

In 1870 the collection was moved to South Kensington, to the building erected for the 1862 Exhibition. Though hardly ideal, these halls allowed the pictures for the first time to be arranged chronologically and less densely than in the past. As Scharf's watercolour of 1885 illustrates (C23), much thought was given to display. Signatures and autograph letters were placed next to the appropriate portraits (the policy of collecting manuscript materials has unfortunately been abandoned by the Gallery), while explanatory labels were provided for each object. These were found to be *'more than ever acceptable to the class of people who attended the Gallery'* on public holidays.[1] Scharf gave much thought to the creation of an appropriate setting: the Tudor galleries, for example, were later painted in white and green, the colours of the Tudor family.

By the 1880s the growing collection again needed more space. Following a fire in a neighbouring South Kensington building, the Gallery moved temporarily

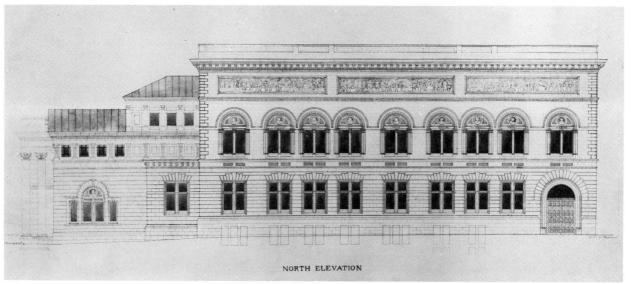

NORTH ELEVATION

C24

in 1885 to the structure now known as the Bethnal Green Museum. There ensued a campaign in the Press and Parliament to persuade the Government – accused by one M.P. of *'ignoble parsimony'*[2] – to provide the funds for a new building, a campaign which the Government resisted on the grounds of economic crisis. The situation was resolved only in 1889, with the offer by a private individual, W.H. Alexander, to give the funds for a new building, if a site was provided in central London. After some discussion land to the north and east of the National Gallery, previously earmarked for the expansion of that institution, was provided by the Government.

Alexander stipulated to the Treasury that the architect of the new building should be his own architect, Ewan Christian. Best known for his ecclesiastical work, Christian was esteemed for his probity and seriousness. He had been closely involved in the design of the Architectural Museum in Tufton Street, Westminster, but had no other experience in planning museums. Christian prepared himself by making a detailed study of museum buildings in Britain and abroad, being particularly influenced, as his later recommendations showed, by German examples. His principal aims were to secure good lighting for the pictures, and to save space.[4] In designing the elevations he conceived the new building as two blocks. The front on St. Martin's Lane, which was to contain a sculpture gallery on the ground floor, was designed in a classical style, deferring to the Wilkins elevations of the National Gallery, but in the northern block, with its main front looking up St. Martin's Lane, *'he changed the style to the Northern Renaissance, the main block being inspired by the Florentine palaces and the principal entrance by the facade of the desecrated church of San Spirito at Bologna.'*[5] This main elevation, intended to display three storeys, the uppermost marked by

sculptural decoration, was reduced in height for reasons of economy and because the Trustees of the National Gallery objected to the scale. This reduction resulted in the building's somewhat heavy proportions.

Internally, the Gallery was planned with convenience and visibility, rather than magnificence, as objectives. Since exhibition rooms were to be provided on three floors, the two lower floors were side-lit, with unusually large windows to shed the best possible light. The stairs, based on Italian palace prototypes, were intended to be easily negotiable, with the additional provision of lifts. The traditional rectangular picture galleries were abandoned in favour of a series of side-lit cabinets of modest size, suitable for a historical collection, and connected by long narrow gallery-corridors. Christian's wish that the cabinets should be furnished with screens, sloping away from the windows, on the model of many German galleries, was not followed; nor, in view of the need to maximise display space, was his scheme for lining the walls of the middle floor with oak panelling.[6] It was finally decided to paper the walls of the exhibition rooms: much thought was given to the best type of paper to be used, with architect and Director submitting a selection to the Vice-Chairman for his final decision, and a number of portraits being hung on the chosen paper, by way of test.[7] The paintings were moved to the new building in June 1895.

1 'Annual Report of the National Portrait Gallery', 1871.
2 *BN* 12 August 1887.
3 *RIBA Jnl*, 30 Sept 1911 p.722 ff.
4 ibid p.723.
5 Trustees' Minutes, 21 March 1892.
6 Trustees' Minutes, 9 May 1895.

C23

George Scharf (1820–95)

Galleries at the South Kensington Museum

Watercolour, 35.1 x 25.1 cm

National Portrait Gallery

C24

Ewan Christian (1814–95)

National Portrait Gallery, north elevation

Architectural blueprint, 52.5 x 75.5 cm

National Portrait Gallery

C25

Ewan Christian

National Portrait Gallery, section

Architectural blueprint, 50.7 x 75.5 cm

National Portrait Gallery

TATE GALLERY (founded 1897)

During the nineteenth century, the concept of a National Gallery of British Art had always been rooted in the supposed supremacy of modern British art over continental rivals. Despite sustained efforts to provoke successive governments into providing a building, including attempts by the British Institution, Leicester and Soane, Vernon and Sheepshanks, and through the Chantrey Bequest, such a gallery took a long time to materialise.

When a purpose-built gallery finally emerged, as it did in 1897 with the opening of the Tate, the idea of national supremacy in the arts which had so long sustained the hopes of artists persisted. David Croal Thomson, a much travelled and well informed dealer and writer on art, and editor of the *Art Journal*, felt able to claim that, Holland possibly excepted, '*no other school of painting excels the British.*'[2]

The nationalistic, even celebratory, resonances which informed Sidney Smith's design are of great interest.

From the outset of the project of Sir Henry Tate (1819–1900) to provide a permanent home, initially for his own collection of British paintings, and then for related works kept in the National Gallery and South Kensington, much thought was devoted to ensuring that the works could be seen in sympathetic and environmentally safe conditions. In this sense Tate's and Smith's aims were the same as those behind most present day museums. The new building was to be modern, embracing the latest developments in heating, ventilation, the fire proofing of floors, the patent glazing of roofs, the inclusion of electric light[4] and the newest wall finish.

Many of these matters were resolved by the collective wisdom of the artistic 'establishment': Royal Academicians played a major role in determining the character of the new building.

Tate certainly chose the architect for his new gallery. He was Sidney R.J. Smith (1858–1913)[5] but despite his being Tate's personal choice, it seems that the artists had some licence to criticise his proposals (C26). Smith's proposals – which predated the final selection of the Millbank site in late 1892 – went through either five or six revisions.[6] As so often with such schemes, potent with national overtones, these revisions represent a gradual scaling down of the architect's original aims. From the first of Smith's designs to be published[7] it is clear that the motif of a central block, relieved by columns on the front, dominated by a glazed dome and flanked by wings, was established early on. Arcades with caryatids partially screening the front facade on either side of a grand flight of steps to the main entrance emphasise that the architectural language was triumphantly classical; it took its inspiration from Wilkins's National Gallery though laboured and dislocated by comparison. This design showed a building with eleven large galleries; the walls and columns of '*not more than two (or at the most three) varieties, with gold introduced into some of the principal positions.*'

Smith's development of this scheme, the extravagance of which was anticipated in the early allusions to gold and marble, was the second of his proposals to be published.[8] Here, he was inspired further by Wilkins's example, raising the central dome on a drum and adding smaller domes at the two ends of the front facade. Almost certainly, these proposals prompted the Royal Academicians to intervene, especially Lord Leighton.[9] In their view, the central dome, which rose more than 150 feet above ground level, was likely to cast shadows over the gallery rooflights below, adversely affecting the lighting of the pictures and so Smith '*was obliged to eliminate it.*'[10] The presentation drawing of the front facade shown in this exhibition (C26) might show Smith's attempt to satisfy the artists' objections and yet retain something of his own concept. The central dome has been removed, though its drum is still visible. A faintly blocked-in area above is a reminder of its former presence. The domes terminating the facade on either side remain as proposed. Leighton and his colleagues may also have been disturbed by the extravagance of the central entrance block. Smith's desire for appropriate ornament is apparent from the section published in the *Building News*:[11] a riot of statuary, arcades, balustrades, domes and laylights inside the entrance hall, while outside, the attic storey is also crowded with full-length carved figures. It was proof of what another artist, Edward Burne-Jones, three years later affirmed: '*An architect ought never to be asked to build a flight of stairs and rubbish of that kind. Who*

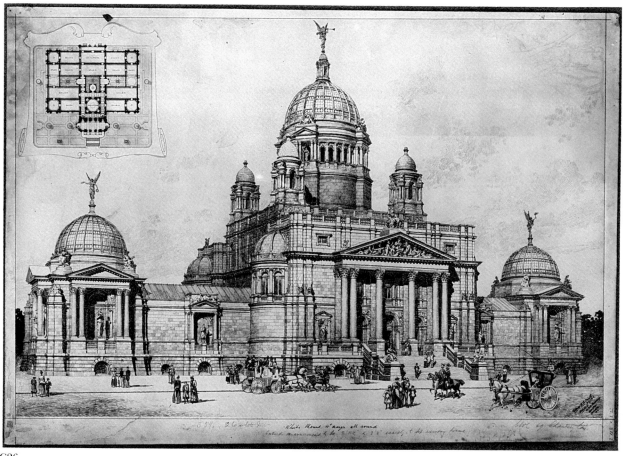

C26

wants his architectural features – damn his staircase – we want to see the pictures . . .'.[12]

The final Tate Gallery scheme, published in the *Art Journal* for December 1894,[13] demonstrates how far Smith had been prevailed upon to simplify his ideas in favour of a more restrained but nevertheless confidently masculine classicism. It was this proposal which was built and which stands today. Appropriately, it was another artist, Tate's friend Sir John Millais who had the last word on the exterior: '*Photographs of the building, in a forest of scaffolding, were submitted to him shortly before his death and he endorsed in pencil the two words "Quite satisfied" beneath them.*'[14]

As far as the interior was concerned, it is again likely that the artists had their say. A critique of the final design by Walter Armstrong, a writer close to artistic circles and later Director of the National Gallery of Ireland, conveys how Smith and his contemporaries must have looked around at other galleries. In his piece for the *Art Journal*, December 1894,[15] Armstrong pointed out how a room in the National Gallery, too wide in relation to the optimum height for bringing evenly distributed top-lighting onto the walls, was not only ill-proportioned but, because of its width, could have screens introduced

into it, disfiguring the larger space, and impeding the display of individual pictures. Because such screens provided a cheap method of extending the display area, governments would be even more reluctant to fund future extensions. Smith reduced the widths of these galleries from 40 and 35 feet, as shown in the 1892 scheme,[16] to 32 feet in the final, built scheme. Turning once again to the National Gallery, Armstrong criticised the unpolished wood floors, '*cold grey drab*' in colour after occasional washing, and also the coloured floor tiles at South Kensington, the unsatisfactory tonality and colour of which distracted from the pleasure of looking at pictures. For Armstrong polished oak, maintained to the same high standard as in the Louvre, was the best floor finish for a public picture gallery. And, indeed, the new Tate had polished oak floors.

Having been requested to remove the large central dome in the interest of even daylight, Smith was probably anxious to solve this problem. He could claim some experience of designing top-lit, day-lit public spaces, having employed a conventional lantern-light along a reading room in a public library in South Lambeth.[17] He certainly demonstrated an awareness of the need to direct light onto the walls,

114

away from the centres of the rooms: highlighted by top-light, viewers in this position will be reflected in glazed pictures – and in 1897 almost all pictures were glazed. Smith pulled the roof-lights down from the roof-ridge towards – but not directly over – the walls, reducing, at least in theory, natural light levels in the centres of rooms. Beneath the ridge he suspended a horizontal duct, and the two angled faces of this duct, whitewashed and parallel with the long walls of the gallery, reflected daylight down onto the walls; linen roller blinds were the sole means of controlling it. Smith's solution was a modest advance on contemporary practice and may have owed something to the example of the gallery of the Royal Society of Painters in Water-colours in Pall Mall.[18] Even so, he appears to have miscalculated to the extent of having too great an extent of roof glazing, for when the rooms were first hung with pictures *it was found that the light . . . was too strong; so the windows have received a temporary shading which gives a strong but sufficiently subdued light.*[19]

Some thought was devoted to the wall covering for the galleries, and its tonal and colour treatment. The wall linings were Oregon pine boards mounted on a framework of studding (fixed to brick walls) which allowed air to circulate behind.[20] This last feature, designed to eliminate condensation between paintings and walls, was typical of Smith: the timber lining was standard because it allowed pictures to be easily screwed to the walls. Obviously, this type of cladding required a surface finish which would conceal the joints between the planks and any other irregularities in the wood; almost invariably, such a finish was either a fabric (silk, baize or canvas) or paper. That Smith had a traditional colour scheme in mind can be seen in his suggestion, in 1892, that the gallery walls should be a *good warm colour.*[31] Smith's affinity with current ideas comes as no surprise, nor does the final choice of colour used in the Tate, since it was chosen by Poynter.[32] It was variously described as *plum colour*,[33] *deep, rich plum colour*,[34] *deep lake*,[35] *porphyry*,[36] and *dull purple brown*.[37]

In his piece about the Tate, Armstrong had clearly stated his view that *the best background for pictures is crimson silk.* However, such a finish had two significant drawbacks: it was expensive and, since dyes were not fast, it tended to fade. Nonetheless, an advantage of fabric was that it could incorporate a woven pattern: breaking up large areas of a single colour with such a pattern was desirable and in a picture gallery the presence of this pattern next to the picture frames enhanced the images within them as zones of comparative calm or activity. If Poynter chose the 'right' wall colour it was nonetheless applied to a surface specially designed and representing the latest advance in wall decoration.

This new wall finish was called Tynecastle Tapestry. It consisted of canvas, moulded to give an embossed effect and stiffened with two backing layers of thick paper, pasted on the unembossed side. This product was the invention of the architect and interior designer William Scott Morton (1840–1903). It is clear[40] that by choosing canvas, he was relying on its texture to give life to brush applied colour. Its earliest public use as a background for pictures was in two rooms at Old Grosvenor House, around 1889, when the embossed pattern seems to have been heightened with toned gold – an effect which, in Morton's words, *proved very favourable*.[41] Tynecastle Tapestry soon became widely used in domestic interiors, as in the library of Tate's house in Streatham.[42] For the Tate, Morton produced a new design (reproduced in a 1920s trade catalogue published by Scott Morton & Tynecastle Co. Ltd.) an appropriately patriotic pattern of entwined foliage from which roses, thistles and shamrocks emerge.[43] Perhaps this was felt to be too chauvinistic; in any case, it was abandoned. Only within the last year, with the stripping out of two of the original rooms and the uncovering of a boarded-up recess, has it been possible to assess how the walls looked in 1897. A small length of the original Tynecastle Tapestry, its *deep rich plum colour* now much changed, is included in this exhibition.

All the galleries in the Tate bar two were covered with this coloured and figured paper. The exceptions were the octagonal rooms which occupied the front corners of the building. These were hung with plain paper and initially painted green.[44] This suggests that Poynter intended a particular role for these rooms and decided that, just as their exterior ornamentation and internal shape were adapted to their status as corner elements, so their decoration should bear the same function. These rooms terminate each end of the first cross axis in the building and their place in helping *the visitor . . . make a complete tour of the gallery without once retracing his steps*[47] was pivotal.

This decorative scheme, which must have originated with Poynter, shows sensitivity to space and circulation. But sometime before the last week of July, 1897, the octagons were repainted prior to the installation of the eighteen oil paintings which G.F. Watts had given to the nation: *In accordance with the desire of the artist, the walls have been painted a deep crimson. It is needless to say that the colour of these pictures triumphs over this fiery ordeal*.[48] Watt's insistence on choosing the background for his pictures underlines the fact that Whistler, by far the most famous exponent of such showmanship, was not alone.

Despite this, Poynter remained attached to his original idea. When ten new galleries (more than doubling the size of the Tate) were opened in November 1899 the two square corner galleries at the rear of the building which counterbalanced the two front octagons were painted in what one newspaper described as *a pleasant green*.[49] This was presumably carried out in consultation with Charles Holroyd, Keeper of the Tate from 1897 (and also an artist), but

it bears Poynter's stamp. Once again, Tynecastle Tapestry was used in these rooms and from a piece of this recovered from the westernmost of these square rooms (originally Gallery 5; now Room 10) in 1988, it is possible to establish the type of design[50] and a more accurate description of the green on the walls.

These square rooms have played a crucial part in determining the form of the twentieth century additions to the Tate. As it happened, Gallery 5 was to become the *ante-room* to the first and most splendid of all these extensions – the Turner Wing. This was donated by the picture dealer, J.J. Duveen, designed by the architect W.H. Romaine-Walker (1854–1940), and opened to the public in July 1910. The grandest of these eleven rooms (Gallery 10; now Room 9) devoted to Turner can be seen slightly in a later stage in John Lavery's sketch of King George V opening yet another extension, the Modern Foreign and Sargent Galleries, in 1926 (C27). There were few, if any, alterations to this gallery between its opening and 1926, and, apart from the change in hanging – from single to double lines – Lavery's work shows how a new generation perpetuated Tate's, Smith's and Poynter's aesthetic. The dark green[51] skirting and doorways of the adjacent Gallery 5 were the cue for the use of a more lavish but complementary verde-antico marble on the door pilasters, dado, and floor edging; the cornice was stick-and-rag plaster marbled to match. The walls were *'covered with a rich Venetian red silk brocade of decorative pattern; this colour was selected as Turner is believed to have used it in his own gallery'.*[52] The influence of the Academicians had not faded.

Robin Hamlyn

1 See Robin Hamlyn and Judy Collins, 'Sir Francis Chantrey: His Bequest in Context' in *Within These Shores* (exhib. catalogue) Sheffield City of Art Galleries, 1989, pp.9–25.

2 *The Tate Gallery. The National Gallery of British Art Illustrated Catalogue*, London, The Art Journal Office, 1897, p.11.

4 Though the wiring for this was in fact installed the new Tate did not at first have electric lighting because the Trustees thought that it posed a risk – presumably of fire (*Daily News*, 22 Nov 1899).

5 For an obituary of Smith see *RIBA Jnl* xx 1912–13, p. 412.

6 See J.G. Millais *The Life and Letters of Sir John Everett Millais*, 2 vols. London (1899) II, pp.369–70; for the number of revisions see *BN*, 14 Feb. 1896, p.381 and *AJ*, Dec 1894, p.373.

7 In *Builder*, 19 March 1892, p.226.

8 In *BN*, 17 March 1893, p.389.

9 *AJ*, Dec 1894, p.373; *Builder*, 2 Jan 1897, p.17. *Lloyd's Weekly Register*, 17 May 1896, also noted that '*to the late Lord Leighton were submitted several designs'.*

10 *Builder*, op. cit.

11 See note 8.

12 Ed. Mary Lago, *Burne-Jones Talking. His conversations 1895–1898 preserved by his studio assistant Thomas Rooke* London (1891) pp 101–02.

13 *The British Art Gallery. The Final Plans for the Henry Tate Collection*, pp.373–5.

14 Henry Tate reported in the *Daily Mail*, 8 May 1897.

15 pp.370–2.

16 See note 7.

17 *Builder*, 17 Dec 1887, pp.840, 859 (illus.). This library was paid for by Henry Tate; it was opened in December 1888 and appears to have been Smith's first commission from Tate.

18 See note 13.

19 *St. James's Gazette*, 12 July 1897.

20 *St. James's Gazette*, 6 Oct 1896.

21 'The New Turner and Vernon Galleries' *Spectator*, 12 March 1859, p.295

22 W. Thornbury *The Life of J.M.W. Turner, RA*, (1877 ed.) p.320.

23 Douglas Goldring, *Regency Portrait Painter. The Life of Sir Thomas Lawrence PRA* (1951) pp.247–8.

24 See *Report from the Select Committee on the National Gallery, House of Commons*, printed 25 July 1850, in Appendix (D.), *Minutes of Evidence taken before the Select Committee (1847–8) appointed to consider the best mode of providing Additional Room for Works of Art Given to the Public . . .* , p.83 (5 June 1848).

25 John Gage, *Colour in Turner : Poetry and Truth* (1969).

26 Described by Farington as '*something like burnt oker but heavier*' *Farington*, 31 Aug 1814.

27 Gage, *op.cit.* p.162.

28 Goldring, *op.cit.* p.248.

29 J.T. Smith, *A Book for a Rainy Day* (1905) p.276.

30 Walter Armstrong, 'The Henry Tate Gallery', *Art J*, Dec 1894, p.372.

31 See note 7

32 *Daily News*, 26 May 1897.

33 *Architect*, 16 Aug 1897, p.88.

34 *Building Journal* 21 July 1897, p.368.

35 See note 31.

36 *Mag Art*, 1897, pp.276–80.

37 *Globe*, 15 July 1897.

38 Athenaeum, 5 May 1877, p.583

39 Athenaeum, 2 July 1887, p.26.

40 Tynecastle Tapestry at the Albert Works, Edinburgh', *Art J*, March 1896, pp.81–8.

41 William Scott Morton 'Art in the Home – V', *Art J*, Oct 1897, pp.303–6 (p.305).

42 It can be seen in a photograph now in the Archives of the Tate Gallery.

43 *Tynecastle Canvas . . . Vellum . . . etc. Manufactured by The Tynecastle Company*, (c.1920), design no. 1076 '*National*', p. 29

44 Described as '*of sufficiently agreeable tone*' in *Builder*, 21 July 1897, p.365; '*sober green*' in the *Graphic*, 16 July 1897 and '*deep grey green*' in *The Globe*, 15 July 1897.

45 See note 21.

46 David Park Curry, 'Total Control : Whistler at an Exhibition', *James McNeill Whistler. A Re-examination: Studies in the History of Art*, vol. 19.

47 Sir Charles Holroyd, *The National Gallery of British Art (The Tate Gallery)* (1905) p.14.

48 *Spectator* 24 July 1897 pp.113–14. The *Architect and Contract Reporter*, 6 Aug 1897, p.88, refers to this colour merely as '*red*', while the *Graphic*, 16 July 1897, describes it as '*bright red*'.

49 *Morning Leader*, 28 Nov 1899.

50 *Tynecastle Canvas . . . Vellum . . . etc.*, Edinburgh and London, c.1920, design no. 1034, p.24. A sample is preserved in the Tate Gallery Archives and from this, which is painted dark red, it is possible to see that it was originally painted viridian green. When Room 10 was redecorated in 1988 with a fabric wall covering, the original Tynecastle Tapestry was left on the timber wall-lining.

51 *Morning Leader*, 28 Nov 1899; the *Advertiser*, 28 Nov 1899, described the doorways in the new galleries as painted in a '*flatted bronze green*'.

52 'The New Turner Gallery', *Connoisseur*, Sept 1910, pp.63–64. Gallery 10 is illustrated on p.63.

C26

Sidney Smith (1859–1913)

Tate Gallery, proposed Galleries of British Art
c.1893

Drawing, 45.7 x 69.5 cm

Tate Gallery

C27

John Lavery (1856–1941)

Tate Gallery, opening of galleries in 1926

Oil on canvas, 60.8 x 50.7 cm

Tate Gallery

C28

**Fragment of Tynecastle Tapestry, c.1897, used in
the Tate Gallery**

Embossed canvas and paper

Tate Gallery

WALLACE COLLECTION (founded 1900)

Altered though it is since its days as a private
residence, Hertford House represents, with Apsley
House, a rare survival of the palaces of the aristocracy
which used to adorn London. The eighteenth century
house of the Marquesses of Hertford was furnished
in the 1870s by Sir Richard Wallace (1818 – 90), their
illegitimate descendant, with the collections amassed
by the third and fourth Marquesses and by Wallace
himself. He made substantial alterations to the
building, notably the addition of the Great Gallery at
the back, to the designs of Thomas Ambler[1]; this was
equipped – a mark of the professionalism of Wallace's
approach – with a water-powered lift.

Like Bridgewater House, the Collection was open
to a select public, with a separate entrance from the
side on Spanish Place.[2] A distinction was made by
Wallace between the rooms used for domestic
purposes and the Collection itself. The Great Gallery
was in the tradition of the galleries in Park Lane
mansions, now destroyed, intended both for the
display of paintings and for glamorous entertaining,
though in the case of Hertford House there was little
scope for the latter. Wallace arranged his paintings
with some concern for order, placing the works of the
same Schools together and devoting rooms to hold-
ings of such richly represented artists as Reynolds
and Canaletto, but the crowded conditions meant that
as many paintings were squeezed onto the walls as
they could take. The 'Modern Gallery' (29 *e*) con-
tained French paintings of the eighteenth and nine-

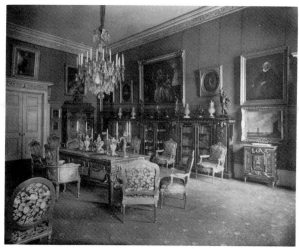

C29(a)

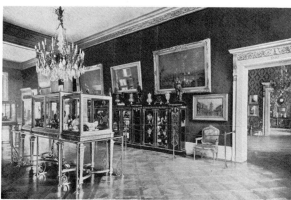

C29(b)

teenth centuries.

The bequest of the Collection to the nation by Lady
Wallace in 1897 presented the Government with a
problem. Lady Wallace's will stated that the works of
art should be housed in a specially built museum in a
central part of London, on a site to be provided by the
Government. The Treasury accordingly set up a
Committee to consider an answer. The Committee,
which included the architect Alfred Waterhouse,
Walter Armstrong, Director of the National Gallery
of Ireland, Alfred de Rothschild and Sir Edward
Poynter PRA, Director of the National Gallery, met
under the chairmanship of the Marquess of Lans-
downe in May 1897 and presented their report to
Parliament in July 1897.

The *Minutes* are of considerable interest, reflecting
as they do the attitudes to displaying works of art held
by the most influential official connoisseurs of the
time. The question of site was much discussed, the
options being to keep the Collection at Hertford
House, to move it to a building close to the National
Gallery, to find a wholly new site or to send it (as

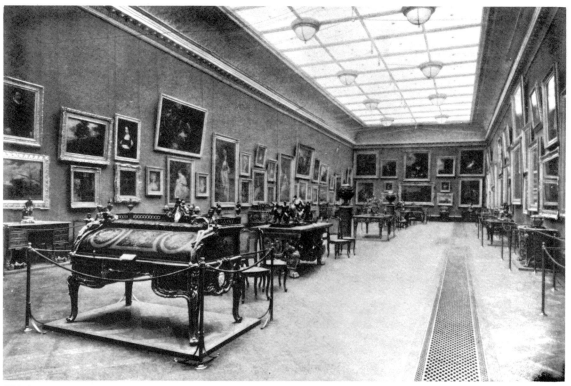

C29(d)

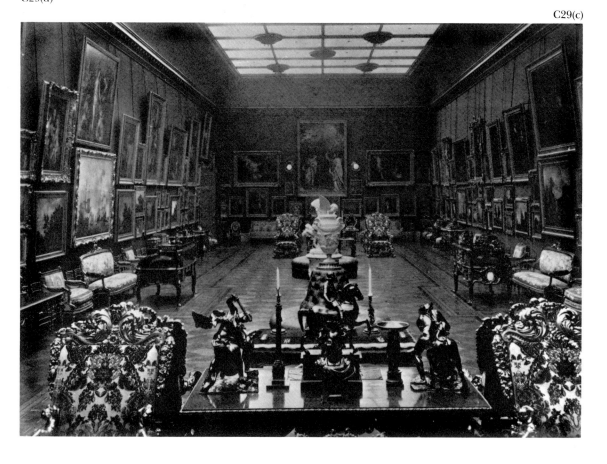

committees were always trying to do) to South Kensington. Of the alternatives to Hertford House, the National Gallery was the one given most consideration, and plans were drawn up by John Taylor of the Office of Works for a structure behind the Wilkins building, a western equivalent to the Barry Rooms. The representatives of the National Gallery were in favour of this option, and in particular Poynter, who signed a minority report. He pointed out that the partial amalgamation of the Wallace Collection with the National Gallery (they would have had to be kept physically separated) would fill many of the gaps in the national collection, notably in its French holdings, and that such a union would make *'perhaps the finest gallery in Europe.'*[3] He also felt that it would be impossible to preserve the character of Hertford House if it were to be converted into a public museum.

The rest of the committee disagreed. Their Report recommended that the works of art should remain *in situ*, with some alterations being made to the house, notably the provision of additional gallery space in the old stables and the family and staff bedrooms. They were also in favour of creating better light by reducing the extent of the internal walls: C29*a* and *b*, for example, illustrate the removal of the walls between two of the state rooms on the first floor. (This wall has since been reinstated). They were eager to retain as much of the atmosphere of the old building as possible, considering that much of the appeal of the Wallace Collection lay in its associations with its founders, and that the objects displayed there – notably the balustrade to the principal staircase, which was specifically named in the bequest, and the chimney pieces – could not be better shown elsewhere. Their attitude concurred with the question put by Armstrong that *'The house is a palace, it is decorated as a palace, and it should remain so if possible?'*[4] At the same time, they regarded the existing interiors as excessively cluttered, and considered that the removal of domestic furniture, and the provision of additional space, should solve this problem. Much thought was given to such questions as the design of suitable vitrines for the display of the collections.

The reinstallation of the building was carried out between 1897 and 1900 by Sir Claude Phillips (1846–1924), the new Keeper of the Wallace Collection, and several trustees. The Agenda Book and Trustees' Minutes show how much attention they gave to this task, frequently making several attempts before settling on a fabric. Since this was a Government enterprise, economy was important, the Trustees going through a number of disputes with the Treasury over the amount that it was proper to spend: after much deliberation, for example, in the summer of 1898 over the decoration of the Great Gallery, and after the inspection of numerous silk brocades and wall papers, they settled on a particular crimson brocade. They instructed the architect, John Taylor, that *'this should be reproduced as closely as possible as a wall paper'* for that room and the Modern Gallery, while the coved ceiling to the Gallery was to be decorated with an embossed paper *'reproducing exactly in design the old flat decoration, the tint of the same to be however an ivory white.'*[5] The retention of the house's palatial character within tight financial restrictions remained their aim, even though, as these photographs show, the character of the rooms changed considerably, with the removal of all the domestic furniture, and a less crowded hang for the paintings. It was left to later generations to redecorate with a sumptuousness of which the late Victorians would have been proud.

1 Little is known about Ambler; he was probably a surveyor.
2 *Minutes of Evidence of the Committee on the Housing of the Wallace Collection*, sect. 5.
3 *Minutes* sect. 252.
4 *Minutes* sect. 160.
5 *Trustees' Minutes*, 27 July 1898.

C29

Photographs showing the interior of the Wallace Collection before and after its reinstallation as a public museum:

(a) J.J. Thomson

The Long Drawing Room (Gallery XII) c.1897

(b) A.L. Baldry (1858–1939), for his *The Wallace Collection at Hertford House* (1904)

Gallery XII, looking south 1904

(c) J.J. Thomson

The Large Picture Gallery (Gallery XVI) c.1897

(d) A.L. Baldry

Gallery XVI, looking east 1904

(e) J.J. Thomson

The Modern Gallery (Gallery XV) c.1897

(f) **A section of fabric from the Great Gallery,** c. 1960

NATIONAL MUSEUM OF WALES (founded 1907)

In the provision of museums, Wales was seriously deprived until the beginning of the twentieth century. Unlike England, Scotland or Ireland, which had all acquired national galleries and museums by the mid-nineteenth century, Wales possessed no national museum until the first decade of the twentieth, when the efforts of private individuals led

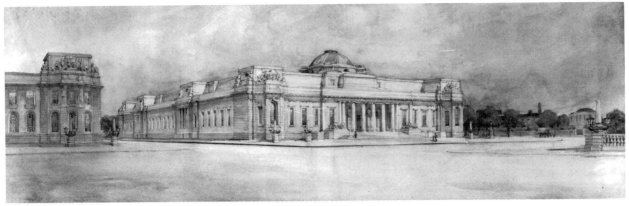

C30

to an appeal for subscriptions for a National Museum. The success of this appeal persuaded the Government to match the sums raised. A Royal Charter having been granted in 1907 after much Parliamentary lobbying (and opposition), an open competition was held. The firm of Smith and Brewer were appointed architects for the new Museum, which after much debate was located in Cardiff (which was not yet official capital of Wales).

The new building was to contain six Departments (Antiquities and History, Geology and Mineralogy, Botany, Zoology, Art, Industries), with an emphasis laid on Welshness. One suite of rooms was and is dedicated to the display of paintings – though the brief stipulated that the use of the public galleries should be interchangeable.

The firm of Smith and Brewer was already known for their highly individual Passmore Edwards Settlement (Mary Ward House) in Tavistock Square of 1896. They designed for the National Museum a building in keeping with the existing neo-Baroque city buildings in Cathays Park by Lanchester and Rickards of the 1890s, but considerably more restrained. Even so, it was a classical set-piece in the Imperial idiom. Its first Director made extended foreign tours, notably to Germany and Sweden, and to Boston to see the much-praised new Museum of Fine Arts. He wished to ensure the application of the most up-to-date ideas to the building, which was to be highly praised for the excellence of its planning. Innovative elements were the centrally placed garden, intended to avert museum fatigue in the visitor, and the location of stores, offices and galleries together for each department, in a building that showed the works of Nature on the ground floor and those of Man upstairs. A bravura feature was the entrance hall, which was raised from one to two storeys during the planning process, providing a spectacular if not altogether practical space which was intended to contain objects emphasising the particularly Welsh quality of the Museum. In general, the architectural character of the building was very restrained: as a member of the building committee put it, the original

conditions for the competition had stipulated that *'Internally the buildings should be finished in a simple and dignified way, free of ornamental or other detail likely to compete in interest with the exhibits'* and he felt that the realisation of this condition had led to *'an austere, dignified beauty.'*[1]

Progress on the building was very slow. Work began in 1910 and was interrupted by the War; the first visitors were not admitted until 1922. Work has continued at intervals ever since, and at the time of writing a further set of galleries, for paintings, is under construction.

Though severely cramped by official meanness, the building is an impressive one, its situation at the heart of the monumental civic centre a fitting recognition of its importance. The recent completion of the side wings by Alex Gordon and Partners, with the continuation of the sculptural programme initiated when the building was begun, at last partly repairs the delay in realising the Museum's potential. The picture galleries have been sensitively restored, with the Pyke Thompson Rooms on the entrance front (the only rooms specifically designed for the display of paintings), brought back to their original form. A refreshingly underivative set of gallery seating furniture has recently been commissioned, for the physical and visual pleasure of visitors.

1 W.S. Purchon, *AR* LIII 1923 pp.47–52.

C30
Smith and Brewer
National Museum of Wales
Pen and wash, 49.5 x 95 cm
British Architectural Library Drawings Collection/RIBA

C31
David Colwell/Trannon Furniture
National Museum of Wales chair
Oak seat, back-rest and feet, remainder ash
The National Museum of Wales

D Exhibitions and Academies

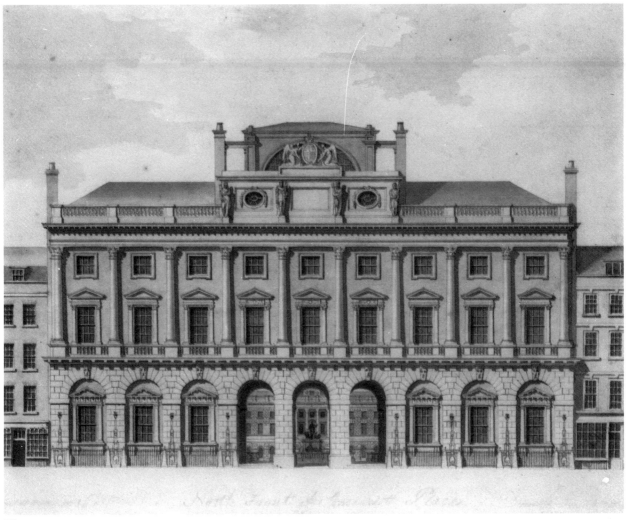

D3

The enormous subject of temporary exhibitions deserves an exhibition of its own. No attempt has been made to cover the field comprehensively, but it is hoped that the attention given to the two leading exhibiting institutions of nineteenth century London will convey the importance of such enterprises at a time when foreign travel, and, at least in the early part of the century, the reproduction of works of art, were much less easy than they are today. The photographs of the Manchester Art Treasures must stand for the many great exhibitions – not least the Great Exhibition itself – to which the Victorian public flocked, and which played an extremely important role in popularising art at all levels of society.

THE ROYAL ACADEMY OF ARTS
(founded 1768)

The English Royal Academy is remarkable among European academies in the influence that it has exerted over the development of art in Britain. In no other country has an Academy survived to the present in so vigorous and popular a condition, with the triple roles for which it was established – art school, exhibition space, and professional institute – intact. Though the Academy has always enjoyed royal patronage, it has never received official Government backing: like the National Trust, it represents the peculiarly British tendency for major artistic or conservation bodies to be left by Governments to fend for themselves. Although from its inception the Royal Academy has fostered public appreciation of the visual arts, and has contributed to the raising of the stature and wealth of painters and sculptors, it has at times exerted a baleful influence in encouraging the deep-rooted conservatism of the British public in visual matters.

Founded by Royal Charter in 1768, the establishment of the Academy represented years of lobbying. The various teaching academies which had existed for short periods in London since the beginning of the century, and the attempts from the middle of the century to create a setting for temporary exhibitions by such groups as the Society of Artists of Great Britain (with which the leading figures in the new Royal Academy were closely involved), found fulfilment in the new institution; as did the desire of many artists for a body that would assert their position in society.

The Academy has had four homes. From 1769 to 1779 its exhibitions were held in temporary accommodation in Pall Mall. In 1780 its semi-official status was marked by the move to purpose-built rooms in the new Somerset House, designed by Sir William Chambers. These proving too small and inconvenient for the growing annual exhibitions, a second move took place in 1837 to Trafalgar Square, where the Academy shared a new building with the National Gallery. This again proving inadequate, the Academy was finally transferred in 1869 to Burlington House.

The Royal Academy is generally associated today with exhibitions: the Summer Exhibition, which maintains the original tradition, and varying temporary displays. The latter were not part of its original purpose: only with the demise of the British Institution in 1867 did the Academy take on the role of organising the Old Master and modern exhibitions which played such a leading part in nineteenth century British life.

One should not under-estimate the importance of the Academy in shaping artistic taste and, by extension, influencing the economic development of the visual arts. When it moved from Trafalgar Square to

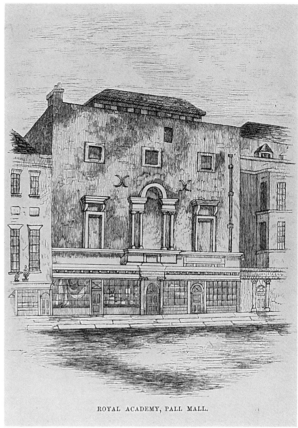

ROYAL ACADEMY, PALL MALL.

D1

Piccadilly, in 1869, so did the centre of the commercial art world, transferring from Pall Mall and the Strand to Bond Street. The collecting of British art by national museums was for many years influenced by the bizarre workings of the Chantrey Bequest, which imposed on the newly-founded Tate Gallery old-fashioned narrative paintings of a type which it did not welcome, while the effect on regional collections was even stronger. With the establishment of municipal art museums in industrial towns from the 1870s onwards, the cornucopia which – at a price – showered artistic fruits on the municipalities was the Academy. In many cases the acquisition policy of these museums consisted of an annual London visit by selected councillors to select from the Royal Academy (and from no other source) a handful of new-minted masterpieces by famous names. The practice continued in some towns at least until the Second World War.

D1
Royal Academy, Pall Mall
Engraving, 12.5 x 9 cm
Trustees of The British Museum

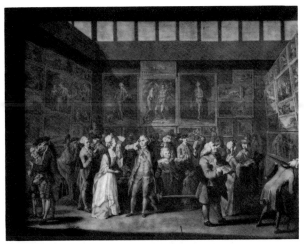

D2

D2
R. Earlom (1743–1822) after C. Brandoin
Royal Academy Exhibition of 1771
Mezzotint, 42.5 x 55.9 cm

Guildhall Library

The Royal Academy was first housed in temporary premises on the south side of Pall Mall, opposite the Royal Opera Arcade. The building had been used by an auctioneer and a print-seller, and its modest square monitor-lit main room was probably typical of such interiors in late eighteenth century London, though little visual evidence survives of their appearance.

Only one room was available for the 276 paintings shown in the third annual exhibition. The idea of hanging paintings 'on the line' was not yet developed, but the clutter anticipated many such hangs. The amorous activities of some of the visitors are not visible in the much more self-conscious Victorian depictions of the same subject.

D3
J. Pass (fl. 1800)
The North Front of Somerset House 1798
Pen and watercolour, 20.3 x 25.4 cm

Guildhall Library

The Royal Academy first became associated with Somerset House when in 1771 the Schools and the administration moved into the old palace, the exhibitions remaining in Pall Mall. In 1775 the Government took charge of the building with the intention of creating a complex of public offices and accommodation for the arts and learning, and it was agreed that the Academy should be allowed to remain there.

Work began in 1776, and the Academy moved into its new home in 1780.

The Strand block was always intended for the Royal Academy, however much plans changed for the rest of the building. It was seen by Chambers as an evocation of the Inigo Jones gallery demolished to allow building to take place, and as a gatehouse to the courtyard beyond. As the architect declared in his Report to the House of Commons of 1 May 1780[1], it was to be the *'principal and most conspicuous part of the design'*, requiring *'not only particular forms and proportions, but likewise some profusion of ornaments to merit its superiority.'* Such ornaments were provided in sculpture, executed by various artists under the direction of G.B Cipriani. These ornaments included the masks depicting Ocean and *'the eight great Rivers of England'*, and emblems of Justice, Prudence, Valour and Moderation, with, at the centre of the attic, the arms of the British Empire, supported by the Genius of England and Fame sounding her trumpet.[2]

Though Chambers was designing a national monument, the building's effect was and is weakened by its position in the street-scape, on the axis of no avenue. The sculptural programme does not reflect the activities planned for it, while the siting of the exhibition rooms – the most important apartments within this part of the building – on the top floor could not be expressed externally. A vocabulary for a building devoted to the muses had not yet been achieved: this facade expresses the official and political character of a public building, rather than a temple of the Muses.

Pass's watercolour shows the block with the lantern for the Great Room protruding, as it would appear from a high viewpoint. The engraving made after this watercolour reduces the height of the lantern to the level normally perceived, and omits the undignified houses left and right.

1 Hutchinson (1986) p.46.
2 Baretti, (1781) p.6ff.

☐ J. Baretti, *A Guide Through the Royal Academy* (1781)
☐ S. Hutchinson, *The History of the Royal Academy* (1986)

D4
Pietro Antonio Martini (1739–1797) after J.H. Ramberg (1763–1840)
The Exhibition of the Royal Academy, 1787
Engraving, 31.6 x 48.9 cm

Dulwich Picture Gallery

The Great Room at Somerset House represents the culmination of the single top-lit exhibition room in its later eighteenth century form. Intended as an exhibition space in summer and a lecture hall in winter, it concludes a processional route up Chambers' demanding staircase. With the other rooms in the

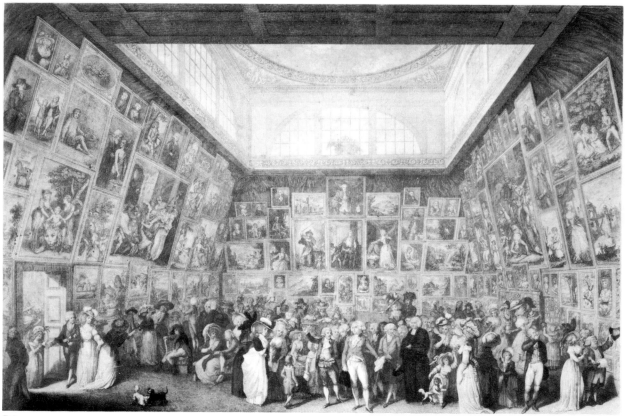

D4

Academy's apartments, it symbolised the union of architecture, painting and sculpture. The lighting of the room follows the established monitor system, with the Diocletian windows to enhance the dignity of the effect.

In this print, the President of the Royal Academy shows the Prince Regent round an exhibition dominated by Reynolds' own paintings. Martini's interest in the theme of the annual exhibition is illustrated by his engraving, also of 1787, of the Paris Salon. The two rooms and the arrangement of paintings are sufficiently similar to suggest that the Salon – where exhibitions of works by French Royal Academicians took place regularly from 1737 – shaped the character of the London Academy. Ramberg and Martini again stressed the social correctness and popularity of the Somerset House exhibitions in their engraving of 1788, showing a visit by the King, Queen and Royal children.

The pressure on space at Somerset House, as well as the vertically oriented character of the architecture, necessitated a crowded arrangement of the paintings which encouraged the production of boldly conceived canvasses of considerable size. Chambers' design had originally been criticised by some Academicians for creating too much space, but his proposal was vindicated within a few years. The

number of paintings displayed rose rapidly: from 489 in 1780 to 666 in 1787, and 780 in 1792. In 1787 almost 400 works were shown in the Great Room, including over 100 miniatures, which can be seen packed together above the fireplace. A further 80 or so paintings hung in the Ante-Room, while the Sculpture and Drawings Room (or Academy of the Antique) contained over 200 exhibits.

The 1787 view illustrates the prevailing character of eighteenth century exhibitions: a preponderance of portraits, landscapes and subject paintings, with a few very large history paintings in prominent positions. Here Opie's *Assassination of David Riccio* (on the left) faces Northcote's *Sir William Walworth kills Wat Tyler*. More congenial to most spectators must have been the Reynolds portrait of the Prince of Wales, flanked by portraits of Maria Cosway and her husband Richard.

The 'line' – a narrow ledge about 8½ feet above the ground, forming a division between the two stacks of paintings – was first introduced at Somerset House but was not found in the Paris Salon; nor was the system of canting out the pictures. This effect was achieved (according to oral tradition at the Royal Academy, a tradition supported by D5) by resting the lowest pictures placed 'above the line' on the line itself. The bottom of the next picture above rested on

D5

D6

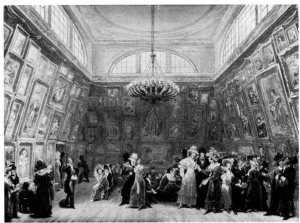

D7

Although the line assumed great importance as the mark of a favourable or unfavourable position in the hanging arrangement (a position 'on the line', i.e. with the picture suspended from the ledge, was considered the most favourable place for a painting), its function was to allow speedy hanging for a large number of paintings. For later generations, the imposing but unyielding character of the Great Room has posed considerable problems. The present (1991) use of the room does not perhaps fully address the difficulties or realise the possibilities of this space.

D5
Paul Sandby RA (1725–1809)

Installation of the Great Room of the Royal Academy at Somerset House 1792

Pen and ink, 25.6 x 39.4 cm

Royal Academy of Arts

A volume in the library of the Royal Academy of Arts entitled *Exhibitions of the Royal Academy 1783–96* contains several drawings in ink or pencil of the 1792 exhibition hang at Somerset House; and a set of four drawings by Paul Sandby, based on the sketches in this volume, also shows the installation of the Great Room. One of these (D5) depicts the chimney (or east) side. *The Drowning of Pharaoh and his host*, painted for the King's Chapel at Windsor Castle by Benjamin West (elected President in that year), hangs over the chimneypiece. Genre scenes by prominent Academicians are arranged in a row above the 'line': Fuseli's *Falstaff*, Opie's *Two Children, a horse and a dog*, with Russell's *Orphans' Visit to their parents' tomb* concluding this affecting assembly. They suggest that the arrangement was made with some thought for subject-matter. According to the usual practice, the miniatures are packed in above the chimney-piece, with smaller pictures placed below the line.

In spite of the crowded display, the drawing illustrates the attempt made to introduce a symmetrical arrangement of paintings.

D6
J.M.W. Turner RA (1775–1851)

Interior of the Great Room, Somerset House c.1810

Pencil and watercolour, 66.9 x 100 cm

Tate Gallery (Turner Bequest)

This drawing was used by Turner as one of the illustrations for the lecture series which he delivered at the Royal Academy as Professor of Perspective, beginning in 1811.

the top of the first layer, and so on to the top. Material of any sort – paper, rags – was stuffed tightly between the back of the top-most paintings and the wall, to which the highest pictures would also be secured by chains.

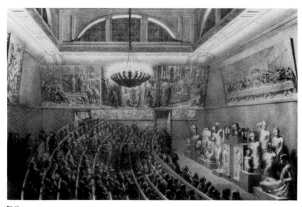

D8

* D7

George Scharf I (1788–1860)

Royal Academy Exhibition, 1828

Watercolour, 18.8 x 25.9 cm

Museum of London

Scharf, a German artist who came to England in 1816, was famous for his views of London buildings and London life. His view of Somerset House shows how little had changed from forty years before, other than the introduction of artificial light in the form of the gasolier. The lack of space at Somerset House was, however, coming under severe attack, particularly since the Schools could not function while the summer exhibitions were in progress, and the Academy moved within a few years to Trafalgar Square.

Scharf's son, Sir George Scharf, was to become the first Director of the National Portrait Gallery.

D8

George Scharf I

Westmacott's Lecture on Sculpture at the Royal Academy, Somerset House 1830

Engraving, 19.7 x 31.1 cm

Guildhall Library

Sir Richard Westmacott (1799–1872) was Professor of Sculpture at the Royal Academy from 1857 to 1868. Like the Academy's other Professors, he gave his lectures during the winter in the Great Room where the summer exhibitions were held, using drawings and casts as visual aids.

D9

Sydney Smirke RA (1798–1877)

Royal Academy: Gallery III

Pencil and watercolour, 28 x 32 cm

Royal Academy of Arts

When, on 20 March 1867, the Secretary of the Royal Academy, J.P. Knight, RA, laid before Council *'the Lease of Burlington House and ground attached, being the side for the proposed New Building of the Royal Academy, granted by the Government for 999 years'*, plans for the new galleries and accommodation of the Schools behind Old Burlington House were sufficiently well advanced for it to order *'that Mr. [Sydney] Smirke the Architect commence operations without delay.'*[1] Indeed, from the moment the President, Sir Francis Grant, had announced to an elated General Assembly on 29 August 1866, his success in obtaining the Burlington House site, a Building Committee, appointed that same day, had worked flat out to decide *'with the Architect as to the best appropriation of the site to the purposes of the Academy, and to define and determine with him the requisite arrangement of space – modes of lighting – ventilation etc. for the Galleries and Schools – The Committee to submit all plans to the Council and General Assembly, previous to their adoption.'*[2]

In his highly influential lecture on the *'Construction of Picture Galleries'* Richard Redgrave RA had stated categorically that *'the perfect adaptation*, of a gallery to the arrangement and display of pictures *'is hardly the work of an architect . . . [but] should be determined by a painter.*[3] Faced with a committee, not just of painters but of sculptors *and* other architects, Smirke might well have feared the worst for his design had he not, as Treasurer of the Academy, himself occupied a key position on the committee set up to approve his own work. That no-one questioned this arrangement until much later, in 1874, when Street and Barry put a stop to Smirke's scheme for a grand entrance hall, is a measure of the remarkable degree of harmony and sense of common purpose – of destiny even – that had broken out amongst the membership once the uncertainty over their future home had been thrown off.

The most important result of this new single-mindedness was to be the creation of a suite of temporary exhibition galleries that expressed precisely the membership's shared conception of the function of such a space. The contrast with the lack of control that Wilkins or the Academy had had over the arrangement of their rooms in the National Gallery building, could not have been more extreme, and was undoubtedly intended to be so. Two factors contributed. Firstly, the Academy was free to build whatever it wanted behind Burlington House – a luxury earlier enjoyed by neither Chambers nor Wilkins. And secondly, there was little time to waste on debating the details of the design, given the pressure on the Academy to complete its new galleries in time for the first exhibition of its second century. An example can be seen in the way Redgrave used his well-recognised authority on the subject of gallery design at a meeting of the General Assembly, to move *'that the General Assembly, having seen the Designs (plans-elevations-etc.) submitted to them by the Building Committee and Architect, express their satisfaction with their labours to*

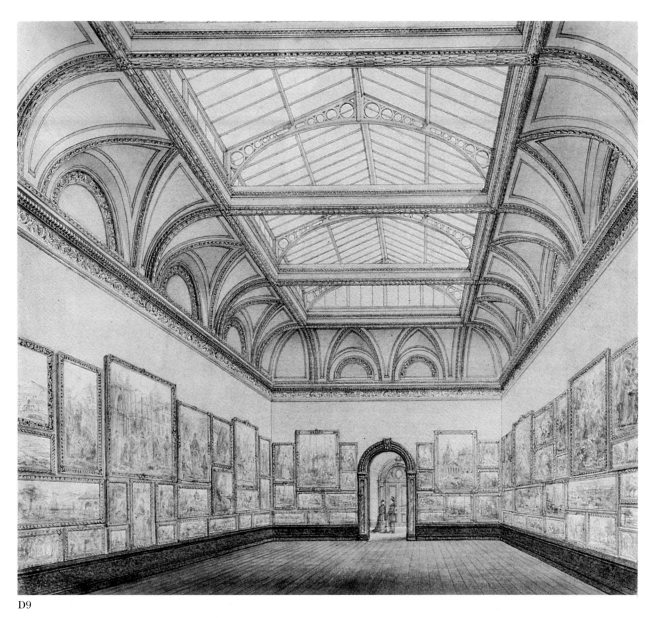

D9

the present time.' The motion, seconded by Westmacott, was carried 'nem.dis'.[4]

There can be no question that Redgrave's opinions on the proportions, lighting and decoration of the new galleries, as expounded in *The Builder* ten years earlier, and now, no doubt, informally expressed to his colleagues in person, had a substantial influence upon both the initial conception and the actual execution of Smirke's design. Nor was the force of this influence, ten years after the successful demonstration of his principles at the Sheepshanks Gallery, dependant on any personal intervention on Redgrave's part. By now it was, for instance, a matter of common knowledge that the correct solution to the problem of reflection or 'glitter' was to build a top-lighted gallery with a horizontal aperture of at least

half the floor area and no higher than it was wide.[5] And as artists, rather than collectors or art politicians, the members of the Academy needed little persuading of the truth of Redgrave's contention that 'in a gallery of art, the art is the one thing to which all should be subservient' and where pictures 'are not meant to serve as subsidiary decorations to the architecture, but are themselves the jewels for which the building forms only a fitting and suitable casket.'[6]

By mid-Victorian standards the interior of the Academy's new galleries was considered properly restrained. Their coved ceilings of 'pleasing form', with 'the leading lines of construction . . . prettily picked out in gold and illumined by colour' managed, in the opinion of the *Art Journal*, to hit 'the happy mean – to bring 'enrichment' to the scene and yet not overpower the pictures

below.[7] The same journal praised especially *the use of solid natural materials* which it saw as *one safeguard against excess*, and found that *indeed, solidity, simplicity and honesty in structure, as well as in decoration, characterize the whole interior*.[8] The semi-circular arched doorcases leading off the Octagon (or Centre Hall) and connecting the north range or galleries, with their architraves and pilasters of dark grey, pink and white marble, and decorated with the walnut, square-headed doorcases linking the other galleries, were *hard to praise too highly, whether for symmetry in design, for sharpness in the mouldings, or clean firm execution in the carving.* The *pure Greek* style of ornament used in the cornices and ceiling mouldings was also much approved of, *the honeysuckle, the fret, and the echinus [being] greatly preferable to the mongrel forms which intrude into styles more corrupt.*[9] It had been proposed to *subdue* the gilding of the ceilings for fear that too much bright gilt would distract the picture viewer, but this was presumably found to be unnecessary, given the much greater quantity of gilt surrounding the pictures on the walls.[10]

The Builder, less concerned to point out the necessary *reticence shown in the use of colour*, described walls covered in *a reddish chocolate paper, with leafy ornament of a similar tone . . . finished with a dado of walnut, with an ebony cornice*, and ceilings that *glisten with gold, relieved by buff and chocolate and green lines*.[11] The colour of the walls had been decided at a special meeting of the General Assembly to view an experimental hang of the Academy's own collection of Diploma works (and whatever members could spare from their walls) in the South-West Gallery (i.e. Gallery III), the choice being between *a low red* and *the colour of a pheasant's egg*.[12]

As the *Art Journal* pointed out, this was a question of much greater moment than it had ever been in the Academy's exhibition rooms at Trafalgar Square since, for the first time that anyone could remember, bare walls would be seen around, between and above the pictures. The tight imaginary hang shown in Smirke's proposed interior of Gallery III (D9), with its timid adherence to the old *line*, was to be a thing of the past – or so it was promised. The General Assembly had resolved *that no picture should be hung with its base line higher than 12 feet from the ground*; *that every picture should be more or less separated by intervening wall places*; and *that the restrictions formerly in force as to breaking the line, and enacting that canvasses larger than the Kit Kat size containing portions of the human figure of the size of life should be placed above the line, shall . . . now be formally repealed*.[13] To judge from contemporary reports the Hanging Committee, for the 1869 exhibition at least, succeeded in establishing a much looser hang, though not without falling into the error of running out of space at the end and having to commandeer the walls of the Lecture Room for architectural drawings and crayon sketches, in spite of danger caused by visitors scrambling up and down tiers of seats to view them.[14]

All in all, the opening of the Academy's new galleries was seen, from the point of view of their fitness to the purposes required, as an unalloyed triumph – *never have works of Art* claimed the *Art Journal* *been seen to greater advantage.* The time for questioning to *whose* advantage was past – as long as the turnstiles kept clicking the Royal Academy would *go on for ever*[15]

Nicholas Savage

(Key: CM: Council Minutes; GA: General Assembly)

1 RA CM, XII, pp.333–4.
2 RA GA, VI, p.362. Besides the President, Secretary, Treasurer (Sydney Smirke), and Keeper (Charles Landseer), the Building Committee consisted of the architects Sir George Gilbert Scott and Philip Hardwick (who retired on 7 December 1868); the painters C.W. Cope and Thomas; and the sculptors Henry Weekes and William Calder Marshall. They were joined at various dates by the painter Solomon A. Hart, two young A.R.A. architect members, E.M. Barry and G.E. Street; and by the Professor of Sculpture, Richard Westmacott. (CM, XII, pp.313, 320, 427).
3 *Builder*, 28 Nov 1857, p.690.
4 GA, VI, p.377 (21 March 1867).
5 *Builder*, 28 Nov 1857, p.689.
6 ibid, p. 690.
7 *ArtJ*, 1 June 1869, p.161; *Builder*, 8 May 1869, p.357.
8 *ArtJ*, 1 June 1869, p.161
9 ibid. Marble work was carried out by W.H. Burke & Co.; 'modelling and carving' was executed by S.J. Ruddock; and the interior decorations undertaken by L.W. Collman (see *Accounts of the New Building & Works at Burlington House*, RA Archives, entries dated between 28 July 1868 and 9 June 1870). The general building contractors were Jackson & Shaw.
10 *ArtJ*, 1 May 1869, p.92. Gilt frames had been obligatory for all paintings and drawings submitted for the annual exhibition since 1847.
11 *Builder*, 8 May 1869, p.357. The colour of the walls was presumably close to that shown in C.W. Cope's *The Council of the Royal Academy selecting pictures for the Exhibition* 1876; R.A. Collection) and W.P. Frith's *The Private View of the Royal Academy* (1881; private collection).
12 GA, VII, pp.4–5
13 GA, VII, p.6. Restrictions on 'breaking' the line (in the National Gallery rooms, a narrow moulding 8 feet from the ground) had been suspended by Council in 1867 and 1868 (CM, XII, pp.340, 421). It was probably for this reason that no similar 'line' was installed in the new galleries, the phrase 'on the line' meaning henceforth no more than simply a position roughly at eye-level.
14 As reported in *Builder*, 8 May 1869, p.357. Although roughly twice the hanging space was available, only six more oil paintings were hung than in the previous year at the National Gallery.
15 *Builder*, 22 May 1869, p.397.

* D10

George Bernard O'Neill (1828–1917)

Public Opinion c.1863

Oil on canvas, 53.2 x 78.8 cm

Leeds City Art Gallery

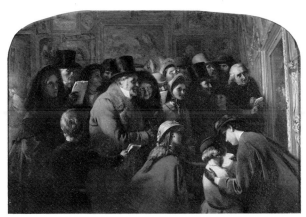

D10

First exhibited in 1863, *Public Opinion* illustrates the phenomenon of the rail placed as protection in front of a particularly popular picture at the Royal Academy Summer Exhibition. This honour was first accorded to Wilkie's *Chelsea Pensioners receiving the Gazette announcing the Battle of Waterloo* and subsequently to various artists, notably Frith, until a semi-permanent railing protecting all the pictures was built in 1885. All the especially popular paintings were narrative works, recalling the contemporary strength of the British novel. O'Neill imitates the tradition of history painting by showing figures of all ages, though not all social classes: everyone except the hatless artist is dressed with total propriety. The painting was seen by contemporaries as satire, though not of a very forceful type: *The Times* criticised the artist for vulgarity and unreadiness to '*look down upon the weakness he is satirizing*'. The painting illustrates the reliance of the Victorian art-audience on catalogues: many of the viewers hold such catalogues, vital to their enjoyment.

Around the favoured work hang history paintings, genre scenes, and portraiture tightly packed together and all equally ignored.

D11

W.P. Frith RA (1819–1909)

Private View Day at the Royal Academy 1881

Engraving, 47 x 91 cm

Private Collection

Intended as a work of satire, the painting from which this engraving was taken illustrates the role of the Academy as social arena. Here, at a Private View, are assembled many of the most notable figures of British society: W.E. Gladstone, recently re-elected Prime Minister, to the left (without a hat and shaking hands), William Agnew MP, Robert Browning, Lord Leighton PRA (without a hat, standing in front of the

arch) with Lily Langtry to his right. The group on the left comprises, according to the artist, '*a family of pure aesthetes absorbed in affected study of the pictures*'.[1] In his desire to '*hit the folly of listening to self-elected critics in matters of taste*', whether in clothing (the painting also attacks the perceived absurdities of aesthetic dress) or art, Frith depicted '*a well-known apostle of the beautiful, with a herd of eager worshippers surrounding him*'. The apostle is of course Oscar Wilde, watched with apparent hostility by a group of artists clustered to his right. Good sense and true taste are throughout contrasted with affectation.

The painting was a major success on its exhibition at the RA Exhibition of 1883; as Frith observed smugly, it was the sixth of his paintings to require a rail. It was bought from the artist by Mr. Pope, a Dorset brewer. At the time of the purchase Frith had already made a plate after the painting, intending to make the customary considerable sums through the sale of engravings: Pope, disliking the idea of further publicity being given to the painting, also bought the plate and the hundred prints already taken from it. The painting caused him some anxiety in later years: a letter survives from the artist to Pope, dated 1895 (the year of Oscar Wilde's trial): it acknowledges that the inclusion of Wilde was perhaps unfortunate but suggests that they should wait for the outcome of the trial before deciding whether so scandalous a face should be painted out.

In spite of the Academicians' resolutions (see D9), the exhibition technique differs little from that of a century earlier, except that the paintings are no longer hung so high or canted so prominently. They are still closely hung, on deep red walls. The painting illustrates the red, black and cream decoration of the arch surrounds, which now are white. The same heterogenous mixture of paintings prevails as in 1787.

1 Frith (1887) II p.256ff.

☐ W.P. Frith, *My Autobiography and Reminiscences* (1887)

THE BRITISH INSTITUTION
(founded 1805)

After the Royal Academy, the British Institution was London's most important exhibition space during the early nineteenth century, as the number of surviving depictions of its interior testifies. Its history illustrates the role played in the promotion of art exhibitions and the encouragement of the British School by the aristocracy and gentry.

The Institution was housed in a building designed in 1788 by George Dance the Younger (1741–1825) on the north side of Pall Mall (now 52 Pall Mall). The

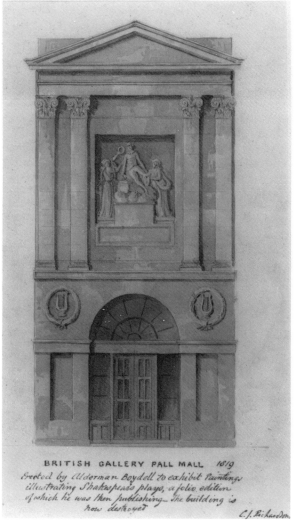

BRITISH GALLERY PALL MALL 1819

Erected by Alderman Boydell to exhibit Paintings illustrating Shakespeare's plays, a folio edition of which he was then publishing. The building is now destroyed

C.J. Richardson.

D14

ground floor was domestic in scale, exploring the contrast between void and solid that absorbed Dance, and was adorned by two sculpted lyres set within wreaths, while the dignity of the edifice was established by the unfenestrated upper storey, with its ammonite Order supporting a plain triangular pediment. The main articulation was provided by the recess between the pilasters, which contained a relief by Thomas Banks showing Shakespeare between the Dramatic Muse and the Genius of Painting. Soane greatly admired the capital that Dance had created, and used a drawing of the facade in his lectures on architecture at the Royal Academy.

The interior of the building played an important part in the development of art galleries in England. It was entered by a *'spacious vestibule'* which in the Institution's time contained sculpture, together with *'the money-taker, and the attendant who has the charge of all umbrellas, sticks, parasols, &c'.*[1] Across an inner vestibule and a short flight of steps, the visitor reached a stone staircase, eight feet wide, which led to the middle of the central gallery. This staircase is visible in most views of the Institution.

The three rooms were of considerable size and in Thomas Smith's opinion presented *'a coup d'oeil...more striking than can be readily imagined.'* The architectural decoration was minimal, with the plain walls topped by coving which rose to the base of the monitor lights. The principal distinction between this building and the Great Room at Somerset House lay in the division of the space into an enfilade of three distinct rooms, linked by arched openings. Ultimately inspired by the ruins of the Roman baths, this form had not previously been used in Britain for major projects. Soane was famously inspired by this concept in his design for Dulwich Picture Gallery, which testifies to the inventiveness of a sequence of spaces distinct from one another but connected visually and in the visitor's perception. A similar but less bold system was used by Smirke at the Royal Academy. The skylights in the Dance building followed the pattern of monitor lights standard at the period.

The British Institution was set up in 1805 by a number of prominent men, with the Queen as patron. The early subscribers included some of the most important collectors, and others associated with the arts in Britain, among them Sir George Beaumont, J.J. Angerstein, the Marquess of Stafford, Holwell Carr, Thomas Hope, Samuel Whitbread, Lord Egremont, Richard Colt Hoare, Sir John Leicester and James Christie the auctioneer. Many of these men were to be active in opening their own collections to the public and in the foundation of the National Gallery. Artists were excluded from any involvement in the Institution's affairs while they remained active in their profession.

The Institution's purpose was avowedly economic, stressing in its publications that the commercial prosperity of the kingdom depended on a flourishing

building was originally intended for use as the 'Shakespeare Gallery', a permanent exhibition space for paintings by contemporary artists, around themes from Shakespeare's plays. This scheme was promoted by the rich and philanthropic Alderman John Boydell (1719–1804), engraver and bookseller, with the aim of encouraging a school of British history painting, and was open to the public. It achieved considerable success until Boydell's financial problems from the closure of the European market during the wars with France obliged him to dispose of the Gallery in 1804. Following a lottery, the lease was bought by the Directors of the British Institution in September 1805.

A learned and fastidious architect, Dance designed one of the earliest purpose-built galleries in Britain. The site, with a narrow frontage on the street and stretching a considerable way back, encouraged him to design a restrained but allusive facade. The

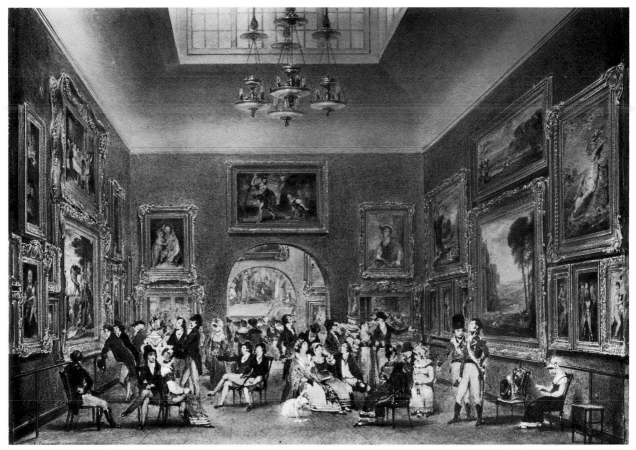

D13

native school of artists, capable of inspiring *'that degree of taste and elegance of design, which are to be exclusively derived from the cultivation of the Fine Arts; and thereby to increase the general prosperity and resources of the Empire'*.[2] This purpose was to be achieved by the organisation of annual exhibitions of work by British painters, at which prizes were to be awarded. A subsidiary purpose, not actively pursued, was *'to endeavour to form a PUBLIC GALLERY of the works of British Artists, with a few select specimens of each of the great schools.'*

The first exhibition of works by contemporary artists opened in February 1806. Equally important were the summer exhibitions of paintings by the Old Masters, to which the subscribers lent works from their own collections. Intended primarily to give painters the opportunity to copy from the great art of the past and initially available only to students of art, these exhibitions were also opened to the public from 1813. The imposition of an admission fee (one shilling in 1805) excluded the lower orders. The splendour of these displays can be gauged not only from the list of exhibits but from Dr. Waagen's comment in 1838 that such exhibitions, drawn from private collections, could take place in no other country than Britain.

The popularity of these exhibitions encouraged several of those involved with the Institution to open their own collections to the public, while the Old Master exhibitions, the first major loan shows in Britain, stimulated a taste which was to be of great importance throughout the nineteenth century. From 1813, they were supplemented in Pall Mall by one-man displays of famous deceased British artists, beginning with Reynolds.

In its early days the Gallery had no artificial lighting except for special occasions, such as the Commemorative Dinner and reception in May 1813, when the rooms were *'ordered to be lighted'*[3] and the red walls on which the pictures usually hung were adorned by the fitting of crimson hangings. By 1816 the rooms were lit by permanent gasoliers. For the earliest exhibitions the noble organisers arranged the paintings much as they would have been shown in their own houses, in two rows. By the 1840s the pictures were thrust closely together.

The British Institution continued its exhibitions until 1867, when its lease expired and its functions were assumed by the Royal Academy. As Algernon Graves, who remembered the 1860s exhibitions,

131

recalled, the sudden cessation of the Institution's exhibitions caused *'a feeling of consternation in the art world.'*[4]

1 Smith (1860) p.18.
2 *An Account* (1805) p.3.
3 Smith (1860) p.136.
4 A. Graves, two articles on the British Institution in *Art J* 1910, pp.336, 377.
☐ *An Account of the British Institution for Promoting the Fine Art in the United Kingdom* (1805)
☐ T. Smith, *Recollections of the British Institution* (1860)

D12

Alfred Edward Chalon RA (1780–1860)

Study at the British Institution, 1805

Watercolour, 31 x 53 cm

Trustees of The British Museum

The success of the British Institution as a school for copyists is apparent in this view of an early loan exhibition. The eager artists at work include both leaders of the profession and younger people (including a number of women, against whom none of the discrimination prevalent later in the century seems to be in force). Rowlandson is third from the left; Benjamin West, hatted, towards the right. Chalon executed two or three satirical drawings in this vein, evidence of the vast attraction exerted by the Institution's early Old Master exhibitions.

The paintings on view include Claude's *Embarkation of St. Ursula* (then in the Angerstein collection, and purchased for the National Gallery in 1824).

D13

James Stephanoff (1784–1847) with figures by F.P. Stephanoff (1788–1860)

British Institution in 1816 1817

Pen and watercolour, with white heightening, 21 x 29 cm

Board of Trustees of the Victoria and Albert Museum

This view of the 1816 Old Master loan exhibition shows the north room of the Institution, with an exhibition that concentrated on Italian and Spanish painting. Among pictures by Murillo, Claude and Titian (there were nine of his works in the show) hangs Murillo's *Flower Girl* (to the right of the central arch), on loan from Dulwich.

D14

C.J. Richardson

British Institution 1819

Pencil and wash, 29.2 x 17.1 cm

Guildhall Library

This signed and dated drawing by one of Soane's last pupils is a copy from a much larger drawing of the same subject in Sir John Soane's Museum, used by the architect in his Royal Academy lectures.

D15

Exhibition of Paintings at the British Institution

The Pictorial Times, 10 February 1844

Engraving, 15.4 x 20.7 cm

Peter Jackson

The 1844 exhibition of works by British artists at the Institution contained 436 paintings. These were hung in a manner similar to the Royal Academy's early exhibitions, but with an avoidance of the top line.

The *Pictorial Times'* critic was not impressed by the exhibition, commenting that it did not *'display so much talent as usual'*. By the 1840s the contemporary shows at the Institution were in decline, artists having lost faith in it. In its last years it was the object of much criticism.

MANCHESTER ART TREASURES EXHIBITION OF 1857

The precedents set by the success of the international exhibitions held in London in 1851, Dublin in 1853 and Paris in 1855, coupled with a desire to promote Manchester as a city of cultural as well as industrial pre-eminence, prompted a group of prominent Manchester citizens to organise the Art Treasures Exhibition of 1857. The event, which enjoyed the patronage of Queen Victoria and Prince Albert, marks an early attempt to trace a synthetic history of art through the display of works held solely in British collections. It is no coincidence that this occurred at a time when a great issue of debate was the miserably inadequate provision for a national collection of art; for many it became the paradigm for a National Gallery, as in the Art Journal's claim, *'let the present unparalleled display at Manchester suggest some notion of the matchless wealth which under such conditions might one day make up the sum of the national treasure.'*[1]

The building which housed the exhibition, covering over three acres in area, was constructed wholly of wrought and cast iron, timber and glass, with the exception of the entrance façade which was sheathed in brick. Its architect was Edward Salomons, a local Manchester practitioner who was also responsible for the premises of Thomas Agnew in Bond Street, London. The interior, clad in wood and lined with calico and wallpaper, was designed to the specifications of J.G. Crace. The three-bay structure,

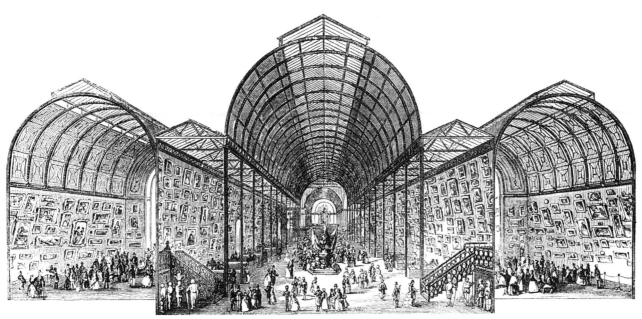

D16(a)

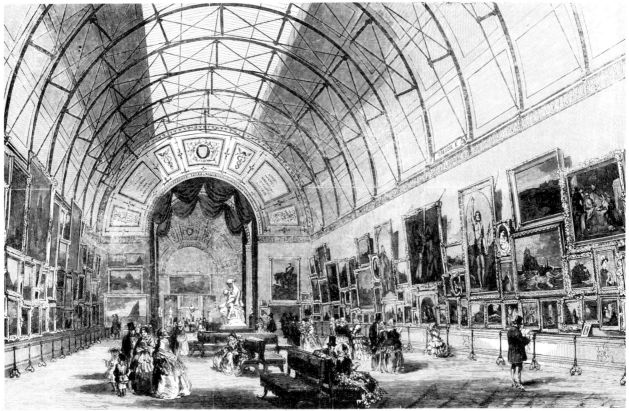

D16(b)

described by The Builder as *'a repetition of the three steam-boilers, side by side, with which Brompton is disfigured'*[2], used the plan of a basilica, proclaiming this temple of the arts *'a joy for ever'* (a line from Keats' *Endymion* inscribed over the main entrance).

The nave housed a wide range of sculpture and decorative arts, while the two side aisles contained the Gallery of Ancient Pictures and the Gallery of Modern Pictures. The former, with works selected and arranged by George Scharf Jr (1820–95), displayed examples from the Trecento through the eighteenth century French paintings on loan from the Hertford collection. Raphael's *Three Graces* and Titian's *Likeness of Ariosto* were on view, but the death of Lord Ellesmere prevented the display of the collection from Bridgewater House. The latter gallery, with works selected by Augustus Egg, offered a comprehensive representation of contemporary British art from Gainsborough's *Blue Boy* to Leighton's *Procession of Cimabue*.

The Art Treasures Exhibition, which attracted over a million visitors and managed to return a profit, is now only retraceable through images such as these and through contemporary documentation. The art works were returned to their owners, and the building was sold and destroyed immediately after the close of the exhibition.

Stephen Fronk

1 'The National Gallery' in *Art J* 1 August 1857 p.237.
2 *Builder* 19 July 1865 p.398.

D16

Manchester Art Treasures Exhibition of 1857

(a) Interior View of the Art Treasures' Palace 1857

Photograph from *Manchester Public Libraries*

(b) Gallery of Modern Painters

Engraving from *Illustrated London News*, 4 July 1857

NEW PICCADILLY GALLERY OF ART (founded 1881)

The New Piccadilly Gallery of Art, built in 1881–82, reflected the commercial expansion of artistic activity in late nineteenth century England, as well as the attention given to housing what was unself-consciously known as Beauty. Situated on the south side of Piccadilly close to St. James's Church, it was funded by the Piccadilly Art Gallery Company, in which the Institute of Painters in Watercolours was a partner.

The architect was E.R. Robson (1836–917): he gained a reputation as a specialist in the field of art galleries towards the end of his life, though much of his career was devoted to the design of schools for the London School Board, for which he was architect from 1871 to 1889. According to his son, the Piccadilly Gallery was Robson's best building, reflecting his profound study of the architecture of Ancient Greece and of such moderns as Greek Thompson of Glasgow, as well as his devotion to the writings of his friend John Ruskin. The exterior embodied a principle, enunciated by Ruskin in *The Seven Lamps of Architecture*, that *'Wherever Proportion exists at all, one member of the composition must be either larger than, or in some way supreme over, the rest.'* The result met with Ruskin's approval: Robson met him in Piccadilly, opposite the Gallery, and the sage remarked that he *'never passed without stopping to admire its freshness'.*[1]

The interior contained dual functions, comparable to the Grosvenor and Grafton Galleries. The enormous Art Gallery, split into three rooms, top-lit and covering the whole site, was intended to accommodate watercolour exhibitions similar to the Academy in being open to all comers, in place of the previously closed exhibitions. The ground and mezzanine floors were given over to shops, while a public hall at the back of the building, supported by kitchens, was available for dinners and other occasions. The exterior was classical, with what *The Builder* called *'a pronounced Greek motive'*: the shops on the ground floor were surmounted by a high blank wall in front of the gallery space, *'a free introduction of sculpture, harmonising with the objects and character of the building, being a distinguishing feature in the facade.'*[2]

The building survives, though the lower part of the front elevation has been removed. It continued to be used for exhibitions until after World War II.

1 Philip A. Robson, 'A Memoir', *RIBA Jnl* Feb 1917.
2 *The Architect* 5 Nov 1881.

D17

Gallery of the Institute of Painters in Watercolours, Piccadilly

Illustrated London News, 28 April 1883
Engraving, 14.9 x 23 cm

Peter Jackson

E Private Collections

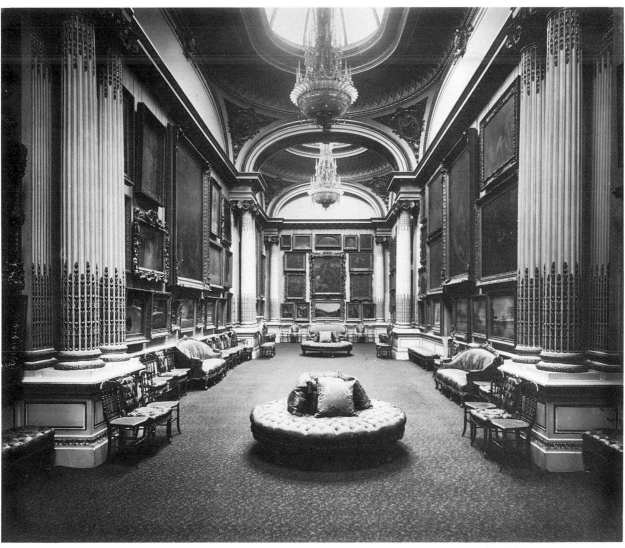

E14

This section continues, from the 1830s onwards, the history, begun in Section A, of the very diverse private galleries of nineteenth century Britain. It could be much expanded: the subject of artists' houses and studios, for example, deserves its own exhibition. The role of great houses in Victorian London (grouped here in a section at the end) is also one that would repay further study; it is represented by a selection of the most important examples.

E1

George Arnald ARA (1763–1841)

Self-Portrait in his Studio 1831

Oil on canvas, 76.2 x 63.4 cm

National Portrait Gallery

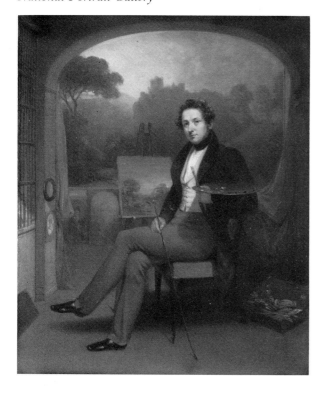

Arnald depicts himself seated in his studio at 2 Weston St, Pentonville. The setting suggests that the studio served as an exhibition place, as was the custom for nineteenth century artists. His celebrated *The Castle of Gloom* (exhibited at the Academy in 1814) forms the backdrop on the far wall, theatrically placed behind the draped arch in a shallow top-lit space. The objects surrounding Arnald attest to his professional skills, while his clothing establishes his position as a gentleman, in contrast to the Romantic vision of the artist.

Arnald, a frequent exhibitor of landscapes and seascapes at the Royal Academy and the British Institution, may have used this picture to advertise his talents as a portraitist. This is borne out by the fact that almost all his portraits, few in number, were executed between 1833 and 1835, just after the completion of this painting.

Stephen Fronk

E2

J.B. Papworth (1775–1847)

Design for alterations to form a Picture Gallery at No. 113 Park Street 1839

Pen and watercolour, 26.5 x 33 cm

British Architectural Library Drawings Collection/RIBA

This watercolour is one of three designs for a private gallery in Park Street, Mayfair, commissioned from Papworth, who had some reputation as the designer of galleries and shop fronts. It appears to have offered accommodation on the attic floor of the house for a collector and amateur artist, since it includes a *'Painting Room'* and *'Color Room'* (where paints could be mixed), as well as a gallery for the display of pictures. The owner of 113 Park Street in 1839 was a certain H.A.J. Munro, but he is not recorded as an exhibiting artist.

The fine small gallery with its traditional red walls is lit by a wholly individual system of diagonal monitor lights, designed to shed as strong a light as possible on the pictures.[1]

1 G. McHardy, *Catalogue of the RIBA Drawings Collections: Office of J.B. Papworth* (1977) p.79.

* E3

Douglas Morison (1810–47)

The Picture Gallery at Buckingham Palace 1843

Watercolour, 27.6 x 38.9 cm

HM The Queen

From 1821 until his death in 1830 George IV was occupied with the last of his major building projects, the rebuilding by John Nash (1752–1835) of Buckingham House, bought by George III in 1762. Work actually began in 1825, but at the end of 1826 the King decided that the building should be regarded not as a private residence but as a state palace. The relatively modest house where the King's parents had lived (to the east of the new garden front), was encased by Nash in a building on a much more considerable scale, incorporating much of the old structure but introducing a series of imposing state apartments. As a result of the King's extravagance, the works became enormously expensive, provoking a national scandal and precipitating Nash's disgrace after the King's death.

The Picture Gallery shown in E3 was formed out of the former Queen's apartments in the old house, and is situated in the centre of the garden block of the Palace, above the Sculpture Gallery: it had to be top-lit because there was no other access to natural light. It formed an important element in the ceremonial circulation route within the palace, and was also used for banquets. For this space Nash designed a remark-

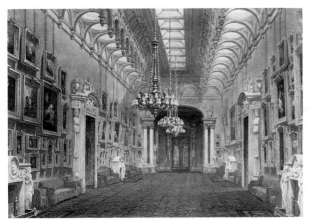

E3

able lighting scheme, inspired by Soane's ceiling for the Chancery Court at Westminster, and somewhat resembling the arrangement in the gallery designed by Nash in 1820 for his own house at 14 Regent Street. At the Palace, Nash introduced a row of individual domed openings along the sides of the room, intended to direct light onto the pictures. This extremely individual arrangement was found to be unsatisfactory from the first – it was criticised in the early Parliamentary Reports on the building – and was altered by Edward Blore (1787–1879) in the 1830s, with the introduction of an additional series of square lights down the centre of the apartment. Further alterations were made by Sir James Penneth-orne around 1852.[1] Later critics varied in their reactions to the room: Mrs Jameson found it too high and dark[2], but Waagen, a greater authority, considered it to be *'lighted very favourably.'*[3]

The Picture Gallery was completely reshaped in 1914 by Aston Webb. The old ceiling was replaced by a curved glazed ceiling, with two longitudinal supports. A neo-Adam frieze was introduced, reducing the apparent height of the room, and the highly decorated doorcases seen here were replaced by simplified versions, the total effect being much more bland. Features of the original gallery that survive are four of the five chimneypieces by the sculptor Joseph Browne (fl. 1815–48), extensively employed at the Palace in the late 1820s. These feature in their central roundels Leonardo, Titian, Dürer and Van Dyck.

The Picture Gallery was intended by George IV to provide a space for displaying large pictures, and is in the tradition of the aristocratic galleries of London houses built throughout the nineteenth century. The King did not have the opportunity to arrange his paintings there since the room was not sufficiently complete by the time of his death, and his successor did not move into the palace. It was left to Queen Victoria and Prince Albert to hang the gallery; their approach differed from George IV's. *The Catalogue of the Pictures at Buckingham Palace* of 1841 records the

new arrangement, clearly made by the Prince: not only was he extremely interested in paintings, but late in her life the Queen stipulated that the paintings arranged by her husband in the Palace (and at Windsor) should not be moved.[4] Among other changes, Albert arranged that all the pictures should be uniformly framed. 210 paintings are listed. Of these, 25, scattered among various state rooms, were portraits, almost all royal. The remaining paintings were concentrated in the Gallery. These included works by Titian and Dürer (possibly in deference to the chimneypieces) but were otherwise almost exclusively British, Dutch or Flemish. The British pictures, by Wilkie and William Allen, were genre pieces close in spirit to the Dutch cabinet paintings which dominated the room and included considerable numbers of works by Dou, Teniers, the Wouwermans and the other Netherlandish artists beloved by George IV and collected by him at Carlton House. Brief explanatory notes were provided to the 1841 catalogue, since in the 1840s the Gallery was open to visitors with an Order from the Lord Chamberlain, when the Queen was not in residence.[5] A further catalogue, of 1852, prepared by Thomas Uwins RA, Surveyor of the Queen's Pictures, gives a somewhat different order for the paintings, and provides a more extensive accompanying text for the principal works, with biographical details for the artists. Though some alterations had been made to the choice and arrangement of the collection, it remained substantially the same as ten years before.

The Picture Gallery was rehung for Edward VII, who took a considerable interest in the collection, by his Surveyor Sir Lionel Cust.[6] The yellow damask seen in this watercolour was replaced by olive-green damask in 1914, when the room was remodelled. In spite of some adjustments, the pictures continued to be hung very densely until their return to the Palace after the Second World War, when a new, sparer, hang was introduced, with the inclusion of various very large works. The walls are now pinkish in tone.

Since 1962 changing exhibitions of works from the Royal Collection have been shown at the Queen's Gallery, created within the walls of Queen Victoria's Private Chapel, which had been bombed during the Second World War.

1 King's Works; Harris, de Bellaigue, Millar passim; Cust (1930) p.28ff.
2 Jameson (1844) p.3.
3 Waagen (1854) II p.1.
4 Harris, de Bellaigue, Millar p. 240.
5 Jameson (1844) p.1.
6 Cust (1930) p. x ff.

☐ Sir Lionel Cust, *King Edward VIII and his Court* (1930)
☐ J. Harris, G. de Bellaigue, O. Millar, *Buckingham Palace* (1968)

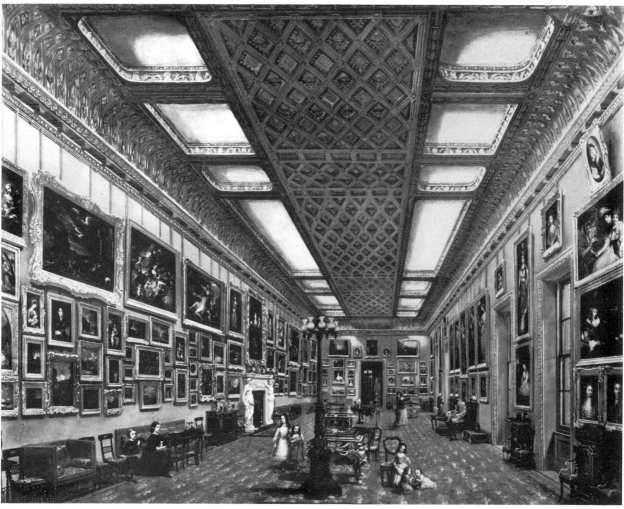

E4

E4

James Digman Wingfield (fl. 1838–72) and Joseph
Rubens Powell (fl. 1835–71)

The Picture Gallery at Somerly 1866

Oil on canvas, 38 x 49 cm

Private Collection

One of the latest aristocratic galleries, this room was
added to his late eighteenth century house by the
second Earl of Normanton (1778–1868) in 1850–51.
An ardent buyer of pictures, Normanton himself
designed the gallery for his notable collection of
Dutch, Italian and British paintings, including almost
thirty works by Reynolds. The lighting system offered
a fine solution, with top lighting on either side of a
dark central strip, and additional light from the lofty
side windows. Dr. Waagen especially admired this
room: writing after his visit in 1854, he commented
on the good proportions, the rich tasteful quality of

the decorations and the excellence of the furniture,
and was enthusiastic about the lighting: *'the lighting
from above is so happily calculated that every picture receives
a clear and gentle light'*, while the reflections so
disturbing in the Bridgewater House gallery were
avoided.[1] The gallery and its collection survive.

Shown at Dulwich Picture Gallery only

1 Waagen, supplement vol. p.363ff.

THE STUDIO OF SIR LAWRENCE ALMA-TADEMA, LONDON

E5

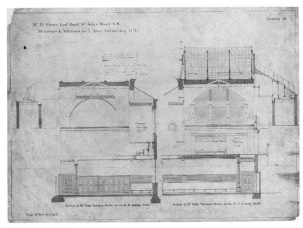

E6

In August 1885, renovation began on No. 17 Grove End Road,[1] St. John's Wood, to the designs of its owner, Sir Lawrence Alma-Tadema, with technical assistance from his neighbour, the architect Alfred Calderon. The house, which was bought from the artist J.J. Tissot, who had already made various alterations to the original structure by incorporating a studio, conservatory and formal garden, grew considerably under Alma-Tadema's scheme. Upon completion in November 1886, the artist and his family moved in, and it remained the centre of Alma-Tadema's personal and artistic life until his death.

Visitors entered the house, externally of deep red brick decorated with yellow friezes in relief, through a colonnaded passageway. The front door, a copy of a doorway from the forum at Pompeii, bore the greeting *Salve* above it, and led the visitor into a hall filled with 50 panels painted by such artists as Leighton, Poynter, Sargent and Dicksee. The magnificent decor extended through the house,

culminating in the studio, sections and plans of which can be seen in E5 and E6. This studio, which was reached by a flight of brass stairs, had walls sheathed in grey Siena marble and an embroidered red velvet dado, with a domed ceiling of the then precious metal, aluminium. It was lit by a window extending from floor to ceiling, and by a small window in the dome fitted with yellow glass.

This example illustrates the dual function that artists' studios served in the later nineteenth century. Here Alma-Tadema could display his work with complete control over aesthetic decisions, and (during the Monday afternoon openings) entertain the colony of artistic people in St. John's Wood, which at various times included Frith, Goodall, Calderon, MacWhirter, George Eliot and Swinburne.

Stephen Fronk

1 Renumbered 34 in 1901.

E5
Sir Lawrence Alma-Tadema RA (1836–1912)
Alma-Tadema's House, plan of first floor 1884–85
Pen and wash, 61.5 x 95 cm

British Architectural Library Drawings Collection/RIBA

E6
Sir Lawrence Alma-Tadema
Alma-Tadema's House, sections of studio 1884–85
Pen and wash, 48 x 67.5 cm

British Architectural Library Drawings Collection/RIBA

LEIGHTON HOUSE, LONDON

In 1864, the painter Frederic (later Lord) Leighton commissioned his friend and architect George Aitchison to build him a house and adjoining studio on the Holland estate. Leighton was granted an unusual lease by Lady Holland, allowing him to adjust interior features inside the existing home '...in the nature of a Work of Art'; this gave Aitchison the freedom to create a house to Leighton's specifications. The extent to which Leighton influenced Aitchison (both were RIBA Gold Medal winners) has left grounds for speculation, especially in view of the extremely personal quality of Leighton's studio and design details. The first floor was dominated by Leighton's sun-drenched studio at the rear of the house, which was coupled with a gallery. For additional privacy and

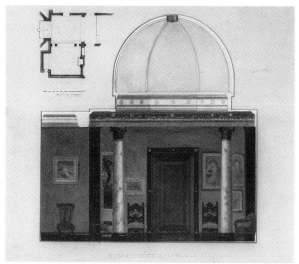

E7

E8

propriety, a side entrance to the studio was created, to allow his models freedom to enter and leave discreetly. Various additions and alterations were made following the initial completion of the house in 1866: the studio was lengthened in 1869–70, the Arab Hall (built for Leighton's collection of tiles) was added in 1877–79 and a top-lit picture gallery to the south side of the studio in 1895.

E7

George Aitchison RA (1792–1861)

Leighton House, wall of picture gallery 1895

Watercolour, 49 x 47 cm

British Architectural Library Drawings Collection/RIBA

E8

Photograph of studio 1895

GREAT LONDON HOUSES

GROSVENOR HOUSE

With Bridgewater and Apsley Houses, Grosvenor House represented the apogee of the nineteenth century town house as palace of art. All three houses had galleries, containing paintings of the highest quality and accessible to visitors. At Grosvenor House, as at the others, development of the building was directed by the owners' desire to house their collection suitably.

Grosvenor House stood on the site of the present hotel, but faced towards Upper Grosvenor Street rather than Park Lane. A private house was erected on the land in the early nineteenth century and from 1805 was occupied by the Grosvenor family, owners of most of Mayfair. It remained in their hands until sold in 1924, and was demolished two years later.

E10 illustrates the exterior of the house in 1828, seen from Upper Grosvenor Street. To the main eighteenth century block, on the right, two additions had been made. The first was the Gallery (in the centre), built by Porden from 1817 to 1819. William Porden (c.1755–1822), who also rebuilt the Grosvenors' country seat at Eaton Hall, had already carried out considerable work for Lord Grosvenor in 1806 in refurbishing the London house for the display of pictures. Porden's correspondence[1] conveys the minute care given to the choice of colour schemes (crimson and scarlet damasks were preferred), and to framing and hanging, questions in which Porden interested himself closely. Earl Grosvenor took his pictures seriously, employing William Seguier, later Keeper of the National Gallery, as curator. The 1817 work involved the erection of a purpose-built gallery with top lighting which, Porden assured his employer, would be much superior to that at Dulwich.

In 1826 Lord Grosvenor asked his new surveyor, Thomas Cundy II (1790–1867), to remodel the Porden gallery (the principal change lay in the reorganisation of the ceiling) and to add a further, square, room for four huge works by Rubens acquired in 1818. This additional room is seen on the left side of the drawing. The exterior of the whole wing was also remodelled by Cundy, who applied a giant Corinthian Order and blind aedicules: the attic storey above the new Rubens Room was ornamented with figures symbolising the arts and sciences. Its disproportionate size and splendour in relation to the centre of the house indicate that though the family from time to time contemplated major alterations to the main body of the house, these were not carried out. Revealingly, the main thrust of rebuilding was directed at rooms dedicated to pictures.

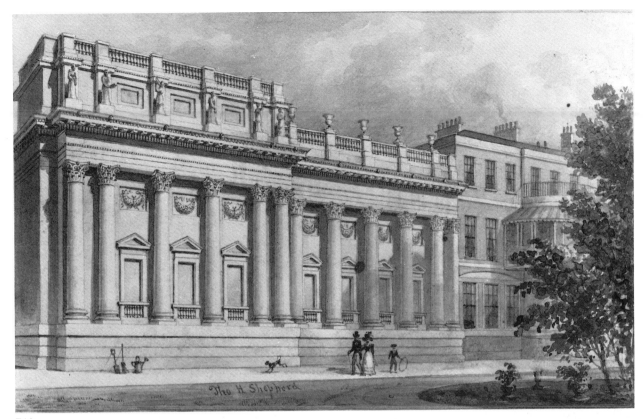

E10

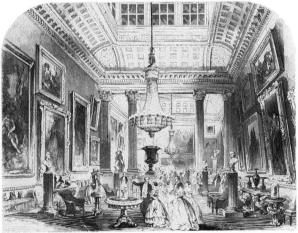

E11

E11 shows the first gallery, with the Rubens Room seen through columns beyond. Like C.R. Leslie's *The Grosvenor Family* of 1823 (collection of The Duke of Westminster), it illustrates the use to which such galleries were put: they were not only exhibition rooms, but were intended for the new style of hospitality, which involved receiving very large numbers of people, and were also used for intimate family gatherings.

In 1870 the third Marquess of Westminster commissioned Henry Clutton (1819–3) to reorganise the galleries, working with J.G. Crace as decorator. Though Clutton did not make major alterations to the plan, he created actual windows onto Upper Grosvenor Street, added an apse towards Park Lane to give grandeur to an understated side of the building, and replaced the top-lighting with ceilings and cornices of the most up-to-date Italianate Renaissance splendour. Bedford Lemere's photographs of 1889 show the result. The contrast in E12(a) between the Gallery, with its furniture set against the walls and its parquet floor, and the Drawing Room beyond, illustrates the semi-public character of the galleries: they were much used in the later part of the century for charity concerts and meetings, with a Green Room added for the purpose, and permission was given in the 1870s for designers and artisans engaged in 'the productive arts'[2] to visit the rooms on summer afternoons.

1 In the Records of the Grosvenor Estate Office; see *Survey of London* XL pp.239ff for a full account of Grosvenor House.
2 *Survey of London* op. cit. p.248.

141

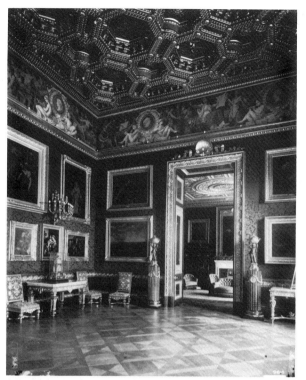

E12(a)

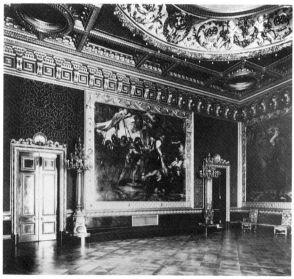

E12(b)

E9
John Young
Grosvenor House Collection 1820
Book, octavo, 46pp.

Charles Sebag-Montefiore

E10
T. H. Shepherd (1817–40)
Lord Grosvenor's Gallery, Park Lane c.1828
Pencil and brown wash, 9 x 14.5 cm

Museum of London

E11
Private Gallery of Marquis of Westminster at Grosvenor House
Illustrated London News, 30 June 1849
Engraving, 17.7 x 23.5 cm

Peter Jackson

E12
Photographs of Grosvenor House by Bedford Lemere:
(a) The Picture Gallery 1889
(b) The Rubens Room 1889

BRIDGEWATER HOUSE

E13(b)

In 1840, Lord Francis Egerton (created first Earl of Ellesmere in 1846), fearing the threat of fire and decay in the existing Bridgewater House, decided to rebuild. During the following year Sir Charles Barry produced preliminary designs for the new building; some of his initial designs survive in tracings made by his student James Murray. A significant alteration from the early plans to the design as executed was the change from five galleries of various sizes and five smaller rooms *en suite* for cabinet pictures, to the single great picture gallery. Over six years various changes were made to Barry's designs, while a more

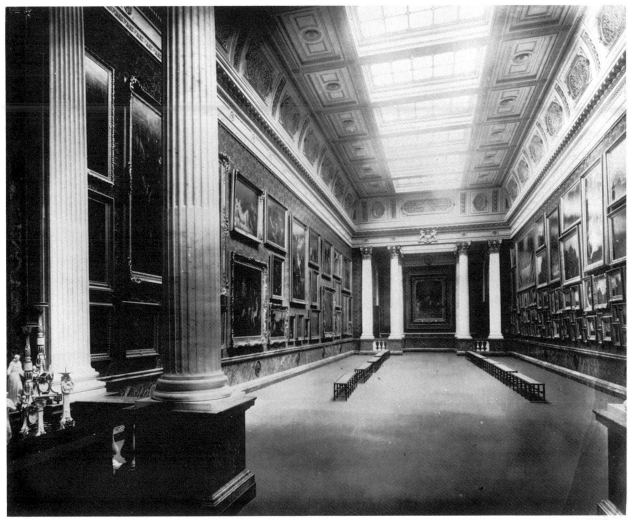

E13(a)

elaborate and imposing site was created for the new house.

Building began in 1847, with the picture gallery, which was completed in time for the Great Exhibition, opening to the public in May 1851; the house was not ready for occupation until 1854. The collection had been readily available to visitors in the old house; Mrs. Jameson, writing in 1844, described it as a *'Paradise of art'* and commented that it had always been the most accessible of London galleries.[1] The new picture gallery was commended because of its *'...free admission, the number and value of the pictures, and perhaps we may add the indifferent light, (which) make us forget that the collection was formed to gratify the taste of a private connoisseur, and that it is not a museum framed for public use and instruction.'*[2] The gallery, with its oblong plan and top-lighting, provided a noble setting for Ellesmere's collection. At either end of the gallery, a Corinthian screen composed of two columns opened into a shallow bay. The east bay had two doorways, an entry into the saloon corridor, and a separate staircase to street level for the public. A testimony to the gallery's vastness is that after its destruction by bombing in 1943, the space was converted into three floors of offices.

The gallery was regularly open to visitors until the Second World War, the family continuing to regard the display of their paintings as a public obligation.

1 Jameson (1844) p.79.
2 *Fraser's Magazine for Town and Country*, vol. 44, no.260, Aug 1851, pp.211–12.

E13

Photographs
(a) The Picture Gallery, 1890
(b) Exterior showing Picture gallery 1917
(c) The Picture Gallery after bombing 1943

DUDLEY HOUSE

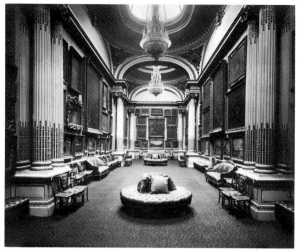

E14

SPENCER HOUSE

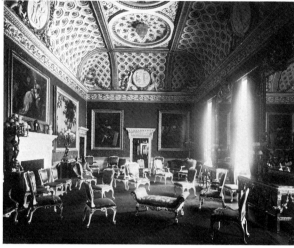

E15

Dudley House, the only large surviving aristocratic house on the Grosvenor estate, was designed and rebuilt for the fourth Viscount Dudley and Ward (created Earl of Dudley in 1827) by William Atkinson in 1827–8. Major alterations were completed by S.W. Daukes for the eleventh Lord Ward, including a ballroom coupled with an 80 foot picture gallery, both decorated in a Louis XVI style and completed in 1858. The picture gallery, which was ornate and extensively gilded, was divided into three sections by paired columns of white Parian marble, disguising its long narrow shape. Each section was supplied with natural light by a top-lit system of windows. The walls were painted muted green and decorated with a gold diapered pattern, a combination considered '*extremely harmonious with pictures frames.*'[1] The gallery housed the Earl of Dudley's extensive collection of Italian and Flemish paintings, previously displayed in the Egyptian Hall, Piccadilly.

1 *Survey of London* XL Part II (1980) p.278.

E14
Photograph of the Picture Gallery 1890

Spencer House was built between 1756 and 1766 by John, 1st Earl Spencer. The House was designed by John Vardy (1718–1765), but in 1758 Vardy was replaced by James 'Athenian' Stuart, then newly returned from Greece, where with the assistance of Nicholas Revett, he had been compiling the first accurate survey of the ancient monuments, published in 1762 as the *Antiquities of Athens*.

Stuart was responsible for the decoration of all the rooms on the first floor, and the focus of this suite, for entertaining and for Lord Spencer's art collection, was the Great Room. This was conceived as a setting not only for receptions and balls, but also for pictures. If the first Earl Spencer wished to be known as a generous and gracious host, he was no less eager to impress on his guests that he was both a connoisseur and a collector, a man of taste and education as well as wealth and rank. The sums which he spent, and the lengths to which he was prepared to go in order to acquire first-rate pictures both in England and abroad, were ample evidence of the importance which he attached to collecting and being seen to collect. Pictures were a passion, and those which hung in the Great Room were the finest the first Earl possessed. As far as the Spencers were concerned, they were the single most important ingredient.

Joe Freidman and John Martin Robinson

E15
Photograph of the Picture Gallery 1895

F University Museums

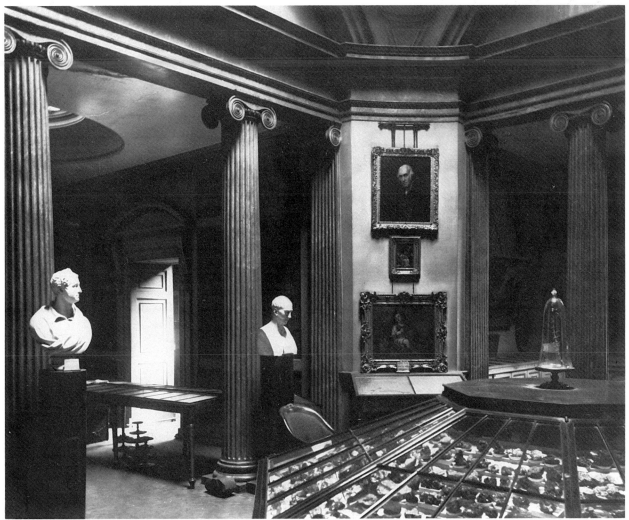

Hunterian Museum

Though never incautiously enthusiastic over supporting their museums, British universities have accumulated through the generosity of private donors remarkable collections of paintings and drawings, as of other artefacts. These collections, and the buildings that contain them, are outstanding within a European context, and are matched only in the United States. In almost all cases, their future is currently threatened or at least seriously hampered by the financial constraints imposed on universities. Traditionally, university art museums have been regularly opened to the public, a privilege which is generally taken for granted.

The selection of institutions here is small and conservative – many more examples could have been chosen. Happily, the tradition continues, as the Sainsbury Centre (H10) illustrates.

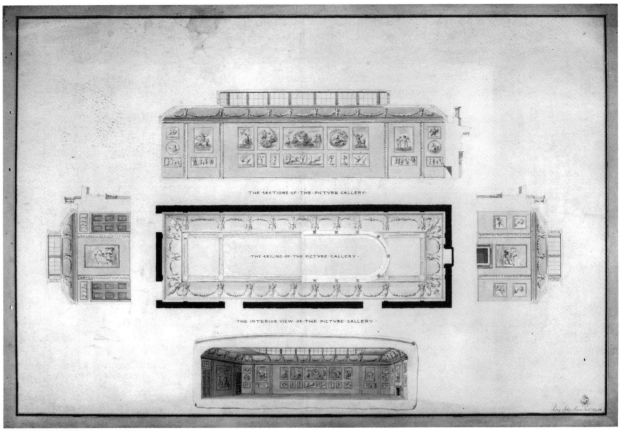

F1

F1

Sir John Soane RA (1753–1837), drawn by Frederick Meyer

Proposed Picture Gallery at Cambridge University 1791

Pen, grey wash and watercolour, 64 x 95.5 cm

Trustees of Sir John Soane's Museum

In March 1791 Soane made a survey of the Senate House.[1] The Syndics of the University, who had recently acquired from King's College land next to the Senate House erected by James Gibbs in the 1720s, were bent on tidying up the area and on completing Gibbs' unfinished building: only one block of the intended three had ever been erected. Soane, who at the time was working on Wimpole Hall, near Cambridge, was asked to produce designs for a second wing identical externally to Gibbs', with a matching elevation onto Trumpington Street. The interior was to contain '*A museum, a picture-gallery, a large Lecture-Room, which may serve also for a Music Room, a smaller Lecture Room, and a Registrary's office...*'.[2] On 1 August Soane travelled to Cambridge taking '*seven fair drawings of the building to correspond with the Senate House.*'[3] The drawing exhibited is a copy of one of this set, which survive in Sir John Soane's Museum together with some smaller depictions of the scheme; all the principal rooms are shown in the presentation drawings. A decision was not made by the University until December, when the proposals were rejected at a Syndics' meeting. No further action was taken, and Soane had to content himself with reorganising the fencing.

Soane's building would have contained the accommodation required by the University on two principal floors. The Great Lecture Room and music room, a smaller lecture room and a hall would have been situated on the ground floor, rising to fill the level above. The top floor was to contain a museum, lit by three domes, and containing glass cases filled with natural history specimens and minerals from England, Scotland and Ireland. The Picture Gallery, shorter and broader than the Museum, was placed next to it. This arrangement reflected the idea, still current in the 1820s when the establishment of the new National Gallery was under discussion, that paintings could comfortably be included in a general scientific or archaeological museum. The Gallery was placed at the top of the building to allow top-lighting: externally the ceiling was concealed behind capital and balustrade, much like the arrangement at Senate

146

House. It was to be lit by monitor lights, with winged figures holding garlands to decorate the coving beneath. The opening at the top did not extend the full length of the room, but ended in a covered area at each end. The coving is indicated as grey, with the pilaster-strips white, while the walls are blue-grey. The design of the whole is highly decorative, unlike Soane's later, more severe, gallery interiors.

The two layers of pictures, shown in formalised patterns, are unrelated to any works then owned by the University.

1 SM Soane's Journal I p.147ff.
2 Syndics' meeting, 13 April 1791, quoted in Willis and Clark (1986) III p.74.
3 SM Soane's Journal I p. 14.

☐ R. Willis and J.W. Clark, *Architectural History of the Universities at Cambridge* (1866)

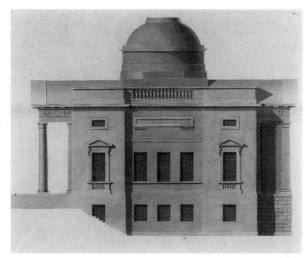

F2

THE HUNTERIAN MUSEUM AND ART GALLERY (founded 1807)

Though now split into several sections, in its early days the Hunterian Museum united the encyclopaedic possessions of Dr. William Hunter (1718–83). These numbered paintings as only one part of a collection encompassing anatomical, zoological, geological and ethnographical specimens, a large library, illuminated manuscripts and one of the largest coin cabinets in Britain.

William Hunter was one of the talented and public-spirited doctors of medecine who made an important contribution to the cultural life of Britain in the eighteenth century: they included Sir Hans Sloane and Hunter's brother John, whose own collections partially survive at the Hunterian Museum in London. A Scot, William Hunter moved in 1741 to London, where he became celebrated as an obstetrician and anatomist. He built up a fashionable practice, was appointed Physician Extraordinary to Queen Charlotte, and was an active teacher, his lectures being attended by some of his most cultivated contemporaries. He erected for himself a house, anatomy theatre and museum in Great Windmill Street, to the designs of Robert Mylne.[1] His success brought Hunter wealth, which he spent on accumulating scientific and artistic specimens. Partly intended for scientific study, and easily accessible to educated visitors, the collections also included over fifty paintings, many of them bought from the engraver and art dealer Sir Robert Strange. A typical assembly of seventeenth century works by Dutch, French and Italian artists, it also included two paintings by Stubbs and three by Chardin.

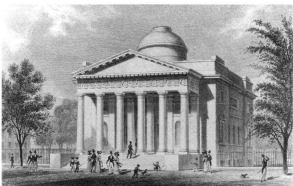

F4

Hunter bequeathed his collections to Glasgow University on condition that they should remain available in London to his nephew and his assistant, for thirty years. In 1806 the collections were installed in a new museum within the Old College (now demolished) in the centre of Glasgow. Following a limited competition, the University had given the commission to William Stark (1770–1813). Much admired by his contemporaries, Stark executed a number of public buildings in Glasgow and Edinburgh, including the Advocates' Library in the latter city, and gained a reputation as a specialist in planning lunatic asylums. Though this skill did not obviously equip him for designing museums, the building he erected for the Hunterian was, historically, highly important: other than private sculpture galleries, it was the first temple devoted to the muses in Britain, a type that was to dominate art museums until the end of the century. The Museum was a four-square classical building with a giant Doric portico, somewhat resembling the Pantheon, though the side elevations fail to maintain the force of the facade.

Internally the building was arranged in a series of rooms dedicated to various disciplines. Captain John Laskie's *A General Account of the Hunterian Museum, Glasgow* (1812), the first printed description of the new installation, reproduces as its frontispiece a print of the Picture Gallery by J. Scott, which was also used as the Museum's book-plate. It is significant that the Gallery was placed under the dome, on the first floor, at the very centre of the museum. Laskie describes how, in these *'superb rooms'*, other parts of the collection were presented: *'six handsome cabinets painted in fresco, with gold mouldings'* and *'five elegant glass cases on mahogany Grecian stands'* displayed the shells beside the pictures and books. Comfort was not ignored: *'elegant seats covered with crimson, occupy the spaces between the cabinets, in addition to which, are several handsome Grecian chairs (F3), in which the visitant may rest, and contemplate with delight the tout ensemble.'*[2]

The collections remained in the old Hunterian, in conditions of increasing dilapidation, until the 1870s, when they were moved to the new university buildings designed by Gilbert Scott. While many of the scientific holdings were gradually dispersed among the university departments, the paintings remained for many years with the core of the Museum, unhappily shown on all-too-permanent temporary screens in a cavernous hall wholly unsuited to their character.

The situation was remedied when in the 1970s it was decided to build a separate Art Gallery for Hunter's pictures and for other works of art given to the University in the twentieth century, notably the Whistler and Mackintosh collections, the latter of which included an actual house at Southpark Avenue, Glasgow. The new building, designed by Whitfield Partners, opened in 1980. It ingeniously accommodates the interiors of the Mackintosh house, which is partially expressed externally. The bulk of the building is Brutalist, finished in concrete. Accounts of the aims of the new building by the curators[3] reveal the detailed consideration given to the technical aspects of the building: the air-conditioning, controlled lighting and provision of service areas are the elements principally discussed. The Old Master paintings are displayed in a large, wholly neutral space, divided by semi-permanent screens. It is remarked of the architect that he *'has avoided decoration and intrusive detail wherever possible'*:[4] a striking contrast to galleries opened in Britain a decade later.

1 Brock (1980) pp.403ff.
2 Laskie (1812) pp.86–87.
3 See C. Allen, 'A Home for the Art Collections' in *Art Galleries Association Newsletter*, Winter 1980, p.14.
4 Allen (1980) p.11.
☐ Captain John Laskie, *A General Account of the Hunterian Museum* (1812)
☐ C.H. Brook, 'Dr. William Hunter's Museum, Glasgow University', *J. Soc. Biblphy Nat Hist* (1980) 9 (4)

F3

F2
William Stark (1770–1813)
Elevation of the South Front of the Hunterian Museum 1803
Watercolour over pencil, 40.6 x 33 cm

Glasgow University Archives

F3
Hunterian Museum chair 1809
Hunterian Museum, University of Glasgow

F4
Thomas H. Shepherd (fl. 1817–40), engraved by Augustus Fox
Hunterian Museum c.1820–30
Engraving, 12 x 16.5 cm

Hunterian Museum, University of Glasgow

F5
J. Scott (fl. c.1807–30)
Hunterian Museum, interior
Engraving, 11.5 x 13 cm

Hunterian Art Gallery, University of Glasgow

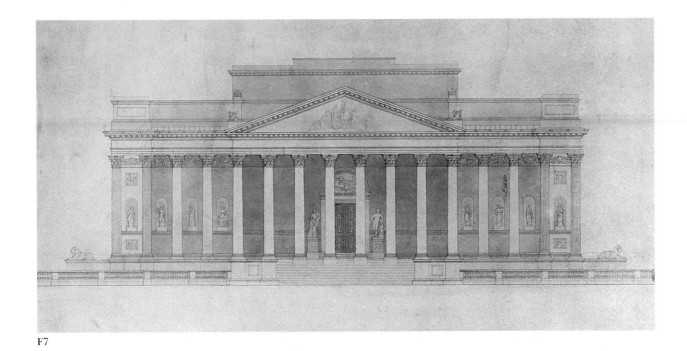

F7

THE FITZWILLIAM MUSEUM (founded 1816)

The University of Cambridge is notably fortunate in its museum of arts. Even though its aspirations have often been frustrated by cash shortages, the Fitzwilliam was early housed in a fine building and has added to it with sympathy and style.

On his death in 1816, the seventh Viscount Fitzwilliam bequeathed to his old university his Old Master paintings, a large collection of prints, and his library, with funds for the erection of 'a good substantial and convenient Museum, Repository, or other Building, within the Precincts of the said University.'[1] Having accommodated the collection temporarily in the hall of a school, the new Syndics of the Museum examined numerous possible sites at the heart of the university, wishing their new building to be accorded as prominent a position as possible. In the end they compromised on land bought from Peterhouse on Trumpington Street, less central than they had originally hoped, and so close to the road that no axial view could be obtained of any building placed there – an important element in the museum finally erected. Problems with lessees delayed progress until, in July 1834, a competition was announced for a new building. The brief was, indeed, brief: it stipulated only that the new museum should occupy the centre of the site, providing space for 200 pictures and possible additions, and cost no more than £40,000.

The history of the competition that ensued has been variously recounted.[2] Among the 36 designs by 27 architects, the majority were classical, though Rickman and Hussey produced extravagant schemes for a Gothic museum and library in the manner of Fonthill Abbey.[3] It was inconceivable even in a city where Gothic was so important that a Gothic design could be chosen, and the winner, by an easy majority of votes, was Basevi.

George Basevi was well suited for this commission. A pupil of Soane from 1810, he had worked in 1811 at Dulwich. Though his vigorous scholarly classicism was in the Soanean tradition, he was no slavish follower of his master. He wrote shortly after leaving Soane's office in order to tour Europe, 'Each succeeding day tells me I have done right in quitting Soane. I still continue to think him clever, but in a peculiar style, I am of opinion I can form for myself a better.'[4] Basevi's correspondence during his tour of France, Italy and Greece is distinguished by the interest he showed in paintings. He visited the Louvre before the dismantling of the Musée Napoléon, and spent much time at the Uffizi and the Roman museums, admiring Italian sixteenth century painting and classical sculpture, and discussing the best lighting and arrangement of pictures (he considered the Louvre too large and over-crowded, the Uffizi being much more satisfactory since 'here one picture is so separated from another as not to be a foil').[5] The attitudes behind his conception of the Fitzwilliam are apparent from his comment on the same tour that 'My eyes are beginning to open and I now feel the precept of Vitruvius, that an architect must have a thorough knowledge of painting and the human figure.'[6] Though on his return to London much of Basevi's time was devoted to urban housing in Kensington and Westminster (he built Belgrave Square), few of his contemporaries were as well suited to the task of designing a major museum.

149

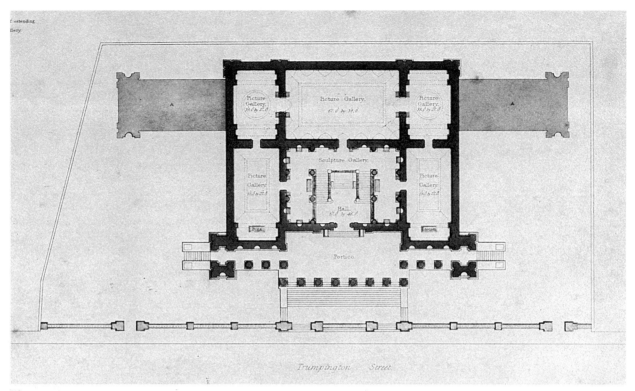

Picture
Gallery.

Picture Gallery.
67.6 by 37.6

Picture
Gallery.

Picture
Gallery.

Sculpture Gallery.

Picture
Gallery.

Hall.

Portico.

Trumpington Street.

F8

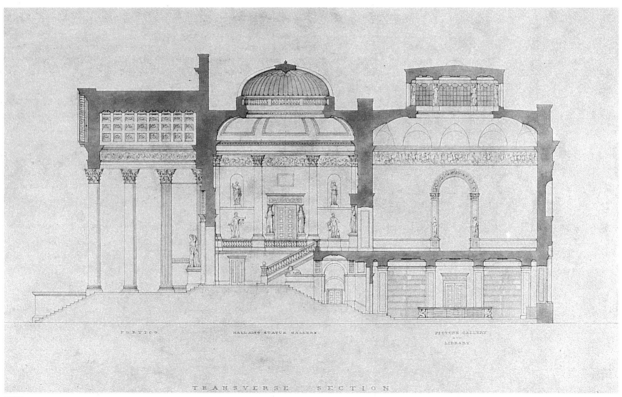

PORTICO. HALLAMS STATUE GALLERY. PICTURE GALLERY
 LIBRARY

TRANSVERSE SECTION

F10

150

In view of the brief, Basevi's building can be assumed to derive entirely from his own inspiration. His choice of a Roman prototype for the portico – the Capitolium at Brescia, excavated in 1820 – is in the academic tradition. He gave much thought to the position of the Museum within the streetscape, commenting on a site plan[7] that a *detached and elevated* Greek temple made much more impact in a city than did, say, the Pantheon, *'injured by its present low position and the vicinity of the other buildings.'* The portico was therefore raised above the level of the surrounding houses, on a high platform. To the plan much thought was given. The building was made almost square, rather than being extended along the street, so that it enjoyed a broad open space on either side and could be seen, not grouped with other buildings, *'but by itself — a point of primary importance in street architecture.'* As executed, the main facade differs only in such details as the balustrade to the street and the sculptural decoration, from the original scheme.

Basevi's building has generally been admired. Thomas Wright in 1845 felt that *'the façade looking towards Trumpington Street (was) perhaps the most striking piece of architecture in the kingdom – original and picturesque in its arrangement – varied, yet consistent in its variety – rich not only in its parts, but in its ensemble, everything being in keeping, and there being nothing to disturb or interfere with the character.'*[8] The writer, who may well have had the opportunity to discuss the building with the architect, praises Basevi for his creation of an *'imposing ensemble'*, in which every element contributes to the total effect, in contrast to the type of building with *'a portico stuck up in its centre, without any thing to harmonize with it...'*. He remarks on the skilful use of the columns to pull together the portico and the walls on either side of it, and on the depth given to the portico, which is drawn back to a level considerably behind the side projections, *'in consequence of which great variety, both as to light and shade, and perspective, is thrown into the whole of the background'*, producing *'richness of effect'*. He stresses the building's success in expressing its purpose: *'Hardly can it be mistaken by any one for a church, theatre, college or other public edifice...'*. In the early part of this century, such buildings, seen as Victorian, were out of fashion: a critic in 1931 was to write of the *'the old dignified, if curiously elaborate, Victorian building'*.[9] A.T. Bolton compared the building to Charles Barry's Royal Manchester Institution – to the Fitzwilliam's disadvantage see (B1–4) – and pointed out a number of defects in the interior, notably what he called *'an element of redundancy'*, from which he felt that Basevi, in his *'natural impetuosity of temperament'* could not restrain himself.[10] David Watkin has aptly described the building as *'ebullient but never coarse'*, with *'a late Roman swagger'*.[11]

Work began on the Fitzwilliam in 1837, and by 1844 the structure was complete. Unhappily, Basevi died the following year. He was succeeded by C.R. Cockerell (1788–1863), chosen because it was felt that he would carry out Basevi's intentions faithfully. Much of the interior was completed to Basevi's design, though in the entrance hall Cockerell altered the intended single dome into three smaller ones, and changed the stairs and ceiling. The ground floor was also rearranged, with the archaeological remains being shown in the rooms on the garden front of the building, while the library was placed in a room beside the staircase. The central downwards staircase proposed by Basevi was removed, while his restrained calm hall, with its gallery around the stairs (F11), was considerably complicated by the introduction of tunnel-vaults at right angles to the entrance.

In 1847 funds ran out and building stopped: work was finished apart from the entrance hall and one room on the ground floor. The hall was completed by E.M. Barry in the 1870s, in a decorative style of his own devising: restraint was not the keynote. The Museum opened to visitors in 1848.

Basevi's plans for the interior are interesting on a number of counts. Like Schinkel's Altes Museum, of which he would have been aware, the Fitzwilliam was to enshrine both Old Master paintings and classical sculpture, while modern sculpture was left to the exterior (the sculpture on the facade was executed by Nicholls after designs by Sir Charles Eastlake). As Basevi's coolly linear drawing (F11) shows, the hall was to contain casts after famous antique sculpture, while in the picture galleries further casts were to close the vistas. Renaissance and later painting derived their finest qualities from classical art, of which sculpture was the most accessible and powerful relic: Greek and Roman art should therefore introduce the visitor to the art of the recent past and the present.

Basevi's wish to treat his staircase as an integral part of the hall, as well as to create an imposing gallery of sculpture, has always presented problems. Too much was required of the hall, which was expected to act as a monumental interior, as a central point of access for floors above and below its main level, and as an exhibition space for sculpture for which a considerable surrounding area was required. Basevi's problem over bringing visitors up to the level of the entrance to confront them immediately with a descending staircase was resolved by Cockerell's design of staircases in place of the offices proposed on either side of the hall. A practical problem remains today for the Museum, of how to welcome the arriving visitor, who finds himself propelled almost as soon as he enters the building towards an array of steps. At the same time that Basevi was designing the Fitzwilliam, Charles Barry was working on the Reform Club. The plans of the two buildings, with a series of rooms ranged symmetrically round a central hall, communicating on first floor level via a broad gallery, and with a major saloon on axis with the principal entrance,

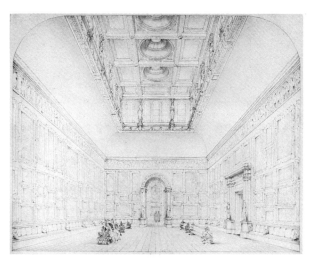

F9

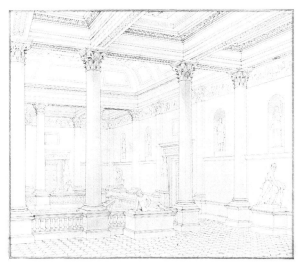

F11

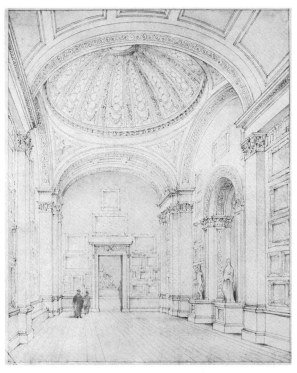

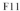

F6

are close to one another, while Basevi's original plan for the ground floor suggests, in the staircases connected by small domed areas, further similarities with Barry. The Reform Club avoids the Fitzwilliam's difficulties by placing its principal staircase to the side of the main hall, which is a more resolved space.

The 'Picture-rooms' on the first floor are some of the finest in Britain. Again, Thomas Wright gives an interesting impression of what must have been

Basevi's intentions. The rooms are on three axes, avoiding the wearisomeness of the extended enfilade. Though united by top lighting and architectural style, *'they are so agreeably varied both in regard to their sizes and proportions, and the design of their ceilings and lanterns, as to produce a well contrasted yet well balanced succession of architectural parts, and striking vistas from the rooms at the angles.'*[12] Particular attention was given to the design of the doorcases communicating from the entrance hall with the picture rooms. The effect intended in the principal gallery (F9) is apparent from Basevi's drawing. This was to be an awe-inspiring apartment, on the lines of Klenze's principal gallery at the Alte Pinakothek, Munich, hung solidly with pictures. Basevi's plans for the coving evidently changed: the presentation drawing (F10) shows vaults of a type popular in the 1810s, to be seen for example at Castle Howard and Dulwich. It also illustrates the monitor lighting that was executed, with the structural supports concealed by caryatids (continuing the decorative theme of the doors), a much elaborated version of the lighting system at Dulwich. The cast of the Panathenaic frieze (from the British Museum) was intended to deal with a recurring difficulty: how to prevent pictures from being lost on the walls of enormously high rooms. Willis comments that on account of the frieze, which demarcates the picture space, *'although the entire height of the room to the centre of the ceiling is 43 1/2 feet, no more than about 18 feet height of wall is left for hanging of pictures.'* This he regards as extremely important, *'not only as regards the destination of the rooms, – which is to exhibit pictures, instead of merely covering walls with them, – but in regard to architectural character...and suitable loftiness of proportion.'* It may indeed be felt that the rooms are somewhat too high for their purpose. Though equally lofty, the corner rooms (F6) are considerably smaller in ground area: the drawing suggests that they were intended for cabinet paintings. The division by pilasters and arches

into three sections is very different to the arrangement of the principal rooms.

The lack of almost any provision for offices or workroom or of a circulation system allowing independent movement of staff or pictures, is characteristic of almost all galleries of the period. This was to be a fixed collection: any further acquisitions would be accommodated in the two wings sketched by Basevi in his presentation drawings.

1 Lord Fitzwilliam's will, quoted in Willis and Clarke (1866) III p. 198.
2 See Willis and Clarke; J. Cornforth in *CL* 22 Nov 1962; and Watkin (1977).
3 Drawings in the RIBA Drawings Collection.
4 Basevi to 'Marion', 13 March 1816, in G. Basevi, *Home Letters 1816–19* (ed. A.T. Bolton), MS and typescript in SM.
5 Basevi to his mother, 4 October 1816, in ibid.
6 Basevi to his sister Mrs. Rich, 22 March 1817, in ibid.
7 Among the Basevi drawings in the Fitzwilliam Museum Library – these are not at present numbered.
8 Le Keux, Wright and Longueville Jones (1845) II p.12 ff.
9 *A & BN* 5 June 1931.
10 Bolton p. XXXVI ff.
11 Watkin (1977) p.2.
12 Le Keux, Wright and Longueville Jones (1845) p.15 ff.
□ J. Le Keux, T. Wright and H. Longueville Jones, 'The Observatory', *Memorials of Cambridge* (1845) II
□ D. Watkin, *The Triumph of the Classical* (1977)

F6

G. Basevi (1794–1845)

Fitzwilliam Museum, Dome Room

Pencil, 27 x 23 cm

Fitzwilliam Museum

F7

G. Basevi

Fitzwilliam Museum, elevation

Ink and wash, 55 x 85 cm

Fitzwilliam Museum

F8

G. Basevi

Fitzwilliam Museum, principal floor plan

Pen and ink, 28 x 39 cm

Fitzwilliam Museum

F9

G. Basevi

Fitzwilliam Museum, large gallery

Pencil, 27 x 34 cm

Fitzwilliam Museum

F10

G. Basevi

Fitzwilliam Museum, transverse section

Pen and ink, 55 x 85 cm

Fitzwilliam Museum

F11

G. Basevi

Fitzwilliam Museum, hall

Pen and wash, 55 x 85 cm

Fitzwilliam Museum

F12

Fitzwilliam Museum, Gallery III with staff assembled 1887

Photograph

Fitzwilliam Museum

F13

Hills and Saunders

Fitzwilliam Museum, Upper Marlay Gallery c.1931

Photograph

Fitzwilliam Museum

ASHMOLEAN MUSEUM, OXFORD (founded 1839)

The Ashmolean Museum on Beaumont Street, as opposed to the old Ashmolean on Broad Street, is similar and yet very different to the Fitzwilliam. The two were begun in the same decade; the same builders worked on each, and the ornamental sculpture was executed by the same William Nicholl; C.R. Cockerell worked on both; and in both cases the new museum represented a somewhat belated recognition by the university of the value of the visual arts. The general conception of the plans is also similar, with classical sculpture housed on the ground floor and picture galleries upstairs. In many respects, however, the Ashmolean is distinct. Whereas the Fitzwilliam was intended purely for galleries and a library, the Taylorian Building (as it is correctly known) was designed to contain the library and lecture rooms for the university's modern languages department in its east block, with the galleries occupying the west block and central portion. These rooms were at first known as the 'University Galleries', a separate institution to the old Ashmolean in its seventeenth century build-

ing on Broad Street (it is worth noting that a recent history of the Ashmolean Museum makes only one, passing, reference to the Beaumont Street building). The most pressing need at Oxford was the provision of proper space for the Arundel Marbles, presented to the university in the eighteenth century and never properly housed; the holdings of pictures were negligible. The dual function of the new building naturally influenced its external character: while the limited scope of the collections at the time produced, in contrast to the Cambridge building, only two long narrow galleries on each of two floors.

In June 1839 an architectural competition for a new building was announced, following a bequest by Dr. Francis Randolph. The competition was won by Charles Robert Cockerell (1788–1863). Revealingly, he had produced no designs for the interiors. For this sensitive, highly educated architect, committed to the continuing development of classical architecture at a time when it was increasingly imperilled, the commission was of the greatest importance: as he wrote to the Registrar of Oxford University, 'My ambition knows of no higher attainment.'[1] Highly esteemed as an academic architect and Professor of Architecture at the Royal Academy though he was, Cockerell's ideals had caused him many disappointments, and for a man of his abilities he had executed relatively few buildings.

The ambiguity and strength of the Taylorian Building derive from its dual purpose. The brief stipulated that the galleries and the Taylorian Institute (the language department) should, externally, read as one building, but that internally they should be entirely separated, with no common space. This disjunction is marked by Cockerell in the abrupt transition from the Taylorian wing to the main block, and by the creation of two principal facades: one on Beaumont Street, for the galleries, and the other, on St. Giles', for the Institute. The relationship between the two is subtle, each functioning independently as a principal elevation. Cockerell was also challenged by the recent erection in Beaumont Street of relatively tall terrace houses, much as Basevi had to compete with surrounding dwellings. His solution was more idiosyncratic than Basevi's: he raised the height of the two wings (appropriately, since one was wholly devoted to the Institute) above that of the central block which contains the galleries' principal entrance. The impact of the building has since been weakened by the erection of the Randolph Hotel across the street, to a much greater height than the Museum.

The numerous alterations made to the competition drawings in the course of building are discussed by Watkin, as are the classical references in the tersely splendid façades, and the use of the Bassae Ionic Order externally and internally. The use of giant columns to support arches was repeated throughout the two wings.

Internally, the building has undergone considerable changes. The arriving visitor was originally confronted by an exedra, containing sculpture (F16), before turning left into the first sculpture galleries. At first painted red, with niches for the display of major pieces, these rooms have the high side-lighting considered suitable for sculpture galleries. On the other side of the hall, the relatively austere staircase, off-centre, contrasts with the magniloquence intended in Cambridge, reflecting the fact that this was a building in which economy had to be followed.[2] The two picture galleries upstairs have been so much altered as to be almost unrecognisable, but they were at the time the subject of much discussion.

In 1840 the university authorities sought the opinions of experts in Britain and Germany, on the organisation of their art galleries. The comments offered survive.[3] William Dyce (1806–64), painter and art educator, and Charles Eastlake list the conditions 'necessary to the effective display of pictures' in a joint letter. Window glass, for example, should be ground, or opaque, to cut down reflections, and transitions in light levels; the hue of the wall covering must be carefully chosen; and the advantages and disadvantages of top lighting weighed. They cite the new museum at Dresden (by Semper) as one where top lighting has been abandoned, on account of its unkindness to small pictures and its tendency to introduce reflection (a consideration emerging from the increasing proneness in mid-century to glaze pictures). Letters are quoted from Professor Schnorr, of Munich (in favour of top lighting, which allows many more paintings to be hung), Dr. Waagen of Berlin (advocating 'a somewhat high side light') and Baron de Friesen, of Dresden (in favour of side lighting, less uncomfortable than top lighting, and preferred by artists). The report suggests that side lighting is 'cheering and immediate', whereas top lighting offers 'quiet and uniformity'. It also proposes that paintings should be separated, with Venetian and Flemish paintings in top-lit rooms, and with early Italian and small northern pictures shown in rooms with side lights, if possible lit from the north.

F15 illustrates the result achieved in the Great Gallery, which occupied the full height (but not breadth) of the west wing. Whereas the smaller room in the central block, with its north lights, was felt by Dyce and Eastlake to be suitable for the display of small pictures, this room caused them some anxiety. The architecture of the building demanded the introduction of large side lights: they felt that these were excessively large and that too little light from the top was admitted. The walls on the east side were held to be especially objectionable, since the opposite wall was the only place where large paintings could be hung. As a result, the lower lights, though expressed on the exterior, were blocked up and side light was admitted only from the top of the east wall.

The view of the Great Gallery (F15) shows the room soon after its completion, painted by Joseph Fisher, the first keeper of the University Galleries.[4]

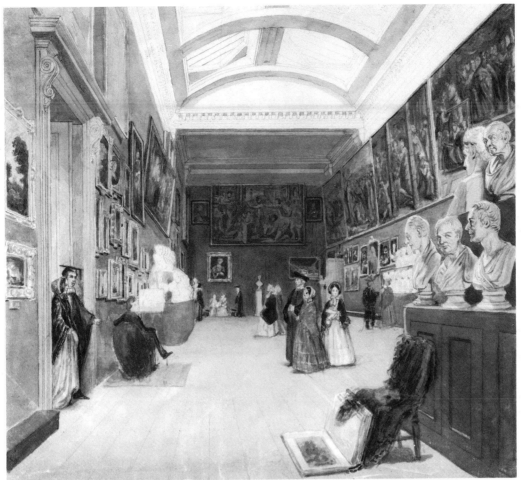

F15

F16

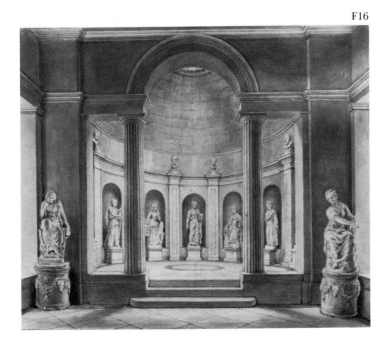

The paucity of the university's collection is apparent, dominated by the copies (possibly by Le Blon, who worked for the Duke of Marlborough at Blenheim Palace) of the Raphael Cartoons. These, given to the university in 1810, remained *in situ* in this room until 1917, in spite of attempts to have them removed.[5] The relatively unsatisfactory nature of the Great Gallery is demonstrated by the later decision to divide it horizontally and vertically, depriving the Museum of any very large space for the exhibition of paintings. Other considerable alterations to the building, particularly those carried out by Sir Arthur Evans in the 1890s, when the Museum's archaeological collections were brought to Beaumont Street, have considerably diluted the original character of the interior, with the exception of the main sculpture gallery, currently under restoration.

1 Watkin (1974) p.199; from which much of this account is derived.
2 It cost £52,000 for 38,000 sq. ft.
3 Bound MS volume in the Archives of the Department of Western Art, Ashmolean Museum.
4 A further drawing by Fisher of 'The first arangment (sic) in the Picture Gallery', close to F15, is in the Ashmolean Museum.
5 It is likely that these cartoons will be lent to Hampton Court Palace for the places formerly occupied by Raphael's cartoons.

☐ D. Watkin, *The Life and Work of C.R. Cockerell* (1974)

F14

F. Mackenzie (1787–1854)

Ashmolean Museum 1848 (for the *Oxford Almanac*)
Pen and ink with wash over pencil, 22.8 x 35.7 cm

Ashmolean Museum

F15

Joseph Fisher (1796–1890)

Ashmolean Museum, view of picture gallery
c.1850
Photograph after pencil and watercolour

Bodleian Library

F16

Joseph Fisher

Ashmolean Museum, view of sculpture gallery
c.1850
Photograph after pencil and watercolour

Bodleian Library

THE BARBER INSTITUTE (founded 1932)

Like many university museums, the Barber Institute resulted from the benefaction of an enterprising individual. Lady Barber (1869–1933), childless widow of a wealthy industrialist, made a will in 1932 leaving the University of Birmingham a sum for the erection of an Institute for '*the study and encouragement of art and music*' together with Professorships in the Fine Arts and in Music.[1] The purchase of paintings, from not later than the end of the nineteenth century, or '*furniture tapestries needlework lace medieval manuscripts finely printed books musical instruments*' (but not, mysteriously, pottery and china), and the organisation of concerts, were part of the Institute's brief. Only works of art '*of exceptional and outstanding merit*' would be acceptable. As her friend Sir Charles Grant Robertson, Vice-Chancellor of the University and founding Trustee of the Barber Institute, wrote at the time of the opening, it was to be neither an art gallery nor a postgraduate art school, but '*a civic (indeed a national) centre of humanistic culture for all and sundry.*'[2] Its role was to encourage art and music to affect all branches of study, and its place was therefore within a centre of learning such as a university.[3]

The architect appointed in 1935 by the Chairman was Robert Atkinson (1883–1952), best known for the exuberantly Art Deco hall in the Daily Express building in Fleet Street. He was asked, according to the then Vice-Chancellor of Birmingham, to provide '*exhibition galleries, a room for recitals of chamber-music, a lecture-theatre, art and music libraries and their appurtenant stack-rooms, offices, practice-rooms, waiting-rooms, cloak-rooms, workshops, storage and living quarters...*' in a building which '*should be in itself a manifest work of art.*'[4] In contrast to nineteenth century institutions, a great deal of space was to be allocated to services, while the provision of a concert hall was also unusual.

The architect responded with a building that is dignified, decent and reticent, though not profligately welcoming to visitors. He and the new Director, Thomas Bodkin, had studied various foreign art museums, notably the Gemeente Museum at 'S Gravenhage, the Boymans Museum in Rotterdam, and the New Courtauld Galleries at the Fitzwilliam. The Barber is built in an expensive Modernist manner, with references to symmetry, and materials of the highest quality; some use is made of carving, though less than the architect had hoped (he envisaged a carved list of great artists on a frieze on the facade, with figures in relief). The decoration is largely structural. The upper floor is delineated as a top-lit space for the exhibition of paintings through its plain walls in reddish-brown brick, decorated only by a diaper pattern, and is forcefully distinguished from the ground floor, clad in white stone. Only the

F18

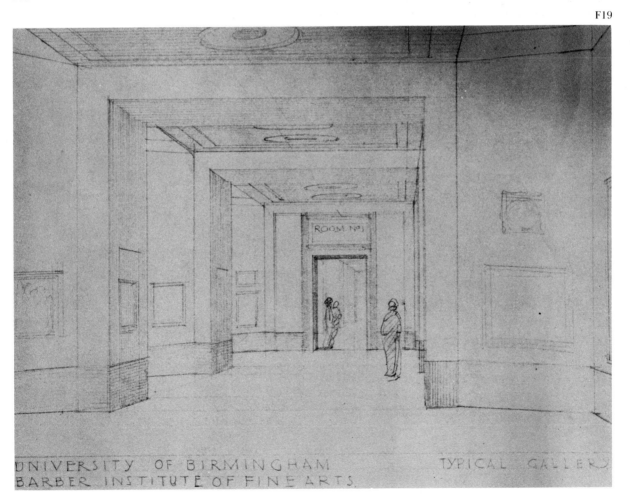

UNIVERSITY OF BIRMINGHAM
BARBER INSTITUTE OF FINE ARTS.

TYPICAL GALLERY

massive portal interrupts the division between the two storeys.

The drawing by William Walcot (F18), the leading architectural draughtsman of the time, was commissioned by the Trustees to celebrate the completion of the building. It illustrates the relationship created between the new Institute and the surrounding buildings, and the thought given to the garden in front of the Institute, dominated by the statue of George I by Van Nost. Contemporary comment in the architectural press was approving, if not ecstatic.

Internally, Atkinson's original plans underwent various modifications, notably the reduction of the space devoted to music in favour of the art galleries, and the elimination of his early plans for the introduction of "Period Rooms" decorated in a historical style appropriate to the works of art. The plan of the building is skilful, with a central auditorium for 365 spectators enclosed on the ground floor by offices and libraries, and on the first by galleries, with service rooms and small prints and drawings rooms tucked into the corners. The main entrance beckons the visitor along a broad hall towards the stairs leading to the galleries, while a second axis, at right angles to that created by the front door, links the row of glazed doors leading onto a garden with the principal doors to the auditorium. Broad corridors communicate with the art lecture theatre and the art and music Libraries: this is a building intended to provide services, and to stimulate and soothe, rather than to dazzle.

The rooms on the first floor devoted to pictures (one until recently contained tapestries) are carefully planned, following much research by Atkinson and Bodkin. They are top-lit, on a modified Seager principle, with the central part of the ceiling blocked in and the light falling on the side walls, which are divided into bays separated by V-shaped partitions. These bays were intended to allow a series of contrasting experiences in looking at pictures, avoiding the weariness felt in viewing a long wall of paintings, as well as to provide the best lighting from the top and side (see F19). The decoration of the new rooms was, characteristically for the time, low-key. As Bodkin put it, *The decoration of the interior is extremely simple, elaborate ornament and positive colour have been rigorously ruled out, lest they should clash with any work of art in the collections. Yet the travertine floors and architraves, the sober wood mouldings, light oak for the most part, and the oatmeal-toned hessian-covered walls, combine to make a discreet harmony that is highly attractive.*[5] These were to be laboratories for the study of pictures.

The Barber represents the height of the neutral setting for the work of art. With no connotation of palace, temple, fairground or private house, it recalls if anything a Scandinavian town hall: the virtues of undemonstrative paternalism are celebrated. Only in the lavatories, wickedly Art Deco, did Atkinson allow himself a streak of self-indulgence.

The architect went on to design the Colman Galleries at the Norwich Castle Museum, in 1950–51, one of a series of rooms commissioned as part of the Festival of Britain.

1 Lady Barber's Will, 13 Dec 1932.
2 Bodkin (1939) introduction p.6.
3 For a full account of the genesis see Spencer-Longhurst (1989).
4 Bodkin (1939) p.9ff.
5 ibid p.10.

☐ Thomas Bodkin, *Inaugural Lecture* (1939)
☐ Paul Spencer-Longhurst, 'The Barber Institute of Fine Arts', in (ed.) P. Spencer-Longhurst, *Robert Atkinson 1883–1952* (1989)

F17

The Barber Institute
Two photographs
(a) North and east facades 1937
(b) South and west facades 1938
The Barber Institute

F18
William Walcot (1874–1943)
The Barber Institute, perspective drawing 1938
Watercolour and bodycolour, 73 x 135.5 cm

The Barber Institute

F19
The Barber Institute, typical gallery 1935
Dyeline print, 40.1 x 48.9 cm

The Barber Institute

G Commercial Galleries and Auction Houses

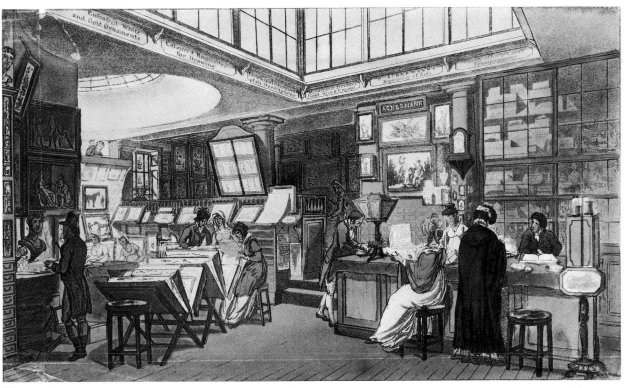

G5

It has only been possible to provide a glimpse into the complex history of commercial galleries. Their role in shaping British collections and British taste has been so considerable that they deserve much more study than they have received, though in very recent years the early history, at least, of the art trade, has begun to receive more attention. In the design of galleries and in matters of display, such galleries have often been innovators, having enjoyed the advantage of free enterprise and having frequently depended on their ability to attract public attention for success and survival. A great deal of material that it would have been desirable to include in this section has had to be omitted for lack of space.

The stress on one particular firm of dealers that may be detected results from the remarkable historical continuity of that firm and its importance in shaping high Victorian taste, as well as its retention of substantial visual records: though many other firms and individuals have played as important a role at particular periods, none is as well chronicled.

The Grosvenor and the New Galleries have been included here even though their founders might not have regarded them solely as commercial enterprises. As alternative exhibition spaces to the Royal Academy and as centres for social activity, they testify to the liveliness and wealth of the late nineteenth century art world.

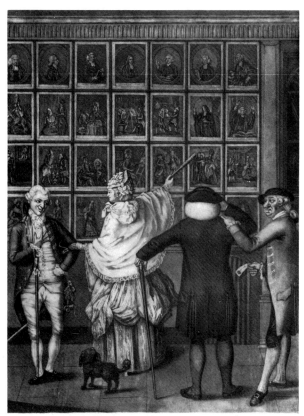

SPECTATORS at a PRINT SHOP in S.T PAUL'S CHURCH YARD.

G1

INTERIOR OF S. & J. FULLER'S TEMPLE OF FANCY, 34, RATHBONE PLACE.

G4

G1

Anonymous, printed for Carrington Bowles

Spectators at a Print Shop in St. Pauls Church Yard 1774

Mezzotint, 32.2 x 24.7 cm

David Alexander

The growth of the print trade in late eighteenth century London was one element in the development of a commercial urban culture. Art became fashionable, and its pursuit was frequently caricatured, as here.

The shop represented belonged to Carrington Bowles and Robert Sayers. It was known both for serious prints (such as the clerical portraits on the top row) and for comic prints, such as the 'postures' or 'drolls' below.

G2
Paul Sandby

A. Robertson, Printseller and Drawing Master, trade card c.1787

Engraving, 20 x 12.3 cm

Trustees of The British Museum (Heal Collection)

G3

D. Mercier, Printseller and Stationer, trade card 1791

Etching, 28 x 16.6 cm

Trustees of The British Museum (Banks Collection)

G4
William Derby (1786–1847)

S. and J. Fuller's Temple of Fancy, trade card

Aquatint, 19.3 x 26.4 cm

Trustees of The British Museum (Heal Collection)

Trade cards were the eighteenth and nineteenth centuries' equivalent of today's business card. Some were very elaborate, and they were often the work of well-known artists. They give considerable insight into the early art trade, suggesting that galleries evolved from firms that traded in a wide variety of luxury items, into businesses specialising in works of art.

The first of these cards, drawn and engraved by Paul Sandby (G2), illustrated the premises of Archibald Robertson (1765–1835) in 'Savill Row Passage' and informed the prospective customer of the goods and services on offer. It also promoted the artist by claiming *'Sandby's works in Aqua Tinta, to be had complete'*. Robertson went to New York around 1790 to set up a drawing school.

Dorothy Mercier bought and sold prints, and

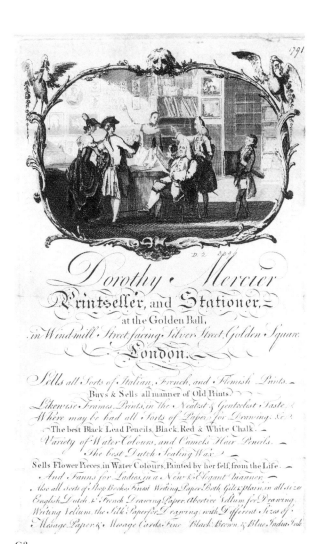

G3

G5

G5

Augustus Charles Pugin (1762–1832) and Thomas Rowlandson (1756–1827)

Ackermann's Repository of Arts, 101 Strand, trade card 1809

Coloured etching, 14 x 24.5 cm

Trustees of The British Museum (Heal Collection)

G6

Ackermann's Repository of Arts, January – June 1827

Book, octavo, 372 pp.

The London Library

provided artists' materials, fans, and her own water-colours of floral subjects.

Samuel and Joseph Fuller, printsellers, publishers, playing-card makers and preparers of superfine watercolours, were well-known for their trade in sporting prints. The market for these was so large in the mid-nineteenth century that the younger Rudolph Ackermann expanded his father's business to compete with the Fullers. The success of the Fullers' enterprise (which closed in 1862) is reflected in the image of their premises on this trade card: a large rectangular room with a lantern ceiling, and Ionic and Doric pillars.

Stephen Fronk

Rudolph Ackermann (1764–1834), born in Saxony, emigrated to London between 1783 and 1786. By 1797 his shop at No 96 Strand had become too small for his thriving business which included the sale of pictures, the publication of decorative prints and illustrated books, the sale of artist's materials and the provision of a drawing school.

To alleviate this lack of space, he moved his business to No 101 Strand, not far from the Royal Academy in Somerset House, and in 1798 named his gallery 'The Repository of Art'. This new building, which had once been the London residence of the Dukes of Beaufort, provided Ackermann with a great room with lantern lighting, off which can be glimpsed a smaller room with a recessed glass dome.

Ackermann's business thrived in his new premises and in 1809 he began to publish *The Repository of Arts*, a richly illustrated monthly journal including such novelties as insets of new dress materials. His importance lay in his success, on the model of Continental printsellers, in popularising prints and making his gallery a fashionable meeting place.

Business prospering, Ackermann rebuilt No 96 The Strand in 1826 to the designs of J.B. Papworth.

161

This new, still larger, building was illustrated in *The Repository of Arts* for June 1827. The account describes the nine storeys of the building, partly devoted to Ackermann's own apartment but principally to the shop, store-rooms and counting-houses needed for so flourishing a business. John Britton in his *Autobiography*[1] recalls the *'fine and spacious gallery'* at the back of the building, which displayed *'a vast number and variety of works of art'*. Here Ackermann, in emulation of the aristocracy, held weekly soirées, frequented by the nobility, artists and scientists of Britain and overseas.

1 J. Britton, *Autobiography* (1850) I p. 310.

☐ J. Ford, *AcKermann 1783–1983* (1983)

G7

Monsieur Jean Baptiste Isabey's (1767–1855) Exhibition Room, 61 Pall Mall 1820

Engraving, 18.4 x 25.1 cm

Guildhall Library

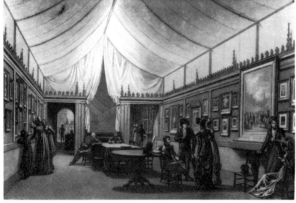

G7

The pupil of the miniature-painter Dumont and of David, Isabey made his debut at the Salon of 1793, and continued to exhibit there until 1841. Having won the friendship of Napoleon and Josephine, he was appointed First Painter to the Empress in 1805. Isabey was also *dessinateur du cabinet et des cérémonies*, scenographer at the Opéra and the Court Theatre, as well as a renowned miniaturist.

Owing to the marketability of his work in Britain, Isabey opened a gallery at 61 Pall Mall. Top-lighting was controlled by the introduction of a cloth tent which prevented direct sunlight from falling on the picture surfaces, while the ingenious placement of a mirror on the far wall created the illusion of a gallery of more generous proportions than was actually the case.

Stephen Fronk

AGNEW'S

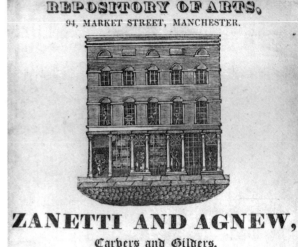

G8

G8

Zanetti and Agnew c.1824

Trade card, 17.8 x 10.8 cm

Agnew's

In 1817 Thomas Agnew (1794–1871) was taken into partnership by Victor Zanetti, an Italian merchant who was long established as a purveyor of assorted goods in Manchester, from which he dominated the art world in the North of England. As the advertisement illustrates, the supply of paintings and their restoration represented only one subsidiary activity of the firm; print-selling was for many years to play a much more important part in its commercial success.

The premises in Market Street were occupied by the firm from c.1797 to 1826, when it moved to

Exchange Street. The title 'Repository of Arts', with its overtones of a permanent collection, sets the building in the tradition of the eighteenth century commercial 'museum', in which a permanent exhibition of works of art encouraged potential customers to pay a visit. The exterior of the building has some architectural pretensions; though still part of a conventional Georgian street facade, it looks forward to the search that persisted throughout the nineteenth century for an architectural vocabulary appropriate for an art dealer's establishment.

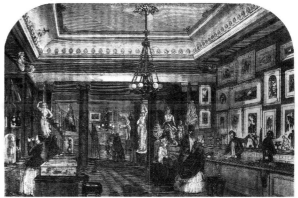

G12

G9

Agnew's, Manchester c.1840

Book illustration from *The Commercial Aspect of Manchester*, p.463
Engraving, 10.2 x 15.9 cm

Agnew's

The firm moved to new premises in Exchange Street, Manchester, in 1826, depicted in this view of around 1840. Thomas Agnew successfully developed a trade in contemporary British painting and in the production of prints. As Sir Geoffrey Agnew has noted, Thomas created the pattern of picture and print dealers owning their own premises and holding frequent exhibitions which has become established as the norm in Britain.

This gallery, presumably on the ground floor, is laid out as a shop, much like the establishment depicted by Watteau in *L'Enseigne de Gersaint*. The walls are densely hung with handsomely mounted prints, of which a selection is being offered to the customers. The decorations are modestly lavish; the lighting is by gas.

G10

Edward Salomons (1828–1906)

Agnew's, Old Bond Street elevation 1876

Ink and watercolour, 68.6 x 54.6 cm

Agnew's

G11

Salomons and Wornum

Agnew's, Old Bond Street elevation

Building News, 19 October 1877
Engraving, 39.4 x 29.2 cm

Agnew's

In 1876 William Agnew (1825–1910) decided to move his London base from Waterloo Place, near the old Royal Academy in Trafalgar Square, to Mayfair, a neighbourhood which with the opening of the Royal Academy at Burlington House had become popular among art dealers. He employed Salomons and

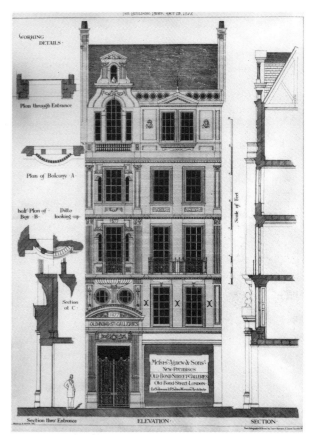

G11

Wornum to design a seven-storey building in Bond Street. It was to contain offices and exhibition spaces on the ground and first floors, while the upper floors were to be let as flats or expensive offices. Built in the red brick that was sweeping Mayfair at the time, the elevations to Bond Street and Albemarle Street were less flamboyant than those of such contemporary or later galleries as the Grosvenor and the Grafton. The exterior has been little altered.

The article in *The Building News* that accompanies this engraving remarks on the porch, projecting from the facade of the building and rising above the lower level of the next floor: it was intended to differentiate the gallery from the shop window next to it, at that time unconnected with Agnew's. The highest storey shown in the print was not built, owing to the objection of the shopkeepers opposite. Apart from the portal – Italian Renaissance in style, and reminiscent of the Grosvenor Gallery – the architects provided a dignified facade in the domestic style of Cadogan Square: externally there is little to distinguish their building from a private house. The windows did indeed light four sets of residential chambers on Old Bond Street (let, to private residents), and seven on Albemarle Street.

Agnew's was one of the first buildings erected by the partnership of Salomons and Wornum, formed in that year. Both partners had close associations with painting. Edward Salomons, a watercolour artist whose depictions of picturesque townscapes were shown in Manchester galleries and reproduced in *The Builder*, had designed the building for the Manchester Art Treasures exhibition of 1857. His practice had offices in Liverpool and Manchester (where it was based) as well as London. His younger partner Ralph Selden Wornum (1847–910), had grown up in the National Gallery, where his father, R.N. Wornum, had lived, by virtue of his office as Keeper. Beginning his career as London manager to Salomons, he was to become a successful architect in his own right, with an extensive practice on the Continent: his later buildings included a summer palace for the Queen Regent of Spain at San Sebastian, and villas at Biarritz.

Salomons and Wornum also in 1878 designed the Exchange Galleries in Liverpool for Agnew's, in a discreet eclectic manner.

* G12

Edward Salomons

William Agnew in his Gallery c.1880

Pen and ink with watercolour, 31.1 x 58.7 cm

Agnew's

William Agnew, eldest son of Thomas and his business partner from 1851, was regarded as the prince of art dealers by his contemporaries. He conferred respectability on an activity that had been regarded as socially, at best, peripheral: a man of enormous wealth, he was a friend of Prime Ministers and served briefly as a Liberal MP. The basis for his activities remained Manchester, and he exerted great influence in encouraging the newly rich merchants of Lancashire to buy works by contemporary British artists. Many of their collections survive in the municipal galleries of Greater Manchester and its environs.

Agnew's expanded their activities to London in 1860, opening a gallery in Waterloo Place. Within a few years a considerable proportion of their sales were made in the capital, and they moved to Bond Street. In this watercolour by the architect, William is shown in the principal ground floor room at the new premises. The contrast to the old Exchange Street galleries is striking: this apartment has the appearance not of a commercial establishment but of an Aesthetic drawing-room, and the furniture is eclectic and carefully chosen to suggest profound historical reference. The watercolours on the walls reflect the firm's interest in this medium, from the 1860s.

This interior has been somewhat altered, notably by the piercing of a new staircase to the upstairs gallery through the central back wall, and the blocking of the opening to the right. Much of its character, however, remains, and persons not dissimilar in appearance to this William Agnew are still to be observed there.

G13

Bernard Dunstan (b. 1920)

The Sickert Exhibition at Agnew's 1960

Oil on board, 29.2 x 19.1 cm

Agnew's

The Upstairs Gallery at Agnew's, an integral part of the 1877 building, has changed little since it was first built. It was intended to house a succession of temporary exhibitions and was built at a time when such accommodation was relatively scarce in London. The boom in the art market from the 1860s, specifically in the sale of British paintings and prints after them, encouraged the erection by dealers of more dignified premises for their own use, in place of the rented galleries often used earlier.

Geoffrey Agnew described the Gallery as having *'the best proportions and the best natural lighting of any medium-sized exhibition gallery in London'.*[1] It was redecorated in 1983 for the first time in its history: the famous red velvet of the walls was rewoven for the occasion, and the painted frieze—reduced to white earlier in this century—was restored to its original colours.

1 G. Agnew (1967) p.30.

☐ Agnew, *Agnew's 1817 – 1967* (1967)

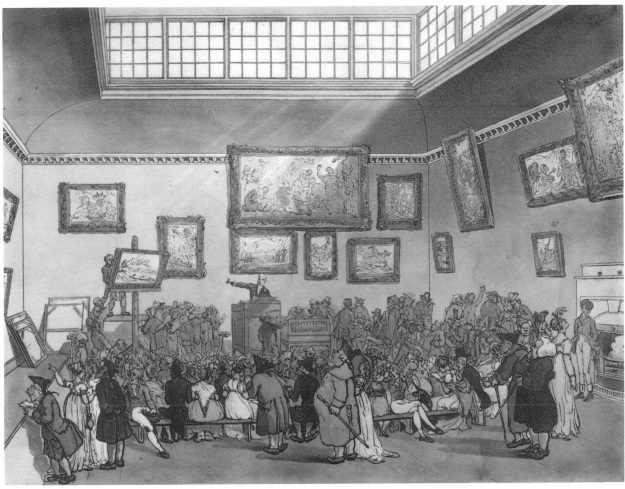

G14

CHRISTIE'S

Numerous auction houses were established in the mid-eighteenth century to meet the growing demand for works of art, though auctions of paintings had been common since the late seventeenth century. James Christie's business was set up in the 1760s, and he built new rooms at Nos. 83–84 Pall Mall in 1767. Revealingly, these rooms were also used for a few years as an exhibition space by the Free Society of Artists: as at the Royal Academy in Pall Mall, auction and exhibition rooms were considered interchangeable. Nos. 83–84 Pall Mall, depicted in G14, remained in use until 1823, when the firm moved to 8–9 King Street, the present site. The King Street rooms had formerly been occupied by the European Museum, a display of pictures for which admission was charged. The arrangement of the main hall – close to a square, with plain walls and monitor lighting – is close to that of the earliest auction rooms.

Christie's was substantially altered and enlarged at the end of the nineteenth century, with J. Macvicar Anderson as architect, but the Great Room was not changed. Macvicar Anderson's dignified facade to King Street survived the bombing which destroyed the bulk of the building in 1941.

G14

J. Black, after T. Rowlandson and A. Pugin

Christie's Auction Room

Ackermann's Repository of Arts, 1 February 1808
Coloured aquatint, 24.8 x 29.2 cm

Christie's

The commentator on this print in *The Microcosm of London* remarks on the number of fraudulent works of art available on the London art market. He expresses the hope that collectors, still categorised as *'the nobility and gentry'*, will be able to distinguish works of quality from poor imitations.

The auctioneer is quoted as saying to his enthusiastic audience '...*Pray, ladies and gentlemen, look at this piece! – quite flesh and blood, and only wants a touch from the torch of Prometheus, to start from the canvas and fall a-bidding...*'.

Shown at Dulwich Picture Gallery only

G15
Constantin Guys (1802–92)
A Sale at Christie's 1830
Pen and brown ink with grey wash, 23.5 x 34.9 cm

Christie's

Guys, a frequent visitor to England, shows the auction room at 8–9 King Street, on the site of the present Great Rooms. Christie's was regarded in the nineteenth century as one of the most sympathetic venues for viewing paintings. It maintained the eighteenth century tradition of the auction house as an informal temporary exhibition gallery.

Shown at Dulwich Picture Gallery only

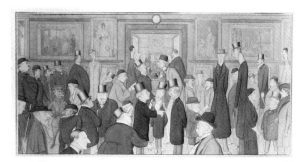

G16

G16
Max Beerbohm (1872–1956)
The Red Cross Sale, Christie's 1918
Pencil and watercolour, 36.5 x 50.5 cm

Christie's

The Red Cross sale was a major event. Lasting thirteen days in April 1918, the sale featured 2,948 items. It was organised on behalf of the British Red Cross Society and the Order of the Hospital of St. John of Jerusalem by a group of committees, and included china and furniture, paintings, drawings and prints, silver, books and manuscripts. Beerbohm's cartoon shows a number of the most important participants in the Great Room at Christie's.

Shown at Dulwich Picture Gallery only

COLNAGHI'S

G17

G17
Edwin Alfred Rickards (1872–1920)
Colnaghi's
Pencil and wash on card, 61 x 53 cm

British Architectural Library Drawings Collection/ RIBA

G18
Colnaghi and Obach's Galleries, New Bond Street, entrance hall
Photograph

The building which stands at nos. 144–146 New Bond Street was designed by the celebrated firm of Lanchester and Rickards. It was commissioned in 1913 by the picture dealers Colnaghi and Obach who needed premises large enough for the joint business of their recently merged firms, and was the last full scale commission for the pair of architects who had worked together for over 26 years. Having won several architectural competitions early in their partnership, they had erected a series of public buildings, including Westminster Central Hall, Cardiff Town Hall and Law Courts, and Deptford Town Hall. Rickards was recognised as a prodigy; despite a limited formal training he showed great creative flair and excellent

G18

Behind the library are smaller rooms in which old mezzotints and colour prints were shown.

The wood used throughout the building is walnut – most obvious in the panelling and carved decoration. The metalwork, best revealed in the firedogs of the hall chimneypiece and the fittings in the vestibule, is bronze. The extant bills ledgers show Lanchester and Rickards' involvement with all the internal fixtures and fittings. They issued invoices for designing furniture, show curtains, valences and even the picture frames. All the ground floor galleries benefit from top lighting, the natural light from above being distributed by mirrors concealed behind attractively glazed grilles. The sophisticated cooling and heating systems are similarly disguised. In acknowledgement of this technology, *The Connoisseur* described the new building as a '*truly modern picture gallery, illustrating the latest and most effective methods of pictorial display*'.[1]

1 *The Connoisseur* Oct 1913, p. 120.

Elizabeth Wright

draughtsmanship. He took charge of designing and drawing the elevations while Henry Vaughan Lanchester (1863–1953), essentially a planner and engineer, dealt with clients and ran the office.

Apart from a brief interlude during the Second World War, the Bond Street galleries have been used continuously to display works of art. Colnaghi and Obach remained there until 1944 when they moved to new premises in Old Bond Street. A year later, the antique dealers Frank Partridge and Sons Ltd (now Partridge Fine Arts PLC), took over the vacant showrooms and have been situated there ever since. Fortunately, both the interior and exterior of the building have been left virtually unchanged; most of the key decorative features remain as does an overall sense of restrained opulence.

The facade is detailed in an Edwardian Baroque style. The ground floor has two large windows and a front door recessed between heavy piers. On the first floor the windows are smaller and carved in more detail. A blind parapet extends across the facade bearing four vases and the central figure of *Painting*, a sculpture made by Henry Poole RA. The ground floor is finished in Roman Stone, while the upper part, including the sculpture, is in Portland Stone.

It is the interior which is of most interest architecturally. Behind the doorway is a deep vestibule, which opens onto a large hall with smaller galleries at either side, and a grand staircase leading to a mezzanine at the end. To one side there are smaller stairs and a lift, beautifully lined in wood, which take the visitor to the first-floor showrooms. The largest of these is the library, lined with bookcases and decorated with an elaborate plasterwork ceiling bearing the date 1913.

THE GROSVENOR GALLERY

G19

Horace Harral (fl. mid-19th Century)
The Grosvenor Gallery, facade 1877
Engraving, 30.5 x 22.9 cm

The Fine Art Society

G20

The Grosvenor Gallery, West Gallery
Illustrated London News, 5th May 1877
Engraving, 33.2 x 23.7 cm

Peter Jackson

Those attempting to launch successful commercial art galleries in London in the latter half of the nineteenth century realised that the way to impress their superiority upon an exhibition-going public was to build the most spectacular premises possible. Art galleries, in architectural terms, announced themselves with as much pomp as contemporary civic monuments.

The opening of the Grosvenor Gallery in 1877 was surrounded by much fanfare and, in the eyes of the art press, was one of the events of the season. While its founder, Sir Coutts Lindsay, proclaimed that the Gallery was not intended to rival the Royal Academy, its programme attempted to revise the exhibition opportunities in London by championing artists who

G19

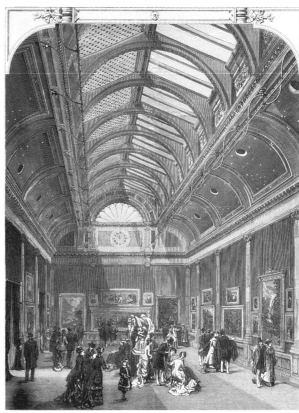

G20

had been badly treated by the Academy or who shunned it altogether.

The facade reproduced the form and decoration of a Renaissance palazzo. For the main facade, four storeys high and three house sites wide, the architect, William Thomas Sams provided a heavily ornamented, three-bay elevation in Portland stone. The two outer bays accommodated shops specializing in luxury goods, while the middle bay was marked by a marble portal in the form of two Corinthian columns supporting a broken pediment. This sumptuous artefact had reputedly come from Palladio's demolished church of Santa Lucia in Venice: its presence in this new shrine of the arts acknowledged the veneration accorded to Palladio in England for many years.

The main, or West Gallery, the largest and most architecturally impressive of the four galleries, was where the most important works were displayed. Its

decoration attempted to transport the visitor into a state of ecstasy.

Directly below the diapered-glass coved roof were iron louvre windows for ventilation, their purpose concealed by zinc panels painted with figures of cherubs by Sir Coutts Lindsay. Below these, bays were painted a deep blue, each ornamented with a representation of the moon in one phase or another surrounded by gold stars. The walls were divided into large panels (matching the division by the bays) by 16 Ionic pilasters, fluted and gilt, which came from the foyer of the Old Italian Opera House in Paris. Crimson silk damask in a rich deep-toned hue, imported from Lyons, covered the upper section of the walls, while green velvet lined the lower dado section beneath the picture rail.

Stephen Fronk

G21

E. W. Godwin (1833–86)

Fine Art Society, No. 148 New Bond Street 1881

Indian ink and red pen with coloured washes, 49 x 68.5 cm

British Architectural Library Drawings Collection/RIBA

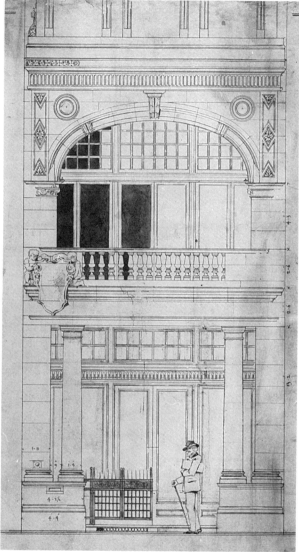

G21

Godwin provided a facade which contrasted markedly with the simpler Georgian buildings which surrounded it. The two existing voids, namely the entrance space which ran the entire length of the frontage and the balcony directly above it, were framed respectively by a pair of square columns on high pedestals *in antis* and a highly sculpted central arch two-and-a-half feet deep. This arch, in addition to monumentalising the entry by making it seem two storeys in height, created a space where the gallery-goer could see and be seen by fashionable Bond Street promenaders. Contemporary critical reaction was favourable, claiming that Godwin had produced *'the most telling and commanding entrance in the whole of Bond Street'*.[2]

Little is known of the original interior of the Fine Art Society, save that the woodwork, which was mahogany, included an effective wall graining for the display of etchings and engravings, and that there was an elaborate frieze in fibrous plaster. The interior was adaptable: quite often artists were invited to decorate their exhibitions to suit the works displayed. Such was the case when Whistler held his famous exhibition of 51 etchings, mostly of Venice, in 1883.

Stephen Fronk

1 RIBA MSS Collection, G/LO.1/12.
2 *Art J* December 1881 p.377.

G22

Edward Robert Robson (1835–1917)

The New Gallery, Regent Street 1890

Photograph

Royal Commission on Historic Monuments

The opening of the New Gallery in May of 1888 resulted from the dissatisfaction experienced by Charles Hallé and Joseph William Comyns Carr, the two assistant directors, with the commercial direction in which Sir Coutts Lindsay was taking the Grosvenor Gallery. E.R. Robson was recommended to the proprietors by Philip Webb as *'the only man in London who can do this for you in the time'*.[1] Hallé and Comyns Carr wanted the existing market turned into a gallery in six weeks.

Robson was faced with the task of making the interior as memorable as possible for two reasons: the comparison that would be drawn between the New Gallery and the Grosvenor, and the fact that the site had no street front on which to articulate the building's function. This, it seems, he achieved, for the premises were described as *'practically the Grosvenor Gallery in a new situation, as far as the pictures are concerned; but architecturally it is more than this'*.[2]

The visitors entered from the street through a corridor, to be overwhelmed by the cavernous space

The Fine Art Society was established in Bond Street in 1876 with a commitment to publishing copies of pictures by British artists. In 1881 its Managing Director, Marcus B. Huish, perhaps as a response to the grandeur of the near-by Grosvenor Gallery, employed the architect E. W. Godwin completely to redesign the exterior to make the façade *'rather less of a shop front'*.[1]

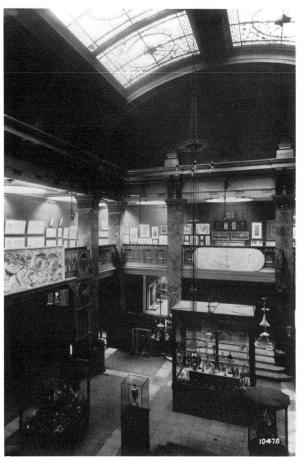

G22

G23

Art, Society and the Grafton Galleries c. 1923
Publicity pamphlet, 8pp.

Tate Gallery Archive

The Grafton Gallery opened its doors in 1893 in Grafton Street, just off Bond Street, claiming that its suite of rooms would be used for the integration of the fine, dramatic and musical arts. The entrance was converted from an existing house to which was added a projecting bay of Aberdeen granite and Portland stone, as well as a frieze on the upper storey in high relief, modelled in Portland cement.

Beyond the small square vestibule lay a short flight of steps lit from an arched ceiling filled with stained glass. On descending these stairs, the visitor found him or herself in the Octagon Room, which was covered by a dome with plastered relief, followed by a large Music Room which lay perpendicular to the axis through the galleries; this led to the Long Gallery, and the End Gallery. The monumentality of the space was intended to impress, for the visitor had to walk more than 250 feet from the beginning of the sequence to the end. The premises housed, as well, a restaurant and a club on the upper floors.

The Grafton Gallery was intermittently extremely fashionable but suffered severe financial difficulties throughout its history. This pamphlet, published some thirty years after the opening of the Grafton when an effort was being made to revive its fortunes, illustrates a constant aspect of galleries: *'the predilection for these galleries as the home for the social functions of the élite of fashionable London.'*

Stephen Fronk

within. This space (G22) was surrounded with a colonnade of square Cippolino columns with large gilt capitals. The walls were lined with panels of the same material, with dark marble plinth and moulding. A gallery with a gilded railing of Greek design surrounded the room at half its height; this gallery, paved with random mosaic and lit by small glass domes, provided an exhibition space for smaller works. The walls above were lined with a gilt diaper paper, topped by a cornice of gilded foliage, with a frieze faced with platinum. The ceiling contained a large skylight filled with yellow stained glass. In the centre of the floor, grey marble banded with red and white, stood a square fountain.

This central hall was primarily for the display of sculpture, or small *objets d'art*. By ascending a few steps one reached the two picture galleries, lit from large central skylights, with walls covered in crimson damask. A restaurant could be reached from the upper gallery and provided a view of Regent Street.

Stephen Fronk

1 *RIBA Jnl*, XXIV p.95.
2 *Builder*, 12 May 1888 p.333.

H Galleries post-1945

H20

H1

Colman Galleries 1951

Castle Museum, Norwich

Robert Aitchison

H2

The Courtauld Institute Galleries 1958

Woburn Square, London

K. H. Urquhart

H3

Kasmin Gallery 1963

Bond Street, London

Ahrends, Burton and Koralek

H4

Kettle's Yard 966–71

Castle Street, Cambridge

Sir Leslie Martin and David Owers (later with Ivor Richards)

H5

Christ Church Picture Gallery 1968

Christ Church College, Oxford

Powell and Moya

H6

Hayward Gallery 1968

Belvedere Road, London

Hubert Bennet and Jack Whittle

H7

Tate Gallery, addition 1973–9

Millbank, London

Llewelyn-Davies, Weeks, Forestier-Walker and Bor

H8

Hunterian Museum, addition 1973–80

University of Glasgow

William Whitfield

H9

National Gallery, North Wing 1974

Trafalgar Square, London

Property Services Agency

H1

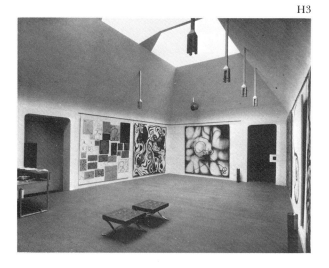

H2

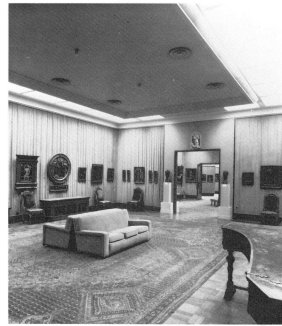

H3

H4

H7

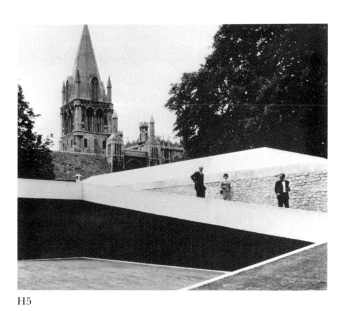

H5

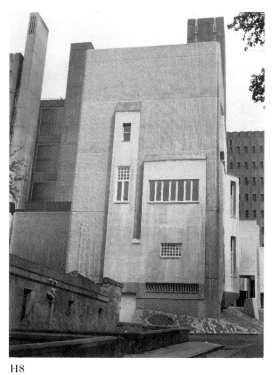

H8

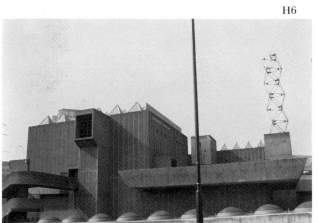

H6

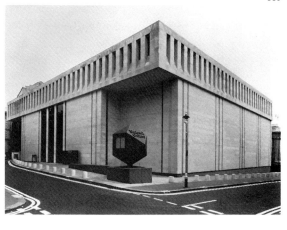

H9

173

H10

Sainsbury Centre for the Visual Arts 1978
University of East Anglia
Norwich, Norfolk

Norman Foster Associates

H11

Norman Foster RA (b. 19xx)
Sainsbury Centre, 4 views
Pen drawings, 21 x 30 cm

British Architectural Library Drawings Collection/RIBA

H12

Tate Gallery, Clore Building 1980–86
Millbank, London

James Stirling, Michael Wilford and Associates

H13

Matthiesen Fine Art 1981
Masons Yard, London

Burnett and Brown

H14

Burrell Collection 1983
Pollok Country Park, Glasgow

Barry Gasson Architects

H15

Saatchi Collection 1984
98a Boundary Road, London

Max Gordon and Associates

H16

Tate Gallery 1985–88
Albert Dock, Liverpool

James Stirling

H17

Grob Gallery 1988
20 Dering Street, London W1

Arata Isozaki

H18

Sainsbury Centre for the Visual Arts 1991
University of East Anglia
Norwich, Norfolk

Norman Foster Associates

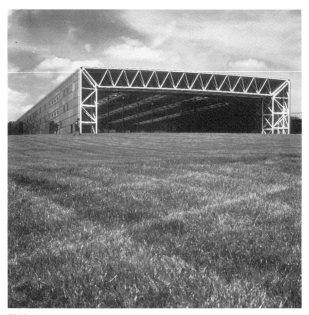

H10

H12

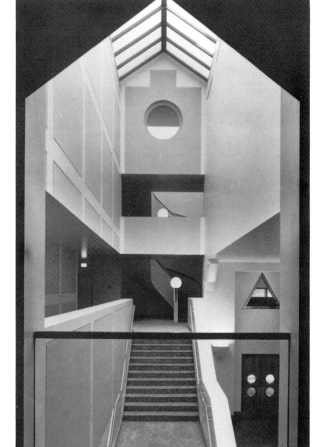

H13

H16

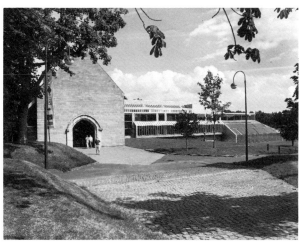

H14

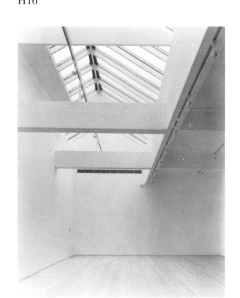

H17

H15

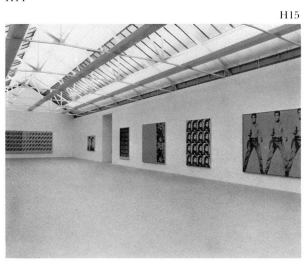

H18

H19
Robert Venturi and Denise Scott-Brown

National Gallery, Sainsbury Wing

(a) Gallery Level Plan 1987
 Grisaille, pen, ink and watercolour, 96.5 x 77 cm
(b) View of Gallery Extension from Trafalgar Square 1987
 Pencil and watercolour, 82.5 x 94.7 cm
(c) View of Galleries 1987
 Pencil and ink, 92.5 x 83.2 cm

The Trustees of the National Gallery

H20

The Sackler Galleries 1991
Royal Academy of Arts
Piccadilly, London

Norman Foster Associates

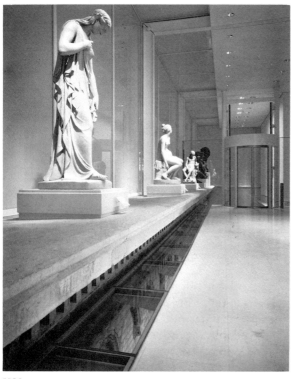

H20

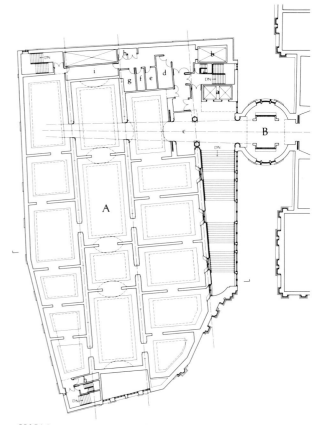

H19(a)

H19(b)

176

The Architecture of Post-War Galleries *Colin Amery*

It was the American architect Philip Johnson who perhaps best expressed the feelings of architects about the design of new museums and art galleries. He was writing about the boom period of museum design in America, Europe and Japan which occurred in the 1970s and 1980s, when he said, *'purely aesthetically speaking, the museum is an architect's dream. He has – as in a church – to make the visitor happy, to put him in a receptive frame of mind while he is undergoing an emotional experience. We architects welcome the challenge.'*

It has probably always been the case that the great museum is one of the finest opportunities for an architect to put his work to the forefront of the public stage. Often the design of a national museum or gallery has been produced as the result of a major architectural competition. The accompanying publicity, whether it is good or bad (and there have been some spectacular rows about the designs of new museums), has raised the level of both public and professional architectural interest in the whole subject. It would not be wrong to say that the architecture of some new museums is more significant than the collections housed. There was a craze for new buildings in the 1970s and 80s that can almost be paralleled by the boom in church building in the late nineteenth century. The new gallery became the focus of social, civic and financial attention. It also became the subject of heightened public discussion and sometimes hysterical professional architectural debate. It is this debate that provides the background to this survey of the history of 'Palaces of Art'.

Anyone looking at Britain since the Second World War with even a half-open eye could be excused for not catching sight of much good architecture, either public or private. If there was some it would be reasonable to expect to find it in the world of the museum and the art gallery. There are a few peaks and pioneers among the morass of mediocrity, but Britain has not generally been as fortunate as Germany and America in the architectural quality of her new galleries. The collection of material in this book and exhibition shows that it was in the nineteenth century that Britain experienced the kind of growth of public galleries that America has enjoyed in the twentieth century. However in the years after the ending of the Second World War, with the notable exceptions of the Burrell Collection in Glasgow and the Sainsbury Centre for the Visual Arts in Norwich, the history of new galleries in Britain has been principally a story of additions to older galleries or modest new ones.

It is the architecture of the major public galleries in this period that is the main concern of this essay. They can be seen as both political and stylistic symbols of the creative health of the nation. Two examples from the 1960s will serve as valuable introductions to the dilemma of gallery design.

In Cambridge the inspired vision of one man, Jim Ede, left to the University and the country one of the most remarkable and important small galleries of twentieth century art, known as Kettle's Yard. Jim Ede's life and work were dedicated to the communication of artistic values to the public, particularly to the young undergraduates of the university, in a way that is not didactic but almost a means of spiritual communication. By gentle exposure to some of the finest works of art of the time in a setting that was domestic and virtually lived in, he hoped to avoid any institutional or rigid approach to art education. Jim Ede formed one of the most remarkable collections of modern British art (of the period 1912–1969) and introduced it to undergraduates by keeping open house during every term-time afternoon. By this means young people were able to come to Kettle's Yard and in as relaxed a way as possible look at works of art and other objects of beauty. Jim Ede encouraged them to visit as friends and promoted the consultation of books and conversation, and allowed students to borrow works of art in order to experience live works of art rather than reproductions. After the collections were given to the University of Cambridge in 1966 additions were gradually made in the form of exhibition galleries in 1970, 1981 and 1984. The architects concerned

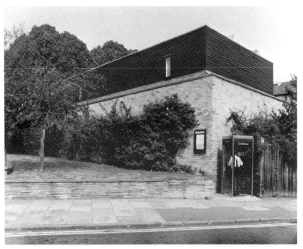

Kettle's Yard, exterior

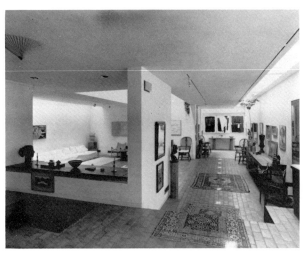

Kettle's Yard, interior

with these delicate and modest extensions were Sir Leslie Martin with David Owers and later Ivor Richards.

The special qualities of Kettle's Yard are best described by Jim Ede himself: *'a continuing way of life from these last fifty years, in which stray objects, stones, glass, pictures, sculpture in light and in space, have been used to make manifest the underlying stability which more and more we need to recognise if we are not to be swamped by all that is so rapidly opening up before us.'* He wanted it to be seen as, *'a nursery for the visual arts'* and an introduction to the formal art gallery like the Tate or the Fitzwilliam. This posed not inconsiderable design problems for the architects who were charged with the responsibility of maintaining the atmosphere of a home. In the house there are no labels; objects, pictures, stones and vases of flowers are all mixed together as they would be in anyone's home. It was the architects' problem to continue the communication policies of Jim Ede in a more public set of gallery extensions. Scale, intimacy and atmosphere and the play of light determined the final free plan of the new galleries. By 1970 some 4,200 square feet was added to the original houses. The plan, an echelon arrangement of open interpenetrating rooms with several changes of level, works well in circulation terms and provides intimate and larger spaces. But it is the careful and subtle manipulation of natural light that makes the galleries especially successful. The setback between the brick perimeter walls and the upper level light-weight timber framing allows for a continuous strip of natural top light. From time to time windows allow both views and the

introduction of side light. This also helps to increase the air of domesticity.

Kettle's Yard seems to us today very much a period piece. The aesthetic approach of the architect Sir Leslie Martin coincided precisely with the material quality of the collection. It is unusual for such a harmony of intention to be manifest in any gallery. The mood of Martin's work is cool and abstract but it also has the air of a vernacular conversion. Perhaps it is no coincidence that Martin occupied for a long time a converted mill outside Cambridge where his own collection of works of contemporary art enjoyed a domestic ambience. There is also a Puritanism in the air in Cambridge – a fenland reserve that resists display and the grand gesture. The sensibilities are restrained and Kettle's Yard precisely captures that low key politeness that produced a certain bloodless vein of British abstraction. We are definitely not in the world of Matisse and Picasso.

It was Sir Leslie Martin who gave the Architects' Department of the London County Council such a strong image in the 1950s. His influence lingered on into the successor body, the Architects' Department of the Greater London Council. But if Leslie Martin's influence can be seen in the planning of the South Bank it was a team under the direction of Hubert Bennett and Jack Whittle who designed the Hayward Gallery from 1965–1968. Many of the younger architects on this team had been enthusiasts for Archigram – the world of the high-tech megastructure devised by guru Peter Cook. The triple-headed cultural monster that arose on the South Bank is in fact Archigram-built, not in

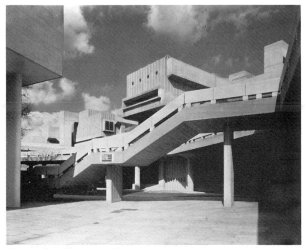

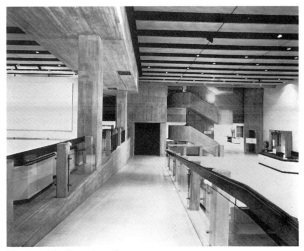

Hayward Gallery, exterior | Hayward Gallery, interior

light weight materials, but in solid concrete. It is difficult to imagine more of a contrast to the private world of Kettle's Yard. The Hayward is a major public exhibition space that makes a major public statement in architectural terms as part of the South Bank arts complex (this is one of the few occasions when the word 'complex' seems entirely appropriate). In architectural terms the Hayward has to be seen as part of the whole design that includes the Queen Elizabeth Hall and the Purcell Room as well as the labyrinth of exposed concrete walkways that are today so much despised.

The Hayward was built for the temporary exhibition of works of art – originally shows organised by the Arts Council of Great Britain. It has no permanent collection. It therefore operates in a completely public way – visitors pay to go into the galleries and they are served by a back-up of services and storage that are appropriate to the temporary display of travelling exhibitions. Stylistically the Hayward is a direct descendant of Le Corbusier. The main structure is of in-situ concrete and there is no external or internal decoration. Sculpture terraces look bleak in the English climate and the curved staircases derived directly from *L'Unité d'habitation* in Marseilles seem pointless here. There is nothing to indicate from outside that this is not a power plant or a secret laboratory for vivisection. The almost windowless facades and the apparent lack of an easily identifiable entrance suggest some dark and clandestine activity within.

In fact, however deeply disagreeable from the outside, the Hayward has worked well for some exhibitions. It has to be treated like a studio in

which almost anything can be assembled. There was a delicious irony when major fragments of some of Le Corbusier's buildings were re-erected in a Le Corbusier exhibition in the Corbusian spaces of the Hayward Galleries – concrete in concrete. Technically the Hayward's 20,000 square feet of exhibition space performs just about adequately, air is filtered, light is controlled – there is some air conditioning and some humidity control.

The experience of looking at works of art in the Hayward (and in the City of London Barbican Gallery) is affected by the sheer brutality of the surroundings. It is difficult to comprehend the architectural decisions that led to the erection on a Thames-side site of a public building that offers no public facilities, restaurant or café with a river view. While it is understandable for an art gallery not to have windows, that does not excuse the contempt shown by the Hayward for its magnificent site and the general disregard for the pleasure of the public. There is another area where the designers fell down very badly. I have worked on a major exhibition at the Hayward and the subterranean conditions for exhibition staff are almost unbelievable. Recent proposals put to the South Bank Board for the demolition of the Hayward Gallery have had a mixed reception. It looks at the time of writing as though the walkways will certainly be demolished and entrances rearranged at ground level but there is little that can be done to improve the dominant architecture. It remains as an inhuman reminder of its time – and a terrifying contrast to the delicate sensitivities

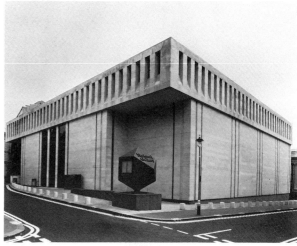

Tate Gallery extension during construction

National Gallery, North extension

espoused by Jim Ede in Cambridge. The mystery remains, why did the designers of this public exhibition space ignore the need for fine surroundings that can enhance the contemplation of a work of art? The bunker mentality that produced the Hayward is a manifestation of an architectural philistinism that almost amounts to nihilism.

These two contrasting examples of the British post-war approach to the architecture of art galleries represent the two extremes. From modest intimacy and a delicate flirtation with the abstract to the brazen brutalism of an inappropriate imported ideology – these are the architectural polarities. There is another stream that flows through British cultural life. It is the stream that runs through the boardrooms of pension funds and around the tables of trustees. It is the water of compromise, the committee decision, the art of understatement.

Two major London museums, the National Gallery and the Tate Gallery, followed this course in the 1970s when their Trustees decided to add extensions to their existing buildings. To be fair to the Tate – they did initially produce a plan that was far from a compromise. A new glass building was proposed that was to be built across the front of the existing portico extending the entire building towards the river. There was a stunned reaction from the conservation and historic buildings' preservation bodies – and the plan was dropped in favour of additional galleries to the rear of the existing Tate. The architects were Llewellyn-Davies, Weeks, Forestier-Walker and Bor. They produced a low key, indifferent building. On the

outside it is a mildly Miesian box – on the inside the weighty concrete ceilings belie the efforts that were made to achieve a lively source of visible daylight. The desire for completely flexible spaces below the grid of the ceiling suggests a curatorial uncertainty – total flexibility seldom produces well proportioned spaces and movable walls are rarely moved. Limited government funding and a bureaucratic building system produced an extension that is both unadventurous and understated.

The National Gallery made similar errors with its Northern extension which was designed by Government architects – the Department of the Environment directorate of ancient monuments and historic buildings (director – J. C. Ellis). This opened in 1975. From the outside the extension attempts in an abstract way, by the addition of a highly articulated top floor, to echo the cornice line of the original William Wilkins building. It is not a success. The galleries themselves have effective natural top lighting controlled by louvres. It is the plan of these galleries which is unsatisfactory, resulting in a series of inelegant narrow high rooms which always feel temporary. Designed in the heyday of fluorescent lighting, the galleries suffer from the deadening effect of a fixed fluorescent supplementary system.

The distinguished architects Powell and Moya also achieved that sense of the discovery of hidden treasure displayed in a private yet public place in their almost subterranean gallery at Christ Church, Oxford. Because of the sensitivity of the site in the Dean's private garden they managed almost to conceal the gallery by rolling back the

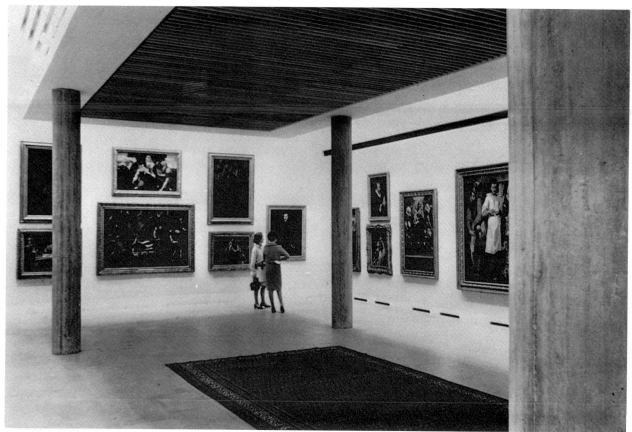

Christ Church, Oxford

carpet of the garden and tucking the gallery underneath. The permanent collection at Christ Church consists of three bequests, the Guise, Fox-Strangways and the Landor gifts, and includes oil paintings, Italian primitives and Old Master drawings. The stone and concrete building has a rugged quality – stone floors and rough plaster walls – which works contextually for a garden building but is not entirely satisfactory as a background for all the pictures. The main galleries have top lighting both natural and artificial. The lighting is successfully concealed but the visitor is left with a retinal impression of very strongly lit walls. It is the architectural dignity and simplicity that carry the day at Christ Church – as well as the appropriateness for the site. Powell and Moya sadly have not designed any major art galleries, although they are responsible for the Museum of London.

A close neighbour in spirit to the Oxford gallery, although designed to house a much larger permanent collection, is the competition-winning building for the Burrell Collection in Glasgow. There was a two stage architectural competition to design

a home for the remarkable bequest of the collection of Sir William Burrell in 1971. The competition was won by Barry Gasson and his building opened twelve years later. The galleries are set in the parkland of the grounds of Pollock House and have been designed to relate closely to the woodland setting. The architect had two firm guidelines – one, the 'green field' setting and two, a fixed permanent collection of paintings and artefacts of all kinds that included three actual rooms from Burrell's home.

Gasson's building for the Burrell is a considerable success. It is stylistically related to Scandinavian mid-twentieth century architecture with its use of a laminated timber roof structure and its open glass walls allowing views into the woods. The influence of Alvar Aalto and also of the museum in the woods at Louisiana near Copenhagen is plain to see. The particular success of the Burrell is the architect's achievement of a timeless but not neutral setting for a range of works of art that cover a period of more than 4,000 years. This has been done by the selection of materials – stone

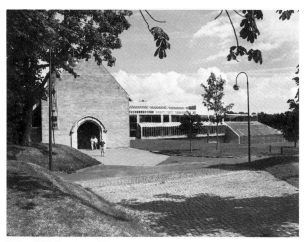

Burrell Collection, Glasgow

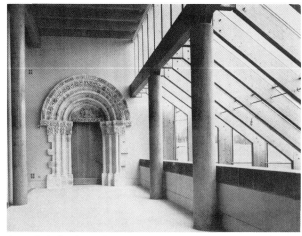

Burrell Collection, 12-century portel

floors, walls of stone or plaster and a great timber roof. There are in the collection major architectural elements – portals from Hornby Castle in multi-coloured sandstone – a Romanesque arch and other elements that have guided the nature of the architectural solution and the choice of materials. The exterior of the museum is simple and contemporary utilising in a very restrained way stainless steel, glass, and stone.

The interior planning of the Burrell has achieved something which many curators and architects have failed to do. Despite the richly varied character of the collection a primary route through and around it has been organised with a skill that makes comprehension both pleasant and easy. It is also possible to concentrate on specialised areas of the collection and for scholars to reach storage areas easily. The Burrell succeeds because working with the architects had the advantage of having a permanent collection and knowing that they had to design specific homes for specific objects. The bespoke nature of the galleries makes them feel right – this is a key factor in the design of galleries that can only be achieved with known permanent collections. This is a curatorial as well as an architectural matter. The actual placing of an object or a painting can make that object memorable or easily forgettable. The stained glass and tapestries at the Burrell are superbly shown but it is also simple things like the placing of the Chinese polychrome lohan figure that remain in the mind. That is the key to the success of gallery design – the enhancement of pictures or objects – and the architect of the Burrell has pulled off a considerable triumph.

The late 1970s and the 1980s have seen some of the most senior and famous contemporary British architects, Sir Norman Foster and James Stirling, design new art galleries. One American architect, Robert Venturi of Venturi, Scott Brown Associates, beat a mainly British field to win the competition for the Sainsbury Wing of the National Gallery which opened in 1991.

The Sainsbury Centre for the Visual Arts which opened in 1978 is a building of enormous interest because it applies all the technology of the most modern architecture to the display and teaching of art and art history. The huge hangar-like building on the campus of the University of East Anglia outside Norwich deserves that over-used epithet – seminal. Foster applies the technology of the serviced shed, the idea of the all-embracing building envelope to the design of fine art building. His language is industrial but at an extremely refined and elegant level. There is nothing facile about Foster's application of technology to architecture as there can be in some more extreme examples of high-tech architecture. The plan of the centre is subtly graded between public and private space, and the recent addition of the Crescent Wing has provided an exhibition gallery as well as remarkable facilities for conservation and the study of museum lighting. The new wing has been described as adding a cockpit to the plane in the hangar – but this has been largely below ground level.

There have been debates about the scale of the Foster building in relation to some of the objects in the collection, and about the appropriateness of the open plan. I have always found the reticence of

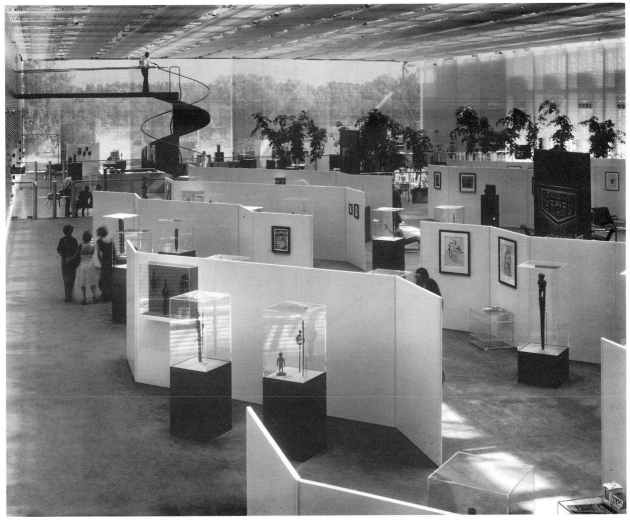

Sainsbury Centre for the Visual Arts, Norwich

Foster's work its most distinguishing factor. There is a pleasure in the way unobtrusive but refined technology at the service of art offers its own quiet satisfaction. That is an area where modern architects can achieve successful marriages between tradition and the functional future.

When he was asked to design new galleries within the hallowed walls of Burlington House Sir Norman Foster faced both a spatial and an aesthetic challenge. The new rooms, known as the Jill and Arthur M. Sackler Galleries, occupy the space on the top floor of the Royal Academy where the old Diploma Galleries were once located. Foster has brilliantly provided the two missing elements – space and light. His elegant glass lift and glass stairs take visitors to a sculpture promenade which sits beneath a lightweight framing structure. The galleries themselves are three solid and simple spaces, their white plainness relieved by coved ceilings.

James Stirling offers another formula. His Clore gallery for the Turner Collection at the Tate proposes a stylistically distinctive architectural solution that is itself a display of architectural references relating to its classical neighbour. The Turner pictures demanded rooms – a series of small and large spaces that relate directly to the permanent collection. The daylighting is of supreme importance for Turner and is achieved elegantly through sun-screened roof lights and sun scoops that make the source of daylight mysterious. James Stirling's architecture is about a new kind of architectural contextualism. On the outside the Clore Wing has four elevations relating to the

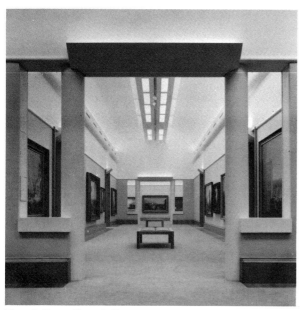

Tate Gallery, Clore Gallery

Tate Gallery, Liverpool

garden, the Tate itself and the service areas to the side and rear. There are mannerist elements in the colourful entrance hall and staircase with its asymmetric wall treatment and bizarre colours. The mild shock of the entrance areas is soon forgotten in the calm and diffused light of the galleries themselves. Although these are dignified and cool spaces they suffer a little from feeling rather narrow and small. The monumental elements that Stirling plays with in the gallery doorways and much more so on the outside of the building suggest that these elements are cut out of a less substantial material than brick and stone. Stirling brings to his public buildings a kind of toy monumentalism that is as entertaining as it is baffling. The Tate Clore galleries are precise examples of the state of architecture at the end of the twentieth century. Traditional materials are used in a non-traditional way, ornament is applied with scissors and paste in a way that can distract from the sculptural qualities of spaces convincingly cut from solid forms. Stirling involves the visitor in his own journey through architectural history. The journey is more elaborate and complex in his Staatsgalerie in Stuttgart; at the Tate his Englishness, or perhaps his clients, have created more of a compromise building, pleasing puzzle.

When Stirling was asked to carry out the conversion of part of the Jesse Hartley Albert Dock buildings in Liverpool for the Tate of the North it seemed a perfect marriage. Stirling's rugged archi-

tectural approach and his awareness of history have made for a powerful set of new galleries. The problem of leaving intact the majority of the Hartley interiors has meant that the installation of elaborate service ducts below the old ceiling plane is an intrusive element. The Maritime Museum (part of the National Museums and Galleries of Merseyside) in the same group of buildings has been much more lightly converted by the Liverpool architects Brock Carmichael.

The opening of the Sainsbury Wing of the National Gallery in 1991 was an event that seemed to offer some kind of consummation of the debate about the design of galleries. The architects Robert Venturi and Denise Scott Brown won a limited competition in January 1986. Their design has been controversial but almost universally welcomed for the high quality of the actual galleries for the National Gallery's Early Renaissance Collection. They have achieved two major things – lively but controlled daylight and an appropriately evocative setting for these important pictures.

The relationship of the new wing to the old gallery is ingenious. Taking some of the elements of the old facade and stretching them like a stone curtain in front of a modern building has contributed a scenographic element to Trafalgar Square that is pleasing and restrained. The public elements of the interior – the grand staircase and the long perspective into the old building – are both architecturally enjoyable and practical. The

184

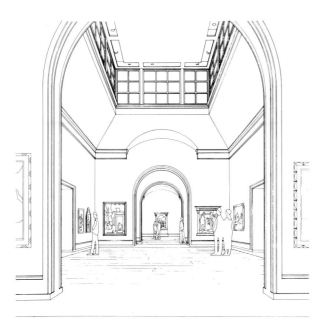

National Gallery, London, Sainsbury Wing

influence of Dulwich Picture Gallery is unmistakable in the main set of galleries but they have their own potent atmosphere redolent of a Florentine Renaissance interior and imaginatively appropriate to the paintings.

The National Gallery's new wing represents at present the end of a long public saga and architectural debate. But the discussion will inevitably continue because of the plurality of architecture being produced in Britain at the end of the twentieth century. Galleries are inevitably caught up in the stylistic intrigues of the architectural profession. The British achievement in the design of galleries is evident on two fronts. A pioneering use of technology married to the best architectural design is present in some of the latest galleries. But there is also a sensitivity to the past which can be utilised to inspire the future. In the end the architect when he is designing galleries is the servant of the artist – a role that is hard to play – because it demands an interpretative skill that can encourage that communication between artist and viewer that is both rewarding and difficult to achieve.

Select Bibliography

This list of works contains a number of general studies of the history of galleries and collections in Britain, many of which are referred to in the text. More specific references about institutions discussed in the catalogue can be found at the end of individual entries.

Chapel, J. and Gere, C., *The Fine and Decorative Art Collections of Britain and Ireland* (1985)

Fawcett, Trevor, *The Rise of English Provincial Art* (1974)

Haskell, Francis, *Rediscoveries in Art* (1976)

Hazlitt, William, *Sketches of the Principal Picture Galleries in England* (1824)

Herrmann, Frank, *The English as Collectors* (1972)

Jameson, Mrs., *Companion to the Most Celebrated Private Galleries of Art in London* (1844)

History of the King's Works

Levin, Michael, *The Modern Museum: Temple or Showroom* (1983)

Maas, Jeremy, *Gambart, Prince of the Victorian Art World* (1969)

McClellan, Andrew, *The Politics and Aesthetics of Display: Museums in Paris 1750–1800* (Ph.D thesis, London University 1987)

Papworth, J.W. and W., *Museums, Libraries and Picture Galleries, Public and Private* (1853)

Pears, Iain, *The Discovery of Painting* (1988)

Pevsner, Nikolaus, *A History of Building Types* (1976)

Pyne, W.H., *History of the Royal Residences* (1817–20)

Redgrave, Richard, 'Construction of Picture Galleries', *The Builder*, 28 Nov 1857

Robertson, David, *Sir Charles Eastlake and the Victorian Art World* (1978)

Russell, Francis, *The Hanging and Display of Pictures, 1700–1850* in (ed.) G. Jackson-Stops, *The Fashioning and Functioning of the British Country House* (1987)

The Survey of London

Waagen, Gustav, *Works of Art and Artists in England* (1854)

Westmacott, C.M., *British Galleries of Painting and Sculpture* (1824)

Index of Catalogue Entries